T0408682

Anarchitectural Experiments

Anarchitectural Experiments

When Unbuilt Designs Turn to Film

Maciej Stasiowski

intellect

Bristol, UK / Chicago, USA

Copy editor: Newgen
Cover designer: Maciej Stasiowski
Cover images: 1. Detail from *The Red Wall* series depicting La Muralla Roja
(Ricardo Bofill) © Sebastian Weiss, 2020. / 2. Detail from Giovanni Battista
Piranesi's *Veduta Dell'Interno Dell'Anfiteatro Flavio Detto Il Colosseo*
(H. 78), 1766. / 3. Detail from John Mallord William Turner's
Shrewsbury: The Old Welsh Bridge, 1794.
Production manager: Debora Nicosia
Typesetting: Newgen

Hardback ISBN 978-1-78938-542-7
ePDF ISBN 978-1-78938-543-4
ePub ISBN 978-1-78938-544-1

To find out about all our publications, please visit
www.intellectbooks.com
There you can subscribe to our e-newsletter, browse or download our current
catalogue, and buy any titles that are in print.

This is a peer-reviewed publication.

Contents

Figures

Introduction
Lebbeus Takes Us Outside

Drawings [...] can be exhibited, published, filmed, digitized, and therefore widely disseminated, when the architect is ready to place them in public domain. Until that time, the architect is freed by drawing's inherent intimacy to explore the unfamiliar and the forbidden, to break the old rules and invent new ones.

(Woods 1997: 30)

The dynamics of contemporary urban life have shown the inadequacy of existing languages in dealing with rapid and continuous change, except by producing self-contradictory – paradoxical – constructions. [...] However, by insisting on the manifestation of paradox in architecture, architecture's language can be expanded to include the unpredictable arising from a dynamism that has become the essence of modern existence.

(Woods 1997: 28)

As one surveys the cityscape, he is likely to find anything but modesty in regards to monumental, massive structures in plain sight. Urban theory urged us to look at metropolitan scenery and infrastructure as a spatial mapping of ideologies. And nothing exposes ideology as fervently as manifestos and their visual equivalents on paper. The speculative line of architectural drawings has always been a haven for criticism, reflecting on the built environment and reconsidering alternative lines of urban development. Lebbeus Woods opted for a more challenging, less acquiescent and thus predictable kind of building enterprise; for an architecture that would go 'rogue'. In the course of his practice, interrupted by his sudden death in 2012, opportunities for embodying Woods's theoretical projects were rather scarce. His proposals were mainly targeted at ruined urban districts, combat zones and post-traumatic sites – places that would benefit from architectural surgeries much more than from developers' schemes. Oddly enough, the 'failure' of Woods's blueprint for architecture-to-come cannot be attributed to usual or 'natural causes'

FIGURE I.1: Lebbeus Woods, *Quake City*. From *San Francisco: Inhabiting the Quake*, 1995. Graphite and pastel on paper. © Estate of Lebbeus Woods.

(for this line of work) – costs and material constraints. 'Guilty' was the scope of his proposals, and their radical character echoed in a call for reconstruction without demolition. Woods preferred refurbishing, patching up and fixing damages inflicted in urban war zones and disaster areas. Tabula rasa politics erases visual remnants of conflict, while at the same time reinstating the mode of living that has been so violently ruptured. This is among the most straightforward ways to distort history. Woods designed with an architectural 'year zero' in mind, envisioning an anarchitecture one could set his expatriate compass to.

Just like many architects before, equally reluctant to silently support the established order of things, Lebbeus Woods became symbolically relegated to the drawing board and labelled a 'theoretician'. Derogatory term in some circles, perhaps, yet in this context it denotes a profound heritage. Eventually, this activity is much more than an end in itself, as it is of use in crystallizing one's vision, spreading ideas in academia and portraying present violence of architectural practice in dystopian rhetoric by means of graphical language (even though, for many contractors, Woods's designs must have seemed like acts of graphic violence themselves). Architectural domain, since rediscovering Vitruvius in the fifteenth century, has increasingly relied on visual aids – plans, technical drawings, perspectival renderings, seen not only as

records informing proper construction but also as means to communicate between the architect and the client (besides other parties involved). Especially architectural renderings, as they rely on pictorial arts to the furthest degree, have been regarded as instruments of seduction. Depicting the finished building in a joyous, semi-utopian environment, supposedly brought about by nothing else other than the architect's in(ter)vention, always incorporates a glimpse into a retouched future that enchants the addressee. In comparison, speculative works of paper architecture seem like a negative, dystopian mirror which counters such enthusiasm. Lebbeus Woods's designs for traumatic, post-disaster sites of Sarajevo, Havana or San Francisco are intriguing, yet ruthless. Instead of depicting accomplished futures, they recast contemporary anxieties, feelings of fracture and incompleteness into the form of makeshift spaces that challenge permanent, although ruined settings.

Even though these projects were destined to remain on paper, exhibitions, magazine publications and art book portfolios proved to be enough of a 'vessel' to pass on the notion of 'freespaces' and 'radical reconstruction' – Woods's main concepts – spreading his philosophies along with the imagery accompanying them. Not illustrations but visual representations of spatial forms resulting from precise ideas on architecture's shape and role. These days, iconicity and overall circulation of imagery is a phenomenon of a viral nature. Woods was not upset with the rejection of his architectural projects. The immunological system of architectural practice would fight off his propositions, but in order to do so, first, it would have to ingest, 'consuming' them visually. His imagery needed to circulate inside the discipline's vast body, nourishing imaginations of students and his fellow artisans not only with prospects of what can be built but what is at all possible to conceive of in spatial terms. Architectural projects of experimental, speculative constitution have always taken advantage of their imagery's entrancing nature, wrapping up the brutal and the radical in a glimmering tinfoil of fantastic creations. Most importantly, Woods's anarchitecture is a direct response to metamorphoses taking place within a society that is concerned with technology, politics and natural environment, among multiple other factors. His structures 'react' to political events in a considerably shorter response time than most 'real life' architectures – the built forms we interact with, inhabit, attempt to make adaptable and functional. Perhaps that is why the American architect never ceased to be regarded as an outsider; a 'paper architect' called upon in times of crisis; who once wrote that

> when society can no longer define itself in classically deterministic, objective terms, but only in terms of continuously shifting, fluid-dynamical fields of activity, then architecture must forsake the monumental, because there is no hierarchy to valorise, no fixed authority or body of knowledge external to human experience to codify.
>
> (Woods 1993: 6)

And it did, although mostly virtually. Since the eighteenth century – the age when Piranesi's engravings informed by discoveries of Pompeii and Herculaneum began to circulate in culture – this has been the modus operandi of visionary architectural projects.

Define: Speculative

A failed work, an unrealized attempt, a fragment: do they not, perhaps, raise problems hidden by the completeness of works that have attained the status of 'texts'? Do not Alberti's 'errors' in perspective or Perizzi's excessive 'geometric games' speak more clearly of the difficulties intrinsic to the humanist utopia than do those monuments that appease the anxiety appearing in these incomplete attempts?

(Tafuri 1987: 13)

There is a considerable difficulty in defining the 'speculative' in architectural texts, without getting lost in a labyrinth of semantic constructions with an entirely different application[1] than that of paper architecture. Examining Giovanni Battista Piranesi's *Carceri* series, Manfredo Tafuri states in the aforementioned quotation that there is a significant surplus value embedded in speculative architectural projects, which makes them stand out as documents of theoretical examinations and investigations into intricacies of built form, sociocultural context of the times, while exploring alternatives for already-built structures, even if overlooking material constraints in the process. 'Speculative' is a considerably broad term (more focused on process and purpose than on content), assuming that architects shall remain preoccupied with abstract, far-reaching concepts when visualizing their ideas by way of trial and error. Also, it encompasses visionary architectural works that remain unbuilt, as well as those that are unbuildable 'by design'. The notion of 'unbuildability' informs this study to a great extent, along with utopian aspects present in specific projects. They force interpreters to read works of paper architecture[2] as irreducible to a set of technical instructions informing building construction. Jeffrey Kipnis provides a clear-cut distinction between 'the service architect [who] seeks to expertly fulfil the needs and desires of a client' and one with an inclination towards utopian imagination, assuming that 'the speculative architect foregrounds his effort to change architecture so that, in turn, can help shape a better world' (2007: 86). Following Kipnis's doubts concerning speculative architecture as a rebuff of the status quo, it indeed appears dubious whether theoretical projects, aside from their purely idealistic ruminations, serve any substantial purpose. Especially if they are viewed from the perspective of a project's future performance, not vague precognition. Thus, these theoretical investigations should only be validated on the basis of the role performed within the borders of

discourse, viewed from the perspectives of: architecture (conceptual sketchpads, student design exercises, visual investigations of theories, 'activity diaries' created in times of economic recession, when commissions are rare), art (art gallery objects, texts of culture, interactive installation pieces) and cinema (background mattes, elements of set design, computer-generated [CG] environments). Also, such designs should not fall under the (patronizing) auspices of experts who judge them on the basis of economic feasibility. Nobody would prove them profitable in the short run. In a different context, the term 'speculative' implies economic assessment of risk factors, putting emphasis on the creation of simulation models, in order to track incomes and losses. These associations abuse broader notions of efficiency, which can be harmful if applied in certain areas of creative production. This is exactly the case of paper architecture, formulating proposals for alternative modes of living and envisioning realities better suited for contemporary needs, habits and rituals; a cogitation which requires anything but haste and precipitance.

In order to reappropriate the term, along with its innovative research methods, formal exercises and trial-and-error investigations into purely architectural themes, I inspect this tradition from the standpoint of emerging animated film productions and design-research projects, conducted in a purely visual field of representation. There is undeniable nobility in unbuilt and unbuildable architectural projects, which seek to investigate architectural discourse as such, instead of 'simply' contributing to the built environment. It encompasses Piranesi's plates and Bernard Tschumi's *Manhattan Transcripts*, NaJa & deOstos's *The Hanging Cemetery of Baghdad* and Neil Spiller's *The Island of Communicating Vessels*. Even if the eponymous island of Spiller's more-than-a-decade-long research project is conducted with traditional methods of architectural representation, they embark on depicting a reality significantly more fluid, dynamic and ephemeral than the usual settings we came to inhabit, traverse or pay visit to. After all,

> architecture is not only what is built; it is also a conceptual trajectory, the comparison of concepts stemming from heterogeneous disciplinary fields, which exempt it from all formal unification and open it up to its future development. This ceaseless exploration, which pushes architecture out to its conceptual and disciplinary boundaries, permeates all the projects in this collection.
>
> (Alison et al. 2007: 15)

Of cargos and vessels

Similar confusion to that stirred up by the term 'speculative' is raised in regards to 'mediatized'. 'The term "mediatization" has been used in numerous contexts to

characterize the influence that media exert on a variety of phenomena' (Hjarvard 2013: 8), and it 'refers to communication via a medium, the intervention of which can affect both the message and the relationship between sender and recipient' (2013: 19). Even though the case studies brought up here will appear as examples of mediated communication, in which the medium affects both the message as well as the parties involved in the act of 'communication', 'mediatization' – as a term deriving from social sciences – is meant to draw attention to the idea that artefacts always function in a wider discourse, affecting not only specific, sample instances of speculative projects but – in a sociocultural practice (and process) – also the modes of their production and exhibition. Alternatively, what Andreas Hepp terms 'mediatization' is a process of establishing and understanding interconnections between media communication and historical transformations (2013: 38), arguing for a panoramic perspective, encompassing and accounting for any long-term changes. 'Mediatization [...] deals with the process in which these diverse types of media communication are established in varying contextual fields and the degree to which these fields are saturated with such types' (2013: 68). Simultaneously, it defines the circumstances in which new generations of architectural students encounter such utopian projects and incorporate them into their own thinking and working methods, as part of a visual repository of forms. Therefore, what is meant by mediatization is a gradual immersion in bleeding edge technologies and media, while leaving enough space for issues concerning the discourse in which these specific instances of technology along with sociocultural practices informed by them are submerged. In turn, those media, which are representative of the episteme,[3] understood here 'as the system of concepts that defines knowledge for a given intellectual era' (2013: 9) are feeding back on the technique, method and content of representation. In this perspective, the 'vessel' is viewed as linked to its 'cargo' in an autopoietic relationship (Maturana and Varela 1980: xvii–xviii, xx–xxi). We do not necessarily have to relate to mass media processes as far as we acknowledge their bilateral influence in regards to medium of representation and discourse involving its role and application. Stig Hjarvard sees the twentieth century as that high point in history which brought about the appearance and expansion of mass media, considering it as a defining moment for media perceived both as a cultural and technological phenomenon of global coverage (Hjarvard 2013: 6). Even though this study focuses primarily on the latter half of the twentieth century, narrating a proliferation of means and representation techniques at architects' and artists' disposal – beginning with film and gradually incorporating video and digital technologies further along the way – there is a substantial reason for analysing speculative projects from the standpoint of technological constraints and possibilities intrinsic to a given medium.

First of these reinstates architectural drawing as a discursive practice, subordinated to a set of conventions chosen for their optimal clarity and transparency in communication:

> Presentation techniques, for different stages of the design process, have ranged from the brief conceptual sketch, geometrical plan, section and elevation, picturesque perspective, physical scale model through to today's computer simulation. Thoughts are represented either subjectively, providing an impression of the building, or objectively, via precise geometry attempting to define the building in advance, the two approaches perhaps reflecting that architecture belongs to both art and science.
>
> (Giddings and Horne 2005: 1)

Obviously, with speculative/experimental projects, this 'comprehensibility principle' is put at stake. Issues of applicability are frequently traded in for artistic and narrative inventiveness, contributing to architectural theory rather than practice. Still, protocols of architectural image-making remained largely unaffected by new media until the introduction of photography, film and computer graphics. Even the medium of drawing, since Filippo Brunelleschi's rediscovery and codification of perspective, underwent significant changes, absorbing cultural, philosophical and technical influences, within its mode (convention) of representation. There are substantial differences between what could be expressed with axonometric projection[4] and with 3D modelling. Just as the unbuildable architects of the Enlightenment had elaborated upon the character of perspective drawings, as well as methods of composition, so have artists-architects such as Tobias Klein, Marcos Novak or Bryan Cantley begun to self-scrutinize their own protocols of digital design. In fact, speculative and unbuildable designs were among the first to ask such questions, reflecting shifts and fashions in terms of media and techniques employed. Along with changing modes of production, they were operating from within the architectural domain – as in Piranesi's treatment of perspectival apparatus, Revolutionary Architects' works commenting on typological classifications or the 'translations' of industrial systems into urban infrastructures in Antonio Sant'Elia's drawings. Similar examples include a discussion of standardized processes from the vantage point of the early twentieth century's mass production,[5] which came to favour contemporary visual language deriving from art (constructivism) and architecture (axonometry). Among the influences we are likely to include constructivist paintings resembling Kazimir Malevich's *architectons*, alongside such expressions of industrial forms and building typologies as Yakov Chernikhov's *Architectural Fantasies*. Their mode of presentation would reflect new industrial typologies and modes of production. They are usually grouped in series, being variations on constructivist assemblages of geometric elements. Not just in Chernikhov's but in

any one of these speculative proposals, we will find not only an attempt to transpose spatial ideas into drawn form but also a stance on technological and cultural advancements affecting architectural discourse of that time.

With the coming of the new millennium, visual languages have been displaced even further with computer models, new coding languages of digital media and protocols of parametric design. Irrevocably, they have been integrated into the networked production line of building information modelling (BIM), whose 'assembly kit' of representational strategies consists of 3D models, not to mention quantifiable data shared among parties involved in the building's construction. Additionally, rapid prototyping techniques that connect 3D scanning/3D printing with CAD/CAM[6] stage enabled access to a previously unavailable territory and – more importantly – opened up the discipline for an unprecedented understanding of architectural space. One such example involves scanning ephemeral phenomena that cause spatialized distortions and digital artefacts in resultant imagery. In effect, they are either rectified (manually or algorithmically) or made even more evident. We will find such objects in the artworks by ScanLAB group (*NOISE: ERROR IN THE VOID, Frozen Relic: Arctic Works* exhibition), in which lacunas and errors were turned into irregular, amoebic volumes, 'knitted' from the same photographic fabric as the scanned buildings. A different image-based manipulation of spatial entities concerns juxtaposing internal cavities of one's body with full-scale architectural interiors – at once designed by and (literally) fashioned after Tobias Klein – granting us access to previously unexplored spaces and territories – new provinces for architectural imaging. These volumetric glitches become actual space only in the form of 3D prints or CG images/3D models. As the technique of representation is pushed to its limits and beyond, only glitches – the evidence of programme's malfunctioning – can demystify the science behind the vessel's magic.

This brings us to the second reason why it is necessary to apply perspectives focused primarily on medium of representation. The search for an inherent bias in such projects came to the forefront with revisionist perspectives on rapid deployment of new programming principles, especially when considering the degree to which new generations are familiarized with digital design methods and protocols of model-making, leaving behind analogue craftsmanship. Those architects who stood witness to this transitioning from traditional to 'parametric' design methods remark that working with NurBs (Non-uniform rational B-splines) propelled their need to probe the limits imposed on models, especially in regards to the range of forms one is able to arrive at or was limited by.[7] In the past, such forms were indicative of sculptural lineages in architectural production. There is a rich record of biomorphic vocabularies in architecture, from Eugène Viollet-le-Duc's ornaments, through Frederick Kiesler's *Endless House*, to Chaneac's *Polyvalent cells*. Resultant forms

in both realms of digital and analogue media are a direct consequence of specific artistic and technical choices and their approach. For instance, Coop Himmelb(l)au's *Open House* emerged from an ongoing 'design-conversation' between Helmut Swiczynski and Wolf D. Prix, each, by turn, making a freehand sketch, with the final project retaining all sharp angles and fractured surfaces that betray the idiosyncrasies of each author's drawing style. Going beyond mere technique of execution, examples such as Ron Herron's (Archigram) *Walking City*, or SUPERSTUDIO's *The Continuous Monument* were both taking advantage of the technique of colliding images taken from various sources (photograph, drawing, etc.). The latter's shots of natural environments clashing with an infinitely expanding graph paper grid,[8] or a collaged environment of *Instant City* – illustrating urban forms as entities composed of multiple layers of cut-out comic book graphics, magazine pages and pop art extracts – provided a commentary, in both subject and form, for the late 1960s commercial culture and an ascendant 'society of the image'. Thus, speculative projects are not only culturally informed but are often examples of verbatim intertextual transpositions of images found in art-architectural circuit. Gradually, this accelerating autopoietic relationship of the medium with visual representation began to absorb pictures and images taken from cinema and mass media, arranging them on a single 'virtual' site, where the emergence of a new, 'freewheeling' architecture becomes worthy of the 'visual culture' moniker.

Throughout this book, I have put an emphasis on the medium of representation, regarding it as a common denominator in all fields of study previously mentioned but – maybe even more importantly – deeming it an often overlooked 'frame' defining the mode of visual expression. In traditional instances of architectural representation, which shy away from dystopian, experimental or visionary elements, such aspects as style, technique or aesthetics become subsidiary. Something quite the opposite becomes a creator's agenda in case of speculative projects, where ambiguity is an asset, adding yet another dimension to the drawing. At the same time it is carrying significant semantic functions to greater extent than those developed to present a not-yet-realized spatial reality. Such emphasis put on the medium of (re)presentation should not exclude the 'perspectival bias'. Architecture always had a troubled relationship with perspective projection. After the Industrial Revolution it tended to regard it as translucent, objective and a standardized mode of building's presentation in a simulated 3D environment (Modern Movement). Beforehand, it had been denied legitimate grounds due to its subjective, if not seductive, quality, going as far as to distort actual dimensions of objects (Renaissance, Enlightenment). In his *Complexity and Contradiction* (2002) Robert Venturi made a bold claim when calling modernism's bluff in a separate issue, when discussing its ideological condemnation of ornament. The architect pointed out that instead of designing architecture of plain facades and elevations, devoid

of decoration that would object to the functionality paradigm – as Le Corbusier or Mies van der Rohe claimed – modernism rather enjoyed the emblematic display and overabundance of industrial elements, mimicked in the non-structural overaccentuated plainness of curtain walls or the bronze I-beams in Seagram Building's façade, expressing structure, yet not bearing the building's load (Venturi 2002: 34). Similar denial characterized statements that rendered perspective into a mode of architectural *re*-presentation; one that is uninvolved in rhetoric strategies, considered a straightforwardly objective rendering technique. Apparently, this too was a Modern invention. As early as in Renaissance, numerous architects and theoreticians warned against potential implications from including a highly subjective mode of representation into an architect's repertoire of techniques.

> Media introduce fundamental ambiguities into how and what we see. Architecture has resisted this question because, since into importation and absorption of perspective by architectural space in the 15th century, architecture has been dominated by the mechanics of vision. Thus architecture assumes sight to be pre-eminent and also in some way neutral to its own processes, not a thing to be questioned. It is precisely this traditional concept of sight that the electronic paradigm questions.
>
> (Venturi 2002: 16)

Architectural drawing as message

We usually envision architectural representation as a message created with purpose of being conveyed as losslessly as possible to clients, contractors, engineers and other parties involved. Jonathan Hill writes:

> The drawing is nearly always the principal means of communication in all phases of building. For the architect, the drawing is as real as the building. First, because the architect makes the drawing but not the building. Second, because the architect has greater control over the drawing than over the building. Third, because the drawing is closer to the architect's creative process: it is made before the building.
>
> (2006: 55)

However, the term 'architectural drawing' implies at least a few distinct production stages, such as the working drawing – which allows for drastic manipulations and experimenting on the idea – or the presentation drawing – which is an agreed-upon outcome of this form-finding process. With speculative drawings the clarity of expression falls under suspicion, for visionary projects aim at presenting

unprecedented forms, unlikely solutions and fantastical structures – and not something that could be instantly referred back to a dictionary of building typologies. In numerous cases of speculative projects the poetic aspect of their utopian forecasting lies in the former's incomplete and open-ended character, sometimes even displaying crude, sketchy quality (Hermann Finsterlin), a visible tension between figurative and abstract modes of representation (Yakov Chernikhov), or a counterpoint of familiarity and alienation, balancing between the structure and its context (Lebbeus Woods, Raimund Abraham). These contradictions, confined to the 'genre' of speculative/visionary/experimental drawings, along with related media of architectural representation, are mainly focused on issues related to the medium, image-making technologies, architectural discourse and theory, or architectural and urban criticism. Drawing is often a solitary mode of exploration of a specific design language; a semi-intuitive arrival at a solution that would meet the expectations outlined in the brief, developing an idea that would be revised in later trials. When viewed as such, putting on post-humanist lenses,

> the drawings are ongoing design conversations. In a cybernetic way, the author designs his work by intellectually building it through constructing the drawing. There is a dialogue between the drawer and the drawing that is constantly changing its syntax, lexicon and attenuation. [...] The drawing is a laboratory for researching architectural space and objects.
>
> (Spiller 2008–13: 7)

Let us look into examples of drawn projects and the act of 'drawing' as such, itself a speculative exploration of ideas, a *work-in-progress*. Its characterization begins with a tripartite division into plan, section and elevation, designating the standard mode of communication, while ending up in a panoply of techniques and

FIGURE I.2: Riet Eeckhout, *Process Drawing*, 2012. Courtesy of Riet Eeckhout.

media. One can see them as peripheral to the practice, for they do not carry the same semantic weight, when it comes to technical information, yet are indispensable as imagining aids, projecting the building in a (supposedly) 3D space – regardless of whether we talk about Renaissance perspectives or 3D fly-through animations. This in-depth retrospection, focused on methods/languages of visual expression, is carried out with yet another purpose in mind. From around the second half of the eighteenth century, and due to the introduction and rising popularity of per-spective projection, architecture began to metamorphose into a painterly enter-prise. Employing drawing as a 'test site' for theories, instead of the sole purpose of making building specifications, allowed for an advent of artistic practices directed at speculation (conducted in architectural form) and critical discussions (commen-taries on contemporary building practice, urban form, role of architects in the chan-ging world), resulting in visionary, if not overtly fantastic, architectural proposals.

The audience for such endeavours, as could be assumed, comprises mostly of the creator him/herself, that is, until an actual audience of art aficionados invades the exhibition. Noise, understood in Claude de Shannon's terms,[9] appears as anything but the undesirable incentive denoting losses incurred during the act of communication, when considered in relation to speculative architectural drawings. In the case of any generic drawing, which relies on strict conventions of architec-tural representation, stylistic ambiguity is best to be avoided. The same goes with abstract 'excesses', especially upon arriving at an image of the idea – contrary to what is bound to happen during preparatory stages, sketching phase or in artistic renderings destined for film or art magazines. Yet, speculative designs are explor-ations in form, as much as they are in language, with the two paradigms often interlacing. Upon expanding on basic graphic premises, these projects never cease to provide significant contributions to theory,[10] education[11] and aesthetics. Still, what might be classified as information noise from one angle, from another appears as a deliberate though inventive manipulation of the source material – a typo-logical exercise or an exuberant interpretation of the production brief. Agreeing that this 'distortion' of communicativity is not employed for productive means (in a general understanding of the term), we can assume that atmospheric 'noise' of artistic expression is vital to speculative productions. Certainly, maverick archi-tectural renderings are not out of place in cinema in the form of matte paintings or as a coupling of optical illusions and set design, let alone an illustration for a book cover that bears more than traces of fictive speculations.

New techniques were always approached with a dose of weariness. 'During the Renaissance, the representation of buildings grew rapidly, with the discovery of the principles of perspective. This new visualization tool also prompted experi-mentation with imaginary architectural scenes' (Burden 2000: viii). With the pro-liferation of methods for architectural representation and their incorporation

into a separate field of artistic inquiry, drawing came to be regarded as a surrogate building site. With the introduction of parametric design methods, speculative projects came to resemble irregular, asymmetric and anti-industrial organic forms. 'The new breed [of architects] has no truck with concepts that have defined architecture for millennia – such as inertia, stasis, and muteness. They explore notions of reflexivity, dynamism, and the cybernetics of personal perception' (Spiller 2010: 51). There is an in-depth discussion on the topic in reference to hypothetical architectural projects in works by Neil Spiller (1998, 2000, 2007, 2008), who writes about the purpose of such productions, while contributing to this 'genre's' history with his own *Island of Communicating Vessels* project. Putting emphasis on architecture's poetic function (especially in regards to projects that exist on paper only), speculative drawings use 'rhetorical strategies' intrinsic to artistic productions, manipulating such qualities as: scale, material, source (as in collages), while including multiple references to a variety of texts from visual culture – cinema, painting, social media and so on. Often, this addition of unlikely details implies a narrative thread or a story that can be deduced from an arrangement of factors mentioned above. Critical literature has always highlighted these 'surplus' aspects of drawings, especially in regards to speculative productions, for only in such cases do they move to the foreground. These could be deduced from sombre, colour-washed landscapes comprising the backgrounds in Raimund Abraham's series of 'houses' (*9 Houses Triptych* [1975], *House without Rooms* [1974], *House for Euclid* [1983]), stick insect buildings designed by Lebbeus Woods as hazy reminiscences of figures in Salvador Dalí's *The Temptation of St. Anthony* (*High Houses for Sarajevo* [1997]) or Spiller's own linkage of his mech-organic albumina with (also Dalí's) psycho-atmospheric objects (*Riverslapper Seen through a Tear* [2008], *The Temple of Repose* [2010]), as caught in their striving for 'containment', though never eventually attaining it.

Numerous elements of these compositions can be interpreted against the convention of standard architectural drawings, deeming them – by default – as spatial projections, presented either in ground plan, profile, perspective or isometry/axonometry. This remains valid even in the case of more experimental and abstract configurations of outlines and 'fillings' on paper. The level of difficulty rises with computer graphics and multiphase processing of the image, using both digital and analogue materials. 'Above all architecture is the manipulation of space – in all its manifestations. Space can be imagined and space can be graphically represented' (Frotscher and Frotscher 2013: 14), which makes out of projects primarily concerned with represented space a general theme of this study. With architecture and cinema stepping into the twenty-first century, one can notice that they come in equipped with similar 'form-generating' tools, capable of transforming our already-established understanding of spatiality. Even before the 'digital turn'

architectural representation has already been opening up to a variety of extrinsic techniques, technologies and modes of expression, which quickly emancipated themselves, overflowing the domain with entire vocabularies borrowed from visual arts, often challenging pre-established notions of pictorial space.

Cinematic space: From representation to simulation

Cinematic space has always been a fertile ground for uncanny projects of futuristic cities, astounding structures and alternate environments the characters are likely to inhabit, or, at least, traverse,[12] frequently 'renting' specific architectural imagery from speculative projects and fantastic designs. Moreover, in the context of film, speculative projects usually serve a double purpose, as they supply plots with credible backgrounds, evoking precise architectural periods, ideas and aesthetics, bringing into the movie a semantic surplus. Though highly eloquent at times, set designs do not necessarily contribute to advancing the plot; sidetracking it, rather. In Jean-Jacques Annaud's *The Name of the Rose* (1986), a Borgesian labyrinth is fleshed out as a structural chaos of Piranesian proportions, explicitly evoking his famous *Carceri* plates, as well as providing a symbolic image of the universe's complexity, cast in the form of an infinite library. But then again, this architectural disorder could have been acquired through montage, not necessarily by means of a static establishing shot, which leaves viewers in awe of the maze's scale and arrangement. Set design in Annaud's film achieves the effect through the implied dynamics of a multiplicity of viewpoints – like Piranesi – instead of resorting to a temporal succession of views. In William Cameron Menzies's *Things to Come* (1936) the utopian community of Everytown dwells in an interconnected complex of industrial-style buildings, as if directly cited from Antonio Sant'Elia's *La Città Nuova*. Even in the 2012 remake of *Total Recall* (Wiseman 2012), upon seeing the establishing shot portraying a run-down settlement, we will most assuredly recall Yona Friedman's *Spatial City* (1959) (Friedman 2020) crossed with Moshe Safdie's *Habitat 67* (1967). These are only literary examples of how speculative architectural designs might end up as spectacular settings in commercial film productions. Of greater relevance is the question involving productions that are primarily concerned with chosen aspects of speculative projects, yet instead of calling upon them directly, they display similar characteristics and share conceptual ground with them. In other words, films that will be analysed here should not be considered solely for their surficial semblance either to utopian architectural works or specific passages from utopian literature, but instead assessed on the basis of structural arrangement of each film's narrative, cinematography and editing.

Contrary to an indexical logic, these visual constructs are far from direct translations of unbuildable architectures into cinematographically immersed environments. Both the speculative architectural projects and imaginative film settings are informed in their basic concepts by relatable spatial philosophies and fields of confluence that bear witness to their struggles in resolving architectural problems. Therefore, instead of comparing Tativille from *Playtime* (Tati 1967) to specific Miesian high-rises, we should inspect live-action/animated features such as *Taxandria* (Servais 1994) on the basis of its exemplary narrative construction. *Taxandria* confronts us with an imaginary city in which state's ideology is laid out spatially, reflecting institutional abolishment of recorded history and archival processing (Figures I.3a-i). In the plot it gives rise to a world entirely rid of memory. If we compare *Taxandria*'s settings to Raimund Abraham's 1970s' studies of houses, which expose his architectural 'archetypes' to the forces of temporal rearrangements, decay, entropy and other elementals, we could point out similarities in architectural forms, rooted in shared construction and design assumptions. It might seem like a thought experiment in terraforming for parallel universes; nevertheless, design practice is also an exercise in narrative inventiveness. Abraham's houses embody and analyse historic concepts of architecture, focusing – among other issues – on the domain's inception[13] and its origin in Marc-Antoine Laugier's primitive hut, or in ideal geometries epitomized by Platonic solids. Like Taxandrians, the lodgers of Abraham's houses also 'fantasize' about an atemporal world devoid of mechanisms for measuring change, buildings suspended in their collapsed state, repurposed cathedrals, where built settings reflect the authoritarian fear of change inherent in urban form. This world has an undisputed origin, even though a forged one.

As speculative projects began to widely appear in film, these formerly static representations gained new ground, allowing them to develop their time-based aspects that drawings could only imply. Of course, I do not want to suggest that film should be regarded as a necessary evolutionary step, which arrived at the right moment, in order to save all instances of paper architecture from falling prey to genre's own calligraphy. On the contrary, certain aspects can be developed in drawing only, while numerous others are able to retain their complexity, or ambiguity precisely due to because they are representing them in a static 2D medium. This is precisely what 'mediatization' stands for in this context. No conversion losses. Cinema, however, is a medium reliant on temporal and spatial progression, paced sequencing of images, and continuity editing as construing transitions between frames. It speaks the language of montage juxtapositions, spatializes narrative development, and irrevocably ties architectural content to a mode of exploration that is meant to develop spatial qualities over time. Nevertheless, film does not neglect the third dimension, yet there is aptitude in this medium

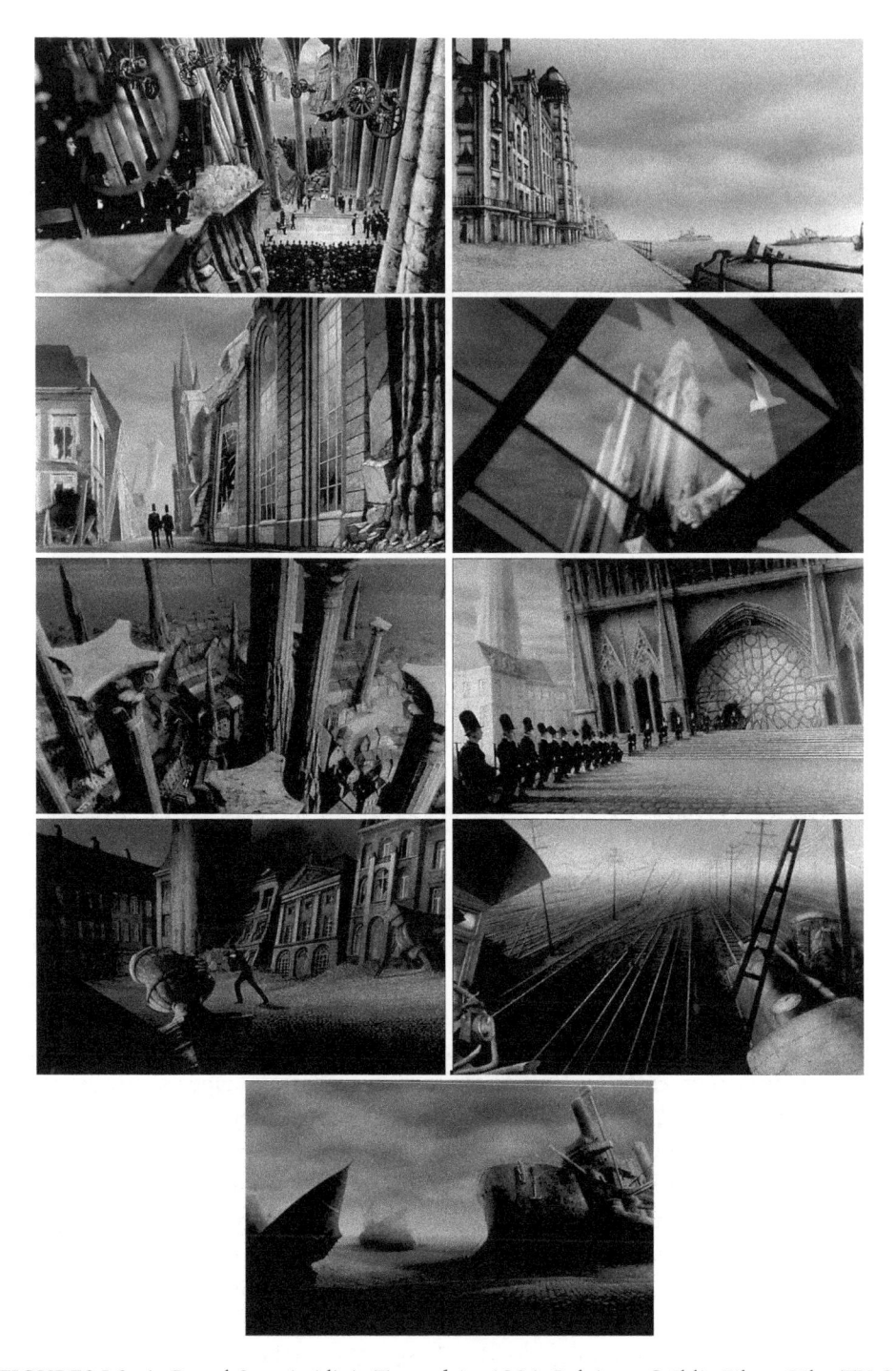

FIGURES I.3a-i: Raoul Servais (dir.), *Taxandria*, 1994, Belgium. © Iblis Films, Bibo TV & Film, Les Productions Drussart, Prascino Pictures.

to create immersive environments instead of arresting vistas – even though Steven Spielberg's epics might not be the best example to prove this.

This brings us to an important ontological shift in the practice of visualization, which progresses from representation to simulation; from critical assessment of a spatialized idea towards its virtual exploration. Unlike David Ross Scheer,[14] however, I do not believe that simulation came to supplant representation, becoming its antithesis, or that any rendered, 3D environment that complies to with rules of cinematic spectacle, necessarily has to leave out viewer's critical assessment of what he/she perceives, while maintaining a heightened awareness of experiential stimuli during the film screening. Instead, many architectural animations that involve such modes of spatial exploration are directed at showcasing scenes and drawing attention to representational strategies, only reinforcing this illusion of embedment. This repositions the medium as a non-neutral carrier of meaning. That premise has been cemented with the domain's opening up to new means and techniques of expression, providing new ground for speculative investigations, as well as new spatio-temporal concepts. Drawn space has ceased to be attributed only to 2D surfaces, while such facets as source (collage), movement (film), interactivity (installation), or the ratio of digital to analogue techniques – when viewed in the context of digitally – processed hand drawings – stepped into the spotlight. Manipulating these factors enables speculative explorations of architectural forms and protocols of creation to be conducted in purely visual terms. Architectural models, especially in the age of graphic design software, are built out of images. Be it collage, or an intertextual visual reference, every speculative project functions within a strictly defined network of spatial concepts, being immersed in – and deriving from – specific media. Thus, a research conducted in methods of representation must give rise to a new understanding of space, which forsakes a previously held status of a casting mould to Modernist volumes, in favour of more recent accounts: microspaces of quantum and nanotechnologies in Spiller, colliding vectors of *freespaces* (Woods), or non-scalar space that transgresses the corporal/architectural divide (Tobias Klein) – to name but a few. Upon entering 'cyberspace' yet another graphic 'figment' steps in to contest Cartesian space, redefining pre-established conventions with an elusive concept of CG environment that conjoins fractured deconstructivist elements into a seamless form. Speculative projects created through parametric design are rarely about the exuberant forms they represent. More often, they touch upon their own morphogenesis and digital protocols that had summoned them into being. Soon afterwards, this neutralizing aspect of all CAD projects, which allows them to disguise their origin underneath the seamlessness of their skins, would become criticized and frequently 'operated on' by the creators of speculative architectural projects, dissected both with traditional,[15] as well as digital methods – in particular, through CG architectural animations.

FIGURE I.4: 'Habitat 67' of the 'spatial' city in *Total Remake* ... I meant '*Recall*'. Len Wiseman (dir.), *Total Recall*, 2012. USA. © Columbia Pictures, Original Film, Relativity Media.

The argument

This brings me to the central argument of this book, which elaborates on the marginal tradition of speculative, experimental and visionary architectural designs – imaginary renditions of utopian and future architectures. They remain unbuilt due to the scope of their intervention into the status quo, complexity, radical nature, or purely visual characteristics that enable the architect to construct a drawing as an optical illusion, though remaining somewhat at odds with actual building principles. Such proposals turn away from considering built environment in static terms, either regarding it either as an enclosure providing shelter, or as a rather inert machinery that hosts and regulates our actions, organizing them in accord with specific programmes of our daily activities – work, recreation, rest. Instead, it promotes speculative projects that appear much more customized to human variability and impulses to transform than already existing structures, which have to meet political, social, and financial demands. Architectural speculations on paper touch upon alternative concepts of space – the space of representation, which, in a state of 'suspended animation', can be regarded as a testing ground, where concepts are sketched out and form-finding research is led. This became their true destination, even if deemed temporary by those utopians, who seriously await actual emergence of Piranesian, Spillerian, or Kleinian architecture. The technique – be it drawing, collage, photomontage, film (as a sequence of stills, chronogram, or actual rendered animation), or an illustrated 'slideshow' narrative – remains an authentic locus, viewed in terms of a hypothetical 'site', in which such architectural productions can be 'implemented', thereby visualized.

Eventually, after a revolution in architectural representation in the fifteenth century, architecture emancipated itself from the very act of building, which, nowadays, might not be a fact that raises anyone's eyebrows, providing that

> architecture results not from the accumulated knowledge of a team of anonymous craftsmen but from the individual artistic creation of an architect in command of drawing who conceives a building as a whole at a remove from construction. From the fifteenth century to the twenty-first, the architect has made drawings, models and texts not buildings.
>
> (Hill 2006: 33)

Drawings, not unlike buildings, have to be constructed, virtually reimagined on paper, complying in this activity to with the guidelines of architectural production. At the same time, in visionary projects, graphic explorations need to preserve enough room for experiment, artistic interpretation, and consideration of alternatives to concrete scenery. To no lesser extent are they solutions to architectural problems, which does not disqualify most of them from being viable competition entries, providing either for unconventional dwellings, modes of habitations, or political statements (as each project is in consequence a vision of the *polis*). Criticism too can be art. However, with unbuildable projects the basic notions of space and site become substantially more complicated due to numerous traits and ambiguities read into the drawing or its mediatized derivatives. Medium structures imagery in a manner akin to optical illusions, viewing images as more than signifiers of building materials and cantilevers for engineering. Moreover, because architecture can be perceived as an apparatus to survey, interpret, and reconfigure the site's space, as in the case of Daniel Libeskind's Jewish Museum in Berlin, the content of architectural drawing can also serve as a research log on the intricacies of a particular medium or conventions of drawing, as well as inquire into issues of representability itself.

Defining speculative drawings in these categories brings up questions of other media engaged in architectural visualization. As artistic tools they offer new techniques of image production, however re-representing the same content can never be reduced to a simple 'translation'. Each medium offers a set of built-in attributes 'designed' for facilitating certain activities on the part of the creator; the same attributes are rendered discrete, or even non-attainable in other media. Temporal progression is impossible to represent in a single drawing, though it can be implied. Still, a two- dimensional image does not impose any real illusion of movement. Instead, it invents a symbolic representation or suggestion of one, structured along the lines of its compositional code. This act establishes rules of the genre for future generations of projects. Far from suggesting that specific media are preferable for certain types of projects, there is certainly an explicit authorial agenda

in employing a medium of choice over alternatives. Multiple architects-turned-artists deliberately decide upon representing temporal ideas spatially, or on using photomontage for achieving the desired effect – a strategy whose 'argument' directly relies on the technique and materials applied. In the case of photomontage, the main strategy relies on juxtapositions of photographic snippets taken from various sources, while deliberately overlooking such aspects as scale of the signifieds, or incongruity of their sources. Artists like Hans Hollein fully exercised the image's shock value, by placing an aircraft carrier in the middle of a rural landscape, or, as in Archigram's illustrations, by putting a gigantic android beetle in a crowd of happy couples from lifestyle magazines, which is the case of Ron Herron's *Walking Cities*. With gradual introduction of film theory and cinematic techniques into architectural production, film, taken as medium, undertook the role of a surveying mechanism, convenient in temporal analysis, while serving as a reservoir of typological forms in a morphogenetic project; for example, in the abstracted films stills of Bernard Tschumi's *Manhattan Transcripts*. With film increasingly standing in as a medium surrogate for model-making and architectural presentation, the emergent forms could be turned into moving, mutating objects 'captured' on film – sequences of 'slices', or phases of this transmutation. Parametric design is informed by a parallel logic.

> Using parametrics, designers could create an infinite number of similar objects, geometric manifestations of a previously articulated schema of variable dimensional, relational or operative dependencies. When those variables are assigned specific values, particular instances are created from potentially in finite range of possibilities.
>
> (Kolarevic 2003: 25)

Cinema is still considered a territory extrinsic to architecture, yet in the past few decades it has been eagerly explored, and frequently harnessed as theoretical support underlying both unbuilt projects and finished buildings, designed by: Coop Himmelb(l)au, Bernard Tschumi, Greg Lynn (Morphosis), Jean Nouvel, and Diller Scofidio + Renfro, among numerous others. In most cases there is no place for artistic expression in building documentation, but at the same time renderings prepared for presentation should not be too overt in displaying the author's idiosyncrasies and mannerisms, unless they stem from form itself (as in the case of Zaha Hadid or Frank Gehry). This assumption holds true even when analysing Hermann Finsterlin's fluid forms, which were striking, if not unbuildable (aside from being underspecified), back in the 1920s, before parametricism took hold. The unstable appearance of Lebbeus Woods's *High Houses* could have induced a terminal vertigo in any sober contractor, though their origin dates back to deconstructivist

projects that incorporate such structural tightrope walks, appearing as if on the verge of falling. In both examples the 'artistic surplus' relies on implied dynamic aspects of portrayed structures; on their prospected habitation, adaptation, and sustainability, not just on outlines of their shells. Architectural animations which take speculative and fantastic structures as their object of study can override these constraints, confronting us – the viewers – with architectures that are not only indicative of dynamics, but which are literally set in motion. Those that can change in accordance to with shifting vantage points, respond to movement. In their case, the movement in question is that of narrative progression or plot thread spun by the film director, in order to visualize not only a scheme but primarily a mobile construct.

This way film medium became yet another methodological update, and by the beginning of 1990s it was already a standard in presenting virtual models of buildings 'in action'. The fly-through animations are a prime example of that, bringing out full potential from the 'computer-aided' paradigm, named by Marjan Colletti as 'digital poetics'.[16] When projects of such provenance support themselves on media 'underwritten' with temporal progression, like film, video art, projection mapping, transmedia narratives, or kinetic installations, they instantly bring out dynamic qualities of metamorphosis, evolution, or interactivity, in the role that supports and reinforces their concept.[17] Even as the animated fly-throughs were gaining their momentum with the growing numbers of commercial presentations, and with 3D visualizations becoming an industry's standard, more than a few years had to pass before this novel 'genre' became aware of its cinematic potential. Already in the approach to applying these techniques we will notice to the what extent had to which the central premise had been redirected from design's optimal presentation to the dramaturgy of narrative's development. But this is not mainstream cinema. Bedazzling the viewers is not necessarily the same as pleasing the clients. Architectural animations of this new kind began to appear over the past decade, making extensive use of modern filmic storylines, presentation modes, and cinematographic strategies. They are the subject of this study, being regarded as the prime area of implementation of the speculative, utopian, and time-based factors discussed earlier.

Object of study

Since the inception of Western architecture in classical Greece, the architect has not 'made' buildings; rather, he or she made the mediating artefacts that make significant buildings possible.

(Pérez-Gómez and Pelletier 2000: 7)

With experimental projects in architecture, the primary concern lies not with the built artefact, but with acts of introspection into design process. With experimental projects architects test the limits of representation, form, and function. For example,

> Hadid explored [Kasimir Malevich's Suprematist abstractions] in painting[s] of her own, which she regarded primarily as a way not only to develop an abstract language for her architectural practice, but also to render the standard conventions of architectural imaging (plan, elevation, perspective, and axonometric projection) more dynamic than they usually appear.
>
> (Foster 2013: 73)

Even if these forms of visual research are usually abandoned at a later stage, in favour of more efficient and faster methods, they still linger on from the halcyon days of college, along with other purely theoretical endeavours that never make it to the building stage. They become paraphernalia – not only crucial not only to one's formative years, but also a conceptual repository for future work, allowing the architect to seriously consider ideas of non-standardized environments, habitable suits, megastructures, and reconstruction works, primarily, through imagery.

Film has opened up new possibilities for such projects, being both a product and the instrument of visual culture's resurgence. Coupled with architectural production, it introduces new methods of viewing (conceptualizing) and creating space, thus investing speculative designs with a 3D interpretation of represented environments. With models and drawings combined into a singular time-based narrative, architects have acquired new ground, where visual and literary (most often utopian) texts can cooperate in their theoretical search for future language(s) of architecture. Film is among those artistic media that are incorporated into design, not just presentation stage. With many of the projects appearing as a refreshing alternative for contemporary 3D design overload, we can envision this revolt under the guise of hybrids – mixtures of traditional and digital drawings, digital models obtained through 3D scanning, rapidly -prototyped objects, or hypothetical projects that oscillate between digital and tactile planes of existence, while developing along the lines of spatialized narratives (like e.g. NaJa & deOstos's *The Hanging Cemetery of Baghdad*). If this post-technological exuberance, facilitating exploratory and speculative modes of 'drawing', is to be regarded as a symptom of maturity, then speculative animations can surely be seen as harbingers for the augmented architectural reality yet to come.

Focusing on the genre of animated films and the way they are taking their cues from drawn speculations, experiments and visionary pursuits dating from Piranesi to Lebbeus Woods herald a new field of artistic spatially-oriented creations, even

FIGURE I.5: Permanent suspense visualized. NaJa & de Ostos, *The Hanging Cemetery of Baghdad*, elevation, 2007. Courtesy of Ricardo de Ostos and Nannette Jackowski.

when yielding to architectural conventions and manufacturing protocols. Often they 'throw into the equation' those utopian fictions that emerged in both fields of literature and cinema. Not merely a waste product of individual prospections, animated films created, for example, by the students of Unit 15 at the Bartlett School of Architecture in London explore notions of cinematography, editing, and methods of imaging, but they also take advantage of rudimentary plotlines, which recur in science-fiction cinema, while alluding to specific works of literature. Narrative is employed for rhetorical rather than dramaturgic effects, and it always 'contorts' to a dominant thread of exploring spatial environments and their transformation by means of architectural intervention.

Content of chapters

I have divided this book in a way that would reflect three distinct conceptual stages, which do not necessarily reflect the structure of chapters (seven in total). The first section focuses on issues of representation, the middle one concerns film- and time-based aspects of drawn architectural projects, while the third and final part concentrates on emergence – due to digital post-production of images – of a seamless and fluid concept of space. This perspective converges in artistic architectural animations, presented here as heirs to utopian and speculative traditions. Movement and perception – namely modes of cinematic exploration – are closely coupled entities.[18] Their symbiosis brings to life an innovative strategy of representing architectural space. In the course of consecutive chapters this perspective

will be rendered more palpable. Discussing the factors that initiated this cognitive shift, I am looking into the domains of architectural representation and its developments and film set design, because here imagery taken from speculative literature gains a setting.

As an introduction, given the panoply of problems concerning architectural representation and their subsequent elaborations, in Chapter 1, I have included a discussion on the techniques of architectural representation, like such as perspective projection, axonometry, or diagram, presented against the historical periods in which they had been introduced. Along with the twentieth century, there has been a proliferation of alternative methods of inscription, like the Smithsons' use of collage, and its subsequent pop art ingestion by Archigram. In turn, either with Bernard Tschumi's 'refurbishing' of the diagram, or with the use of photomontage by experimental post-war groups, these techniques were often considered as fit for visual provocation. Deepening reliance on computer-led techniques, brought about a recomposition of these modes in digital environment, and thus an ontological transformation of represented space, which will be explored in the subsequent chapters (3, 5, 7 and, 8). At this point, I also propose to reconsider the 'drawing' (or any alternative medium) as an indirect, prodigiously convoluted message involving artistic *defamiliarization*, which accentuates, or even develops, the project in ways that would not have been possible for traditional, standardized documents. These mental peregrinations conclude in a case study of Alexander Brodsky and Ilya Utkin's graphic works, scrutinized as an example of architectural *analytique* deployed as compositional mode, exploring their narratives through descriptive aspects of the genre, and by means of a detailed architectural study of its subject – here, allegorical short stories – which is intrinsic to the technique. These Russian architects' recontextualization of the *analytique* puts forward an extensive critique of historic forms, and building politics in the post-Stalinist Soviet Union.

What the chapter offers is a historical outline of the evolution of cinematic space, and of devices/strategies employed in its creation; mainly, focusing on illusion-sustaining set extensions, matte paintings, and the fixed interrelationship between viewing apparatuses and set parts that collaboratively bring into existence impossible environments and paradoxical filmic spaces. This brings us to the issue of collating motion with vision, in order to convey architectural experience – a subject regularly explored by artists (Duchamp, Moholy-Nagy), architects (Kiesler, Holl), and filmmakers (Raoul Ruiz, Alain Resnais, Tarsem Singh). An important asset of this insight is that it re-evaluates the role of architects on set, from designers of scenic decorum to 3D digital image-makers in contemporary cinema driven by CGI (computer-generated imagery). In relation to the plot the function of sets is also viewed as operating on at various levels of prescribed

meaning and expression. Among these are instances in which architectural forms portrayed on screen become visual supports for main ideas in the story (Fritz Lang's *Metropolis*, 1927). Less frequently it conveys its message through a dynamic array of transformations and transpositions imposed on the setting, as in David Fincher's *Panic Room* (2002). Any film's spatial layout allies with cinematic choreography, calling upon numerous special effects to perform cuts, incisions, and sections on the diegetic enclosure, revealing the degree to which digital imaging recomposed filmic space in contemporary cinema.

Defining visionary projects in relation to their originators – Piranesi, Boullée, Ledoux – comprises the contents of Chapter 3. Examined here is an outer-architectural context of their productions, in relation to the tradition of theatrical sets, or notions of character communicated in Boullée's designs, expressing connotative and atmospheric aspects suggested by the architectural objects in the picture. What concludes that discussion is an important distinction between two types of unbuilt projects – one considering them unbuildable by design or unintended to be erected in material space, whereas the second category collects those instances which never got to the building stage at the time of their inception. Only the former batch are is of true significance to this study, as they it often takes advantage of such characteristics of the composition, becoming treaties on optical illusions, graphic paradoxes, and mockeries of our cognitive reliance on visual cues in understanding and mental reconstitution of architectural spaces. This feature will return in the animated films analysed in book's final chapter. Thus, the study moves on from early Baroque and Enlightenment artists-architects to the twentieth-century's instances of the unbuildable, constructed in drawings/paintings by Sant'Elia, Hugh Ferriss, Constant Nieuwenhuys, and Constructivist architects in the likes of Yakov Chernikhov. As a summary, these graphic endeavours are suggestive of later developments in post-digital representation, evidencing new ontological status of drawing-object, and replacement of representation with simulation.

Jumping ahead to the latter half of the twentieth century, we will notice a radical shift in representational strategies. Post-war reiteration of the practice sees rise in distribution outlets: magazines, exhibitions, mass media (e.g. cinema, television, and the internet), and – along with these new platforms – innovative modes of graphic expression, let alone subjects explored by anti-utopian groups of the 1960s (commodification of architecture, its 'reduction' to a system of signs). These groups would be labelled 'spatial urbanists'. In their works functionalism becomes contested by megastructures. Not even a decade later it too will plunge into solipsistic iterations of this newfound language of forms. In this account, architecture becomes media, and – as Beatriz Colomina suggests – heralds a gradual dematerialization/mediatization of architectural projects, along with their distribution in architectural magazines, films, and the internet, mainly due to an iconic value – or

caractère – of their constituents, namely, the imagery. Chapter 4 looks into such instances, while – in its second part – it includes a discussion on an increasing interdependence of architecture and cinema, this time revising the subject from the side of architectural reappropriations of filmic vocabulary and its representation strategies, together with storytelling modes. These include anti-design and cinegrams (Tschumi), visual essays and motion studies (Venturi, Lynch), while exhibiting affinity for encoding or reading a sense of dynamism into architectural objects and projects, which expands upon other disciplines lending it their perspectives on space (as mediatized, cultural, social, or temporal construct). Numerous projects aim at describing architecture through the discourses of performance, movement, narrative, culture theory, therefore my focus is on theoretical projects that deliberately support themselves with dynamic new media, harvesting them for language, methodology, and imagery. In terms of setting forth dynamic accounts of space, the post-relativist perspective on humanistic sciences is another area contributing to this inquiry. Architecture witnessed this paradigm shift through complexity theory (Jencks), which is discussed later on, in the example of the graphic novel *The Fever of Urbicande* (1985) graphic novel. Being the second instalment in a series dedicated to impossible, utopian, and (after Italo Calvino) poetic cities, the novel weaves its narrative around an infinitely expanding modernist grid, which disrupts social and political life in a city, while proffering a dynamic account of urbanism. At the same time the eponymous MacGuffin is the ultimate expression of spatial urbanists' agenda – an indestructible and voracious megastructure – one that would not succumb to limits of architectural representation.

This inquiry will be concluded in Chapter 5, which amounts to a series of case studies concerning speculative projects that either entail cinematic modes of viewing temporal succession, or directly borrow their envisioning techniques from filmmaking. They do so in order to articulate those aspects of a project, that would have been largely absent from traditional working and presentation drawings. The chapter is a look into four speculative projects that negotiate between former modes of architectural description and the aforementioned dynamic account of space. Many of them, while inventing fictional narratives on urban transformation (*Underground Berlin*, Woods 2009b), or universal parables for summarizing the history of architecture (*The Continuous Monument*, Superstudio 1971), propose new *terrain vague* or immaterial site for their prospected intervention, transforming not just the depicted constructions and infrastructures, but also a general understanding of how architecture provides solutions to problems of a spatial nature. Each of them exists primarily on paper, while simultaneously giving rise to a para-cinematic narrative. It reconsiders the relationships established between architecture, culture and, society, or, alternatively, between architecture and its iconic image, in addition to visual prosthetics (techniques, visualization

strategies) it makes use of in order to condition its emergence. In some of them, the site is imaginary; in others – historic. Elsewhere, the site is congruent with the representation technique employed in given project's conception (*Temple Island*).

Beginning with a reconsideration of the aesthetics of folding, seen as design strategy and ontology, the sixth Chapter discusses architectural animations – from their initial role as kinetic (or kinematic) alternatives to scale models to stand-alone art forms (artistic animations, opening and special effects sequences). It can be traced back to the early twentieth-century avant-garde movements (kinetic art, experimental animations) and their post-war follow-ons, ranging from abstract op art to proto-computer animations. By contrasting smooth and seamless morphology of Lynn's *blobs* with a deconstructivist bias towards sharp juxtapositions and conflicts in form, this shift in the image's status is, in turn, paralleled by the narrative's structural logic. One can see this shift echoed in the strategies of depiction employed in cinema, in two examples, which are in stark oppositions to each other in terms of production methodology, use of CGI, and final composition, namely: Christopher Nolan's *Inception* and Alfonso Cuarón's *Gravity*. While the latter promotes a fluid and uninterrupted understanding of filmic space (coupled with film's cinematography), the former spotlights conflicting and dynamic montage juxtapositions. Digital imagery becomes a shared base for both domains (architectural and cinematic), and as such it is best analysed in relation to its antecedent – animated film. Paul Wells characterizes this form against the background of agreed-upon conventions, artistic styles, and attributes of the painterly medium (elusiveness of space and character in traditional animation, degree of manipulation available to the animator), which so eagerly lend themselves to CGI-enhanced live-action environments. Material (now photographic) objects and settings are now often recomposed as CG props. By following this evolution of digital special effects and imagery, we arrive at the inception of a concept of seamless space. I refer to it this way due to its CGI constitution and symbiotic relation to cinematography (swift, laminar movements, frequent dematerialization of 'material' obstacles), as well as implied in the narratives – that is, in 'liquid' transitions between scenes, or composited sceneries brought to life on screen. Such technological robustness enables immaterial, image-based architectures to merge with the mode of their visualization, as perceived by the camera (or its virtual surrogate). Architecture becomes a phantasm generated in the mind of its user. This theme is to be encountered in most animated film texts, studied in the final, seventh chapter.

My focus is thus put on those episodes in architectural history, which saw this domain's language 'plagued' with terminology deriving from film studies (Chapter 4), when visionary pursuits came to rely on cinematic modes of representation, even if (or especially when),[19] projects themselves would still be traditionally executed on paper (Chapter 3). This is concluded with a discussion on

set designs and their gradual evolution, and eventual dissolution into CG matte paintings. In accordance to the line prevailing in the practice of multimedia artists and animators, these last ones head towards a complete unification of space with camera-mediated sight (Chapter 2). All of the aforementioned aspects of this study – development of techniques of architectural representation (Chapter 1, but also in regards to visionary projects in Chapters 3–5), and, finally, cinematic space – the interaction of *matte*, and then digital backgrounds, film sets, and profilmic spaces rendered in digital form (Chapters 2 and 6) – come together in the final analysis of Factory Fifteen's (alongside works by other members of the 'filmic' units at Bartlett) animated film productions in the Chapter 7. This final chapter builds upon the premise of medium's 'inherent dynamics' as conveyed through certain speculative projects, while simultaneously coming to terms with augmented, and computer-based media and techniques of design, in both cinema and architecture.

Utopian drive

Visionary drawings have been emerging at different times in history. There has always been a substantial connection between the mode of their presentation, usually a 3D model, a number of technical documents, and sets of renderings, collages, CAD printouts, each taking advantage of the medium's 'predilections' to represent movement, creating sharp juxtapositions, or drawing attention to the source of materials (as in the example of collages). Moreover, what had primarily been a peripheral activity, ranging from exercises to para-artistic research projects, came to be somewhat legitimized as a separate tradition. Its historical accounts include Neil Spiller's *Visionary Architecture*, Peter Cook's *Drawing Architecture*, together with a wide range of art books containing reproductions of works by visionary semi- or non-practitioners, from Giambattista Piranesi, Étienne-Louis Boullée and Claude Nicolas Ledoux, up to Lebbeus Woods, Raimund Abraham, CJ Lim and Tobias Klein. Some of those art-architectural inquiries intersect with utopian themes in literature. Both these disciplines are to varying extents informed by philosophical concepts, and they share an awareness of technical innovations, whereas each reacts to specific historical events and, watershed moments, or develops conceptual remedies to natural and man-made disasters. Numerous utopian constructs in literature operate according to the rule of extreme distortion of present-day conditions, portraying current fashions, tendencies, lines of scientific research and social phenomena in an exaggerated way, emphasizing their crucial aspects. Genres of science-fiction and utopian fictions resemble encapsulated versions of philosophical treatises. Utopian *reductio ad absurdum* always arrives equipped with extensive descriptions of foreign

kingdoms, specifics about their urban infrastructure and architecture, in a way that is meant to reflect social, cultural, or religious ideologies. Narrated architecture is therefore *architecture parlante* by design. All this masquerade somewhat distracts attention from an outright critique of residing authorities. Paper architecture is just as political and sharp-edged as its literary kin. Alexander Brodsky and Ilya Utkin's drawings made in the USSR during the Brezhnevian Stagnation viciously dissected Khrushchev's building policy and an anti-historicist stance of demolition/building projects. They disguised their agenda as a children's book, conveyed through illustrations accompanying absurd short stories, similar in style to the writings of Kōbō Abe or Italo Calvino. Louis Marin, the author of *Utopiques*, uses the term 'dislocated representation' to tie down depicted ideal(ized) places to their author's native land. This premise fits in well with most projects analysed here, because they do not only deviate from contents of typical architectural renderings, but also diverge from model techniques of representation – a touch of grim hue here and an overabundance of sterile platonic solids there would enrich the artist's intent, not just describing space, but fleshing out its atmosphere, or *caractère*, as the French neoclassical visionaries like such as Boullée or Ledoux would have said.

The second Chapter focuses on set designs and general factors informing creation of space in films. Concept artists and set designers have often-times been more than willing to bring up 'samples' from fictional sciences and dystopian artworks. Fantastical urban designs, as it seems, appear where disbelief had already been suspended. The primary concern here is to look into cases in which literary descriptions turn into actual – though temporary – constructions. In the long shot films can be seen as crossovers between architecture (space) and narrative (plot), thus filmic backgrounds are not there to merely embed, or illustrate scripted tall tales. They dress philosophical concepts in visionary architectural skin. Among other subjects, by the time of its inception, film was a medium dedicated to recording and storing evidence of architectural practice, either in the world outside, or mimicked by life-size studio mock-ups. Subsequently, it became an instrument for spatial inquiry, suited for constructing an impression of spatiality. With wide access to 3D design software, like such as Autodesk's AutoCAD, creating animated films has been greatly facilitated. This technological novelty had an immediate impact on the tradition of speculative drawings. Moreover, it became an incentive to re-view improbable constructs of the past, engaging with and designing unbuildable architectures in the present.[20] This way, the new medium of representation – simultaneously a designer's aid – has drastically altered the character (morphology, spatiality, static-dynamic relations) of projects. Digital drawings became to be invested with a dynamics that was missing (or only implied by) from the experimental projects of the past; even though architecture has always been as much about the permanence of built form, as about

FIGURE I.6: The chronogram for *Spacetime Hybridity* (at the time called *Space-Time Drift*). This short film is analysed in the final chapter. Soki So, *Spacetime Hybridity* (chronogram), 2012. Self-produced (UK).

temporal performance. Today's drawings move and make their background contexts more vividly (sometimes literally), animated. Disparate spaces can be juxtaposed, montaged or, collaged, or they can seamlessly flow into one another. Speaking about indexical provenance seems like looking at 2D entities from the vantage point of the third – or in this case, the fourth dimension. When seen as a narrated sequence of images, that is, a short architectural film, this quest for motion, mutability and change, made evident by the portrayed forms, that would explain and 'animate' the ideas behind their conception, has been transferred from atemporal to time-based media; from the slippery surfaces of Kiesler's *Endless House* to Nic Clear's *chronograms*, or Paul Nicholls's *The Golden Age: Somewhere* (2012, short film) – each calling upon a dynamic account of space.

The question of inherent dynamics

Just like any other genre, experimental drawings had their recurring 'heyday' moments, when fantastic architectures seem to have flourished and inhabited our imagination, as well as periods more akin to post-modern revisionism, when even the ephemeral plinth, upon which they were 'built' upon, is called into question. While in the first instantiation they are overlapping with periods of economic crisis, the second one characterizes technological breakthroughs. At the same time they are specific, focused modes of inquiry and self-examination, which enable the architect/ artist to view technological, social, and cultural changes from inside of the medium of representation employed. What comes as an intriguing about-face around the latter half of the twentieth century, is a growing dependency of those architectural projects on kinetic, time-based technologies, which simultaneously defines the scope of their interests. Bernard Tschumi, reflecting on this methodological shift, writes:

> It also influenced the graphic techniques, from the straight black and white photography for the early days to the overcharged grease-pencil illustration of later years,

stressing the inevitable 'mediatization' of architectural activity. With the dramatic sense that pervades much of the work, cinematic devices replace conventional description. Architecture becomes the discourse of events as much as the discourse of spaces.

(Tschumi 1996: 149)

One such example involves Constant Nieuwenhuys's *New Babylon*, a project envisioned as a daring attempt to map out – by means of numerous models, semi-abstract canvases and floor plans – a 'Situationist City'' with mutable, generative infrastructure. Both, the look of its physical models, and the paintings, were informed by – on the one hand – cybernetic circuits on the one hand – and artistic currents, on the other, with abstract expressionism and Francis Bacon's deformed figurative art at the helm. The unavailability of kinetic modes of representation[21] has enforced Constant's search for surrogate methods, among which one can count spilt paint (reminiscent of action painting), and visual associations they display to integrated circuits in the layout of sectors, going as far as to mark surfaces of his models with a bustle of scratches, resembling traces of past choreographies or ionized paths left by particles in a cloud chamber. Unsurprisingly, many years after the project's termination Nieuwenhuys's son created a series of short films, similar in fashion to fly-through presentations. Architectural dynamics, as reimagined by a nose-diving pilot, in the end, turned out to be the default mode of the project's presentation.

By its classic definition architecture is best expressed in terms of static structures. Thus, the twentieth century's post-war years witnessed a significant change in what would fall under the auspices of the so-called 'architectural' paradigm of art projects, heralding a move into art galleries (Walter Pichler's *TV Helmet/ Portable Living Room, 1967, and Oasis No. 7*, 1972), encompassing events-installations akin to performance art (Rachel Whiteread's *House*, 1993; Gianni Pettena's *Ice House I* and *II*, 1972, and Gordon Matta-Clark's *Splitting*, space 1974). In essence, incorporating new perspectives on space and the built environment, now reinspected from a dynamic 'vantage point', putting an emphasis on such aspects as motion, speed, transformation, adaptability and evolution. As architectural thought progressed from modernist machine metaphors to parametric organic models, even technical drawings seemed to fall short of representing these qualities, best visible in its dependence on sequences of still images, meant to collapse changes in structure against the passage of time. Architectural representations support themselves on agreed-upon conventions regarding their design and decryption (i.e. perspective projection). As far as all of these exchanges are technology-dependent, it is mainly the way ideas are shaped and expressed in graphic form, which encourages or even necessitates introducing alternative modes of visualizing projects.[22] Initial attempts to incorporate film as a research and survey tool were made by Donald Appleyard, Kevin Lynch, and John R. Myer

(*The View from the Road*, 1965), and Robert Venturi, Denise Scott-Brown, and George Izenour (*Learning from Las Vegas*, 1972). Each invoked a handful of techniques borrowed from outside of their field, such as sequences of images – movie stills – that illustrate temporal and spatial progression when surveying the city from a moving vehicle's position (windscreen view). There were collages, photomontages, diagrams, and even plans (in Venturi's case) for a film project. With the coming of CAD, short animated films were already integrated into model-making and visualization processes, an option 'embedded' in the software, enabling architects to generate virtual models and 'narrate' routes through and around their future buildings, in order to showcase the project in the best way possible.

The course of cinematic portrayals of architectural spaces ran along similar lines. At first, it has been conceptualized by Le Corbusier's take on Eisensteinian principles of montage in the architectural promenade of Villa Savoye,[23] subsequently having re-emerged in deconstructivist architecture, although revealing significantly more hectic iteration of the filmic syntax, as if reinterpreted by post-modern theory. In different media and disciplines this maturation in terms of film references could be noticed in shifting away from an idea of architectural cinema, that relies on spatial ordering and editing sequences akin to those in Villa Savoye (directing user's attention and navigating his route around and inside the building), to a perspective that allows us access to a cognitive frame structuring architectural ideas along the lines of cinematic narratives (Bernard Tschumi, Peter Eisenman). Instances of the latter fall back on the 'language' of camera movements, tracking shots, framing and so on. These are subdued to editing rhythm and punctuated with scripted events. Architectural animations verging on the speculative tenet too can harness these modes of spatial constructions. With contemporary ubiquity of CGI, the nature of represented (or rather simulated) environments has been radically transformed, along with modes of their presentation. Conflict came to be replaced with confluence, echoing present-day dilution of material reality with the intangible data sphere.

Literature review

This study pursues its albino whale by connecting a range of disciplines, among them: cultural theory, historical accounts and critical works from the fields of film and architecture. Most prominently it touches upon architectural representation and visionary projects. As speculations conducted in drawing hail a range of conventions and modes of representation, there arises a substantial need for analysing various methods of architectural imaging, including sketches (Smith 2005, 2008; Belardi 2014), accounts of the design process (Edwards 2008; Dernie 2010), but also of its history (Bingham 2013), counterbalanced with a history of perspective

projection (Damisch 1994; Panofsky 1991), complemented by a discussion of the 'perspective hinge' in an evolution of architectural representations (Pérez-Gómez and Pelletier 2000).[24] Among these insights visionary production has always been the steepest path to tread. In-depth studies concerning the subject cautiously elucidated the intricacies of speculative designs, while simultaneously postulating typological categories that help to discern them on the basis of techno-cultural developments in the twentieth century (Spiller 2007). In other cases they are focused on various properties of drawings, filtered through the sieve of style, composition, imagery, atmosphere and expression, or the way they forsook past preoccupations in order to pursue an independent reality of represented space, researching new rules that govern architectural imaging in the post-digital age (Cook 2008).

The interdisciplinary approach employed in this book collates those accounts with publications on film theory and books that target the history of architectural space in cinema, along with transformations of filmic space as such. This perspective is an important one as the space of representation we encounter on screen could have rarely been – in its history – boiled down to profilmic elements visible on set. When it comes to compositing spatial layers and objects visible on screen, alterations go much further than that. In fact, most often we are looking at a well-stitched composite of (partially) built sets, actual sites and 'forced perspectives' – matte paintings placed in precisely demarcated position in relation to the camera, reinforcing their optical illusion. More often, we are watching purely artificial, in-studio footage, which has been expanded in post-production with CG additions, having digitally effloresced from disjointed actions that make up the actors' movements around the location. Additionally, this space is raided with CGI objects, or, should we say, *objectiles*, following Deleuze's theory on epistemological shift in digital age, postulating thereby an emergence of the new object, which 'assumes a place in continuum by variation' (1993: 19). This status of digital imagery, which defines its qualities – weight, volume, light reflection and so on – only through interaction with live-action footage, can be reminiscent of the problematic status of 'physics' in animated films, as described by Paul Wells (1998, 2006). But this is hardly surprising, when recalling that CGI was introduced to both live-action cinema and computer-animated films primarily through the 'backdoor' of special effects. The evolution of objectivity into a rendered, pro-viewer subjectivity, or the dematerialization of the (architectural) object in filmic space, is an important achievement of the 'digital turn' as much in cinema as it is in architecture. I discuss this on the example of architectural manifestos (Lynn, Spiller, Woods, etc.), while also looking into theoretical accounts (Pérez-Gómez and Pelletier 2000; Dunn 2012; Carpo 2013). Authors who characterize this technological transition as an ontological shift propound a new spatial concept as integral to the projects, touching upon notions of the filmic image (Pallasmaa 2007), mediatization

(Tierney 2007), subjective/objective space (Vidler 2000) or architecture's framing of immaterial realities (Hill 2006).

Even before the actual possibility of creating mobile buildings in 'cyberspace', a noteworthy turn towards non-static visions of our surroundings could be observed on multiple levels, involving narrativity (Psarra 2009; MacLeod et al. 2012; Madge and Peckham 2006), memory (Bevan 2004; Coward 2009), metamorphosis (Diller and Scofidio 1994; Wigley 1998; Sadler 2005; Walker 2009; Cantley 2011) and relativity of time (Keller 2003). Each of these studies places a dynamic *clinamen*[25] at the heart of an architectural project, recognizing drawing, film or other media of representation as documented sites, where this interference takes place. With this inherent bias of the medium issues of coupling vision with motion, along with the optics behind graphic representation of space, became the main object of study, placed on the metaphorical 'drawing board'.[26] Thus, the perspectives mentioned above contract in a new understanding of the imaged locus – the space *inside* representation. Instead of a void, gap or interval enclosed and partitioned by the structure, space came to be regarded as a field invested with vast libraries of potential actions, as if readied to be performed by the user. 'Perhaps the symbolic function of the new architecture is to make the invisible visible, not by the monumentalisation and formal expression of the function or shape of these invisible networks, but as an essential part of their function' (Frazer 2013: 52). Perhaps it is, and speculative drawings (among other media harnessed for architectural imaging) were among the first to tackle this new cognitive frame. Because drawing has always been the 'motive force behind architecture', media used for speculative projects were turned into sites of research, form-finding and reconsideration of ideas in spatial terms. Processes and techniques which allow for a manipulation of architectural concepts on equal terms with imagery, following in the footsteps of modern filmmakers and special effects artists, also had a significant impact on the attempts of realizing the unbuildable. If not in material reality, then, at least, as input material that makes up the filmic space. Numerous authors had already singled out the way architects conform to techniques of filmmaking (Cairns 2013), or 'force' their perspectives on film theory (Tawa 2011), along with essays on the topic, written by architects themselves (Tschumi 1996, 2012; Appleyard et al. 1965; Koolhaas 1994; Lynn 1998; Diller and Scofidio 1994). Nevertheless, hardly any research has approached this subject from the side of special effects and animated cinema.[27] Traditional objects, when represented on screen, do not only assume the status of images, but are equated with deliberately artificial creations elevated to the status of spatial entities (2.5D and 3D mappings of space). There is substantial ground for an image-based account of space and a further reconsideration of space 'spun' from (digital) imagery, just as it has been done in relation to cinematic spectacle and Vfx (Rickitt 2000; McKernan 2005; Murray 2008; Purse 2013).

Could there be a better site for the 'un-making' of imaginary of architecture, which aligns itself to the rules of both a representation and simulation, than cinema itself? Opening up this vast new terrain of cultural production to architectural speculations implies a reliance, to some degree, on narrative models, aesthetics, as well as themes taken from utopian and science-fiction literature (and cinema). Instead of transplanting specific examples into architectural visualizations, or referring to them at length, animated architectural films are prone to referencing specific generic determinants in the form of visual cues or atmospheres (colour palettes and their juxtapositions, narrative modes, settings, stylistic conventions). It would be more appropriate, therefore, to speak of utopian drives, instead of storytelling as such – the essence of speculative literature, distilled by numerous literary (Suvin 1977; Bloch 1996; Moylan 2000; Jameson 2007) and architectural (Tafuri 1976; Coleman 2005) critics. The above-aforementioned areas of interest, ranging from literature and cinema to architectural representation, converge in animated architectural productions. They are analysed in the final part of this book. Among the examples included in chapters devoted to film and CGI are works of architects like such as Robert Mallet-Stevens, or Joseph Urban, who had the opportunity to implement their ideas on (or as) film sets. Younger generations are also evoked, especially contemporary architects-turned-filmmakers, because of their ability to translate much of their training to the big screen (Joseph Kosinski's *TRON: Legacy* [2010], and *Oblivion* [2013]). An interesting reverb of this practice came with the involvement of graduates in architecture with professional film productions, in which context they become members of art departments, production designers, or subcontractors creating visual special effects, opening sequences, and entire CGI environments.

Methodology

In order to approach material this diverse, an array of methods was involved not only as the preferred mode of inquiry, but nothing short of necessity, when analysing architectural representations and films. In particular, methods taken from literature studies can be applied to instances of live-action and animated films. Here, they have evolved into post-structuralist case studies. Visionary architectural productions, for the purpose of this work, came to be regarded as texts of culture, interpreted against techniques of their development (the discourse they partake in), and viewed from the standpoint of art theory and criticism. As objects whose status is at the same time that of artworks, architectural projects, and films, the methodologies used for analysis often interchange in order to arrive at the most efficient and revealing conclusion (though, more often, a vantage point). Studies in literature allow for extracting an underlying narrative structure, but also help in recognizing

the main distinctive features of genres reliant on speculation (science-fiction, fantasy, utopian literature). This, in turn, can be applied to their cinematic counterparts (and indeed was). An additional demand is the inclusion of perspectives on visual arts of 'higher complexity' – the intricacies of representation, and spatial imaging for/in 2D, 3D (models, both digital simulations and fabricated objects), and 4D (film, animation) media. As the argument moves from 2D analogue representations towards 3D CG models, a still fairly recent studies of semantics behind the use of CGI in cinema proved to be very productive, especially in a comparative analysis of consequences and ontological shifts initiated by the 'digital turn' in architectural and filmic practices. As these modes of production are interchangeable, or rather overlapping in film and architecture, a fruitful approach requires of the researcher to correlate them with theories that focus on problematic aspects of 'digital age' animated films. A substantial body of literature focusing on extreme manipulations of artificial (in contrast to pro-filmic) imagery has been published on the subject, interpreting parametric designs in architecture, CG imagery, and digital post-production in films. Still, this study owes just as much to cultural theories, such as the Deleuzean fold or Derridean deconstruction, both applied in architectural discourse profoundly, covering such issues as form-finding and morphology (form generation), as well as inquiries into designer's visualization tools. These collaborations were evidenced by architects' notebooks and graphic endeavours, as in the case of Bernard Tschumi and Peter Eisenman, who maintained a long-lasting correspondence with the latter theoretician (collected in 1997 as *Chora L Works*). The same can be said of film theory and the way it was 'hijacked' by architectural discourse. In the beginning of the twentieth century cinematic vista of architectural practice was still slippery ground for modernist architects, but five or six decades later, in the 'aftermath' of the 'performative turn'[28] in arts, it was re-interpreted in the 1980s by deconstructivist architects (Tschumi, Prix, Eisenman, Koolhaas). Yet another decade closer to the Y2K millennial fever, and the creators of *blobitectural* forms could be seen fiercely invading the same province through the backdoor of visual special effects in Hollywood block-busters (Lynn). In the course of these twenty years which have passed since the publication of Greg Lynn's essays on computer-aided drafting, numerous theorists, both from the fields of architecture and cinema studies, eagerly contributed to this interdisciplinary endeavour. Only a handful of them did so from the perspective of architectural speculations.[29] None have approached it from the other side, analysing productions in the emerging field of architectural animations, and inspecting their functioning not within the architectural, but cinematic discourse. In fact, only in the course of the past decade architects started gaining ground as visualization artists, filling their portfolios with TV commercials, trailers, opening sequences, or CG environments (nowadays, a term more appropriate than 'matte painting' or 'set design', which it came to replace),

rather than directly contributing to the cityscape. As virtuosi of the craft are turning into animation artists, the architectural background adds yet another dimension to their filmic output. We have reached that point in the development of high-definition technology that makes us notice wooden dowels hammered into the Death Star's hull, let alone any minor faults in the designs of architectural spaces that usually appear on screen for no more than just few seconds. Photographic veracity can be a curse. Having refurbished our living rooms into tiny cinemas, we can attain crystal clear still life each time we freeze-frame the screening/streaming. Long gone is the VHS tape jitter. High definition is a requisite not only in film, therefore architectural space needs to be properly constructed; primarily, from imagery. Architects who venture into filmmaking, instead of complying unanimously to the task of 'painting backgrounds', with their fluency in AutoCAD and CityEngine, turn into art directors. Unsurprisingly, animated architectural films turn in their hands into virtual construction sites, where visionary projects can be pursued at length.

Cine-Eye and the CGI

Even if film form can be seen as a means to evolve, unwind, and develop time-based strategies of design, it is thanks to experimental projects for inflatable *Cushicles* and *Suitaloons*, adjustable *New Babylons*, concealed *Glacier Cities*, tremor-alignable *Slip Houses* that fall into place after shock, or endlessly configurable *Houses for Euclid*, that brought about an architecture of liquid forms, which inherited their dynamics (though mainly implied, due to their paper form), making it work in the digital environment. Implied motion becomes motion distilled from 3D models and their NURBS surfaces defined by control points (Carpo 2013: 9). One other aspect irrevocably binds together the object and the observer. It gained gradual recognition by those architects, who were primarily interested in the connection between vision and motion, conducting their researches on built-in properties of simulation, while 'probing' it by means of virtual cinematography, photogrammetry, and match moving. Just as baroque art specialized in embedding optical illusions into buildings' decorum, in order to unveil certain architectural features noticeable only from precisely defined vantage points, the digital iteration of this play with constructed illusions is conducted, nowadays, in CG space. It has been pushed to its (il)logical extreme, revealing before our eyes an altogether distinct construct with each shift in the position of the 'cine-eye'. Far from merely showcasing virtuosity, this certainly falls within the scope of visionary architecture. Essentially, the purpose of such spatio-visual coupling lies in imag(in)ing and setting forth spatial speculations on the nascent modes of habitation, forecasted by bleeding-edge technologies.

Taken as a whole, this study aims at mapping that new territory, eagerly opening up for speculative architectural projects as they draw upon a variety of sources taken up from literature, cinema, and cultural studies, while retaining the complexity of an architect's mindset and attitude. With an emphasis put on the inherent dynamics of filmic medium, these strategies flourish in animated architectural films created by the latest generations of architecture school graduates, familiarized with new digital media of architectural representation, and just as much with the history of cinema. The borderline between material environment and spatialized imagery becomes progressively more blurred, while a demand for visionary works that make sense of this merging, has never been greater, especially due to the fact that present-day film productions can be viewed as the aboriginal site, which had more than contributed to this hyperreal paradox. Peter Cook, one of the founders of Archigram, expressed that far more accurately, by saying that

> architectural drawings are easily able to transcend any reference to reality. Yet this is not some abstract or nihilistic position; more an ambition that is essentially borne of the belief that architecture has much left to discover and that the architect can make drawings that transport him or her into a form of séance.
>
> (Cook 2008: 177)

May this séance be cinematic, while discoveries remain uncompromising in terms of prefabricated definitions. Let architectural filmmakers forget about constrictions, regaining lifeblood that comes from animating their speculative projects.

1

On Techniques of Architectural Representation

'Although drawings, prints, models, photographs, and computer graphics play diverse roles in the design process, they are regarded most often as necessary surrogate or automatic transcriptions of the built work', wrote Alberto Pérez-Gómez and Louise Pelletier (2000: 3) in the introduction to their book *Architectural Representation and the Perspective Hinge*. The tradition of sketching, understood not only as an educational method but also as a tool for brainstorming, visualization and refining of ideas, even in the age of computer-aided design (CAD) remains as vital as in the days of École des Beaux-Arts. Imagine young novices eagerly sketching Greek or Roman ruins during their Grand Tour, or – some hundred years into the future – Le Corbusier himself sitting at the feet of Parthenon, committed to the same activity. No haste. Just the rigour of tracing lines on paper, catching both the outlines of architectural objects and the surrounding atmosphere. Watching this, we could well imagine that a free-hand sketch on paper is actually the primary 'site' of idea's translation into graphic composition, where future structure is traced in pencil, then ink and finally in proverbial stone.

In 2014, the Drawing Center at the San Francisco Museum of Modern Art organized a show to commemorate the late Lebbeus Woods. However, art gallery exhibitions like this one reveal a truth quite contrary to the practice, which relegates sketches and preliminary drawings to the status of waste products of architectural thinking-design process. Also included are other techniques of visualization that are not meant to inform the construction process directly. In the contemporary overabundance of images these examples hold a remarkable, if not heroic, position in the realm of architectural visions, remaining sole artefacts that offer insight into style and composition skills, together with the architect's radical views on built form and architecture's prospected applicability. When denied possibility to build, one must draw and write. Except Woods; he used to 'build' his drawings. What was in fact exhibited at the Drawing Center were visual polemics

and critical texts inventing permanent and makeshift constructions in reaction to urban disasters – both natural and man-made. Despite their 'unbuilt' status, they are legitimate spatial proposals. Projects such as *Quake City* (1995), dealing with the consequences of the 1994 Northridge earthquake by conceiving houses which submit to the tremors through resilience and dynamic reconfiguration, or *High Houses* (1992–95), elevated like mutant stick insects over the panorama of war-damaged Sarajevo, are anything but incomplete or preparatory.

While Woods might have appeared like a lone wolf on the architectural scene, he was far from a quixotic expatriate. Lineages of maverick designers both preceded him (providing necessary conditions for emergence of such works) and followed in his footsteps. When it is impossible to build monuments, the monumental finds its home in the imaginative potential of the drawing. We can trace the history of experimental architectural drawings, as Neil Spiller characterizes this visionary province, narrowing the number of culprits down to three antecedents: Francesco Colonna's *Hypnerotomachia Poliphili*, geometrical buildings of Claude Nicolas Ledoux and, most prominently, the etchings of Giovanni Battista Piranesi, 'the first "paper architect" to purposely draw unbuildable propositions' (Spiller 2007: 11).

Techniques of architectural representation

This chapter's main focus falls on the concept of drawing regarded as compositional experiment. Such makeshift definition makes room for all sorts of adventurous

FIGURE 1.1: NaJa & de Ostos, *The Hanging Cemetery of Baghdad*, site plan, 2007. Courtesy of Ricardo de Ostos and Nannette Jackowski.

proposals that can somehow evade reality in economic, political or engineering terms. Therefore, the tradition sketched out earlier functions mainly as an artist-architect's conventional support; a generic means to encrypt one's vision. These modes of visualizing, and generally externalizing ideas, have proliferated over the years. In the twentieth century, specifically, they branched out into a breadth of parallel disciplines, as the architects who were unable to get commissions and those who were constrained by typical requirements of private, municipal and commercial projects entered the galleries. And so the pop architecture of Archigram or Superstudio popped up in the late 1960s, using diversified mixed media to represent their radical projects. These groups were treated either as radicals in their own field or counted among artists-provocateurs, for whom architecture was a language of choice. The foundations for this art-technological convergence were laid a few centuries ago. Let us embark on a historical tour of representational techniques.

> Clearly, the history of representational methods cannot be recounted by following some imaginary line that takes us from two-dimensional representation to an illusionistic one in a sort of virtuous progress finally culminating in Renaissance linear perspective. A better understanding may be gained by studying the cultural properties and techniques that in each epoch became the convention.
>
> (Scolari 2012: 326)

While Vitruvius had conceived of three major forms of architectural representation – graphia (plan), orthographia (elevation) and scaenographia (perspective) – the next generations codified this palette, enriching it with section cuts, 'illustrative' perspectives and orthographic projections. This typology has prevailed for centuries. Built upon Alberti's ichonographia (ground plan), orthographia (elevation or façade) and dispositio (a preparatory drawing, which is a projection of the building for both architect's and client's better understanding of projected structure), architecture came to regard the triad of section, plan and elevation as its 'plinth' – a syntax indispensable to any proper documentation. Architectural drawing, when considered integrally to other stages of production, is a rigorously codified set of representations, including orthographic projections that reveal three main views of a prospected building. They translate it into 2D forms: plan, an aerial, God's-eye view; elevation, which roughly equates the façade; and section, a cut at an angle perpendicular to the axis. Subsequently, the Renaissance, Baroque and Enlightenment introduced new 'genres', elaborating on past techniques by adding a wealth of conventions, or modes of expression, characteristic of particular stages of the design process. For example, with *designo*[1] – not to be mistaken with 'design' – students were able to practice visual expression skills, searching for and giving shape to their initial concept. According to Aristotle such actions ought to

be treated as anticipatory of the work of art's emergence (Smith 2005: 10), due to their manual nature. Giorgio Vasari used to connect it also to theory, because it involved abstraction of natural forms. This emphasis on theory and 'thinking with one's hand' expands on purely abstract readings of architectural spaces, operating on concepts and mainly concerned with methods of construction, much less than their verisimilitude to real-life buildings. The praxis of conceptualizing architecture, by envisioning it as something dematerialized, soon began to spawn multiple critiques and polemics, published mostly as treaties in perspective construction, which deliberated on its closer association with painterly conventions or, alternatively (and at a later time), with the architectural method of interpreting space. Among them were Sebastiano Serlio's *Five Books on Architecture* (1545) – the first painter and architect who has dedicated a whole chapter on problems of perspective; Antonio Filarete's *Trattato d'Architettura* (1464); Niccolò da Cusa's *De Visione Dei* (1453); and Jacopo Barozzi da Vignola's *Due Regole della Prospettiva Pratica* (1583) (Pérez-Gómez Pelletier 2000: 17–22, 32–33). Majority of these works served as manuals for construction of perspective drawings, although the most famous among them, Leon Battista Alberti's *Della Pittura*, did not include even a single drawing. Such discussions on numerous techniques that could be used for refining the effect of the picture led perspective away from architectural exactitude and its origin in optics into a realm of purely spectacular and hypothetical constructs that would soon proliferate into an artistic province, treading from *perspectiva naturalis* to *perspectiva artificialis*. Two 'genres' of Baroque art took the lead in falsifying designs this way: *capriccio*, a combination of imaginary and real places; and *veduta*, the deformed, grotesque views of real sites (Smith 2005: 47). Another expression that can be roughly translated as 'sketch' – this time of French provenance – gained its ground in times of the École des Beaux-Arts. *Esquisse* indicates a method of swift visualization of a given problem in the form of an organizational diagram.

> The *esquisse* was used to quickly visualize the solution, express the character of the building, and compose the page. Although mainly freehand, the *esquisse* was not the loose first thoughts sketch, but a rough rendered drawing that conveyed the essence of the solution.
>
> (Smith 2005: 71)

In each of these instances drawing is defined as a critical method of evaluation, research and creation of conceptual forms. This process is self-referential, as it comprises a mode of enquiry that requires probing at once imagination and memory, treating them as incentives to (or in the process of) design. Also, it is purely graphic, bringing in rules and protocols of perspective's (and other graphical

projections') construction for initial validation of the design, before conducting the test on an actual construction site.

> Sketches and drawings are modes of architectural representation, as they may represent a mental impression of a visual perception of a setting as it is observed. The representation often gives the ability to see beyond appearances to a deeper meaning. The act of drawing facilitates interpretation.
>
> (Smith 2008: 4)

In this regard they are not audience-oriented, as they deliberately fail to convey a direct message that meets requirements of standardized architectural specification. They are acts of intimate conversation with oneself. Instead of forming clear messages, they leave gaps for interpretation. Drawing for the sake of drawing, remote from any material 'signified', intersects with interests of speculative and experimental projects. Visionary architects of the Baroque, and their successors as well, branched out precisely in the direction of hypothetical constructs, relying, to a great degree, on graphic depiction strategies,[2] thus developing conceptual works with the aid of specific design methods, while taking these ideas to their (il)logical extremes. For example,

> [the] architecture [of Piranesi] suggests a potentially different way of recasting truth into work, a different future 'order' for human life beyond the conventional opposition between the traditional 'fine arts' and technology, an opposition now clearly obsolete. Looking retrospectively at the modern era, we can now easily identify architectural ideas embodied in critical projects of many kinds, acknowledging the difficulties of building a symbolic order in a world preoccupied with production and programmatic shelter.
>
> (Pérez-Gómez and Pelletier 2000: 78)

Speculative drawings and theoretical projects[3] often forsake standardized methods, essential for communicating the project, and plunge into avant-garde tactics of representing space. The aforementioned 'genres', or modes of expression, such as *capriccio*, *veduta* or *designo*, became media in which the architect-artist was able to convey his vision. Moreover, they were ones which facilitated specific methods of graphic construction, such as sight lines in perspective projection that reinforced the outlines of a building's geometry. In a similar manner the juxtaposition of photographs and drawings from various sources in collage works were balancing between neglect of their former scale, signification and context. Instead, upon their compositional arrangement in a shared space, stark contrasts were brought to the fore of the presentation. Methods of composition are thus like graphic protocols – scaffoldings – leading us away from familiar grounds of a codified system into

new modes of writing/reading. Such acts require knowledge of art conventions, media and techniques, as well as an acquaintance with general history of cultural forms, not only architectural artefacts. This helps out in understanding, let alone recognizing, 'quoted' fragments; therefore, a sort of interdisciplinary literacy is developed. It operates through assigning to an experimental architectural project the status of a textual embroidery of traces and patterns 'translated' from multiple media, akin to hybrid genres in cinema.[4]

Historical section through the perspective cone

Let us stop here for a minute and inspect the widely reproduced image of Jeremy Bentham's Panopticon. A single drawing combines a semicircular plan with a frontal view that juxtaposes elevation with section, allowing us to imagine the Foucauldian prison virtually, in 3D space. It employs Piranesian cuts, which apply a range of lighting effects that render the represented building, as if performing an actual intersection. They reveal the building's interior as if it were indeed intersticed, in a way that reveals the interior by letting the light seep in. Complemented by technical documentation, this triad of privileged views has not always been indispensable for the project to be built. 'Plan, section and elevation drawings and models are the conventions used to communicate the idea; however, they need to be created using a system that can be measured and is understood by the architect, builder and client alike' (Farrelly 2009: 34). Still, communicating one's idea, or – in other words – selling the product, involves an aesthetic surplus, that is, an atmospheric rendering, which employs linear perspective.

Read with less difficulty than orthographic projections, perspective introduces a view of the project that most closely resembles a generic observer's experience of architectural space. Even if the vantage point is suspended high above, or the building is perceived at an extreme angle, we can discern from the scene crucial information based on our experience as navigators of three-dimensional space. However, in his classic book *The Origin of Perspective*, Hubert Damisch disproves of this intuitive claim, as it neglects a range of other methods of representation. Rather, he suggests that we regard it as a cognitive framework allowing us to structure spatial interrelationships between objects and settings. This mental scaffolding gives rise to independent architectural creations, which are concurrently optical illusions. Initially, there was no sharp distinction between painterly and architects' takes on the technique. In Damisch's view,

[P]erspective, whether the work of a painter or an architect, was inseparable from architecture [...] in no case does the latter constitute an empty form, and that there

can be no perspective [...] save *of something* – this something being above all architecture, from the moment there's not, and cannot be, anything but a constructed perspective, and that perspective is, fundamentally, an architectonics?

(1994: 270–71, original emphasis)

The account given by Alberto Pérez-Gómez and Louise Pelletier in *Architectural Representation and the Perspective Hinge* should suffice as an evolutionary outline of architectural drawing's vocabulary. Contrary to contemporary opinions, in Plato's *The Republic* (1992: 273), and even in the days just after Filippo Brunelleschi introduced an earliest example of constructed linear perspective (1420), perspective was far from being considered as a precise and reliable technique for architects. During the Renaissance, only the 'paper templates, *modani* [...] [being] 1:1 profile drawings of building cornices, architraves, and column bases, subsequently cut with scissors along their profile and passed from the drawing board to the stone masons on the building site' (Foote 2015: 30), were considered indispensable[5] to the activity of building (Pérez-Gómez and Pelletier 2000: 7). Therefore, a distinction should be made between standardized/necessary views and those that are just supplemental aids to imagining/visualizing architectural proposals. 'Although drawings, prints, models, photographs, and computer graphics play diverse roles in the design process, they are regarded most often as necessary surrogate or automatic transcriptions for the built work' (2000: 3). What if we were to step out of this biased perspective on architectural representation and look into the instances which appraise these peripheral aids strictly as supports for the thinking and imaging processes?

In typical perspective drawings that were created prior to the introduction of descriptive geometry, potential usefulness and technique's appropriateness as architectural tool have been widely disputed. It was probably not until Abraham Bosse's and Girard Desargues's *Maniére universelle pour poser l'essieu* (1636) that the concept of an abstract observer, whose location could be projected to infinity, had been introduced (Pérez-Gómez and Pelletier 2000: 69). Desargues argued that the point of convergence of the sight lines should be located at infinite distance. Advances in optics and cognitive sciences later revised this assumption, presenting examples in which the eye's position would be mobile.

In the early seventeenth century, [...] Guidobaldo del Monte was the first to seriously consider the position of the observer, the distance to the object, and the angle of view as points of departure for a perspective construction, which would enable the eye to take in the object in a single glance. This awareness of the embodied observer as an element in perspective construction was absent in earlier writings, in which the observer and the viewing distance remained implicit.

(Pérez-Gómez and Pelletier 2000: 19)

Novelties like del Monte's propositions allowed for perspective projection to be reconsidered from a subjective account. At the same time they probably paved the way for audaciously radical opponents of the perspective's alleged objectivity, deeming it false. They were countering it with exaggerated inventions along the lines of anamorphosis or deformations arising from an observer's unusual position, skewed angle of view or movement (parallax). Before the introduction of Renaissance's *perspectiva artificialis*, it was too soon for architects to concordantly agree upon using strictly geometricized techniques of representation, which would eventually end all critiques of Cartesian codification of space. Even such attempts as performing sections through the pyramid of vision were met with unease (2000: 20, 27). On the other hand, section cuts through architectural bodies came to be accepted as 'a legitimate embodiment of architectural ideas because they were more precise than composite drawings, and therefore were considered more appropriate to embody Platonic truths' (2000: 41). Seventeenth-century philosophy only reasserted this view, along with a standpoint that presents reality as governed by laws of mathematics; a world which has not yet 'shifted gears' to wild spin in a chaotic universe of probabilities but remains 'a homogeneous, geometrized space' (2000: 55), which would later be scrutinized by the 'audit commissions' of Team X or the 1950s *spatial urbanists*. In their projects postmodern architects commenced stretching, twisting and folding of the orthogonal grid. The nineteenth century saw the emergence of a modern model of science, as well as novel methods of inquiry, exemplified by collaborative research, data collection and experiment trails. This way architectural discipline was led away from natural philosophy and became underwritten by a belief in a mechanistic and mathematically defined universe, relegating perspective – now reinforced by Cartesian coordinate system – to a tool of objective projection; every designer's first choice of visualization aid.

> Once geometry lost its symbolic attributes it had maintained in Renaissance and seventeenth-century philosophical speculation, perspective ceased to be the preferred cultural form of ordering nature and the built world. Instead, it became a simple re-presentation of reality, an empirical verification of how the external world is presented to human vision.
>
> (Pérez-Gómez and Pelletier 2000: 71)

Despite the specified codes of representation according to which both architects and painters can construct valid perspective projections, the technique remains vulnerable to numerous tricks of the eye. Illusionist painters, scenic designers for theatre and the Baroque period's draughtsmen had taken advantage of this 'leverage'. Piranesi must have seemed like the greatest trickster among them. When inspecting his

Dungeons series, many critics noticed the constructional impossibility of these spatial arrangements. Certain spaces of his infernal compound seem to be simultaneously contained within one's visual field, while at the same time entrapping the beholder in an act reminiscent of Michel Foucault's study of Diego Velázquez's *Las Meninas* (1656). Elements which should be obscured by bridges come to the spotlight. In his student designs (*Micromegas*, 1979), Daniel Libeskind would return to the Piranesian underworld, with his incredibly complex structures codified in axonometric projection. *Micromegas* were undermining claims of accuracy and mimetic verity congruent with this representational method by multiplying the depicted machineries' rationalist ordering with pedantic scrutiny. Cartesian Rationalism gone amok.[6]

Contre perspectivisme

The twentieth century pushed perspective even further back, to a 'players' bench' of representation methods, by turns gaining and losing esteem in architectural circles (Sennott 2004: 58–59), sometimes in favour of axonometric projection (Bauhaus, De Stijl, deconstructivism), which was considered more adequate for making quick measurements, and devoid of shortening errors. Near the end of the twentieth century, and into the next millennium, with the advancement of computational design there came a radical shift in the approach to linear perspective, using technical means even further advanced in terms of scientific accuracy. Contemporary artists like Enric Miralles and Benedetta Tagliabue (EMBT) can produce correct one-point perspective photomontages, algorithmically stitched from multiple converging architectural perspectives, extracted from photographs and collaged into a homogenous work (Shields 2013: 166–67), while others, like Michael Alling, compose panoramic photographs out of rendered views, akin to those made by Viollet-le-Duc at Château de Pierrefonds. Instead of standing guard over a realistic reconstruction of human perception, perspective became a membrane for artists, a malleable genre to play around with. In turn, multiple projects consider perspective projection as a technique studied under a 'magnifying glass' of other modes of visualization, deconstructed with digital technologies, and redefined by dynamic media of photographic (live-action films) and pictorial (animated film) provenance.

Even most accurate linear perspectives cannot substitute for the actual experience of traversing architectural space. Interestingly enough, this new technique of visualizing space was approached with caution, and even

> [i]n the fifteenth century, the growing fascination of painters with linear perspective did not lead to a geometric systematization of pictorial depth, nor did it instrumentalize the process of architectural creation [...]. Homogeneous space could

exist only in the supralunar realm, where the regular motions of heavenly bodies provided a normative order for auspicious action in the human realm of constant change and corruption.

(Pérez-Gómez and Pelletier 2000: 21)

Four hundred years after its inception, it became beset by alternative systems: Auguste Choisy's (1841–1909) axonometric drawings, first used in the nineteenth century; collage, employed as both a generative tool and a mode of presentation; photomontage, with its role in illustrating proposed designs against an already existing context; and a practice of diagramming that – under Tschumi – mutated into cinematic storyboards, in order to showcase the way buildings are meant to be experienced over time and how they ought to 'perform' in response to their users' actions. Despite the fact that Choisy's axonometric projection was intended as a critique of perspective projection, it was precisely this mode of representation that had spawned multiple utopian fancies. Viewed as an objective method of depiction, it allows the architect to construct complex mechanisms with great clarity and take precise measurements from the drawings (Mandoul 2008: 155). Popular in the academia with architects like Koolhaas or Eisenman, it garnered playful detractors, eager to expose axonometry's hidden bias towards reductive uniformity, in which the object fuses with coordinate axes, thus revealing its 'blind spots'. Along these lines Eisenman's *House E1 Even Odd* is an axonometric exploration of representation, not merely another design following its rules. It undermines the convention by imposing an axonometric projection onto a minimalistic contour drawing, which results in the project's appearance as superimposed on the frame of reference. Other techniques characterized here, rather than aiming at depictive clarity, act like methodologies in research. Recall Le Corbusier's interest in painting, collage and avant-garde art forms, which would influence many of his designs. Collages created by Mies van der Rohe are not any different, resembling samples of textures and surfaces laid out on the page as directions to the intended future clashes of tactile materials. It is important to notice that this critical examination of architectural techniques has been a constant in the history of speculative projects, deconstructing building's creation into a sequence of activities consisting of preparing plans, models and renderings, and progressing to the execution stage. In essence,

once geometry lost the symbolic attributes it had maintained in Renaissance and seventeenth-century philosophical speculation, perspective ceased to be the preferred cultural form of ordering nature and architecture. Instead, it became a simple re-presentation of reality, an empirical verification of how external world is presented to human vision.

(Pérez-Gómez and Pelletier 2000: 71)

Such statements may echo arguments, posed by Massimo Scolari, regarding axonometric projections. The so-called cavalier, or military perspective (orthogonal parallel projection), due to its reliance on a 45-degree angle, allows building's right angles to remain right (90 degrees) on paper, presenting a slightly elevated view of the structure. Military engineers demanded greater clarity in fortresses' plans, upbraiding fashionable perspective renderings for their distortions in size and occlusions. Moreover, unlike perspective projection, in axonometry parallel lines remain parallel, while the technique avoids being subjected to such extreme distortions generated by foreshortenings of depicted structure's dimensions.

In 'Sophisticated Geometry, Baroque Composition', Philippe Potié noted that after Renaissance, as growing tendencies towards standardization of methods of architectural representation began to take hold, perspective was considered a dangerous 'system of falsification'.

> From the standpoint of the 'externalization' and specialization of architectural practice through the tool of drawn plans, the work done by artists was counterproductive. Using the same plan-and-elevation system, painters could play on the vanishing point to produce a fictive building before the client's eyes, with no guarantee of the constructive mastery that the geometric system precisely provided.
>
> (Potié 2008: 108)

This is quite contrary to what Quatremère de Quincy and the École des Beaux-Arts type of education (after the 1824 reform)[7] expected from students, regarding perspective as a scientific practice derivative of mathematics. Although the school's attitude towards it remained ambiguous (it was not included in the curriculum of obligatory courses), by the early twentieth-century it attracted a wider interest among architects, not only among sculptors and artists (2008: 142–43), with the reproduction of atmospheric renderings in burgeoning mass media. But with the works of Eugène Viollet-le-Duc it was not sole perspective as such, but descriptive geometry which attained prominence and, in turn, 'consolidated' that visualization technique. 'Whereas the specificity of perspective representation lay in its dichotomous merger of geometry with pictorialism, by the end of the [nineteenth] century architects tended, on the contrary, to separate the two' (2008: 149). When descriptive geometry became the 'official' mode of architectural utterance, and more scientific of the two, perspective subsisted as a personal training device, critical study; an artistic endeavour. This illustrative novelty with all its atmospheric charm was indeed subject to various shortcomings (from an architect's point of view), and illusionistic manipulations (from the artist's perspective). Still, as Potié points out, even most elaborate and 'capricious' plays of represented space and viewing angles have to be precisely constructed in order to deceive.

Two centuries ahead Maurits Cornelis Escher, the Dutch master of impossible figures, drew complex staircases, aqueducts, bridges and arches while displaying style, which had little to do with any fondness to for Mannerist deformations. Instead, his line appears formal, handled with textbook clarity, following the rigorousness of axonometric and perspectival projections, suggesting that the drawings had been made by an ardent student of architecture, albeit 'tis' a pity' the student was a madman. Again skipping ahead, 50 years this time, and we will encounter Escher's staircase (*Ascending and Descending*, 1960), yet reinterpreted by Roger Penrose (*Penrose stairs*) modelled in the form of a film set (Figure 1.2). It features among many unbelievable sceneries in Christopher Nolan's *Inception* (2010). In a sequence from the film the cinematographer presents us with fixed axonometric projection, from which the staircase appears as a continuously ascending loop. Any unchoreographed swerve of the camera would have spoiled the illusion sustained by the excellence of the projection. As in Eisenman's studies of houses certain spatial arrangements are possible only due to graphic reduction and occlusion – constraining the vista to a composition attained by a forced perspective.

Modern methods of architectural representation

These examples reveal that architectural tools intercepted by rampant artists can stray far off, towards the fantastic. Not that it is necessarily a downside – most projects described here remain(ed) unbuilt or unbuildable for a reason.[8] What

FIGURE 1.2: A cinematic 'translation' of *Penrose stairs* from an MC Escher's lithograph, *Ascending and Descending* (1960). Christopher Nolan (dir.), *Inception*, 2010, UK/USA. © Legendary Pictures, Syncopy.

can startle, however, is the degree to which some virtual constructions depend upon trompe-l'œil and optical illusions. Even more intriguing is the double status attained by represented architectural objects (in terms of 3D models), which is echoed in Bryan Cantley's observation that 'in the [...] post-digital, we see rise of the architectural drawing in the dual-aspect view – the thing-in-itself and the thing-as-it-appears to us are two sides of the same thing' (Cantley 2013: 41). His argument touches upon the disparities between program's code and interface of actual software. He discusses the peripherals of 'digitalia' – those applications of 3D computer modelling technology, which enable us to visualize phenomena previously too ephemeral to grasp. Radiation, heat, electricity, or radio waves can now be not only detected, but rendered, visualized, and 'built' (modelled) in the digital environment. The objectification of such ephemera into 'binary casings' allows users to operate on their (3D) models in a manner reminiscent of handling any other material artefact.

Architectural image-making, seen as practice, would have remained somewhat narrow and hermetic, if its sole means of communication were informative only of the contents or future assembly strategies. Ordinary plans with no extras included. Our everyday experience of perceiving architecture relies on exploration, as much as it does on vistas. This experience needs to be conveyed through motion, even if it means destabilizing the design's image along the way. Imagine yourself walking down a long corridor. Especially on the verge of art's venturing into kinetic, time-based arts, which came about by the turn of the twentieth century, this ontological shift paved the way for the introduction of multiple new media and representation techniques eagerly explored by architects. Collage and photomontage were probably the ones gathering most interest. Both preserve heterogeneity in terms of composition, as well as by involving methodology relying on contrasts and clashes between the juxtaposed materials (re)drawn (and photocopied) from other sources. While 'photomontage [...] combines an existing site photograph with a sketch of an architectural idea or proposal, creating a composite image that offers a realistic impression of a future architecture' (Farrelly 2009: 29), collage,

> as an art form unique to the modern era, emphasizes process over product. A collage as a work of art consists of the assembly of various fragments of materials, combined in such a way that the composition has a new meaning, not inherent in any of the individual fragments.
>
> (Shields 2013: 2)

In the works of 1960s architects – take, for example, Hans Hollein's *Aircraft Carrier City* or Superstudio's *The Continuous Monument* – it is precisely the act of re-contextualization executed through stark contrasts, which invokes a sense of

unfamiliarity. In turn this is evidenced by a futuristic structure that is 'shot against' a tranquil rural landscape. Nevertheless, these methods of composition are rarely used for the sole purpose of amplifying dissonance. Rather, their creators merge objects with backgrounds, guided by an intent of non-violent integration of their new proposal with the existing urban context, going even further, and decorating the picture with human figures. Not for scale. Not for sale. By this they augment potential audiences, presenting readers with a variety of atmospheric renderings, which take on the role of cognitive aids to imagination. It is hardly surprising to see a detailed and elegant use of shading in the work of Enlightenment's Revolutionary Architects, or to catch a glimpse of it in a 1920s cityscape by Hugh Ferriss, crowning his skyscrapers with a nocturnal glow. In the former's case,

> it was the aspect of being in shadow that defined for Boullée the true character of a cemetery gate [...]. And it is here that the full impact of the pictorialization of architecture on his work can be seen, for only a complete absence of materiality could instantiate the ultimate outcome of burial and death.
>
> (Levine 2009: 93)

In the 1980s the widespread use of computer-aided techniques allowed for a combination of various representation methods mentioned above, while also facilitating the act of switching between these techniques.

Up to this day film is counted among the techniques, that had a turbulent relationship with architectural representation. Since the early twentieth century architects have been analysing films with the acuteness of editors. Frame by frame, at times drowning in their own analyses. Le Corbusier's dialogue with the Soviet director, Sergei Eisenstein, is a well-known story, in the course of which both parties came to be influenced by each other's ideas. In *The View From the Road* (1965) Donald Appleyard, Kevin Lynch, and John R. Myer studied the unravelling roadside landscape using film strips for their survey. A common denominator of these examples can be found in the two-fold task each of those techniques (either film, collage, or CAD) is meant to perform – one concerns research-study, the other – design. Contemporary architects are exploring the design process and conceptual thinking, utilizing new media to manipulate images in new ways. Regardless of the medium used, architects still rely on the image to evoke a dialogue (Smith 2005: 209). In the wake of significantly more advanced technologies – like such as rapid prototyping, 3D scanning, or, what Mark Garcia calls *acheiropoieta* (designs done not by hand, but 'grown' by evolutionary algorithms into the form of a 'drawing') – the process might soon completely emancipate itself from the very creator-architect, driven instead by optimal construction and infrastructural arrangements. Any sharp distinctions between types of visual texts has already been blurred, notes Garcia.

Today's architectural images complicate such distinctions, often being either more specific and distinct types of images including diagrams, texts, photographs, films, digital models and paintings (with possible interactive and kinetic elements) or different combinations of these, or those made with specific media and techniques.

<div align="right">(Garcia 2013: 30)</div>

Every handmade drawing can be altered digitally, each printout can be traced over. Furthermore, explorations involving new methods of visual expression naturally ally and align themselves with visionary designs, which, in turn, push the envelope even further, to a point beyond which new generations of projects seem to be realizable only in their mixed-media space, despite having their origin in a classic *designo*.

Our experience too becomes highly mediated, and, at this deep end of technological augmentation, it primarily refers to representations – images and interfaces rather than actual objects. As space of representation gradually becomes superimposed on actual space, the rift between CAD objects, 3D-printed models, and holographic projections ceases to have any significant bearing on the contractor-consumer relationship, when it comes to communicating an appealing prototype of a future construction. No reservations about novelty are necessary. What is required instead, is a literacy in nascent types and methods of media production. Arresting one's suspension of disbelief would also come in handy, in order to critically assess and navigate this virtual building site. Architects-artists of the younger generation – CJ Lim, Soki So, NaJa & deOstos, and Tobias Klein among them – are years into their research, investigating and probing these new frontiers of architectural representation in their spatial constructs and unbuildable projects.

(Rendered) Difficult to read – beyond traditional techniques

At times some ideas seem so ground-breaking, that they appear as blatantly extravagant. This is the case of *Learning from Las Vegas*, which had received hostile reviews just after its publication, only to be 'posthumously' canonized by the same crowd of critics. As Paolo Belardi points out in his second essay from in *Why Architects Still Draw?* (2014):

> [W]hat had seemed foreign to the detractors wasn't the object of the study, but rather the method. To survey the gigantic statues and huge neon signs, the team led by Venturi and Scott Brown had set aside the conventional tools (pencil, plumb line, tape measure, etc.) and, following the pioneering example of Michelangelo

Antonioni in the film Zabriskie Point, adopted others that were seemingly eccentric (microphones, tape recorders, movie cameras, etc.).

(Belardi 2014: 106)

This new methodology was not a pop-art-influenced publicity stunt, but an inventive attempt to regain symbolic control of the American landscape in the apogee of urban transformations, at a time when it was becoming dictated by the vectors of velocity (sprawl, junkspace, city edges, the flow of highways), and event (meaning the brash aesthetics of billboards and neon signs, being a capitalist rendition of 'the survival of the most eye-soring' species of ads). Surveying Las Vegas, along with its roadside attractions, was not the first time architects had questioned available techniques of representation, deeming a large number of them inadequate, or – to say the least – insufficient for the kind of project they had in mind. We can notice these harbingers flocking in visionary architectural works, or speculative and radical proposals, which usually offer us not so much a glimpse into a distant urban future, as a vivisection on (but also in) the medium they are communicated in. While remaining within boundaries of convention, they strike us as unconventional by posing – to cite Peter Cook – a 'challenge to conventional, pragmatic architectural thought [that] is built up by the accumulation of information' (Cook 2008: 24). Are there any maps for these territories? Viktor Shklovsky's category of 'defamiliarization', although intended for literature works, accurately describes the effect intended by experimental drawings. Daniel Estéevez and Gérard Tiné applied Shklovsky's classification to drawn representations in their article (Estévez and Tiné 2008: 167), concerning ambiguity in architectural drawings, especially ones which employ moderate means and show polysemy also in terms of their composition. If we consider architectural drawings as acts of communication between two parties, assuming they rely on a set of codified rules commanding depiction, a prospected optimal outcome must involve minimal loss of information, hence maximal clarity and intelligibility of the project's interpretation by the client. Noise will inevitably occur in each such instance, according to the law of normal distribution formulated by Claude Shannon in his theory of entropy, usually applied to describing data transmission and signal processing. But what about those cases in which difficulty in decoding the 'message' does not arise from randomness; moreover, in which it is an intended impediment to be conquered by an imaginative interpretation? One that contributes a meaningful surplus. Considering the way writers employ similar strategies in literature, we can assume that architects wend towards an analogous purpose of the text, when trying to distance readers of their drawings by an overtly elaborated form, presentation of complicated, 'overgrown' structures, or employing confusing vantage points in perspective projections – a panoply of non-standard compositional

ideas that reduce clarity, yet introduce ambiguity (or 'complexity and contradiction'). Piranesi's constructions on paper, though realizing a theme of Ancient ruins, common to the eighteenth-century paintings, did not easily comply to with typical strategies of reading. Roland Barthes could be of assistance here, when considering categories of writerly and readerly texts. He characterized the latter as a passive act of reading,[9] while the former activates/engages the reader, inviting him to participate in co-creating the text. To complete its absences and fill in the blanks. It 'coaxes' the reader to reconstruct the story's 'narrative' by assembling fragments, or disparate vantage points, combining them into a coherent interpretation.

With the proliferation of building and drawing languages in the present day, we are able to name numerous figures exercising this 'impediment principle', already present in Joseph Gandy's (re)imagining of Sir John Soane's *Bank of England* as ancient ruins in an aerial cutaway view, or Zaha Hadid's painted landslides viewed at an 89-degree angle (*The World [89 Degrees]*, 1984), taking after Constructivists' explorations of abstract geometries. But it was mainly in the twentieth and twenty-first centuries, when that architects began to challenge conventions of drawing (along with its lucidity) quite deliberately, treating it as an act of inventive research in itself. Potential suspects are usually narrowed down to theoretical projects, often seen as solipsistic, instances of 'intelligent' drawings that feed back on themselves. Architects who had subverted specific modes of representation, did not necessarily employ methods of representation to explore only themes of visionary and fantastic architectures. Peter Eisenman's diagrams or Bernard Tschumi's cinegrams pertain to this category. They make up the lineage of morphogenetic experiments and extend to modes of visualization, which remain the preferred aesthetics for years onward. In the same fashion Zaha Hadid's acrylic paintings, according to Hal Foster, outline her primary influences, among them the importance of volumetric, colouristic, and architectonic concerns of Russian artists in the 1920s.[10] He makes a connection with her acute-angled perspectives and fractured tectonics of *The World (89 Degrees)* or *The Peak* (1982–83). Foster considers her an architect who 'went further still, as she pushed familiar modes of architectural representation – not only isometric and axonometric projections but also single-point and fish-eye perspectives – into strange explosions of structure and "literal distortions of space" ' (Foster 2013: 79). Painting remained the basic mode of her visual investigations, helping her to expand upon a basic vocabulary of elevation, plan, and section, when turning to the 'street level' (perspective, axonometry) or aerial views (ground plan). Simultaneously, graphic explorations facilitated imagining the structure in the fourth dimension, which – keeping in step with Belardi's line of thought – would depict its 'expansion' in time and transformations through use, considered in cultural, social, and performative contexts (Belardi 2014: x–xi). Does this mean that projects like such as Constant Nieuwenhuys's *New Babylon*,

with its expressionist canvases reproducing a pedestrian angle, are anything other than an expression of their creator's desire to maintain control? Especially as they reflect much more than construction details – its programmatically freewheeling inhabitation, evaluation, utilization.

Analytique – *Brodsky & Utkin's illustrated tales*

While pre-established modes of habitation make up a scientific manual, any ruptures in the normative fabric – like the ones under the guise of fantastic and visionary architectural structures – open up a surplus 'space', which can rarely be boiled down to the intent of meeting practical, material, or economic requirements. Not exactly a pristine tabula rasa, this research space is akin to the playful work environment of the pendulous scrolls upon which the Texas Rangers indulged in student games of 'exquisite corpse'.[11] Documenting trial and error in drawn form, such as test site privileges borrowing, stealing, and taking inspiration from parallel disciplines/arts; especially those that transgress limits of traditional architectural representation by means of media sensitive to temporal progress, sequentiality, and narrativity. The last item considerably expands upon typical programmatic descriptions.

Alexander Brodsky and Ilya Utkin's artistic project, conducted on and off for years, conjoins a specific convention in architectural design and fantastic short story form, by employing the *analytique* mode of composition, developed in the École des Beaux-Arts as a mode of in-depth study pursued both in visual (details, plans, perspectives) and textual terms. This pedagogical method was an exact opposite of the *esquisse* – denoting either a rough, though complete, outline drawing of a structure, or a preliminary sketch to be incorporated into the design as an intermediary stage of the process. In contrast, *analytique* focuses on depicting parts. As an analysis of architectural fragments to work through a specific architectural problem in a series of views, it describes their interrelation and placement in the context of the total composition. Necessarily accompanied by inscriptions, this representation technique renders text an integral part of the showcase:[12]

> The analytique, as a codified design problem dealing with the basic elements of architecture, provided the foundation for all subsequent training in design. It consisted of exercises in the design of relatively small architectural elements, either constituting part of a building – as in the case of a door, balcony, or loggia – or as a structure itself, such as a small pavilion or ceremonial arch. In the Beaux-Arts system, style was a problem of the analytique – the study of architectural elements and their proper combination (*disposition*) into an integrated design.
>
> (Pai 2002: 41)

Normally, it would have been vaguely interesting to look this astutely into a method primarily dedicated to students' education, if it were not for its two facets. The first reveals a predilection for narratives. Although probably dispensable in the majority of cases, a description accompanying this 'montage' of drawings (collage is also a proper term, as the technique originates from Piranesi's *Campo Marzio* plan) was there to help out in solving the architectural problem assigned, a way to combine visual fragments layered on the page(s). Its second facet derives from a tradition predating the period of working drawings – *analytique* does not require precise measurements. Along with a compositional strategy borrowed from comic strips/graphic novels, which brings out contrasts between depicted views[13] for purely exploratory purposes, the above-aforementioned aspects converge in the projects of these two Soviet architects:

> Brodsky and Utkin and the others began producing visionary schemes in response to a bleak professional scene in which only artless and ill-conceived buildings, diluted through numerous bureaucratic strata and constructed out of poor materials by unskilled laborers, were being erected – if anything. As such their work constitutes a graphic form of architectural criticism, [...] an escape into the realm of the imagination that ended as a visual commentary on what was wrong with social and physical reality and how its ills might be remedied.
>
> (Nesbitt 2015: n. pag. [7])

Labelled 'paper architects', as for throughout the 1980s it was impossible for the duo to realize their designs due to political circumstances. Brodsky & Utkin favoured *analytique* as the method of representation of their architectural parables. Nowadays, when analysing the copper-made prints of their page-sized projects on permanent display at Tate Modern, London, visitors notice their monochrome aesthetics, greyish palette, and page layout resembling that of a comic book, or an illustration from a children's book because of the laconic descriptions. Laconic they perhaps might be, but most definitely allegoric at that, predominantly in their descriptions of totalitarian chapters in USSR's architectural history. The stories themselves often come encrusted with a combination of quotes from authors such as Pushkin or Chekhov. Recognizable are textbook orthogonal projections, complemented by an aerial view, section cut, and elevations – usually only a few, incomplete, although never failing at conveying mystery and an obscured idea of space and. Going to the lengths of rendering fragment as a credible unit of material's organization, in their ironic solution to the problems of urban planning in Stalinist Moscow. Traditionally, *analytique* was regarded as a design exercise meant to refine one's individual style. In Brodsky & Utkin's works it has certainly evolved, although taking after comic strips and caricatures (somewhat untypical

sources), which made it onto the pages of these para-architectural productions; a feature we are likely to notice when surveying the characters seated by a long table, on top of a wooden skyscraper in *Ship of Fools or a Wooden Skyscraper for the Jolly Company* (1988), or in the enlarged figure projected on a curtain wall turned into a display in *Glass Tower II* (1984).

Yet, Brodsky & Utkin's narrative progresses beyond aesthetic concerns. Their black and white engravings are a representational technique reminiscent of obsolete media, analogue tools, and negative aspects of building policy in the USSR, which targeted old, historic architecture as an impediment standing in the way of housing projects, executed en masse and without remorse. Soviet Union of the late 1950s saw an official condemnation of Stalinist era neo-historicism, unbashful in the heroic palaces and their richly ornamented facades. Stalin's successor, Nikita Khrushchev, initiated numerous housing projects. Executed quickly (and badly), with little attention to veneer, it applied large-panel prefabricated elements, hence the nickname given to quickly sprouting blocks of flats – the Khrushchyovka. Brodsky and Utkin's silent rebellion, therefore, was forced to operate on two levels simultaneously. Firstly, the graphic/compositional 'layer' made use of the *analytique* – as mentioned earlier. That representation technique was primarily dedicated to study details and ornaments, therefore overtly rejecting requisite conventions of design by establishing a connection with pre-revolutionary historical forms. The second level was textual, permeating the melancholic stories of their invention that disapproved of the idea of contemporary socialist city, seeking solace in a bygone era of the 1950s' over-decorated palaces, or, even further back in time, recalling pre-revolutionary rustic cottages, wooden churches, and countryside dachas. Their projects were intended as allegorical fictions. In a magical-realist way they embarked on processing hazards brought about by civilization, senseless urban schemes, and anxieties experienced by modern man – inherently, a city dweller. Narratives of their invention are meant as surrogates that would preserve urban history in this graphic form, imaginatively taking stock of what planners and conservators failed to carry out. Regarding the duo's 'paper architectural' heritage, their comic book *analytiques* act as replacement media, stepping in, where official restorers succumbed to extensive urban planning schemes, allowing for a landscape monopolized by Khrushchyovkas. In the absence of archival records, and in the heyday of rampant demolitions, there is no place for memory as inscribed in Pierre Nora's *places of memory*. Regarding these circumstances, remembrance space can be 'leased' by 'paper architecture'.[14] Moreover, in fulfilling their mission, Brodsky & Utkin's projects harness storytelling modes akin to short story collections by Italo Calvino (*Invisible Cities*, 1972) or Jorge Luis Borges (*Fictions*, 1962), in order to convey their message in both a condensed and an allegorical way. They engage with the parable mode of storytelling and magical realist convention for the sake of bringing out the absurd, surrealistic intricacies in their

plots. They never fail to dramatize the essentially architectural character of their descriptions. Threat of censorship might have loomed over their approach, yet the shadow it cast was only as long as it would be useful to them in enriching the metaphor and carefully concealing all cryptic messages.

Columbarium Habitable (1989) is among many such structures (*Columbarium Architecturae [Museum of Disappearing Buildings]*, 1984), carrying testimony of erased traces, (not) left in the Moscow's urban landscape. The physical shape of storage space for urns is (a nearly well-formed) cube, modernistic in its fixed rhythm of niches containing old buildings slated for demolition. Lying in wait for the moment they become uninhabited, the tenement houses will have been moved to the great hall's centre, delineated only by the swings of a large wrecking ball. While in *Columbarium Habitable* any additional views (section, elevation, plan) are present on the bottom of the page, embedded with text, the perspective projection above presents interior space from a vantage point supposedly belonging to one of the residents of the niches. And who beholds this spectacle of destruction? Who has been confined to his 'cell' all this time? We see shelves as a matrix of equal cubes, a gridded ordering deflected at an angle. Drawings that make up the *analytique* were to include a detailed, contracted image of the building. In *Columbarium ...* we are given in fact several miniature architectural projects, presenting a neoclassicist idea of building typologies, as if we were looking at adjacent pages in a Eugène-Emmanuel Viollet-le-Duc's *Dictionnaire raisonné de l'architecture française du XIe au XVIe siècle* (1854–75, vols. I–X), Jean-Nicolas-Louis Durand's *Précis des leçons d'architecture données à l'École Royale Polytechnique* (1802–05) and *Partie graphique des cours d'architecture faits à l'École Royale Polytechnique ...* (1821), or the three volumes of Antoine Chrysostome Quatremère de Quincy's *Dictionnaire historique d'Architecture* (1832). The technique of representation is therefore a drawn evocation of entries in architectural history, conveyed through the haunting image of a gigantic columbarium, where obsolete building types are laid to rest. Other plates by Brodsky & Utkin hold similar subversive potential, which promotes their work from a mimetic/conceptual exercise to a meta-investigation oriented towards its own method of production. In other words, the shape of depicted structures is not as important as programmes they give rise to, or functions they perform. Thus, the metamorphosis implied by content, form, and medium of the 'architectural paper project', expresses:

> Brodsky and Utkin's longing for a time when cities were more liveable is a basic concern with the quality of life. [...] Their use of past icons, motifs, and strategies is motivated not by formalist gamesmanship but by a deep humanitarianism. [...] Bridges, an architectural metaphor for this linking [reconnection of people to nature, past traditions, to history], appear frequently in their work, from the glass span of *Nameless River* [...] to *Diomede II*, [...] which postulates that an ancient city once

FIGURE 1.3: Alexander Brodsky and Ilya Utkin, *Wandering Turtle*, 2015. Courtesy of Princeton Architectural Press, originally published in *Brodsky & Utkin* (3rd ed.), 2015.

> straddled the gap now existing between the US and Soviet land masses – reflecting a nostalgia for a hypothetical period when the world was not divided into separate countries and time zones.
>
> (Nesbitt 2015: n.pag. [11])

We should not be negligent of the narrative content in this work. The main theme of the columbarium projects relates to temporal aspects that are non-representable through traditional techniques, privileging, as well as emphasizing, factors that allow architects to evaluate a project's performance over a period of time. Conversely, they chart the likelihood of given scenarios in regards to its future development. In this case, it is demise that we speak of. These time-based aspects are present in Brodsky & Utkin's drawings as accounts of events or (ritual) actions. They order the fantastic settings by means of linear progression, arranging sites into sequences, just like in comic book panels – this way they are following not only Calvino and Borges's preoccupations but also those of Bernard Tschumi, Peter Eisenman or Nigel Coates, who will step into the light in consecutive chapters.

In turn, they will bring us to reconsidering broader narrative traits, often arising from 'translations' of literary works into architectural (i.e. spatial) configurations. Such speculative projects bridge the gap between static, descriptive arts (sculpture, painting, but also accounts of architectural and cinematic space) and novels, especially the utopian genre's substantial contributions in depicting future, distant, or oneiric spatial realities. This way issues of represented architectural space intersect with narrative concerns. Like arguments in polemics, they are indispensable to the project, aiding 'illustrations' in conveying seeds of a programme, its conceptual background, or putting forward an interpretation. They are more than a simple description, providing additional perspectives on the project's premise and modus operandi. From this analogue status quo of paper architecture we must now set out. Now it is necessary to see the project in performance.

Conclusion

There is a large variety of optical strategies devised for the sole purpose of fooling the observer. Making him mistake a *quadratura* painting for actual space receding from view is a notable achievement. Baroque exuberance of formal illusionism served as an instrument by which to interrogate the perceiver's visual apparatus – assessed on the basis of correspondence between mobility and architectural exploration. Giovanni Battista Piranesi's and Jean-Laurent Legeay's legacies of theoretical projects truly reveal themselves, when articulating the methods of their construction, while analysis gives precedence to *caractère*, symbolic order and typological constituents. 'Unbuildable' might not be the most appropriate term, though. Lebbeus Woods claimed that each of his projects had already been built. Visionary constructions are often realizable in drawing only, which nevertheless does not deny a different agenda to artists such as Woods or Brodsky & Utkin; an agenda which is focused on historical inquiry, memory storage containing past architectural forms as well as treaties on methods of building and design. In addition, the speculative endeavour is for keeping record of theoretical alternatives to what is contemporarily being built – a (musical) 'score' of conceivable architectural works, resonant with that age's episteme, while 'programmatically' oblivious to material and engineering constraints. Ability to read construction drawings in architecture is substantial to understanding the language of architectural imaging. We do not really need to solve the mystery of why architecture's more artistic and pictorial productions turned out to be negligibly less important, even though it was better suited for conveying critical views and historical accounts of built form, theories and changes in discourse. This rule holds true even at the utopian scale. Urban proposals are usually outlined by given philosophical concerns, which

FIGURE 1.4: Alexander Brodsky and Ilya Utkin, *Habitable Columbarium*, 2015. Courtesy of Princeton Architectural Press, originally published in *Brodsky & Utkin* (3rd ed.), 2015.

FIGURE 1.5: Alexander Brodsky and Ilya Utkin, *A Glass Tower*, 2015. Courtesy of Princeton Architectural Press, originally published in *Brodsky & Utkin* (3rd ed.), 2015.

extrapolate contemporary turmoil into the future. Primarily not a period but a setting, this 'future' is usually just a far-off land, located 'nowhere', or in a 'no place' of an anonymous, yet vast metropolis removed from our immediate present. Like architectural speculations that take place on a sheet of paper, utopian literature inhabits the page like a plan, prospect or perspective. Like in Brodsky & Utkin's works it is the reader who animates these architectural settings to life. Just imagine …

2

Architecture in Filmic Space

Drawing can be perceived as text of culture, while being invested with such aspects of dystopian writings as self-reflexivity, language interception, application of narrative traits and cues referring to utopian literature, art history, mass culture and so on. The engagement of narrative structures echoing dystopian novels makes use of non-standard (from an architectural standpoint) means of expression to communicate its multi-layered message. Such images can be blueprints or critiques of radically different contexts than typical site-specific conditions. However, frequently they travel both paths, projecting visions of barren lands, emptied out like graph paper and no less depressingly apocalyptic. All Raimund Abraham's 1960s drawings were dystopias, haunting with their tabula rasa aesthetics, filling the void of MAD (mutually assured destruction) scenarios with *Glacier Cities*, hidden in empty river beds, away from sight, in underground complexes and atomic bunkers. We see them wrestling with extreme conditions, balancing on the ledge. Similarly to architectural prospects by Lebbeus Woods, collected in his monograph *Anarchitecture* (1992), most of them aim for a kind of kinetic equilibrium – dynamic, as Woods would call them, calling upon general relativity theory to back up his world-view with the concept of a mobile observer, involving a subjective frame of reference. Chosen, as if to justify the technique of representation already employed. And just how inherently kinetic were these structures supposed to be? These are stability free zones.[1]

This a(na)rchitecture needs to move, shake up social order, rearrange political schemes, to keep up the pace with civilizational speed gain, especially towards the century's culmination. Consider *Antigravity Houses* (1991). Defying the law of gravity allows them to escape Cartesian space, drifting away from the deterministic universe of the Enlightenment. Science-fiction was prone to absorb these nuclear winter fantasies as fetishes. Disaster site urbanism – concurrently with literal and cinematic texts – is likely to become such a site in the near future, duelling with present-day issues of terrorism, financial crises, global urbanization and

'wholesale' reality augmentation. Principally the last of them introduces a range of subjects concerning a novel concept of space. These are incentives, which altered architectural practice, while making architects advance in their researches on visualizing and materializing the intangible. Unfortunately, a great many of themes similar to these are oftentimes pushed to the background of recent film productions. Film adaptations of utopian and science-fiction literature should not be deemed as illustrations for processes of this sort, which – depending on the way they are exposed – can come across as either radiant or obscure. Rather, they try to engage in a mode of visualization that is distinct from both disciplines (of architecture and cinema). In nature, there are no sums of parts. There are synergies, if one has to resort to mathematics at all cost. This is where film steps in as yet another medium and technique of representation; a 'language' for architectural production to apprehend, then make use of.

Spatialization aids

Architectural representations can also be called visualization aids. First, a building 'takes its place' on the proverbial page, thus turning the inscribed surface into an interim 'construction site'. Techniques of architectural representation evolved from their codified combinations of views, dating back to the nineteenth century and the École des Beaux-Arts, although most solutions can be traced back to Alberti, or even Vitruvius. Cinema is still negotiating terms of its becoming such a surrogate construction site. Even today its status is quite ambiguous, due to optical illusions it trades in for presenting genuine architecture. Many architects think otherwise, though. A hundred years after its inception cinema appears as a fertile ground for spatial ideas, a source of techniques and a repository of visualization aids to numerous studios and architectural innovators. One reason for this probably lies in the fact that aside from giving an impression of three-dimensionality, facilitated by the camera's movements, choice of lens and montage, it has the advantage of reconstructing temporal progress from sequences of still frames; the ability to record/depict spatial structures and their transformation in time. Every 'film is created by *movement*, and where there is movement there is also *space*. In other words, even the most abstract and experimental films [...] have a natural spatial dimension' (Koeck 2013: 32, original emphasis). There is no film without temporal or spatial progression. Even extreme examples such as Andy Warhol's *Sleep* (1963) and *Empire* (1964), or James Benning's films (*13 Lakes*, 2004; *Ten Skies*, 2004; *Nightfall*, 2011) enhance the sense of temporality, precisely by feigning the illusion of stillness.

Architectural space never becomes just a negligible background for action in the course of film history. Some of them were quite challenging, as Juhani Pallasmaa

recounts. 'Architecture serves as a metaphor for the human mind in accordance with the traditional psychoanalytical view: characteristics of architecture are reflected in mental structures and mental contents are projected in architecture' (Pallasmaa 2007: 97). Expressionist cinema is very often pointed to whenever the context of semantically imbued architectural settings comes up. Directors such as Fritz Lang and Robert Wiene employed buildings, interiors, sets, matte paintings and other props to externalize human psyche – an inner turmoil of the characters, 'projecting' it onto the scene.[2] In comparison, spaces of neorealist cinema may appear as documented evidence of war atrocities, yet they also are meant to be bringing out an equally distorted and 'ruined' psyche of the characters. This wreckage is as much emotional as it is architectural.[3] 'Theatres of memory'[4] are well-tailored arguments for such a discussion, as they enhance specific attributes of space for the benefit of subjective, cognitive activities. In these examples an inner cognitive map is projected on the surroundings. Emotions, thoughts, concepts, which cannot be expressed in words, require this material scaffolding, thus transforming any architectural space we see in film into partial commentary or interpretation of the actions and states of mind unravelled on screen. This prevailing condition of filmic characters would normally be linked to a psychological disorder described by Giuliana Bruno in her *Atlas of Emotion*, namely, 'psychasthenia, a disorder of personality in which the body is so tempted by space that it blurs the distinctions between itself and the environment and *becomes* the space around it' (2002: 40).

Deconstructing/liquidizing – The 'morphogenesis' of cinema-architectural space

Architecture and cinema are accomplices by design, working together to attain a sense of surrogate spatiality with filmed cityscapes, or interiors 'swept' with sophisticated cinematography. Since its inception filmic space has been a composite of materials coming from miscellaneous sources, mixing built sets, imagery, real settings and CGI for the benefit of creating a totalizing experience of convincingly realistic or even hyperrealistic environments in which viewers would be able to immerse. From a neurocognitive perspective this is bound to happen with the participation of

> the cerebral cortex, the ventral path, which is involved in object recognition, and the dorsal path, which is involved in spatial processing, help to construct this spatial environment. Filmmakers have developed techniques that engage these spatial construction processes while watching movies; as if we are enveloped within the 3-D world portrayed on the screen. Again, it is not as if we actually *believe* we are in

the world projected, but we co-opt these basic cognitive processes while watching movies, and these processes drive our experience.

(Shimamura 2013: 18, original emphasis)

Their disposition, being components of this volumetric jigsaw, relegates them to the status of images, animated and spatialized.[5] There is a long-standing tradition of explaining correspondences and intricacies of cinematic language as conveyed by editing, framing, shots, cuts and so on by relating them to techniques of building, application of specific materials and cross-programing spaces by embedding filmic traits in design. What is much more relevant to this study is the translation of these attributes, taken from narrative strategies in filmmaking and relationships between built forms, to those taking place on the plane of representation.

Visionary architectural projects and cinematic space share the status of manipulated space, combining profilmic material with imagery taken from other sources (matte paintings, CGI) or built from scratch (as in animated films). Finding common theoretical ground comes as no surprise, as deconstructivist and *blobitectural*[6] architects are percipient readers of cultural and film theorists, restoring the bond established 60 years ago – one that connected Le Corbusier's projects to Eisenstein's concepts of montage. Construction of spatial arrangements can easily be paralleled with methods behind architectural production prior to the introduction of CAD/CAM as design methodology. From a morphological perspective, we can view this architectural style as a process of arriving at a given shape/form.[7] While the deconstructivists delivered fractured multiplanar vector fields, backing up their design decisions with Eisensteinian logic of montage cuts (although updated for rapid cutting and diverting juxtapositions of post-modern cinema of the 1980s), *blobitecture*-produced fluid surfaces, folded seamlessly, in accord with Deleuze and Guattari's philosophy. This emphasis on issues of spatial representation found in films, rather than on indexical relations of depicted buildings with their original contexts and histories, encourages us to retrospect on the history of set design. In particular on the progressive integration with painted backdrops or actual spaces placed in front of the camera, in service of flawless realism. Current stage of cinematic (hyper)realism arrived at a high level of verisimilitude in the practice of integrating CG backdrops with parts of actual sets and photographic rear projections. Combined with contemporary, second ascendancy of stereoscopic cinema (which arrives at three-dimensionality in an incomparably more convincing manner than the first iteration from the 1950s), this trajectory seems to be striving for an absolute and overwhelming immersion into the visual spectacle. We gain entry into a new kind of filmic space, where the subject of what we see (vision) and the way we see it (movement) meld into a single cinematographic 'organism'.

As seen previously in Chapter 1 on methods of architectural representation in relation to speculative works, this paradigm underwriting artworks, oriented at grasping viewers' attention while engaging/including him or her into the drawing/novel by a breadth of illusion-sustaining techniques, can be traced back to post-Renaissance paintings. One could measure levels of confusion caused by the painstakingly executed digital composites[8] by the amount of time spent on de-constructing layers of effects in supplementary materials (containing: breakdowns of shots and title sequences, Vfx processing, or match-moving demonstrations). However, the present-day homogeneity of representation we encounter in each new blockbuster would not have been possible without the innovations in analogue compositing (*optical printing*), developments in digital special effects (preceded by analogue photographic processes), or advances made in animated film, in the 1980s.

Architect on set! – Or, the function of filmic décor

> In literally 'moving pictures', the camera moves through rooms and glides around related spaces, all of which require three-dimensional constructions, [...] structures like those domestic environments customarily created by professional architects.
>
> (Ramírez 2012: 28).

Even before turning into CG visual artists, architects were no strangers to Hollywood film sets. Furthermore, they were able to realize designs more daring in comparison to their typical commissions. Cinematic designs did not require withstanding the test of time, and they would not fall victim to a change of fashion. Nor would they be required to provide shelter and endure permanent habitation. As Juan Antonio Ramírez points out, those constructions were destined to make the best of their five- minute prime, and after that gracefully rot away on a studio backlot. However, before a surge of inspiration coming from Weimar street films, German Expressionism, or epics like such as *Cabiria* (Giovanni Pastrone 1914), or *Metropolis* (Fritz Lang 1927), architects were mainly requested to step in as partisan historians, capable of recreating the looks of any époque on the set. Additional advantage came from hiring those 'spatial consultants', who were allergic to historical purism, for anachronisms were quite common and 'fine' with the audience.

> From the beginnings of cinematography, the need for reproductions of various historical styles generated considerable overlap between the contemporary practice of 'disciplinary architects' and those who worked for the movie industry.
>
> (Ramírez 2012: 16)

Specialists like such as Joseph Urban[9] – an architect of the Vienna Secession period, recognized for his innovative theatre set designs, as well as real buildings, such as the Austrian Pavilion created for the 1904 World Exposition – were rare gems, as many on-set 'architects' carelessly 'drew upon history, without much (if any) concern for the archaeological accuracy of their imaginative creations. In many cases, such errors were the product of ignorance and improvisation, but they could also be deliberate' (Ramírez 2012: 23). As Urban demonstrated through his frequent conflicts with producers, in his view the role of an architect-artist was to design structures that would bring out each scene's atmosphere and not only to make sure that walls were erected at the correct angle.

> [Film] sets provide a film with its inimitable look, its geographical, historical, social, and cultural contexts and associated material details, and the physical framework within which a film's narrative is to proceed. […] sets aid in identifying characters, fleshing out and concretising their psychology; and, […] [also] they help in creating a sense of place in terms of 'mood' or 'atmosphere', and thus evoke emotions and desires that complement or run counter to the narrative. […] sets are also crucial in determining a film's genre, and they play a defining role in popular formats as varied as historical drama, science fiction, horror, melodrama, and the musical.
>
> (Bergfelder, Harris and Street 2007: 11)

Contrary to what American film historians say, the best sets do not necessarily have to go unnoticed. If they do, it may be either due to their secret service in keeping main characters in spotlight, or their unimaginative blandness. Certain genres, such as science-fiction films, specifically emphasize their illusionary backgrounds and sets, in order to render future worlds more appealing. This frequently gives film an additional layer of meaning, substituting for detailed descriptions of social, spatial, and political organization of the world portrayed (as laid out by urban infrastructure, scale, and visual references conveyed by buildings). Sometimes the choices made by production designers can be narrowed down to specific strategies in associating political systems with architectural style, for example, Albert Speer's totalitarian architecture in a dystopian political thriller. Recalling the grandeur of Enlightenment's Visionary Architects, combined with a Stalinist neo-historism in décor, must have been the template of first choice when adapting dystopian fictions, from *Nineteen Eighty-Four* (Michael Radford 1984) to the *Hunger Games* (Gary Ross 2012; Francis Lawrence 2013, 2014, 2015) series.

In the final instalment of Suzan Collins's saga the action is placed in the heart of Capitol. At this point the city has been raided by rebels from united Districts. The urban space seems to be an amalgam of war photography from Sarajevo and Grozny, capturing post-socialist blocks of flats located on the city's outskirts.

As the characters move further 'downtown', the metropolis begins to appear as filled with monumental displays of *architecture parlante* that echo Judge Dredd's famous motto: 'I am the law'. It is built in brutalist concrete greys, yet still recalling post-modernist 'paranoia' of oppressive mockery, as in the courtyard of Ricardo Bofill's Les Espaces d'Abraxas. Sets like these should not go unnoticed. Evidenced by CGI fillings placing gun turrets in the walls and 'ornamental' ambushes, they usually do not. Their presence has been digitally accentuated, thus revealing a truth about production design, which nowadays is largely outsourced to studios specializing in development of 3D animations, Vfx, and compositing CGI materials with live-action footage. There conceptual art, modelling, editing, narrative structure, storyboards, photography and art direction can be prepared from the ground up. Contemporary architects working in film are relegated to tasks of image-making, being on close to equal terms with the directors supervising them. For years now, artists from the art department, digital matte technicians, and special effects teams have been responsible for guiding the viewers' attention. Designing with cinema in mind requires both architectural skills and talents of a graphic artist. Their contribution caused an alteration in film production line. Special effects sequences and CGI-equipped scenes were planned out beforehand, in advance of principal photography, rather than making adjustments in post-production. These days architects working in film are draughtsmen, making use of their skills as designers and digital model makers.

Since its beginnings Hollywood has relied on visual trickery, filming action which – in reality – takes place in partial sets. Filling them in with necessary details, providing general decor, that is, completing mock facades with painted interiors of buildings. 'The built environment for a feature film consists of the physical sets and props as well as various kinds of composited imagery that extend, elaborate, and fill in what has not been built directly for live action' (Fischer 2015: 145). No sooner than in the 1950s film crews began to venture into real-life spaces. New technical means, post-war aesthetics,[10] studio crisis,[11] and an urge to attract new audiences – alternately, winning back the affection of old ones – forced filmmaking to leave the sound stage and bottle some fresh, though unscentable air outside. Not even four decades later, with the introduction of blue box technology, filmmaking came full circle. 'This trend is a return to the tradition of back-lot filmmaking, which had been the standard industry practice during the classical studio period' (2015: 144). This last transformation enabled directors to regain complete control over environmental factors, masking random flaws in the footage. It allowed for a 'surgical intrusion' into re-composited imagery, together with a more convincing set of optical tricks for authenticating deliberately artificial source-material, as in the example of painted backdrops. 'In the digital era, matte paintings are dynamic, three-dimensional components of a composited environment' (2015: 146). One

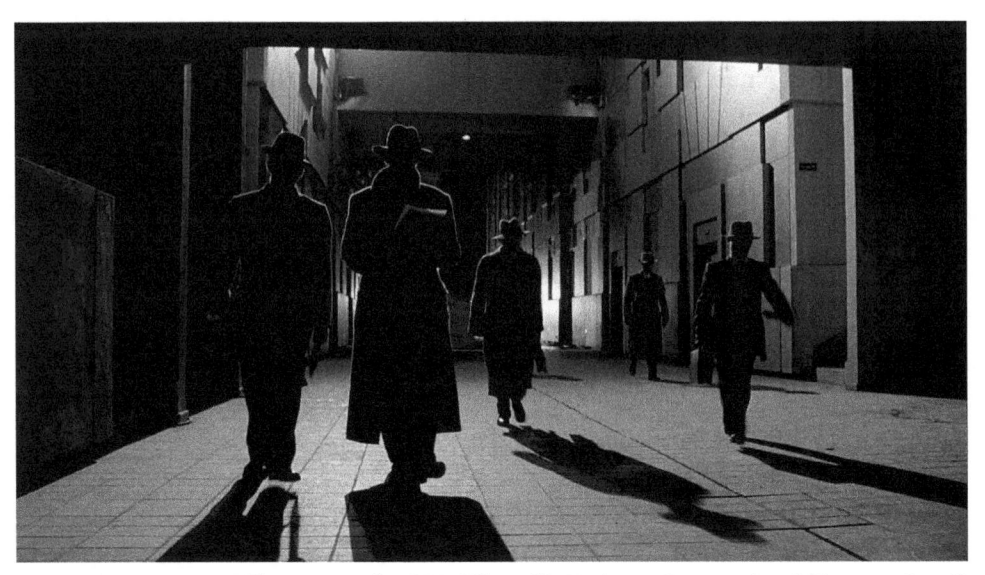

FIGURE 2.1: Terry Gilliam, *Brazil*, 1985. Film still: Embassy International Pictures, Brazil Productions (UK, USA).

example involves *motion perspective*, which is practically unachievable, when simulating camera pull-backs with frame size readjustments executed on an optical printer. Such panoply of techniques is aimed at emulating human perception with greater accuracy, even by reproducing sight defects, motion blur, and giving a sense of peripheral vision, which embeds us in the environment. Strategies purposed for this task allow for constructing represented space in a way that may be called architectural, as it evokes sensations of volume, corporeality, mass. Neither of them is truly accessible during screening, given the standards of screen ratio and its flat surface. Nevertheless, it is possible to reimagine these indicators of spatiality following traits similar to the ones already harnessed by architectural drawings and perspective renderings.

Set design is history – Redefining filmic space

This seamless merging of materials from different sources, which goes unnoticed in contemporary cinematic spectacles, whereas glaring in films made decades ago (pre-optical printing), would not have been possible without digital enhancement (and reappropriation) of an already existing practice of compositing. Unlike spatial experiences in actual architectural spaces the final image of nearly any frame

FIGURE 2.2: Francis Lawrence, *The Hunger Games: Mockingjay Part 2*, 2015. Film still: Lionsgate Films Color Force, Studio Babelsberg (USA). Both Brazil (1985) and *The Hunger Games: Mockingjay* are set in Ricardo Bofi ll's Espaces d'Abraxas.

is always a collage of heterogeneous elements – most of them formerly 3D, like set designs or filming locations, even if scaled differently. They come as complemented by components, which intensify the experience of spatiality by means of matte paintings in the background, or objects of various sizes, paralleling viewer's lines of sight. They either increase or decrease depth using multiple illusionistic techniques.[12] In the 1950s, 'the dominant studio practice was to synthesize a location using partial sets, miniature models, matte paintings, rear projection, and composites achieved on the optical printer' (Fischer 2015: 144). Since optical printing, on a grand-scale in contemporary film productions, this alteration of each single frame of the 'picture' takes place in the aftermath of filming, at the stage of post-production. Space represented on screen is thereby beheld as a product of interpretation and manipulation of the filmic material by the editor, and additionally by visual artists who graced (or grazed) the film stock with finishing touches.

Étienne Souriau distinguished seven levels of reality in terms of film (Buckland 2007: 47). Among them is the 'profilmic reality', which denotes the environment put in front of the camera, and diegetic reality, that is, the totality of spatial composition we see on screen. Areas encompassed by these two definitions do not exactly match up, because the latter is significantly larger than the former. Also a film set does not entirely engage every element of the profilmic reality. Pinching problems of filmic space with such broad-jawed calliper, a further division should

be presented here, which distinguishes sources, or layers, of space – real, manipulated, illusory. Their superposition amounts to the final aesthetic experience. Real spaces can be both natural (filming locations) and artificial (film sets created in the studio, either complete or partial), as long as they come from a material root, whose substance we see recreated on screen through photographic means (blue screens have to be excluded here). Even though actors do not interact directly with scale models (unless they wear Godzilla suits), 3D miniatures of buildings, like the ones used when filming *Metropolis*, must come from a material base as well. Even if models are engaged at all, their performance in recent film productions is usually retouched, tinted, and combined with digital imagery.

Fritz Lang's film is a perfect case to examine how a compelling vision of a futuristic city are is designed with the intent of appealing to audiences. Set designers and artists – Erich Kettelhut, Karl Vollbrecht, and Otto Hunte – multiplied tiny buildings with mazes of mirror surfaces, placed at an angle in relation to the camera – the so-called Schüfftan process.[13] Currently, trompe-l'œil techniques, in cinema having originated from matte paintings, are exploited in digital edition, attaining two- and two-and-half dimensionality with photogrammetry (taking measurements from pictures).

> Previously, environments in film were used solely to situate the action and offer establishing shots. The domination of stage shoots over location shoots in the 1940s also fostered the static nature of established space, using backdrops or glass-based matte paintings to extend and fill the horizon.
>
> (Hanson 2000: 66)

Finally, the province of visual special effects created by painterly, photographic, and successively by means of computer graphics introduced its own type of animated space. Such examples can generally be encountered in experimental, and science-fiction films (Douglas Trumbull's Stargate sequence in *2001: A Space Odyssey* [1968]; cyberspace in *The Lawnmower Man* [Brett Leonard, 1992]) (Cornea 2007: 94). With today's ubiquitousness of Vfx enhancing, completing, or substituting for material settings, the emergent term of CGI more adequately makes us aware of the intrusions' presence. On the other hand, disaster cinema and mainstream productions ventured far, when it comes to the overarching idea behind the spectacle, from John Martin's tableaux – the realist Victorian backdrops for scenes of wonder, grandness, and divine wrath.

The categories of narrating paper and 'concrete' architecture introduced in the previous chapter, like such as cross-programming and binary narrative, can also become useful in the context of film, because they describe modes in which architectural places in film actually 'perform'. Even as representations on screen

they are still indebted to their own histories. In equal measure they are in debt to scripted meanings ascribed to them by the director. Double coding of real-life spaces creates a cognitive, estranging gap. Narrative strategies do not only belong to spatial programmes realized in more exquisite examples of architecture, where certain paths are singled out, modelled for user's experience, but characterize generic interior spaces in films (binary narrative). Even when shooting a movie at the Guggenheim Museum, New York, the setting never merely blends in between dialogue scenes, establishing and travelling shots. It directs the flow of actions taking place,[14] as in Tom Tykwer's *The International* (2009), or sets the rhythm of frames, choice of angles, and pace of filming for meditative rituals as the one depicted in Matthew Barney's *Cremaster 3* (2002). Therefore, places and spaces seen in films – either real or reimagined by set designers and carpenters – are not only taken out of their primary urban contexts, but also crossed with a new programme. They may seem counterintuitive to the logic of a skyscraper's lobby, hotel's foyer, or – as in Tykwer's and Barney's cases – museal space, yet, which is entirely subjugated to events in the script. Cinematic architecture seen through the lens of binary narratives reveals an act of double coding, which relies on viewers' competences, knowledge of architectural styles, and fashions, as well as historical background of the buildings' design. Paradoxically, film history shows that in some instances, if it were not for cinema, certain architectural visions would not have ever been visually 'realized'.

Cataloguing film sets

The area of film studies concerned with set design engendered two seminal publications, I would like to bring up here. Each offered its own set of categories, elucidating, consecutively, the role set design plays within the context of film's narrative (*Sets in Motion Art Direction and Film Narrative*, co-authored by Charles Affron and Mirella Jona Affron), and the outer-diegetic areas of viewer's competence, that is, real-life spaces which specific designs refer to (Charles Tashiro's *Pretty Pictures: Production Design and the History Film*). What the Affrons applied to spatial constructs brought about by production design, was a measure of efficiency in the narrative's propulsion. Therefore sets can be characterized on the basis of their: denotation, punctuation, embellishment, artifice, narrative. The first of them, denotation, is indebted to reasserting the 'reality effect' in film, putting in conventional solutions when they are mostly expected, while the second – its amplified variation – intrusively punctuates parts of decor that are crucial to the set. The last three categories are focused on either unfamiliar examples of architectural settings (artifice), atypical ones, which – when appearing on screen – will not go unnoticed

(embellishment), or which themselves take up a narrative function (narrative), assigning action to a distinctive singular location (Bergfelder et al. 2007: 18–20). By taking the opposite stance to that of the Affrons, Tashiro argues for a view of filmmaking practice closer to (Joseph) Urban's, in which production designer is able to embed his own meanings in the set. Thus he creates a semantic surplus, causing Umberto Eco's ideal viewer to be troubled by the 'curse' of overinterpretation. Tashiro's theory shifts emphasis from textual analysis to a study of cinema audience, while also addressing viewers erudition (or lack thereof), bringing outside readings (cultural, historical) into the text. Thus, he ascertains a mode of reading set designs, which basically means overinterpreting them along the lines of Eco's definition of the term. 'Tashiro argues that some sets impose their presence, work against narrative flow and heighten the sense of the image. He is interested in images and frames that invite the spectator to look outwards, to suggest meaning that cannot be contained within the frame' (2007: 21), and communicated in the areas of: 'landscapes/cosmic space', 'the walkable: the street', 'the liveable: the house/the set', objects/furniture, and costume/make-up/jewellery (2007: 20).

All films taken for this study are animated shorts. Some of them incorporate live-action footage, although in each case it is excessively processed in the aftermath. They exclude distinctive categories which are essential to live-action cinema, and divide profilmic material into sets, backdrops, actors, props, and so on. In CGI 'environments' photographic materials arrive already conjoined with artificial creations (we can tell apart painted backgrounds from translucent cels, yet, without paying regard to their source, each one's status is primarily determined by an agreed- upon drawing convention). The typologies introduced by the case studies should be viewed from the perspective of the Affrons' 'narrative' category, as in each of the presented cases, diegetic space defines narrative content. Furthermore, these shorts' narratives appear as commentaries purveyed through the depiction of spatial practices; instances of 'new urbanist' criticism, often implemented by a utopian/dystopian mode of storytelling. Some of the films resemble an involuted meta-treatise, investigating multisided aspects of their own medium of representation. Either analogue drawing or NURBS,[15] the protocols by which they were modelled into existence, harbours structural implications for the ontological status of architecture, imaging, and image construction. In the case of animated film projects these terms often converge. Self-enquiry modes of narrating appear closer to 'sets', which exercise aspects of speculative, visionary, and fantastic forms. They do so in terms of both the content of representation and the technique. In this particular example it should be read as the cognitive function of estrangement – delayed apprehension and immediate appeal.

According to Tashiro, yet equally so to the Affrons, not every setting seen in films is necessarily subjected to the narrative paradigm. In the case of traditional

film sets it was true that film 'architecture is constructed, and its importance is appreciated only for the short moment of being filmed; after that it rots away as a tiresome ruin or is taken down, unless it becomes part of a studio tour' (Schaal 2000: 13). Contemporary film projects require holistic thinking when conceiving of architectural space. Even Craig Barron, the co-author (with Mark Cotta Vaz) of the book *The Invisible Art*, acknowledges this shift, when speaking about the evolution of matte paintings. In his view, matte artists ceased to work on/in painting backgrounds. Now they are involved in 'environment creation', which is a slightly greater change than a simple change of label, more akin to designing virtual immersive sceneries. They, in turn, will be employed as furnishings for 'blue boxes' (Robertson 2003).

This transition from designing structures on set to filmic environments traditionally separated designers' work on live- action films from the task assigned to animators by trade. Returning to the province of 'pure cinema', we can assert that art design interests of Charles and Mirella Jona Affron correlate with those of Charles Tashiro, although not necessarily intersecting with rules that can be applied to animated productions, in which – as Paul Wells remarks – significant:

> [t]ensions emerge from design strategies, representational associations, and the redefinition of space, completely challenging the dominant orthodoxies of visual perception. Even in the most hyper-real, stylised and simulated of animation, the reproduction of the physical, or the seemingly non-tangible, in a material way, is provocative and incisive in illustrating apparently inarticulate *essences* of meaning that are extraordinarily difficult to communicate in any other form.
>
> (Wells 1998: 93, original emphasis)

With the contemporary surge of productions combining live action with animated sequences it is easy to forget that animated reality on screen is not 'merely' designed, but created 'from scratch'. Even when it re-employs photographic materials, it does so with a demeanour worthy of animated cinema. It is true, that

> [l]ong before the advent of CGI, and going back as far as the 1910s and 1920s, designers have relied on visual trickery, compression, painted backdrops, and miniature models in orders to detract attention from the fact that few sets were ever more than an assemblage of carefully selected partial creations suggesting a nonexistent whole,
>
> (Bergfelder et al. 2007: 14)

but, along with a transition into computer graphics territory, architectural imagination became mandatory when assembling those elements into a seamless whole.

We can recognize in this practice the proper successor to traditions of painting backdrops and creating scale models. Nowadays they can be flawlessly interwoven with actor scenes, without refraining to rear projections, or close-up/long-shot transitions in editing.

Filmic architecture as an extra-narrative layer of meaning

Examples of set designs reinforcing film's main thesis, and simultaneously shaping its looks, are anything but rare. Andrew Niccol's 'genetically perfect' world of *Gattaca* (1997) ostracized the main character for his shortcomings through its laws, institutions, let alone by the stainless steel look of the settings, devoid of asymmetries and irregularities. Released a year apart, the tech-noir city-machine of *Dark City* (Alex Proyas 1998) steers its plot directly through spatial transformation that the eponymous city undergoes at night, at the same time offering 'a parable for the mutation of the cityscape that proceeded apace with urban "redevelopments" in the 1980s and 1990s' (Lyssiotis and McQuire 2000: 8). What about those cases in which architecture becomes as important as an additional character, acting for or against human ones? Space becomes claustrophobic, alienating, while refusing to be reduced to a background. It turns out to be literally kinetic or dynamic ('haunted house' scenario). Not unlike an intelligent home, which is an example taken out of Joseph Kosinski's *Oblivion* (2013). It remains calm, surveilling their owners. Then it suddenly springs into action, trying to eliminate its inhabitants.[16] When 'transplanted' into cinema plots similar to Kosinski's are a voice in favour of the analytical separation of environments and events, databases and narratives (Manovich 2001: 218–21), and – when analysing and interpreting (film) texts – an incentive to focus exclusively on spatial issues.

If we agree to look from this vantage point at filmic environments and architectural settings in science-fiction films (among multiple other genres), considering them dynamic, mutating entities, which condition the plot's development, we may unlock new ways of reading filmic space along the lines of Charles and Mirella Jona Affrons' 'narrativity', while debating whether Tashiro's view of certain cinematic sets, rendering them independent of the plot, is not just as valid. With films such as *Panic Room* (David Fincher 2002), *Cube* (Vincenzo Natali 1997), or *Alien³* (David Fincher 1992), it is increasingly difficult to discern, which set designs only direct the flow of events, and which ones bring actions into being, making them responsible for twists and turns in the plot, while still executing an individual agenda.[17] Opening up a discussion, filmic architecture is likely to address a range of spatial issues. Among them are: alternate concepts of living; limits of the programme and preconceived design proposals, when faced with actual habitation;

FIGURE 2.3: Architectural 'eugenics' in Andrew Niccol's *Gattaca*, 1997. Film still: Columbia Pictures, Jersey Films (USA).

phenomenological accounts of urban and architectural exploration; material and virtual relationships, thus remoulding general ideas about the role of architecture.

Plots that coil around a given space – Panic Room's *CGI de-materialism*

In the examples above meaning was conveyed by surroundings. Other semantic detours prompt a reading of set design that positions them as a surplus to the narrative. Let us now immerse in a discussion on texts, which touch upon architectural problems by means of constructing their narratives around a specific space, giving characters time to explore, inhabit, and become affected by their settings; activating their programmatic premise. This is a look into the structure of a traditional plotline, which preserves unities of time, place, and action, although espousing a view from the other side of the 'looking glass'. Still, as the examples of *Alien*[3], *Event Horizon* (Anderson 1997), *Cube*, or *Panic Room* show, we do not have to be confined to a situation of a Pirandellian, or Sartrean kind, a *No Exit*-type plot. These cases develop their own spatial pathologies in order for each to fulfil its dystopian script, placing the characters in an oppressive situation of puzzle solving, exploring possibilities at hand. Fighting off potentially harmful, or threatening architectural solutions, very much in the spirit of Jane Jacobs, who wrote about ways of salvaging social housing projects through thoughtful design that breaks up urban monotony. 'The corridors of the usual high-rise, low-income housing building are like corridors in a bad dream: creepily lit, narrow, smelly, blind. They feel like traps, and they are. So are the elevators that lead to them' (Jacobs 1961: 399).

This 'New Urbanist' agenda, when rethinking failures and mistakes in urban planning by depicting them on film, is one of the main aspects of filmic cities. Those analysed here epitomize urban planning, creating scenarios in which buildings are put to use, act out their programmatic promises, but in extreme circumstance. Even though action cinema usually trivializes such situations, crime dramas, psychological thrillers, survival horrors, or 'chamber' science-fiction films allow for a notably low-key reconsideration and inclusion of architectural space as a mute and immobile actor, hosting and simultaneously partaking in action. For instance, consider the *Aliens* franchise, along with its – now emblematic – shots of hostile Xenomorphs approaching through air conditioning ducts, narrow corridors, and sewage systems, turning the building's infrastructure on its creators. In horror films it is customarily a (haunted) building's floor plan, or knowledge of secret passageways, which grants protagonists safety. Also, the formerly overlooked, hidden-away spaces in high-rises and building complexes are reintroduced as settings crucial to the storyline. In *Event Horizon*, the protagonists have to fight fiercely against their surroundings, stranded in a spaceship, which is modelled after a Gothic cathedral. *Alien³* sets the action inside a cloister-like prison, blending prison plan with La Tourette's ascetic brutalism, and an industrial ruthlessness of a foundry. In each of the films survival depends almost exclusively on one's knowledge of architectural surroundings; not just the main routes, but – to even greater desirability – hidden passages.

Fincher's *Panic Room* takes an even bolder step in depicting vast, three-storey apartments, which had fallen under burglars' siege. Here, specifically, the narrative uncoils by confining the film's two lead female characters to an isolated room, and dissecting the house, tearing it up like a demolition crew in order to reach the barricaded prey. Allowing camera to penetrate into walls, punch through floors and diffuse bars in windows, reveals by means of dynamic cutaways the building's viscera of electric cables and piping. Showing reciprocal placement of rooms in the apartment can be used either to the advantage of the intruders or of the intruded. In an issue of *Architectural Design*, entitled *Drawing Architecture*, Nic Clear addresses this aspect of cinematography in Fincher's film.

> The camera moves through the space as if it were an independent entity. It allows the viewer to experience the space in a way that no drawing or set of drawings could. [...] What this shot also demonstrates is the extraordinary potential for film and animation to communicate complex spatial ideas, both possible and impossible, at a variety of scales.
>
> (Clear 2013: 76)

Moreover, the house's spatial layout organizes the narrative into a sequence of spatial obstacles, or pitfalls, for the protagonists to overcome, revealing strong

and weak spots of the building project. This trail is delineated by the main characters' progression from room to room, as well as unceasing burglars' attempts to break into the eponymous panic room. In the meantime Fincher makes us draw a 'mental map' of the compound, concentrating on areas of its faulty design (those that work against the inhabitant).[18] An additional insight is provided by the *Interiors* online journal. Focusing on film's final scenes, authors discuss the increasing awareness of the new tenants in regards to their immediate surroundings.

> In the closing scene of the film, Meg and her daughter can be seen sitting on a park bench, searching through ads for a new home. The daughter comes across modest sized home with three bedrooms. The mother claims, 'Do we need all that space?' The use of space – its vastness, its logistics – has now affected the lives of its characters and has embedded itself into the narrative of the film.
>
> (Jon Ahi and Karaoghlanian 2012)

Fincher performs a vivisection of this domestic space, in order to characterize the relationship between intruders and the women, but also between mother and daughter, taking it up to a metaphoric plane. At the same time he outlines possible strategies, which could be undertaken by a victim of such circumstances, utilizing every aspect of the old brownstone's internal design that could be used for their advantage. Gordon Matta-Clark utilized the technique of section cuts through an actual structure, to expose load-bearing elements and spaces between walls, invisible to their occupants. Not on paper, but inside actual buildings. He focused on those, which had already begun their descent into ruin. The cavities revealed signs of wear and tear, quite unlike their pristine drawn prototypes shown on blueprints. Exposing fatigue, material durability, and spatial relationships through collaged views, the result would incorporate unwieldy perspectives, amounting to an intriguing architectural documentation of the buildings. Art department in Fincher's film was also striving for an unprecedented treatment of the location. The building itself may not appear as too extravagant, but it is not a regular New York brownstone. Due to ordinariness[19] in terms of its plan, however, we are able to mentally reconstruct its architecture, without experiencing (too great of a) disorientation, when the camera makes swift transitions between rooms, using non-standard entry points, while occasionally passing through walls. One such transition is composed of 'a single tracking shot […]. In the sequence, which lasts for 2 minutes and 40 seconds, the camera moves through the house, changes scales, passing through impossible gaps, moving through the structure and defying gravity' (Clear 2013: 75–76). With *Panic Room*'s cinematography recreating a look at one's surroundings with heightened inquisitiveness, scrupulously woven into the plot, the director embarks on a critical analysis of design solutions. But we

have already seen such engagement with domestic spatial discourse in numerous suspense thrillers directed by Alfred Hitchcock, such as *The Lodger: A Story of the London Fog* (1927), *Rebecca* (1940), *Notorious* (1946), *Rope* (1948), *Dial M for Murder* (1954), *Rear Window* (1954), not to mention *Psycho* (1960). *Panic Room*, which can definitely be counted among the innovative highlights of the digital era, also operates at another, Hitchcockian level. Cinematographic dissection of the edifice serves viewers' comprehension of the narrative. It creates a metaphor for the actions taking place, and puts set design in at the centre of narrative structure, simultaneously an architectural reading of the film. At the same time the technology used is feeding back upon itself, rendering long takes and visual effects visible, giving off an impression that physical boundaries have somehow been dematerialized by a CG sleight of hand. Like Hitchcock's *Rope*, but taking place in a slightly less chaotic universe.

Photogrammetry and match moving allowed Fincher to re-view this residence in an innovative way, creating a semi-simulated, semi-photographic vivisection of the estate's structure. Visual artists have rendered the house in 3D, recreating it on computers. The footage, choreographed in advance, is then transferred and substituted for a virtual recreation of the environment. Finally, photographic textures are 'painted over' the polygonal model. Parts of buildings which were obscured by a matte mask while shooting, have now been replaced with constructions recreated in CGI, and subsequently merged with live-action footage. CG set extensions are used in multiple shots – descendants of matte paintings that reinforce optical illusions. Still, digital enhancement, even when counted among numerous other visual special effects, does carry a semantic value that alters or builds upon the events portrayed.

> Digital visual effects also have broadened the scope of narrative expression, offering the best of recording and representational tools to storytellers. By extending control over every aspect of the image, DVFx offer additional means of visually representing concepts and creating environments and performances.
>
> (Prince 2012: 67)

The long-lasting impression made by dematerialization of *Panic Room*'s architecture 'relegates' the supposedly photorealistic live-action footage to the status of images; to a form of visual representation – specifically, (computer) animation. The era of speculative architectural projects making their appearance on screen – maybe aside from science-fiction features, overloaded with utopian/dystopian paraphernalia – might not be upon us yet, but films, which abolish physical constraints – thus following in *Panic Room*'s not-so-fearful footsteps – doubtlessly make room for such an option.

FIGURES 2.4–2.7: David Fincher, *Panic Room*, 2002. Film still: Columbia Pictures, Hofflund/ Polone, Indelible Pictures (USA). In *Panic Room* the camera penetrates every duct, passage and brownstone's 'nook and cranny' with extensive help of digital cinematography.

We are in a golden age of building fantasies. The dream makers who construct cinematic images take their inspiration from myriad architectural influences – unsurprising, considering that architects are concerned with the invention and design of environments in which humanity can evolve and live in the decades ahead. In turn, our spaces are becoming progressively more cinematic as the future gets nearer and digital entertainment visions loop and feed back into architectural reality.

(Hanson 2005: 8)

Filmic space: a composited image

How deep is the focus on technological innovation of these architectural fantasies, which resemble classical matte paintings replenished with scale models, only digitized? History of visual special effects, viewed from the perspective of represented space, offers a fascinating detour through alternative illusionistic methods of compositing disparate images of objects and backgrounds, as well as processing images on optical printers, with rear and front projections, or numerous other processes, devised with the purpose of sustaining an illusion of reality. For instance,

[*Citizen Kane*], now ranked as one of the greatest ever made, was a *tour de force* of matte paintings, miniatures and ingenious optical printing techniques. Perhaps

45

it is a tribute to their invisibility that the film was not even nominated in the special effects category of that year's Academy Awards.

(Rickitt 2000: 22)

Because nearly every cinematic image is already a composited image, 'thinking' with layers resolves various issues concerning image provenance and interconnections. Actors are shot independently of the background, and later combined with scenery, along with a tandem of (male, and female) mattes created for each of the images to avoid the 'ghost image' problem of double exposure. In order to sustain the illusion of uniformity, each of the objects present in the image has to agree with the general perspective, speed of motion, focus, and angle of view. Such features are achieved through the selection of control points, that allow one to track relative motions of the camera in space, in relation to the observer. 'Tracking is used to map the relative motion of objects within a scene so that any element added to that shot during compositing can be matched or "locked" to that movement' (Rickitt 2000: 83). This technique is frequently resorted to in the age of CGI inserts. It is important to notice how peripheral production, that which had formerly been limited to the area of 'surgical' Vfx intrusions, has spread as to include the design of entire environments, layer after layer, comprised of virtual camera movements, colour adjustment and lighting levels correction. 'Generation loss' was a nuisance of the analogue era, causing fatigue in second-generation copies of tape/footage. With digital media no loss of quality occurs.[20] Thus, in comparison with optical printing, the process of creating mattes gained in accuracy. An example of this can be 'difference matting', where two takes of the same scene are used (one containing the elements that are to be isolated, and a second one without them) in order to extract an object from any kind of background, regardless of its colour.

However, rear and front projections have always supported themselves with moving matte techniques. Relying just as much on foreground miniatures as on background mattes, history of creating illusion by placing actors in between edges of the composition, known also as 'Introvision', would not have been possible if it were not for Kubrick's inventive use of front projection in *2001: A Space Odyssey*. This issue of integrating the actor, who is placed in an altogether different setting against a black (Williams process), brilliant yellow (sodium vapour process), blue (blue-screen colour separation process) and, finally, bright green (contemporary 'green screen' techniques) background, was key to developing special effects. It was also the first step in an in-depth manipulation of filmic space. Many single elements of the final composited image are either enhanced, retouched or manipulated to the point of substitution of original elements with digital 'wallpapers' and props – adding cerulean to the sky's hue, substituting fair weather for foul. 'Since digital images are really no more than an abstract collection of numbers, they can

be subjected to almost limitless manipulation through the use of specially written image-processing software' (Rickitt 2000: 82).

Long before the dawn of computer graphics most of these processes were already in use. Unachievable at the time was the utmost precision in their execution. The 'seams' were still noticeable, despite consumed time and effort. But in the digital age filmmakers have acquired other tools for reproducing/multiplying imagery – practically unaffected by the loss of quality.

> Crowds could be replicated, removing the need for hundreds of extras in expensive costumes. Physical effects were made practical and safe because safety wires used to protect actors during filming could easily be digitally removed. Futuristic and historical locations could be conjured up with the minimal use of sets and locations.
>
> (Rickitt 2000: 37)

One can argue that when photons capture a chosen view, transferring it onto the film stock, any object – regardless of its former material constitution or origin (whether it is a 3D object or a painted backdrop) – is instantly downsized to the status of images. Source is not that important as long as it provides a veritable and photogenic addition to the composition. Still, what might be intriguing to moviegoers and special effect artists does not have to prove so in the opinion of architects.

Purely visual space

Building upon this premise of 'relegating objects to imagery', purely visual (special) effects can be turned into an environment of their own and on their own terms. Along with such abstract segues (however, 'non sequiturs' would be more appropriate) as the 'Stargate sequence' from *2001*, achieved by Douglas Trumbull through slit scanning technique, experimental animations were introduced as special effects to live-action feature films. What is significant in this transition is not even the technical description of the process but a new type of space created by it – a purely optical play of abstract forms, blobs and fluids smeared on (milk) glass surfaces, rendered by the narrative into a representation of an alternative, interstellar space. Before the coming of *2001*'s plot, similar visual experiments were conducted either in animation, involving moving variations on *art informel* paintings in the films of Hy Hirsh and Harry Smith or as early displays of computer graphics, created by the Whitney brothers. However, when introduced into and bonded with science-fiction live-action features, they usually appear as sequences portraying altered psychic states, dreams, hallucinations, fantasies or other-worldly environments. A new kind of space is brought to life.

While the excessive depth of field and Op Art effects apparent in earlier science fiction films [...] can be taken as forerunners to these later films [*Star Wars*; *Close Encounters of the Third Kind*; *The Last Fighter*], I would suggest that the 'tunnels of perception' did not operate in the same way as they did in later films. The 'new art' science fiction films of the late 1960s and 1970s were frequently discernible by their innovative use and manipulation of existing photographic and cinematic technologies to create psychedelic episodes and visions inspired by counter-cultural artists of the period.

(Cornea 2007: 93–94)

This space of pure visual excess, indicating an entirely artificial environment, painted or designed, was the harbinger of digital matte paintings and CG set extensions. The advent of match moving allowed for a tight coupling of perspectives represented by the artists with virtual camera's movements. Moreover, the digital 'paint' superseded oils and acrylics that were used to compose static backgrounds, back when

the limitations of these techniques meant that the camera normally had to remain in a fixed position for the duration of a shot. Moving it could result in a change of perspective causing 3-D set and 2-D painting to become misaligned. Today, computer technology allows real physical environments to be supplemented with 3-D digital set extensions, allowing camera to move around freely within a scene.

(Rickitt 2000: 207)

Even though actual virtual sets and environments were soon to be manufactured en masse for both scales of the generic cosmos – for science-fiction epics as well as kitchen sink dramas – cinema maintained its composure, rarely drawing attention to digital traces. The only exception to the rule would be when approaching the subject of simulacra and emphasizing ambiguity in represented filmic space.

One such example occurred at the beginning of the 1980s, when general interest of film studios turned towards imaginary constructs, like geometrical shapes reminiscent of Ledoux, although rendered inside computer's 'core'. 'Tron offers up minimalist but memorable moments in its virtual landscape: fractal mountains, wireframe canyons, deserts of data pulses, Sarks's Carrier, the I/O Tower, and, at the mainframe's core, the Master Control Program structure' (Hanson 2005: 27). *TRON* (Lisberger 1982) contains no more than seven minutes of CG footage, which is all the more surprising since this film's 11-year-younger peer *Jurassic Park* (Spielberg 1993) gave its dinosaurs a total amount of six minutes of screen time. Astounding as it is, technical innovations do not adapt easily to the requirements of filming industry, as far as audiences are concerned. Similar factors could

probably also explain why rear projection came to replace travelling mattes, even though the image quality of projected backgrounds was noticeably paler in colour than of the actors in the foreground.

> All travelling matte techniques – old and new – rely on the same fundamental principle of providing background element with an empty hole in it and a foreground element that contains nothing but the moving object which is to be slotted in the background.
>
> (Rickitt 2000: 45)

This question does not concern key stages in a process of improving the technique but change in the ontological status of filmic space. Resultant images – contemporary mattes – move away from 'drawn' representations of places and near CG architectures built solely out of images.

Conclusion

Approaching set design from the side of matte paintings (even in their digital incarnation) does not give them visual precedence over the spatial aspect. On the contrary, it suggests a tight coupling of the two, going as far as to – by the suggestion of matte painters and model builders – subjugate all plastic and architectural creations to the exhibitionist logic of guided attention. Juhani Pallasmaa wrote that the '[p]resentation of a cinematic event is [...] totally inseparable from the architecture of space, place and time, and a film director is bound to create architecture, although often unknowingly' (2007: 20). Because of that one has to keep track of all spatial arrangement(s) in the narrative, which – in a normative model of Hollywood cinema – would be taken as the means to supervise the composition of frames, along with the amount of information they give off. In this they follow Eisenstein's strategy of assigning a dominant component to each film frame, as conveyed by his 'polyphonic montage' theory. The viewer is supposed to notice only that which is put on display. This means that any objects apart from those directly involved with the action, though depicted within the frame, should be considered backdrops. But let us not dwell too much upon the composition (or indulge in an overly scrutinous examination). In predigital cinema it was within the director's or editor's area of competence to recognize how much screen time particular settings/mattes should be given, before cutting to the next scene. Cinema remains an illusionists' enterprise. Even more so in its digital incarnation. The difference lies in partial sets and optical tricks employed, involving solid objects which used to pose harsh restrictions for cinematographers, yet nowadays have been

rendered ephemeral. This is due to CGI, set extensions and adjustments that can be manipulated in three dimensions, granting artists access to virtual camera software, which can plunge into rotatable, zoomable and traversable spaces, without being restricted by the staticity of forced perspectives.

From the age of the analogue, which conceived of film frames as paintings, we move into the era of recreating spatial arrangement consisting of film sets and profilmic reality inside artificial environments of graphic design software. This comes with the possibility to integrate CGI with live-action footage (match moving) and widespread application of '[p]hotogrammetry [which] enabled the film's effect artists to model the photographed buildings in 3D computer space and to use these models for generating hundreds of buildings needed for wide views of [the city] that the film would show' (Fischer 2015: 150). One can only wonder in what aspect this digitalization of filmic images, describing them in mathematical terms, recalls Albrecht Dürer's technique of placing a screen in between the draughtsman and the subject. Framing images this way, Dürer would divide their surfaces into equal portions, thus applying to them a grid, or matrix, fragmenting the figurative composition into equal blocks of abstract data: fields of colour, contours of shapes, levels of hue. The process of scanning digitalized images in search for 'discrete reference points' can be regarded an inheritor to this technique practised by placing tracking markers for any additional imagery introduced into the picture, for it to comply to the same vantage point. This apparatus made by a fifteenth-century artist allows any painter/draughtsman to construct a proper perspective or, conversely, to distort the scene painted, thus giving birth to an anamorphic projection. The present-day creator, who is backed up by image-comparing algorithms, performs a similar operation on represented space, cognitively reducing it to abstract forms, contours and areas of pigment. There was no need for matte painters to painstakingly achieve a hyper-realist precision in their paintings, for even precise, highly detailed paintings would be eventually pushed to the background. But why is it that we do not immediately recognize painted images combined with live-action shots or impressionistic smudges grouped into areas of colour, labelling them as fakes? Has not the answer already been provided by Rickitt in a conversation with the matte artist Harrison Ellenshaw?

> What makes these distant objects look like windows or trees is the fact that our brains see them in context and tell us what they are – our brains fill in the fine details that our eyes don't actually perceive. If you were to create a matte painting in which every detail was visible, you might think that it would look incredibly realistic. In fact, it would look like the most fake image that you have ever seen.
>
> (2000: 198)

These should give us considerable grounds for acknowledging optical illusionism, which is exercised cinematically in its CG-enhanced incarnation, as the co-creator of filmic space. This strategy becomes a strong component of architectural animations studied later on, along with other concerns of spatiality that not only inform their production mode and medium but become a theme in themselves. Perhaps even in this they remain quite illusory, if not utopian, with regards to the unattainability of utter dematerialization of architectural form. Is it any wonder that graphic utopian fictions appear so convincing, even though they are hardly anything but a blur, looming on the (painted) horizon?

3

Leaving Buildings on Paper

Visionary architectural projects operate on a peculiar basis, which implies that 'the represented object does not exist prior to its depiction in drawing. [...] Buildings are both imagined and constructed from accumulated partial representations. The drawing as object, like the musical score in performance, disappears at the moment of construction' (Allen et al. 2009: 7). Unbuildable designs are inherently bound to the medium and form of their presentation. They partake in a meta-discussion on history and future purpose (as well as shape) of architecture, regarded as discourse, through investigating formerly marginal aspects of design. Peter Cook, when perusing instances of architectural drawing, distinguished eight categories, giving priority to such aspects as: motive, strategy, vision, image, composition, expression and atmosphere, technics and surface. Obviously, purely speculative proposals put less emphasis on technical aspects, developing those connected to 'imageability', atmosphere and their creator's vision, while refraining from transgressing any convention of representation whatsoever. After all, '[v]isionary drawing does not stand outside the basic scheme of architectural development – it just, sometimes, wants to make a leap forward' (Cook 2008: 73).

In the introduction to his *Visionary Architecture: Blueprints of the Modern Imagination* (2007) Neil Spiller outlined several motives for building solely in drawn form, guided by pedagogical aims, self-improvement, political ends or sheer will of 'injecting noise into the system', as phrased by members of Archigram. Throughout history, from Enlightenment to 'alter-modernism' (or from whatever contemporary vantage point we would like to review the field), visionary projects invited culturally diffused readings, deriving from literature, psychology, art and urban and architectural theories. Having reviewed the history of architectural representation techniques and media of (project's) communication, we should now inspect its (meta)tradition, existing on the margin of that practice, and ask about the speculative factor in visionary drawings. It will be done from the perspective of dynamic, that is, kinetic features implied in drawings, as well as by looking into subsequent methods of representation that architects-artists

had chosen to work with. Focus on the medium would help in bringing out qualities inseparable from form. Architecture should 'blaze' – recalling the famous statement by Wolf D. Prix[1] – and make system resound with noise. Reverberate from the eighteenth-century workshop of one indie archaeologist.

Paper architecture and its ineffable contents

How to define Piranesian? Ideally, by looking through items filed under Quixotic, though relating to architectural productions slightly different than windmills. Conjured up are images of tiered labyrinths, colossal ruins, depicted as if in an aftermath of a battle with evanescence. Remnants of Ancient civilization devoured back by Nature are overcome by vegetation. These spectacular vedute practically overshadowed other interests of the 'unbuildable architect', like sketches of Pompeii, created together with his son, in the twilight years, or a broad study chimneypieces' design. Studying in the 1740s under Giuseppe Vasi, Giovanni Battista Piranesi acquired mastery in the art of etching, which would bring him fame just a few years later, after creating a series devoted to the city of Via del Corso. With *Le Antichità Romane de' tempo della prima Repubblica e dei primi imperatori* ('Roman antiquities of the time of the first republic and the first emperors') and subsequent series of engravings published in 1762 (*Campo Marzio dell'antica Roma*), he established a reputation of lifelong proportions, focusing on restoring the architectural Roman past through drawing. Piranesi's take on ruins would echo the Baroquean tradition of landscape paintings displaying faded grandeur of ruins as a memento mori, executed widely by the likes of Nicolas Poussin or Claude Lorrain (Brodey 2008: 28–29), although in the Venetian's works the debased wonders of Antiquity acquired imaginative fill-ins, matching their ancient cloth. In this they often forsake last traces of harmony and proportion left in these structures, in favour of antiquarian citations. Ruins in Piranesi are still sturdy and morose; untamed and sorrowful. However exaggerated one might find these instances of reimagined classicism, they are crucial points in a discussion on the eighteenth century's discourse on depicting ancient past, conducted at a time when modern archaeological discourse was being born. Numerous subjects are touched upon by them, as listed by Tafuri in his metadiscussion on utopias as reliant on historical conditions, while projecting those contradictions into the future (1987: 29). Also, they take aim at the concept of privileged centre (1987: 27), implied by Renaissance perspective, while at the same time contributing to architecture's transformation into a highly conceptual endeavour – one that is prone to formulating hypotheses in the architect's studio, rather than inscribing them in stone in the building site (1987: 30). For the purpose of creating a treatise in architecture, his fantasias

could be taken as visual arguments in a disquisition. Therefore, it would be quite reductive, in regards to any of his projects (*Campo Marzio* among them),

> to judge [their] [...] topological and architectural inventiveness as utopia or, worse, as an architectural fantasy. Rather, Piranesi's *Campo Marzio* can be considered the summa of a vision of the city that developed between the fifteenth and eighteenth centuries: *instauratio urbis*, which literally means 'the instalment of the city', and in practice involved the reconstruction of the ancient form of the city.
>
> (Aureli 2011: 93)

Given this context as the point of departure, further analysis of Piranesi's works encourages one to examine his portfolio in detail. As architectural fantasies, or *capricci*, his works place emphasis on the interrelatedness of architectural fragments, displacing the Vitriuvian ideal of symmetry and articulating the composition, rather than merely evoking atmosphere. At the image's supposed centre, instead of stumbling upon a phi of the golden ratio, one finds a flock of fulcrums – an heir to conceptual shifts from Euclidean to Cartesian space. Spiller locates this ambiguity at the core of Piranesian constructions. 'His vanishing points are unaligned, and his projection planes multiply with unparalleled fecundity as he constructs the representation of an unrealizable group of objects and spaces' (Spiller 2007: 13). Tafuri's discussion of *Carceri* plates delves even further into this visual havoc.

> His perspective reconstructions of the plan, in particular, tells us a great deal about Piranesi's method of composition: Piranesi's complex organisms are seen to have their origins in planimetries whose dominating element is the randomness of the episodes, the lawless intertwining of superstructures, the undermining of the laws of the perspective, so as to make *nonexistent* sequences of structures seem *real*.
>
> (1987: 26, original emphasis)

However, this does not necessarily add up – as Eisenstein could have wished for – to an output precursory to cinematic montage strategies. These collage juxtapositions cannot be treated as compositions created out of separate film stills, as if they were expanded perspectives in constellations of Polaroid photos, reminiscent of Gordon Matta-Clark's projects. This does not resemble anything like temporal progression, mapped out on the same (paper) plane. However, like in editing, the task to be accomplished on the viewer's part is to reconnect those fragments into an imaginary, though still self-contradictory spatial construct. The difficulty lies in an impossibility of the task, as far as one aims at creating a coherent model of the structure. In fact many of those intersecting views are preconditioned by vantage points, from which they have been depicted. As in anamorphosis or forced perspective, if

the perceiver does not take advantage of any of the presupposed vantage points, then the spatial entity simply ceases to exist, dissolving into an impressionist blur. More than any other series of plates created by Piranesi, *Prisons* adds up to a Quixotic detour around an exclusively communicative purpose of architectural drawings, which makes beholders take part in a thought experiment, undermining the representational apparatus employed. Instead, shifting interest from object to its context and constitution, assembled from architectural fragments invoking historical realities presented against contemporary practice of reconstruction (precisely, *instauratio urbis*) and ruin lust. In this we can notice how Piranesi uses his medium (of drawing), as well as technique (etching), arriving at an apparent obscurity, created out of a compulsive pedantry of the draughtsman. In the case of *Carceri* it becomes coupled with a mode of representation akin to theatrical dramatic effects, specifically *scena per angolo*, endowed with several vanishing points. Invented by Ferdinando Bibiena in the early eighteenth century (and passed down in the family), the technique made set designs appear more spacious, spreading, with an optically increased depth, this way facilitating adaption of this illusion to random seats in the audience. Employing Bibienas's variation on perspective projection, Piranesi was merely recognizing the fact that this technique of architectural representation (perspective) cannot maintain its claim to objectivity, as projective geometry would deem it. 'Each representation describes a different aspect of the object, a different way of perceiving it. When an author chooses a particular representation, she is providing a clue as to how the audience should understand the object' (Scheer 2014: 25–26), writes David Ross Scheer on any kind of traditional architectural representation, as opposed to the twentieth century's bias against simulation. Recognizing that even most visually stunning renderings disclose the fact that perspective is a set of conventions – rules guiding/governing the composition – we will notice how reluctant speculative projects are to mask traces of their making. At the same time they remain – like, in Piranesi's etchings – structured along the lines of chosen architectural convention, which they set out to criticize from within.

On the other hand, monochrome sombreness achieved with black chalk, greys, browns and ink adds up to an effect of impenetrable space, receding into infinity. Employing such measures not only for dramatic ends but to mark his observations on architectural theory, urbanism and (what was soon to be termed) archaeology not only classifies Piranesi among the first paper architects but also defines the determinants for all fantastic and experimental endeavours relegated to design, theory and conceptualization stages of architectural production. Tafuri suggests of Piranesi's *Campo Marzio* to be read as a 'virtual catalogue', or 'typological sample book' (1987: 35), lacking any hierarchical organization (as it does not add up to a single body of building). In his view *Campo Marzio* is a stance against the eighteenth century's obsession with relegating every architectural production into a matrix of codified types.[2] It

FIGURE 3.1: Giovanni Battista Piranesi, *Carceri Plate XIV*, 1745. Etching on white laid paper. Image in the public domain.

is primarily the organizational principle behind any puristic collection or wunderkammer, which gets revamped as columbarium. An ideology so vividly undermined by Piranesi. Name everything. Leave little or no room for artistic decision. Especially on the threshold of Enlightenment's rational and scientific efficiency in design archeologically driven neoclassicism and the nineteenth century's revivalism of styles were in debt to various *dictionnaires raisonnés*, primarily those of Jean le Rond d'Alembert and Denis Diderot's (*Encyclopédie*, 1751–66), Quatremere de Quincy (*Dictionnaire historique de l'Architecture*, 1832–33) or Eugène Viollet-le-Duc (*Dictionnaire raisonné de l'architecture française du XIe au XVIe siecle*, 1854–68), turning architecture into a system based – consecutively – on taxonomy, language and ideal forms.

Revolution with caractère

But Piranesi was not the sole Quixotic crusader. A generation of the so-called revolutionary architects emerged soon after him, presenting a discussion focused, to

an even greater degree, on the inherent logic of types and monuments. Never mind the moniker. Visionary architects of the late eighteenth century perished in either obscurity or confusion; some were completely forgotten in the final days of their lives, unable to receive commissions or even persecuted for their (somewhat unintentional) alliance with former authorities (Ledoux's project for barrières/tollgates of Paris, and early buildings designed during the *Ancien Régime*). Revolutionary architects of the Enlightenment were victims, rather than beneficiaries, of the French Revolution (even though Lequeu designed several monuments dedicated to *liberté*, *égalité* and *fraternité*). 'The fact that Boullée's, Ledoux', and Lequeu's fantasies – at least part of them – originated long before the political revolution broke out gives one much to think' (Kaufmann 1952: 545). What kind of revolution are we speaking of then? Although regularly mentioned in the same sentence, they never formed a unitary movement. They slightly vary in style. The projects – despite being allied in their affinity to Platonic solids – were created with different purposes in mind. These ranged from civic commissions, through industrial workplaces (Ledoux's saltworks at Chaux), to fantastic monuments at the borders of rationality, like the nightmarish *Temple of Death* (1795) by the same author who designed Newton's Cenotaph ten years prior, not yet disillusioned by debasement of revolutionary ideals. Étienne-Louis Boullée's (1728–99) drawings present structures 'suspended' in an eternal pursuit of the sublime.[3] They intended to affect the viewer with scale and contrast, with a penchant for chiaroscuro effects making up an atmosphere of the composition. Aside from that, '[t]he means which Boullée regards as especially appropriate are distribution of masses, illumination, monumental dimensions, and emphasis on the character of the building' (Kaufmann 1952: 472). All this is achieved with great moderation, avoidance of ornaments or surface details, because in the architect's opinion purity of form was an ornament by itself. On the scale's other end were projects of Jean-Jacques Lequeu (1772–1837), whose exuberant architectural fantasies probably seemed more suited for baron Münchhausen's peregrinations than as 'poster art' for masses storming the Bastille.

> From the point of view of its artistic meaning, the compositional principle of the Tomb of Porsenna and the Castle of the Sea […] [is] an agglomerate of elementary geometrical forms; a spherical dome, a hemicylindrical portico, and flanking prisms, with a halo-like crowing arch.
>
> (Kaufmann 1952: 555)

Halfway between the two we can locate Claude-Nicolas Ledoux (1736–1806), whose progressive ideas came close to anticipating the constructional itinerary of the upcoming centuries. His neo-rationalist preoccupations, alongside proto-modernist aesthetics of frugality, mass and architecture, fulfilled its service in

refining the production process. With Boullée he shared an interest in stereometric forms, regarding sphere as the ultimate embodiment of perfection – a reactionary solid ideal for battling Baroquean chaos.

The common denominator for all these non-conventional designs (with their monumentality and vastness lying outside of buildable projects) was a protest against prevailing paradigms of the age. Just as Piranesi mocked rationalism and commented on the archaeological endeavour, so did Boullée and Ledoux counter the revivalist movement, speaking out in a language of form-types, while simultaneously envisioning architecture that would surpass any limits imposed by *architecture parlante*. In the end they were left alone with their theories based on that epoch's scientific discoveries.

> Having lived in the atmosphere of growing political and social discontent, the revolutionary architects wished to realize, for the common good, the ideals of the time by contriving architectural schemes such as had never existed before. [...] In the end they themselves became disillusioned and reactionary. Of the three, Boullée represents primarily the struggle for new forms; Ledoux, the search for a new order of the constituents; Lequeu the tragic ultimate stage of the revolutionary movement – despair, resignation, and return to the past.
>
> (Kaufmann 1952: 435)

This generation grew up in the shadow of typological frenzy, initiated by abbé Marc-Antoine Laugier in his *Essai sur l'architecture* (1753). Dividing buildings according to their function, theorists like Laugier speculated about architecture's genesis, locating it, in more than symbolic terms, in a prototype of the primitive hut, chosen probably due to its primary function of providing shelter, not to mention the simplistic and reasonable form achievable with unadvanced building technology. Following the lead from natural sciences, architects devised their own genealogy of historical building forms in order for it to be copied throughout upcoming centuries, depending on their applicability – habitation and use. Germain Boffrand introduced the term *caractère*, understood as an expressive aspect of buildings, communicating their function. Jacques-François Blondel, the great master of Ledoux and Boullée, would pass on to his students the importance of classical aesthetics, slightly brushed up by the eighteenth century's leading theoreticians, namely: character, contrast and variety. This notion of *caractère*, in relation to typology, anticipates the nineteenth century's definition of *architecture parlante* (as Ledoux's adversaries would point out in regards to his projects). Nevertheless, it becomes apparent in the neoclassicisms of Boullée, Ledoux and Lequeu. Their visionary projects explicitly look for ideal forms that would illustrate the concepts of Enlightenment, while remaining independent of material

constraints. All this accords with de Quincy's concepts of imitation of natural forms, taken as the basis for architectural production. Symbolism of the façade often becomes unduly 'talkative' with such designs as Lequeu's *Gate of a Hunting-Ground* (*c*.1800), decorated with heads of wild boars and dogs, or Boullée's *Cenotaph for Newton*, taking its spherical shape from gravitational properties of celestial bodies. As Kaufmann writes, in respect of the draughtsman's style:

> [Newton's] memorial, as well as the conic cenotaph is surrounded by rows of trees on different levels, probably to alleviate the sternness of the whole. The interior of this memorial is empty, except for the sarcophagus: nothing to distract the eye. The curvature alone, without beginning, without end, is to dominate. The lighting is to be effected through tiny star-shaped openings grouped like celestial constellations.
>
> (Kaufmann 1952: 461)

Projects for Palais National and the Ministry of Justice were conceived in a similar fashion. While the ministry's allegorical character relied on placing courthouse above the prison, the headquarters, projected for the revolutionary government, were to be graced with a façade inscribed with sentences from the Constitution.

The *caractère*, or atmosphere, of prospected buildings frequently hints at a mystery, toying with outright literariness in copying natural forms. It highlights the intent of confronting his architectures' recipients with ideal forms. While Boullée strolls down the path of sheer size, sleekness and uniformity, in Lequeu we will find an absurd mixture of styles; *Castle on the Sea*, *Temple de l'egalite* … all reach towards ideal concepts, either through evocation of similarly perfect shapes or a recombination of ideal types from the historical repository. 'For architecture, invention [according to de Quincy] means synthesizing the constructive, formal, functional and ecological principles in nature through an original and imaginative synthesis that creates the houses, temples, monuments and cities' (Guney 2007: 7). Yet this inventory of fantastic constructions finds an unexpected development (but also divergence) in the work of 'revolutionary architects', who associate such principles with the language of projective geometry – tetrahedrons, spheres and pyramidal shapes. They find in them if not immediately a rumoured origin, then definitely a model of typological grandeur, distinct in the history of architectural forms.

> We know from Boullée's work that the pure sphere appeared particularly dignified to the revolutionary architects, for structures connected with death and eternity. Ledoux finds the spherical form as grand and as meaningful as the pyramids, the shape of which he compares to the tapering flame.
>
> (Kaufmann 1952: 524)

Rather than architecturally speaking for specific institutions, these architects strived for embodying concepts. Only in drawing could they avoid compromises and preserve the ideal as image. Even though ascribed with the 'programme' of a hollow mausoleum, Newton's Cenotaph is a building dedicated not so much to the late physicist as to his body of work expressed through theoretical concepts that 'envelop him in his own discovery'. The project 'exhibits metaphorical character by depicting the earth to the exterior and the universe inside. It achieves symbolic character through the temple-like space of its interior' (Etlin 1994: 21). We can notice how this strategy becomes complemented by a technique of the architect's own choice. 'Boullée employed the atmospheric qualities of the wash to create dramatic lighting effects, giving grandeur to the otherwise simple pyramid' (Smith 2005: 79). Additionally, atmospheric aspects of the drawing are spotlighted. An overcast though brightly lit sky (alternately, the night sky against an illuminated interior), the structure towering above hardly visible human figures in an otherwise desolate landscape, along with clashes of colour schemes – all this amounts to a disturbing, otherworldly scene. If Ledoux, Lequeu and Boullée were named 'revolutionaries', it is precisely due to their radical treatment of the Enlightenment's techniques of representation. Not the French Revolution, which left absolutist monarchy in ruins and new republic under construction, but that which speaks of revolutionary concepts in natural sciences is prospected to make an even greater impact on future history, even though it would eventually be put in an unflattering light by totalitarian architects, who would cite them as inspirations.

The unbuilt and the unbuildable

> From the unbridled symbolism of Ledoux or Lequeu to the geometrical silence of Durand's typology, the process followed by the architecture of the Enlightenment remains consistent with the new ideological role it has assumed. Architecture must redefine itself as it starts to become part of the structures of the bourgeois city, dissolving into the uniformity ensured by preconstituted typologies.
>
> (Tafuri 1998: 10)

Visionary architects commented on this epistemological shift in visual terms, opening up new discursive space with their speculative projects, most of which were primarily concerned with city form. Quatremere de Quincy's discussion of types, followed by Jean-Nicolas-Louis Durand's genealogical account of building typologies, would branch out, seeking solution in prefabricated elements of the subsequent era affixed with the seal of industrialization. Additionally, it was present in the 'Bauhaus studies in dimensional standardisation of building

FIGURE 3.2: Étienne-Louis Boullée, *Cenotaph for Newton, section cut (day)*. Drawing. Image in the public domain. The perforation in the dome is visible, resembling a starry sky.

components' (Banham 1970: 78), and the capitalist types of prefabricated elements and schemes that constitute Reyner Banham's first machine age of Corbusian *maison-types* (1970: 213). A preference for sublime, unitary, starkly monumental structures depicted in architectural drawings would be picked up later on by numerous visionaries, whose portfolios comprise of works of paper architecture – from Sant'Elia's profiles of power plants to clashes of tawny polished cubes with steel-grey sky in Raimund Abraham's works.

Renderings of perspective projections must seem like bastards to architecture, striving, since the late eighteenth century, for scientific precision unto univocity. Reyner Banham, as well as Adolf Loos and Le Corbusier, viewed this 'onanistic endeavour' of architectural drawing tradition as a waste product, useful only as long as it becomes eventually succeeded and replaced by the tangible outcome. Discard-after-use order of design and construction would be advocated mainly by the architects of the machine age, picking holes in any disparities between blueprints and material constructions – viewed in close to gnostic terms, as irrevocably removed from the original intent. The nineteenth century's technological progress, backed by an emergence of new modes of production (assembly line, use of prefabricated elements), as well as expansion and densification of capitalist cities in the

aftermath of the industrial revolution, resolved multiple engineering and material constraints, inspiring critics, designers and artists alike to rethink the visionary agenda in unbuilt proposals. Precisely because of the fact that many designs of bygone eras – at the time considered unduly complex or risky – could now be constructed with cutting-edge technologies, a clear line should be drawn, telling apart projects that are genuinely unbuildable[4] from those which simply were not built at the time of their inception, having no luck with investors/clients. In essence,

> we are discussing architectural ideas that can only be visualised or drawn but cannot be made[,] [...] [and] ought not to be viewed as competing or being opposed to the buildable. [...] [It is important to recognize] [t]he autonomous function of this type of architectural project, through which architects have often critically thought and experimented.
>
> (Cridge 2015: n. pag. [5])

While Piranesi's vedute were clearly marked with the first symptom, and Ledoux's portfolio comprised of both kinds of proposals, projects of the modern era – specifically the 1920s' avant-gardes and fin-de-siècle excursions in art nouveau aesthetics – would be deemed utopian due to the sheer scale of prospected enterprises. Usually, they were meant to encompass entire cities, devouring previously scattered urban fragments, while spitting out unitary blueprints for an industry-driven metropolis (or an agrarian recluse). In the eighteenth century Piranesi's views of Rome would be sold as souvenirs to 'passengers' on their Grand Tours. Also, in the École des Beaux-Arts,

> [t]he competition system was a way for the students to quickly formulate a solution to a specific program, one that was acceptable and proper according to the theories taught at the school. They were not buildable projects, in that they stressed character, proportion, and composition, with less emphasis on building materials and contemporary technology.
>
> (Smith 2008: 72)

Not even a century later spectacular projects – both buildable and otherwise – would be far from comprising bottom-drawer paraphernalia. 'Great perspective drawings at this period [1900–13] were made to seduce the client, dazzle the exhibition visitor and be published' (Bingham 2013: 8).

As media of visual communication improved – techniques of printing among them (Bingham 2013: 30) – a breadth of artistic currents made an impact on the zeitgeist, inspiring new fashions and affecting the style of architects working at the time. Neither did visions of such prominent figures as Antonio Sant'Elia or Bruno

Taut limit themselves to single aesthetics of buildings, but intended to grasp whole cities, restructured according to socialist ideas that would heal the increasingly tumultuous metropolis. Visions of new cities for the industrial age were to become predominant subjects in many of the projects, and the task of imagining their shape was self-assigned to artists working in architectural drawing. Such urban landscapes, rendering civilized world like a prefabricated structure, relied in large part on technological innovation. At least in terms of imagery being employed. By the end of the nineteenth century it was extending its typological vocabulary to include the industrial vernacular. The introduction of new construction materials – reinforced concrete, steel and glass – brought about novel typologies, which began to sprout up in the heart of the city. Skyscraper, as the main fetish object among them, would settle in for good in the nocturnal caverns of Hugh Ferriss renderings. There was a shared desire for clarity of form, though other than that which would revise neoclassicists' obsession with Platonic solids. It is present in the depiction of machines, industrial crudeness, construction details (like rivets, cogs, pistons), curtain walls and three-nave factory floors of Auguste Perret, bringing out engineering intricacies in the design. Apotheosis of the machine in search for its exclamation marks. However, by means of unfettered industrial progress – whose rational end, or just its ultimate manifestation, would eventually come with the Great War – the designs engendered also less techno-fetishist projects in the Weimar era. Those architects abhorred the war's terrors, instead of praising its automated bedlam. They were seeking solace in flowing, wavy forms of Expressionist architecture, longing for crystalline purity reminiscent of romanticized medieval towns, sprawling around cathedrals of light – revived as city crowns of the modern age.

Ideas expressed in the medium – in the case of each drawn and unbuildable project – would evidence idealistic pursuits, not just interim solutions, highlighted by unattainable visual effects (recall the 'crown's' angelic glow) in their compositions. Simultaneously these architects sought new vocabularies of natural (Expressionism), mechanical (Constructivism, Futurism) or tectonic (Ferriss) forms, while deploying artistic strategies, so they could be pictured in a seductive manner. As Spiller wrote of the potential alliances of architectural representation with diverse currents in the pre-millennial artistic movements, 'The testing of architectural limits and the differing modalities of the architectural drawing were the other large preoccupations of twentieth-century avant-garde discourse' (2007: 13). Ubiquitous mechanization, immoderate progress, war and pollution were considered new diseases of the age that could be properly aided only by a genuinely utopian endeavour. Each finding a nexus for its criticism in either the Arcadian harmony of ideated (and idealized) past or the auspices of human reason, which warned against trusting nostalgic clichés.

Antonio Sant'Elia ought to be counted among the apologists of technological progress. In a series of drawings for *La Città Nuova* he could flesh out his manifesto

for Futurist architecture (1914) – the zealous, indispensable 'deep end' in an automated (gene) pool.

> There is an extant series of drawings on which Sant'Elia began to work from 1909 onward and which the critics have classified together under the denomination of 'monumental buildings'. While it is difficult to establish their exact use, all of these works exhibit similar characteristics that allow them to be defined as exercises in composition.
>
> (Asensio 2003: 31)

In his drawings one instantly recognizes a collection of vistas upon the city made up of power plants, factories, airports/train stations resembling dams, supplemented by integrated 'habitation units'. There is a typological continuity in these sketch-like 'snapshots'. Sant'Elia's buildings are usually a combination of standardized, though differently arranged, elements, including ramps, power lines, concrete pylons, turbines, chimneys and towers. These architectural fragments are connected one to another not only through layers of roads, walkways and skyways, but each of them becomes a power station in an electrical grid, networked with other such structures deployed around the 'new city'. As Llorenç Boner remarks, in the Italian's pencil drawings there was no interest in probing space with lights and shadows, as if citizens of his New City were to work and rest only at permanent noon. Unlike neoclassicist *caractère*, Sant'Elia's architecture shied away from expressing its function (2003: 45), diminishing the importance of the façade. His theatres could be mistaken for funeral parlours, whereas hangars resembled power plants. In spite of this confusion in representation the architect regarded all institutions as terminals/outlets for a vast network of power cables. Even though many of them are nothing more than outlines, they never fail to make a statement about their spotless monumentality, calling upon industrial forms of power plants, foundries, warehouses, hangars and factories to behold. Sant'Elia's breakaway from tradition materialized as 'grouping of masses on a grand scale and plans of vast *disposition*' (Sant'Elia [1914] 2009: 200). This treatment of ideal cities as a mound or rock formation was a cry for cohesion in a perpetually delaminating urban fabric. Hugh Ferriss achieved similar effect with slightly different (pictorial) means.

With avenues hundred feet wide, placed half a mile apart and separating clusters of 'tremendous towers', Ferriss, Imaginary Metropolis complies with zoning regulations, solves problems of traffic congestion and creates a cavernous landscape with buildings amassed like dripstones. The tower-buildings are

> not to be compared simply to mountain formations which happen to have arisen, abruptly at certain intervals, in a plain; rather, each tower seems to have a specific relation to the low-lying district which immediately surrounds it. The heights of

FIGURE 3.3: Antonio Sant'Elia, *La Città Nuova* (detail), 1914. Ink over black pencil on paper. Image in the public domain.

the lesser buildings increase as they approach the central tower; each peak, so to speak, is surrounded by foothills.

(Ferriss 1929: 110)

Except for the urban planning under totalitarian regimes it is quite uncommon to design entire cities single-handedly. Neither Sant'Elia's nor Bruno Taut's, and not even Hugh Ferriss, renderings could have been carried out in their totality.[5] Prnjavorac Cridge discusses these and other unbuildable projects of this kind,

65

FIGURE 3.4: Hugh Ferriss, *The Science Center* from the *Metropolis of To-morrow*, 1929. Drawing. Image in the public domain.

inspecting them against an array of artistic creations compiled into series – an example of increasingly precise iterations of their authors' spatial ideas. In 1933 Yakov Chernikhov produced a series of drawings that seemed negligent of scale and architectural context. Created at a time when cinema was considered superior to other art forms thanks to its kineticism, the series was intended both as a sequence of spatial constructs, as well as graphic symbols (*101 Architectural Fantasies*). There is little room for wonder about the sequence intended by the architect, somewhat paralleling that of a film strip, often juxtaposed, one against another, complying to with the logic of intellectual montage. Applying the same discursive frame to Piranesi's series of antique monuments, or to his *Prisons*, might prove problematic. While refraining from discussing them in terms of storyboards, they can clearly be interpreted as successive vistas and variations on the spatial idea of an infernal complex.

However, a significant shift in (re)production technologies did occur between Piranesi and Chernikhov. We should not ignore such problematic issues as the range of media available at the time, or the artistic techniques considered means of communication at the architect's disposal. Issues concerning mechanical reproduction would not be as pressing for Enlightenment's architects, as they were for Sant'Elia, for instance. Returning to the idea of series that ought to be perceived

as fragments building up to a coherent (alas confusing or even incomprehensible) construct, when closely examined Piranesi's *Prisons* is closely examined, it does not actually add up to a 'proper' narrative. This project certainly employs numerous implications of kinetic mechanisms, and – by proximity – movement. Racks and other torture devices do belong to this category, yet the motion implied is all the more present in the entanglement of floors, staircases and bridges, not to mention the dynamics expected of the reader's eye, required for ingesting these drawings. To get a glimpse of actual architecture, one has to apprehend the series of represented vistas, building his own mental representation out of the fragments and; solving the reciprocal confusion they infuse.

> [Piranesi's *Carceri*] is one of the pioneering, if not the first, examples of architectural series that is so fully contained within the unbuildable. [...] [T]he often overlooked quality of this work could not be so much in any of the individual pieces but in their overall seriality, in the number of likely combinations. [...] Fragmentation should not be perceived as failing but a sign of truly novel departure from the established architectural conventions. All elements – building, plan, site, and scale – become variable with constantly changing multiple points of view.
>
> (Cridge 2015: n. pag. [145])

Why have these projects remained unbuildable? One of the reasons is their inherent reliance on the form of presentation – chosen perspectives, style, or media and techniques used for this purpose.[6] Smudges of charcoal can denote a sketchy quality of the drawing. Otherwise, they might evoke a hazy atmosphere, implying movement inside the structure. The possibility of double readings akin to these should be kept in mind, propelling one to look at the composition in context of a supposed series; taking note of variations, displacements, conjunctions of adjacent frames; recognizing vantage points and recurring elements in the picture.

Such series of variations on a recurring set of objects, being nothing short of sequences of frames, can also be observed in Yakov Chernikhov's *101 Compositions 1925–1933*, as Cridge observes. These architectural fantasies display common features, intended to be organized in cycles not just on the basis of the similarity in their shapes, but also perspectives and arrangements of forms. In their case architectural representation aligns with Suprematist paintings, highly evocative of specific compositions by El Lissitzky, Alexander Rodchenko, and Kazimir Malevich, who was also the author of numerous architectural sculptures based on kindred configurations and rearrangements of 3D solid objects. Speculating on the shape of future cities by proliferating arrangements of standardized industrial elements, they use abstract and aggressive clashes of reds, dark blues, and blacks, also employing slanted and aerodynamic, geometric shapes, usually associated

with vectors of motion and speed. Visual language of these works 'lies' within the domain of avant-garde movements. It subverts purely abstract compositions and forces us to read them as spatial diagrams, perspectives, or axonometries. Over half a century later it will be excavated and cultivated precisely because of this implied motion, which brings out proactive connotations in building design. Each entry in the Chernikhov's series varies in size, yet, as a fragment of a larger entity, remains a miniature. This can point to several formal concerns regarding architectural drawings in general. For example:

> Chernikhov could have realised that architecture need not be confined to any scale in particular. This also possibly suggests an understanding that an architectural composition can be made to work both from a distance and close-up. [...] [Also] he often uses scientific terms to describe his experimentations, where graphics tend to have worked through a number of options of different arrangements and compositions based on a set of themes, which then develop their own logic and rules from within.
> (Cridge 2015: n. pag. [131])

A typology of architectural forms, organized according to the rules of natural sciences, resurfaces in this designer's oeuvre. Clearly, it is a self-imposed assignment that evolves into an examination of the architectural discourse, not another entry.

As the interest in form-finding and form-types subsisted from Enlightenment into the twentieth century, constructivist tendencies displaying the abstract side of industrial forms began to give way to organic morphologies. Expressionist utopias were not made entirely of crystal, even though this material is a recurring motif in the works of artists – Paul Scheerbart's novels, Wenzel Hablik's *Crystal castles*, and Bruno Taut's *Alpine architecture*. Nevertheless, Hermann Finsterlin's 'automatic' drawings remarkably rely on a recycling of organic forms, which are 'based on the natural formations of caves, bones, sand dunes, and plants' (Benson 1993: 37). Were these preliminaries for the morphogenetic turn in the 1990s? Without doubt the organic theme was signalled by design. Finsterlin's and Erich Mendelsohn's projects display a flexible, cartoonish line, reminiscent of Winsor McCay, and a prevalence of outlines over detail, while Taut's watercolours make an impression of illustrations taken out of a children's book. Rounded, pliant shapes guide the eye uninterruptedly along the contours, presenting architecture that seems to have poured out of a single spontaneous idea. Like a sketch, yet encased within a continuous shell, a well-knit interior and exterior space. One flows into another. The use of softened, washy lines, and colourful images, aimed at emphasizing what has already seemed seductive and charming in the Glashaus, made for the Werkbund exhibition in Cologne (1914). In Taut's design, '[t]he play of natural colored light was heightened in the interior by a water cascade on the lower level

and a mechanical kaleidoscope' (1993: 127), although on a larger scale of utopian cities and glass cathedrals. Regardless of whether we take Ferriss's *Manhattan of Tomorrow* or Little Nemo's *Slumberland* with its Jack Frost's palaces, both assigned to the oneiric crystallography a romanticized mission of reinstalling in the core of an utterly mechanized metropolis an element of the natural world. If this idyllic reinstation was not meant to proceed through agrarian communities of the nineteenth century's revisionism, or primal huts of a rumoured architectural origin in the Enlightenment's dictionaries, then it surely would through contemporary accounts coming from the emergent fields of botany, geology, and zoology. Despite their naturalness, there is yet another advantage of these emergent forms. Combating the machine metaphor, denoting an assemblage of disparate components, by an organic aggregate of tissue, viscera, and bone might be the prime agenda of the Expressionist architects. Their perspective on built habitat is epitomized by an interconnectedness of organs to themselves, yet under the 'auspices' of a larger body. Thinking on city scale, by regarding architecture as an environment; protective, housing inhabitants' actions, and 'acting' as an extension of his/her own body, just like Frederick Kiesler's *Endless House*.

> The *Endless House* was correlated to the human body in terms of both function and form. The health and comfort of the occupant were key concerns, as was a perceptually and experientially rich environment that Kiesler felt would be spiritually and physically enhancing.
>
> (Warlamis 2005: 31)

This idea is best expressed by installations, for example, Kurt Schwitters's *Merzbau*, because they 'plunge' the visitor into an entirely unfamiliar setting. Into a room that upsets any preconceptions of its interior space. This distancing effect, achieved through architectural form, would call for a variety of methods of representation, in which floor plans seem like a 'bare' necessity in communicating structure and layout, but fail to convey the experience. While Kiesler relied on constant reiterations of his idea in the scale model of his *Endless House*, Constant, apart from model-making, attempted to visualize the Situationist city of *New Babylon* by means of paintings, drawings, collages, lithographs, theoretical texts, while – in later years – also 'moving pictures' (Wigley 1998: 5). Directed by his son, Victor E. Nieuwenhuys, short films about *New Babylon* are in fact fly-through animations realized in relation to a physical model, and shot with actual camera. With considerable amount of planning and post-production work, they probably would have been indistinguishable from similar tracking shots featured in *Metropolis*, or *Blade Runner* – given the novelty of portrayed landscapes. Nieuwenhuys's oil paintings, on the other hand, are rooted in his experiences with the CoBrA group,[7]

which translates into the intangible character of his idea of *New Babylon*. Upon viewing his works, we are reminded of events rather than static spaces. We see inner streets and corridors arrested in motion, after a violent rapture. We see Bacon instead of a dormant Hopper.

> Space is psychological. *New Babylon* is produced by cross-fertilizing early 1950s architectural culture and early 1950s social geography. [Guy] Debord presented Constant with a fully formed critique of urban life and Constant presented him with a fully formed critique of architecture.
>
> (Wigley 1998: 30)

This connection with SI (Situationist International), formally broken up only after Nieuwenhuys was expelled from the group, never completely erased any of the ideological link-ups with Debord's criticism of consumerism, urban infrastructure, or strategies of *detournement* or *dérive*. *Dérive* stands for an intuitive drift around streets and quarters of the city. It was imaginatively intercepted for the ceaseless differentiation of *New Babylon*'s structure. Traces of this joie de vivre are 'scratched' upon the architectural settings, resembling strings of paint, or particle trails in a cloud chamber, as seen in his oil paintings – *Ode à l'Odéon* (1969), *Ladderlabyrint* (1971), *Entrée du labyrinthe* (1972), *Labyrintische ruimte* (1973).[8] They indicate marks left on the city's platforms, like memories of absent choreographies. In the multitude of scratches reminiscent of human figures, shadows, or Duchampean afterimages, it anticipates Peter Cook's *Instant City*, and follows Yona Friedman's *Spatial City*, remaining consistent with the line of projects that envision the future as consisting of iterated urban fragments. Layer upon (historical) layer, while simultaneously stressing the importance of their interrelatedness, *New Babylon* maintains its services through a changeable linkage of mobile parts, like an architectural *dérive*. One of the main advantages of such unbuildable, utopian projects lies in that they are allowed to remain freeze-framed in their permanent revolt.

In Cridge's book we will find yet another observation regarding the nature of unbuildable projects. As objects of art, and simultaneously texts, both equally concerned with architectural discourse and protocols of imaging/creating them (idea, representation, codification, technique, medium), they have been closely related to the issue of media of visual communication, as well as to emerging modes of their use. What seems to be a fashion affecting contemporary architect's 'hand', reflects in equal measure the age's episteme – its general ideas about what can be called a 'visual representation', and what concepts are supposed to be expressed by it. 'The peak period for the unbuildable is strongly related to the advances of image-making, i.e. perspective, printing, photography, cinema, and other technologies'

(Cridge 2015: n. pag. [155]). These periods, marked by intensification and waning, oscillate in a disharmonious way, nonetheless in accord with technical developments introducing new techniques of representation. Architecture has always been a forerunner to innovation. Nowadays it seems even more reflective of these advancements, when specific modes of design-thinking venture into post-digital territory, and with younger generations of architects rekindling their interest in analogue media. Handwritten marks and ink bolts replace glitches, even though they must have been digitally altered beforehand.

Post-war manoeuvres on the front of representation

Apparently the most important shift occurred just after the Second World War, when 'paper' architects found a 'refuge' in art galleries. Coming from the side of technology and pop art, at the same time being a reflection upon the 'performative turn' of the 1960s, a redefined approach to architectural practice has been introduced to new modes of artistic expression. Most of them were important additions to any art critic's vocabulary, like happenings, action painting, performance, or chance operations.

> Architects have always looked beyond their own disciplines for inspiration, but it was only starting in the 1980s that the forms and methods of film, television, and other mass media started to overwhelm the formal traditions proper to the discipline. The paper architecture of the period makes more sense when seen from the traditions of modern art, including collage, systems abstraction, and Pop art, but gains strength when one sees it in terms of science fiction as it has populated our imagination with images of a possible galaxy perhaps far, far away, but in reality inherent in our current reality.
>
> (Cantley 2011: 42)

Drawing on these new modes of art-making, a powerful rush of speculative projects displayed a critical perspective on contemporary metropolis, ecology, commerce, and space travel. They have entered architectural theory's bloodstream, incorporating visual languages of film, comic strip, with a 'topping' of artistic provocation along the way. Even projects such as Superstudio's *Continuous Monument*, intended as a critical view on iconicity (the 'heroic structure'), became icons in themselves – at least for the cult of the unbuilt, within architectural circles. These will be characterized at length in the next chapter. As for now we will focus on those unbuildable productions, which succeed in re-setting the rules of architectural representation, though still not yet venture with their visual deliberations to

71

the 'fourth' dimension. Time, as a silent protagonist, will return in the context of films and animated videos, having introduced a new possibility for conceptualizing design, revealing its 'malleable' and kinetic aspects, but also engaging with cinematic methods in analysis.

It was during the events of May 1968 that a young student of architecture built his first anti-architectural construction. Not a barricade, but the prototype for theoretical constructions that were to follow and deepen this disjunction of buildable and hypothetical creations, courtesy of Bernard Tschumi. Aaron Betsky, in an essay accompanying a book of Bryan Cantley's projects, writes:

> Rooted in structuralist and post-structuralist theory, this architecture came out of the belief that built reality was only one possible construction inherent in the systemic relations of various forms of coherence that were all inherently linguistic. [...] After digging into what appeared to be solid structures and logic, the architects found impossible planes that they unfolded into fantastic structures.
>
> (Cantley 2011: 41)

Deconstructivism – as Tschumi's 'style' was named in retrospect – would explore film techniques of image-production even further, simultaneously tuning to Debordian methods of critique (détournement), as well as Derridian ones (deconstruction) in analysis. They followed in the footsteps of constructivist architects, who implied (a sense of) motion through abstract forms in painting and sculpture, re-employing film theory of montage to engulf traditional techniques of architectural representation with notational methods from other arts. Even as these designs translate purely kinetic/dynamic concepts into drawn form, they never use the actual medium of film in order to achieve their aim. At the time immersion into a variety of art forms permeated the field of architecture, loosening some of its rigour. All this was happening, when computers were still a novelty. Let us stay a while with the medium of drawing, looking into how CAD and digital processing of images allowed for a breadth of techniques informing digital and analogue manufacture. These were summed up in a 2013 issue of *Architectural Design*, guest edited by Neil Spiller. The transition might seem like a simple digitalization of a formerly freehand practice, but in fact is far from that – explains one of the contributors to the issue:

> Historically, the architectural drawing was used to describe an object, a known set of conditions and a quantifiable system. This had very little to do with the fluctuation of architectural space. These new works become the semidocumentation of the act of architectural thought and experience, simultaneously voyeur and occupant, the no-longer-passive stare of the intent of the drawing.
>
> (Cantley 2013: 41)

Venturing into digital media, architectural representation acquired a double status of the thing represented and the representation as the thing-in-itself. Examples of true paper architecture were among the constructions that could be envisioned, yet not necessarily built. Compositions of this sort might appear to us as amalgams of diverse modes of presentation. A similar problem to that of constructivist architecture harkens back to the ambiguity residing in abstract forms (Chernikhov, Finsterlin), which can be read due to their framing as architectural texts, and by default spatial constructs. At the same time *hybridrawings* – to borrow the term from Cantley – flinch from delivering the promise of a standardized building, being much more absorbed with scrutinizing its own mode of production. In place of Ledoux's ideal forms comes Cantley's contorted geometries – a relativist take on the axioms of Newtonian universe. Not just an exploration of typologies, or geometries, but vectors and diagonals that constitute the drawing.

Nowadays, with 'cyberspatial' concerns at the helm of progressively dematerializing practice, architecture has already been rendered anew in terms of simulation. Simulation – David Ross Scheer argues – has replaced the critical apparatus underlying activities of representation. Given that we live in an image-permeated culture, it does seem like at the tail end of nearly every enterprise, there was room for nothing less than an overwhelming experience, immersion and impression prospected by imagined spatial constructions. However, why do so many experimental projects deliberately dwell on the transition from analogue to digital; progressing from material to intangible space? With these projects we behold the emergence of a new ontology – the concept of 'uncertain space'. Uncertain, because it is dynamic, prone to metamorphoses. It swiftly adjusts and evolves. As stressed by the author of *The Death of Drawing* (2014), these discrepancies are at the heart of analogue and computer-based approaches to design and representation. In the instance of CG environments accent may be put on visual and immersive sensations, rather than on evaluative approach to image construction.

> Representational design thinking is based on a system of signs and their referents, with the critical space for imagination and play that exists between them. Simulation-based design asserts an identity between the design and the building that forces the imagination to find other spaces for its work.
>
> (Scheer 2014: 15)

And further on, '[a]nother way to view the essence of simulation is that it inverts the relationship between experience and model. Whereas representational models are generalizations of prior experience, a simulation is a model that precedes and determines experience' (2014: 43). In contrast, 'drawing incorporates such spatial experience into design through immense abstraction of reducing spatial

experience to two-dimensional, linear geometric constructions' (2014: 209). Due to a proliferation of representational techniques introduced to the practice throughout the twentieth century, the pre-established codes – genre's rules – have already been bent, if not broken. As architectural concepts turned away from the task of representing spatial constructions that appear as habitable and traversable, for the sake of re-envisioning of graphic forms and visual media productions, they have soon broken this ground even further, which meant a complete dematerialization of depicted forms. Also, it would lead to an inherent conjunction of the represented space (or space of representation, seen as a composition on a plane), with the visual apparatus – the way we perceive drawings, how we reconstruct them mentally, and how our learned knowledge allows us to discern spatial constructs from abstract compositions. This type of architectural projects is less about fantastic buildings, and much more about the way we perceive them. In turn, it allows for building one's own concepts out of the ingested imagery.

Scheer's statement about simulation lacking reflexivity may be a bit far-fetched. It seems that many architects-turned-artists would oppose his allegation as well, negotiating, in their design practices, between analogue and digital forms of visualization. Even though they frequently mix pure simulation modes in which the user is experiencing the structure, they do so with a critical edge, attributed by Scheer to the realm of drawing. Computer-generated forms – even when they appear susceptible to user-friendly augmentation, highlighting assets of efficiency – are a dismantlement of those strategies, not a try-out for their experiential creation; representing representation, as often is the case. Such artists as Pascal Bronner, Perry Kulper, Mark Smout and Laura Allen, Tobias Klein, and Bryan Cantley, in their digital and post-digital projects, investigate permeability of the digital-analogue border, demonstrating sensitivity to the codes involved in both modes of production. They problematize intricacies of the medium employed, along with technique and artist's style as message-carrying aspects of their designs.[9] From there they progress even further, addressing the technique of representation in subject and form of their drawings; alternatively, films and animations. 'Drawing itself can become a tool for revealing conventions for what they are: a set of often unacknowledged assumptions that embed ideas in design, making them seem natural and inevitable when in fact they channel thinking in certain directions' (Scheer 2014: 87). These architects operate on the fabric of architectural drawing, understood here as a historical convention – a pre-established system of signs and mode of communication. Precisely by contesting a number of their axioms, not unlike abstract/spatial reading of compositions, they put forward new morphologies and critically reassert an expanded array of interpretative strategies. Many of them operate quite explicitly within the work's context, just like literary texts, or art movements/

traditions to which they refer. This has been summarized by Cantley of Form:uLA Dimension Laboratory in an interview given to Corrado Curti (2010):

> The dynamics of change … even the dynamics of daily navigation … are the subject of these new diagramming explorations. I'm trying to codify an entity that refuses classification, or at least refuses to be placed within permanent boundaries. If architecture can become elastic in its notions [with or without its actual construction becoming so], then I think there are new territories for understanding how the word 'function' is thrown about, and therefore new territories of architectural experimentation.
>
> (Curti 2010)

This new generation of architects – with Cantley among its more audacious representatives – has reached high dexterity, having mastered computer-based design to the extent of refusing to be fooled by its promise of instant problem solving. Just as well it could be an end unto itself. Developing hybrid techniques would take advantage of digital post-processing, while maintaining an 'analogue' stance in drawing, model-making, and artistic idiosyncrasies that could be smoothed out in a polygon-based environment. Architects coming from Cantley's generation critically approach the tools they employ, as well as adopted modes of representation. Just as with their Piranesian predecessors, this line of artistic research under the auspices of the discipline also appears detached from any need for actual building to be eventually realized via a commercial commission. As if returning to the 1980s, we are looking at a generation (Marjan Colletti, Tobias Klein), which experiments and explores new morphologies. One that – only at a later stage – 'narrows down' their array of potential incarnations, facing the question of materialization as a choice of medium: painting, sculpture, installation, or software. The representation as the thing-in-itself.

In the post-digital age we are experiencing a reversal of former values, hierarchies, and categories. Design software enables the user to create multiple versions of the same project. To compose and decompose it into layers. Storing a particular version in memory, in favour of a different one. In the past this process of selection and optimization of an idea, developing it into proper design, would have been resolved at a preliminary stage (sketching) by necessity. At the time of creating the final draft, preliminary ideas would be but a vague memory. In his drawings Cantley uses multiple methods of representation, from 2D plans and sections to 3D exploded views, often juxtaposing them in a shamble of lines imposed multiple times one over another. He favours the diagrammatic convention, which serves him as spatial layout for alternatives and variations on the project. As Cantley recounts in an interview for the journal *Cluster*, in his hands,

FIGURE 3.5: Bryan Cantley (Form:uLA), *TypoGraph No. 2*, 2011. Ink in sketchbook. Courtesy of Bryan Cantley.

'the diagram becomes a tool to make a number of possible architectural objects collapse into a single representation' (Curti 2010). What he strives for is thus a sense of polymorphy, denoting architectural object's existence as a potentiality, not actuality. If we were to come up with a visual metaphor that could illustrate the philosophy behind this approach, we should imagine multiple exposures, one overlaying the other. Each one is accessible and immutable, even though they adhere to each other at any given time, forming a homogenous organism. Cantley condensed this idea, encapsulating it in the concept of the 'dirty drawing', which denotes an unfinished state imbuing the content. It does not aim at representing singular objects, but allows for 'predicting drawings of drawings'.

Instances of operational drawings, as if taken from a DIY enthusiast's handbook, are also to be found in the works of Marjan Colletti. And they do not get any closer to exemplifying how 'proper architecture' should look like than Cantley's specimens. In his designs Colletti explores the notion of fractalized dimensions, concurrently 2.5D and 3.5D space, although employing the notation of '&1/2' to differentiate it from semi-immersive Vfx, so eagerly making their way from cinema's 'big screen' to architectural presentations. 'I decided for the term 2&1/2D rather than 2,5D for various reasons; the main being that I wanted to make

sure that we are looking at an augmented 2D domain, not a truncated, muti-lated 3D space' (Saunders and Colletti n.d.). This hypothetical space is implied by mathematics (and technology), though impossible to experience in real life. Unless we apply to it the dictum of cyberspace, and that of digital images, which stratify our perception, 'projecting it' onto the built environment. With architecture opening up to all these new phenomena Colletti's 'open theory of design-research in architecture' renders architectural creations – be they 'drawings', or instances of project's documentation, even actual buildings – potential 'candidates' to dive into the gene pool of 'cultural productions', with an emphasis on the artefact's indeterminate, material/immaterial state such term implies. As cultural productions, they can retain an autonomous status. This is not unlike preserving the architectural idea in 'suspended animation', before it becomes concretized in one among many forms of embodiment – architectural being optional, yet not obligatory. Colletti remarks, that

> all digital drawings are per se metaproductions, expressions and mediations of a non-reproducible original, which in its digitality dwells beyond the realm of *Technik*. What this means is that 2&1/2D and 3&1/2D metareproduce not images or thing, but whole worlds of poetic phenomena.
>
> (Colletti 2013: 200)

Such premises do not relegate designs into the realm of the unbuilt. Rather, it is their ambiguous, abstract character that predestines them to bear the tag of 'speculative' – not actual – productions. Computer-aided design introduced algorithms that allow to render most daring forms in virtual, 3D space. Architects, who tap that potential, are also prone to translating supposedly flat figures, or compositions seemingly unrelated to architectural productions, into spatial forms.

A number of speculative projects takes advantage of this predetermined assumption, which makes us read any architectural drawing as a representation of architectural object, searching for indications of spatiality, relations which can be mapped out in plan or section, even when apparently there are none. Tobias Klein is one of the chief artists, who exploit this bewilderment at its most daring, by combining visual data taken from diverse and rather unrelated sources. In his *Contoured Embodiment* (2009; materials: 3D print [selective laser sintering], water colour paper [laser cut], mirror), we see, in 3D, a scanned representation of a cathedral interior occupied by a human heart (acquired by an MRI scan). This is a 3D-printed sculpture, although first it had to go through the 'birth canal' of digital drawing composed out of heterogeneous images. The resultant form is a spatial collage, which never masks any incongruities between its source materials. It is a seamless amalgam of two insides, the LIDAR-scanned interior of Christopher

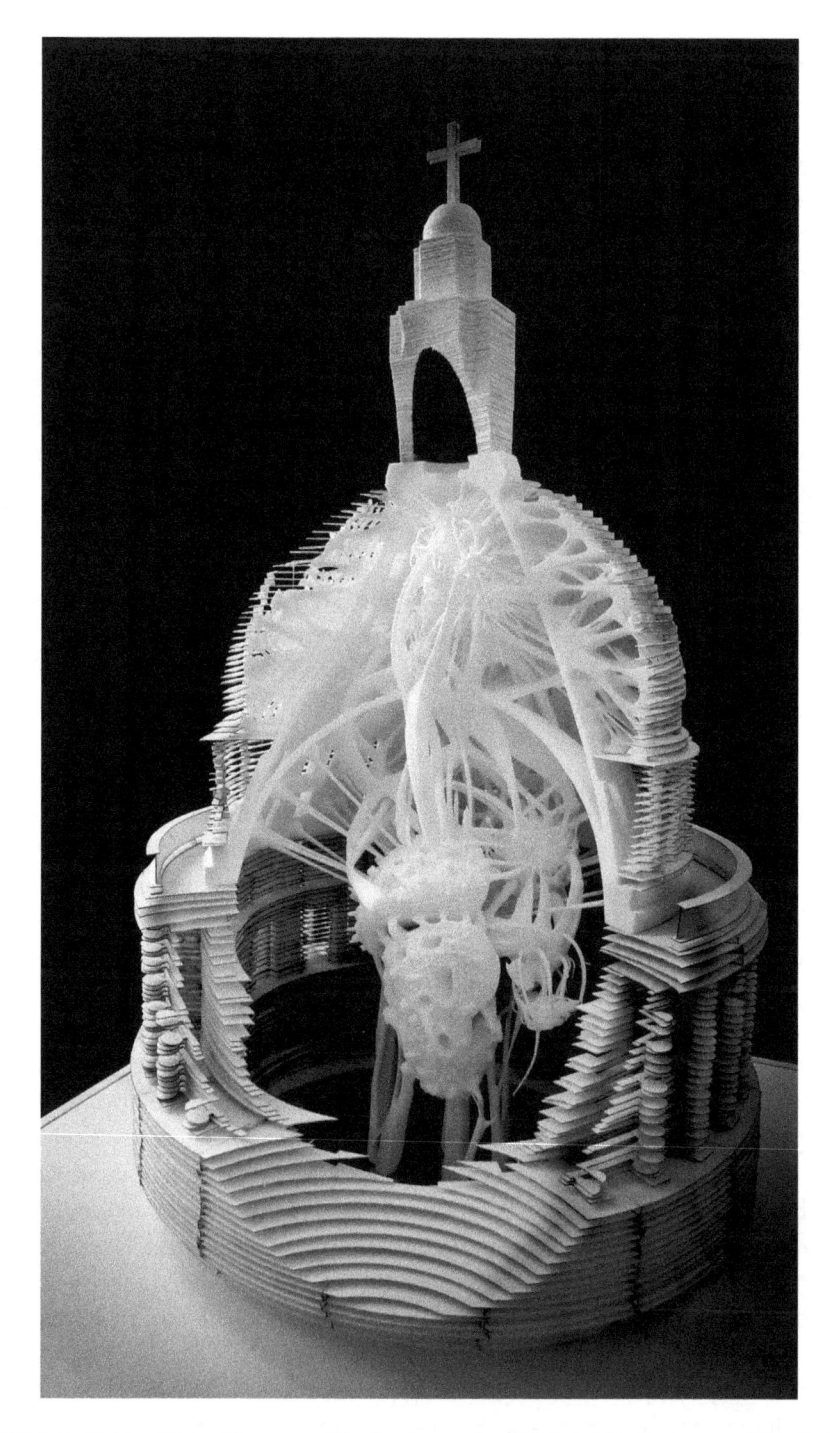

FIGURE 3.6: Tobias Klein, *Contoured Embodiment* [outside], 2008. Courtesy of Studio Tobias Klein. Photograph © Ute Klein.

Wren's St Paul's Cathedral, and an enlarged cavity of Klein's own chest, superimposed on each other, as if the architect intended to update the style of high baroque with a biomorphic rendition of the pericardium connected to an architectural surrounding with viscid tissues. Oblivious of scale, material, and source, the architect manipulates 'his' images, employing imagery as the sole building material.

Conclusion

When provided with a scrutinous insight, we will find a dash of algorithm-aided improvisations in the area of new drawing practices, too. Cantley, like Colletti, takes full advantage of user – computer interactivity, involving (intelligent) feedback from the latter. It is like responding to drawn lines by generating shapes. Unlike drawing, which either succumbs paper to hand's pressure, the graphic software's environment is responsive, and can feed back in pre-programmed ways to any of the decisions made by the designer, who invents circumstances for its occurrence. He defines principles and restrictions for this improvised dialogue with the drawing. What is actually being transgressed in this instance, is the definitive determination of the output medium. 'A research project can start as a morphological experiment, continue as 1:1 installation, become a design studio brief, express itself as an article and end up as a book' (Colletti 2013: 8). Aside from preference for creating hybrid drawings, all of the aforementioned architects acknowledge multiplicity in terms of design ideation, championing indeterminacy of a processed conceptual sketch, instead of narrowing down the range of possibilities straight away, and formalizing their thought process on paper. Drawing, in their dictionary, is used as a transitive verb; a 'layby' with enough space to contain all iterations of an idea under scrutiny. In each of the cases presented in the chapter the author couples representation with simulation in order to generate a design that is experimental, unbuildable, or inviable to build. The product – often still suspended in the act of virtual embodiment, a work-in-(permanent)-progress – should not be taken at face value. Instead, we need to consider it as a support for reflection on the issues of digitized environments, utilized in the process of form-making, and the space of simulated reality.

With its reflection on the modes of architectural ideation and self-reflexivity in (what is to be regarded as) the transitive stage between digital and analogue drawing, Klein, Colletti, and Cantley touch upon distinct qualities of architectural works and projects, that are impossible to represent with traditional means. As is the case of *Contoured Embodiment*, or Cantley's *Dirty Geometries + Mechanical Imperfections* (2014), such qualities would have been difficult even to arrive at in a process of conceptual abstraction, without the aid of technology. Consider

FIGURE 3.7: Tobias Klein, *Contoured Embodiment* [interior/cutaway], 2008. Courtesy of Studio Tobias Klein. Photograph © Ute Klein.

Cantley's *Hybridrawings* on Digital Paper as a bundle of multi-layered potentialities, or, respectively, Colletti's attempts to rival the notion of integer-based dimensionality in relation to either 2D drawings or 3D simulations, and Klein's contestations of scale and provenance as determinative factors in the process of architectural ideation. Each of these graphic peregrinations is representative of an unprecedented morphogenetic methodology, which engages dynamic qualities formerly inaccessible to paper-based representations. Cinema, though hardly on the final frontier (with the contemporary abundance of hybrid media), definitely shares multiple strategies with these explorations, especially when engaging with architecture through theories of montage, cinematography, and image-processing. Movement, after all, has primarily been regarded as the filmmakers' domain.

4

Inscription Deconstructed by Means of Cinematography

(Call:) Replacement part needed. (Response:) Will dispatch ASAP. *Sent from my iTrilithon* – signature said. 'The meaning of Stonehenge in Tralfamadorian, when viewed from above, is: "Replacement part being rushed with all possible speed." Stonehenge wasn't the only message old Salo had received' (Vonnegut 2009: 276). What is the meaning behind this cryptographic game of beads? And who is Salo, anyway? An interstellar traveller robot, one of the characters in Kurt Vonnegut Jr.'s *The Sirens of Titan* (1959), having crashed in our solar system about two hundred millennia ago, apparently he has just received a service message sent to him from Earth. Message regarding the broken part was conveyed by means of the most durable of man-made works, namely, architectural edifices. Large enough to be visible from space. This one-way transmission is as old as the planet itself. Given the turbulent history of past civilisations' rise and fall, there must have been nearly as many errors as there were actual information relayed. From his vantage point in the solar system, Salo was able to observe both – glorious built achievements, as well as half-realized attempts at sending an intelligible 'SMS'. And thus,

> [o]ld Salo had watched many communications failures on Earth. Civilizations would start to bloom on Earth, and the participants would start to build tremendous structures that were obviously to be messages in Tralfamadorian – and then the civilizations would poop out without having finished the messages.
>
> (Vonnegut 2009: 278)

Let us assume that history of architecture is one such act of communication. Now that we got UNESCO World Heritage Sites out of the way, we should inquire about what happened to all the 'corrupted texts' and 'working copies' that had stuck in the outbox folder?

Recognizing patterns

When network operators of urban planning came to be replaced by real estate developers, Salo's mailbox started to fill up with junk mail. But there is much to be learned from corrupt messages which delineate a heroic chapter in architecture's alternative history, belonging to experimental and speculative proposals, remodelling the landscape once again. Though not in the way post-war reconstruction projects did, as these simply reimagined the past, underwritten at this point with International Style buildings, Functionalist urban grids and 'habitation units'. The experimentalists' projects went against the grain of the Athens Charter, overlaying cities with vertical frameworks, infinitely expanding 3D grids and networks supposedly suspended in thin air. The late 1950s saw an emergence of multiple, usually multi-layered models meant to resolve problems of traffic congestion, densification of cities and chaotic sprawl, while somewhat diverting the course of urban transformation, at the time developed by vectors of the supermarket, suburb and freeway.[1] It was indisputable that motorization had reshaped the appearance of modern cities to the furthest degree, imposed by force unto structures too cluttered to negotiate a middle ground for pedestrians and vehicles. Utopists, who responded to this urban crisis, took aim at entire systems of interrelationships, which are characteristic of a contemporary, complex view of the city. They counteracted with designs more akin to Sant'Elia's conjoined systems of architectural programmes, working together like an enclosed thermodynamic system, rather than 'restoring' order with the reinforcements of Expressionist 'city crowns', standing as axes for an emerging whirl of urbanity. The ongoing conversation revolved around superstructures. Had they ever been realized, their appearance would resemble a large LCD display with an RSS feed, notifying Salo of the status of his order. In 'all caps'. Conceived as spatial resolutions to urbanism's ails, they were to remain unbuilt and unbuildable. A decade later the genre fell into its nightmarish caricature, delineated by programmatic freedom and prosperity that the superstructures were meant to implement. Remember that Constant's *New Babylon*, as a project, came to an end with 1970s countercultural disillusionment (even though the painter-architect would revisit it in his final years), sealed off by a genuinely Ballardian imagination surfacing in artist's paintings. There was bloodshed erupting in the 'streets' of the *Gelle Sector* (*Yellow Sector*).

And yet, *New Babylon*'s 'architectural situationism' could be regarded as model among similar endeavours, collected and described by Larry Busbea in his *Topologies: The Urban Utopia in France, 1960–1970* (2012), Neil Spiller in *Visionary Architecture: Blueprints of the Modern Imagination* (2007) and by Alison Sky and Michelle Stone in *Unbuilt America: Forgotten Architecture in the United States from Thomas Jefferson to the Space Age* (1977), among a limited number of other

accounts (most notably, Neil Bingham's *100 Years of Architectural Drawing 1900–2000* [2013] and Ernest E. Burden's *Visionary Architecture: Unbuilt Works of the Imagination* [2000]). The most interesting post-war incarnations of such pursuits come from specific groups associated with the academia and gaining their voice in the 1960s, including: the United Kingdom's Archigram, Italy's Superstudio and Archizoom, French avant-garde groups such as Equipe Miasto, Michel Ragon's Groupe International d'Architecture Prospective and Architecture Principe comprising of Claude Parent and Paul Virilio. No less intriguing were projects by the Metabolists (Japan: Kiyonori Kikutake, Kisho Kurokawa, Fumihiko Maki) and the Austrian radicals (Walter Pichler, Raimund Abraham, Hans Hollein, Günther Domenig), along with singular 'acolytes and satellites'. The acolytes circled the world giving lectures on engineered habitats (Buckminster Fuller), while the satellites preferred a desert retreat, where they could put their models for bottom-up organization scheme for new societies to the test (Paolo Soleri), conducting social and urban experiments. In essence,

> the 1960s saw a generation of architects – the Metabolists in Japan, Archigram in London, and loosely affiliated radicals in Italy and Austria – in open revolt against the values held by the modern establishment. Tellingly, their stinging critiques of postwar architecture and urbanism, and the visionary pre-war foundations that preceded them, did not extend to modernism's embrace of the heroic scale of modern engineering.
>
> (Riley 2002: 12)

However, in *The Changing of the Avant-Garde: Visionary Architectural Drawings* (2002), published by the Howard Gilman Collection, Sarah Deyong draws a systematic borderline between the optimism of the early 1950s and the late 1960s' ironic, or even cynical, stance (2002: 24). Those early proposals seemed to echo Modernism in the righteous ubiquitousness and scale of their spatial solutions (at once domestic and global). The critical stance of the latter, disillusioned ones matched the level of the former's enthusiasm only in terms of its ferventness. The projects labelled 'paper architecture' are usually closely interrelated. Mikhail Bakhtin's concept of dialogism best describes the relationship between subsequent proposals, their heirs and ancestors. This way it is logical to interpret them as arguments in an ongoing debate. What we are speaking of is a strictly limited discussion group, comprising of students and their teachers in the likes of Michael Webb, Peter Cook, Raimund Abraham or Neil Spiller; also, often centred around institutions, like Lebbeus Woods and Olive Brown's Research Institute for Experimental Architecture (RIEA),[2] which launched a publishing group specifically dedicated to experimental, highly theoretical works of architecture. None of their books resembles a typical collection of architectural designs. Rather, they are illustrated

essays that support a philosophical stance. Mutual appreciation does not exclude substantial criticism, which acts as an evolutionary mechanism for this tradition, forcing later generations to expand into new territories, inspecting technological innovations of the time. High awareness of the medium of representation is displayed here as well, along with a proficiency in incorporating 'languages' from outside disciplines. We can recognize influences of Salvador Dalí in Woods's *High Houses* (1993) or traces of Francis Picabia (an interest shared with his frequent collaborator, Vaughan Oliver) in Spiller's *Island of Communicating Vessels* (2000– ongoing). Aside from dialogism the forms taken up by such proposals reflect contemporary areas of knowledge and science. Since Piranesi fantastic architecture had been absorbing techniques and styles from painting and theatre set design, but not until the twentieth century had the practice fully grasped a wide array of artistic phenomena, including fashion, film, sculpture, performance, installation and video art. Social and cultural developments, coupled with technological advancements, were seen as *terrain vague*. Waiting to be reclaimed. For example, new discoveries often served as form-giving models, that is, Francis Crick and James Watson's discovery of the double helix structure of DNA acted as structural 'parent' to Kisho Kurokawa's *Helix City* (also inspiring architects like Chanéac or Peter Cook in their search for modular megastructures/polyvalent cells) or the emerging cybernetic models and electronic circuitry, echoed in Cedric Price's *Fun Palace* (1964), as well as in Gordon Pask's architecture-generating software.

Those projects' common denominator reaches beyond their megastructural shape, defining their drive towards a complex view on the interrelationships between use, living and built environment.[3] Visual props become a matrix, meant to act as a working model for city/environment/building, coalescing these flows and making sense of the chaos of urban living. Unlike finished constructions those that never were built urge viewers to imaginatively 'activate' them, envisioning their existence and each structure's performance in actual spaces. If the utopian proposals of Yona Friedman, Michel Ragon or Iannis Xenakis operate this way, helping us to imagine alternative modes of habitation along with a perspective on society, then the 'counter-cultural' revolt of Arata Isozaki's *Re-ruined Hiroshima* (1968) or Archizoom's *No-Stop City* (1969) draws our attention to contradictions, abuses in the area of total(istic) visions, while probing limits of architectural interventions by providing a working model that simulates these aspects.

Unlike overtly inanimate utopian accounts their dystopian successors display an inherent dynamics in terms of critical vision, trying to encapsulate in visual form the intangible aspects of architectural spaces. Regardless of whether we conjure up the anxiety caused by the threat of a mutually assured destruction scenario (1960s) or the angst in relation to a vision of subordinating all spheres of social life to consumerist values targeted in the projects of Archigram, when expressed in

architectural form, such sociocultural contexts transform the projects into philosophical inquiries into built environment. Film productions of the group Factory Fifteen can be regarded as heirs to utopian/dystopian interests of the 1960s. They were compared by Dan Tassell – a member of the Bartlett's "Unit 15: Film" course – to ' "visual essays" [...]. They're not straight up predictions but more explorations, a journey into uncharted realms' (Holmes 2011). Architecture on paper takes on the form of a visual essay on contemporary issues, and frequently engages with artistic methods and techniques, to represent more elusive ideas. Activating critical awareness in the viewer facilitates solving spatial conundrums. The space of representation is not only a plane composed of signifiers denoting hypothetical material objects. It is also meant to encompass social, cultural and political spaces, along with a range of problems implied by them, transposed to visionary architectural environments.

Categories of the unbuilt/architecture as media

In *Unbuilt America* Alison Sky and Michelle Stone exhume unmade constructions prospected for realization in the United States of America, with a repertoire spanning the past two centuries (although the book was written in 1977), explaining their provenance, thus further exploring the concept of unbuilt and unbuildable works. Their creators have often been 'rejected because they did not build, they were labelled as eccentrics or incompetent because they were involved with philosophical statements which either fell out of favour or never caught on' (Sky and Stone 1976: viii). At least few categories of the unbuilt are to be distinguished here, following Sky and Stone's study, varying in their purpose, context, which brought them about, scale, not to mention any of the more pressing questions, like those whether the projects were at all intended by their authors to be built. Remaining in the form of purely graphic and theoretical endeavours, they can be evaluated on the basis of being: (a) unsuccessful entries in competitions, (b) not carried out as planned, and (c) proposals that were not really intended by their instigator to be realized. Student exercises and artistic provocations would also be included in that last category. Not of interest to this research but also included in Sky and Stone's book are those projects which were never completed due to a variety of circumstances, together with the architect's or client's death (1976: 2). An afterlife of speculative projects was virtually non-existent without a publishing platform.[4] There used to be little interest in architectural works, which never made it beyond visualization stage. When studying architectural works by two of the early twentieth century's prominent architectural figures, Beatriz Colomina characterized the mutual dependence of medium and text, along with mass media discourse which had germinated around it.

The *symmetry* between [Ludwig] Hoffmann and [Adolf] Loos interests me because it points to the theme of how the press – the architectural magazines – invented a means of *producing* architecture with words, drawings, and photographs; as well as to the consequences that this could have in a profession that is structurally linked to permanent things and materials of substance.

(Colomina 1998: 42, original emphasis)

The post-war years saw a surge of novel distribution platforms. First with television and later on with the World Wide Web, an even greater proliferation was to come about. Concerning circulation of such products, an already well-established practice of publishing in architectural journals was pursued in the first place, thanks to the prominence of architectural photographers. Despite such luminaries as Le Corbusier and Adolf Loos (Colomina 1998: 43, 47, 73, 181, 213), whose works and visual documentation thereof came to be widely reproduced, many of the emerging practices were still seen as unprecedented.[5] Architectural representations – blueprints, plans, drawings, as both sketches and renderings – were being introduced into art gallery spaces, although without much haste. In 1960, Arthur Drexler curated an exhibition entitled *Visionary Architecture*, collecting over thirty forsaken architectural projects deemed 'too visionary to be built'. As the brief indicated, 'true visionary project usually combines a criticism of society with a strong personal preference for certain forms' (*Visionary Architecture*). Drexler grouped the projects he had gathered into categories. Some 'spoke' the language of ideal geometries, whole others resembled mountains, due to their predilection to natural forms. A vast majority of the prospects were intended as aids to the crises of the (post)modern metropolis, uncontrollably scattered into archipelagos of urban fragments. Such proposals would include Kiyonori Kikutake's *Marine City* of 1959, harnessing overpopulation by creating artificial islands or floating cities fit for habitation or Buckminster Fuller's blueprint for a huge *Dome over Manhattan* (1960, with Shoji Sadao) that would protect it from radioactive fallout just as fiercely, as it would from the whims of the weather. Among the exhibits one could fish out film memorabilia, such as the stage set from Vincent Korda's *Things to Come* (1936), this way blurring distinctions between projects intended as architecture and those 'formatted' for cinematic screens. Some, such as Frank Lloyd Wright's *Mile High Illinois Tower* (1956), would eventually come close to being realized,[6] as we might assume by the looks of present-day Burj Khalifa in Dubai, which pigeonholes Wright's proposals as a case of the temporarily mismatched due to material constraints of day and age. With the *New York Times* calling the exhibition 'the second most important show at the MoMA' after Modern Architecture in 1932,[7] the fate of architectural documentation seems to have been sealed, taking this line of production out of the shadows and creating for them a

viable outlet.[8] The emergence of this novel art market wooed private collectors, such as Howard Gilman, whose 'emissaries' would search for interesting unbuilt projects crammed at the bottom of architects' drawers, stocked in private archives or already residing in dustbins. As Pierre Apraxine – the collection's curator, between 1975 and 2000, after it was passed down to MoMA – recounts, many of the architects whom he had approached, instead of being reluctant to let go of their 'unlucky' projects, seemed surprised that anybody expressed any interest in them.

CIAM

Critical projects of the likes of Archizoom's *No-Stop City* deliberately presented

> [a]n extreme vision of industrial civilization as the producer of a decorative-repetitive, and horizontal system, and one thus devoid of cathedrals. A system based on the repetition of signs, at once diffuse and fluid, within which architecture and nature, like so many exceptions and incidents, dissolved and disappeared into the amniotic space of metropolises.
>
> (Branzi 2006: 150)

Along with the prevailing and ill-executed scheme of Unité d'Habitation, modern movement seemed to have successfully exerted its influence over the city by means of a tessellating frame.

> The grid was preferred over more complex types of planimetric organizations (radial, concentric, diagonal), because right-angled buildings were cheaper, faster, and easier to construct. [...] The difficulty in identifying the center of a grid has promoted a notion of nonhierarchical, repetitive spatial structures.
>
> (Trancik 1986: 35)

General criticism of the functionalist principles espousing grid as its flagship symbol of imposed uniformity came not only from Team 10 but also from the side of: the Rationalist concepts of Léon Krier, opposing the 'symbolic emptiness' of that style, Robert Venturi's attack on modernist architecture's supercilious independence (frequently mistaken for contextual autism) and Colin Rowe, who called upon stylistic diversity in terms of urban fabric to counterbalance modernism's monotheism (1986: 35–37).

Many projects envisioning future in the shape of a megastructure would rival CIAM's planning hegemony with mockery, or radical, literally 'larger than life', adjustment of total planning to contemporary needs. They pointed out disparities

between the Athens Charter and actual post-war reality, showing that neither one of historical cities functioned on the basis of a strict separation of its circulation into defined zones. Letizia Modena, when analysing Italo Calvino's writings concerning urbanism and architecture, reflected those utopists' preoccupation with 're-writing' the city, creating a kind of visual palimpsest, instead of raising it to the ground and starting anew, as projects in the vein of Le Corbusier's *Ville Radieuse* most likely would have done. Because of this it is barely surprising that collage and photomontage, both usually complemented with drawings, were among the most popular forms of expression available to paper architects.

> Voices of this urbanistic vanguard responded to this crisis by exploring form *in potentia* of what they called the *spatial city*: urban hypotheses born of the interplay of principles of atomism (lightness and its derivative mobility and combinatory capacity), on which Calvino's *Invisible Cities* was to rely heavily, as visual stimuli and as structural characteristics. Visionary architects and urban planners envisioned future cities that might counter the heaviness and chaotic asphyxiation of the building surface through the most radical and visionary of solutions: *freeing the earth's surface from* the city by shifting the latter's physical mass onto a vertical axis, whether straight up or straight down. The design projects of spatial urbanism placed buildings, rooms, and thoroughfares aloft on highly elevated support structures while they often lowered warehouses and other large buildings to underground spaces.
>
> (Modena 2011: 143, original emphasis)

The city would be hidden away – either in clouds or underground – whereas in its place social contracts and cultural interchanges came to the fore, animating otherwise concrete settings. Compressing the urban fabric into a homogeneous, ordered structure with clear boundaries, not the monster that, on its own accord, descends into radial sprawl. One of possible scenarios exercised by utopian megastructures would involve a complete dematerialization, leaving nothing but a framework for daily activities, thus devising a space for 'scripted' events. Plain architectural surface that could be seen in Superstudio's *supersurface* collages; alternatively, a setting for human actions or – if taken down to micro scale – a spacesuit (a wearable environment or inflatable carry-on). Architecture envisioned this way was supposed to reflect contemporary discourse of mobility and acceleration of information exchange. By putting the city away from view, the accent would fall on the type of architecture that – just like an object of art – dissolves into thin air, remains elusive. One that could not be narrowed down to an artefact or a commodity to obtain. Alas, this is precisely what happened in the aftermath. The trophies most treasured are probably those which show architectural images that battle consumerist culture with the greatest zeal.

Exhibitions

At the time multiple other exhibitions around the world drew attention to intangible aspects of space and architectural production, paving the way for ascending generations of architects to invade the scene. Central advantage of the ones like *This Is Tomorrow* (1956), organized by the Independent Group, *Growth and Form* (1951), held at the Institute of Contemporary Arts in London, or Archigram's *Living City* (1963) is that each of them acquainted architectural students with emergent areas of potential research, ranging from marine biology, genetics, pop culture, even science fiction (android Maria from *Metropolis* greeted visitors at the Archigram show). Having achieved this with reproduced images facilitated the conceptual collation of outer space with inner space. Each seemed like a new frontier for architects. Neil Spiller hinted at the groundbreaking character of these shows, as they saturated new generations primarily through imagery and models of visionary architectural works, even if mainly encoded in suggestive, atmospheric drawings:

> The [Growth and Form] exhibition was also innovative because of its multimedia presentation. It included cine clips, photomicrographs, radiograms and much else. It illustrated the myriad ways people had developed to explore and record images of biological form. In effect it was a dictionary of scientific visual prostheses. Many established critics' feathers were ruffled, but the show did start to set the young ICA members apart from their more formal, older colleagues.
>
> (2007: 60)

Visualization aids, often seen as disposables produced during a wide range of processes – from frequency charts to mathematical modelling of complex systems' behaviour – can serve as a probe for designers. 'The established codes of the representation of architecture – plans, sections, elevations and the cyclopean perspective – are also notations of spatial repression. Film scripts, story boards and choreography provide other ways to describe architectural events' (2007: 126). Thus, turning to outside media, and adapting them for architectural representation, has in itself been an act of protest, privileging previously overlooked aspects of architectural imaging over the already established reputation of blueprints. Groups like Archigram employed iconic, mass culture imagery not just for establishing a connection with a younger audience or obtaining new clients by appearing 'hip'.

> Archigram defied all closures, preferring a dialectical relationship between its mutable designs and its elastic ideology. *Archigram* magazine clipped together news items, advertisements, technical releases, and architectural history into

new architectural assemblies. This was Archigram's supermodernist aesthetic *and* its avant-garde ethic: to promote a world of perpetual becoming. Endless permutations of existing forms or extreme outcomes for established methods were to be discovered.

(Sadler 2005: 47, original emphasis)

Pop iconography has been mass-produced and distributed through magazines, movies, television and other media, which would soon conquer city space. In the hands of Archigram they were turning into a language of their own – one that directly addressed contemporary problems of the *polis* – commercialism, media discourse, increasing dependence on technology, heightened mobility and nomadic modes of habitation (with the emergence of counterculture).

Through the production and dissemination of imagery, the Archigram enterprise formulated an architectural vocabulary and shaped the visual output for what are now commonplace tools in the practice of design. The functioning of the publication sought to do away with the division between what was architecture and what was not – from theoretical propositions to consumer products.

(Steiner 2009: 3–4)

In order to catch up with the world at large, it was necessary to incorporate current issues and aesthetics into design. But technological prostheses, which had allowed for this mediated vision of the future to surface, proliferated by means of the same distribution channel, passing out images deriving from microbiology, genetics, astronomy and cybernetics. If discoveries in aforementioned fields of science were considered 'game changers', they were likely to not only affect the design of our environments but redefine our understanding of them. Here visionary architectural projects took after science-fiction novels, speculating about far-reaching consequences of the application of given technologies, instead of adapting to the initial stages of their implementation.

Iconic imagery ...

Through such endeavours as modular superstructures, whose instantly recognizable image acted as both *signifiant* and *signifié* – to use Ferdinand de Saussure's distinction – iconicity has been established as the prime field of study for media-related humanities. Designers were welcome as visitors as well, assuming they approach architecture as a system of signs, recognizing visual production as an unrestrained area of its deployment. Obviously, the array of potential buildings-forms possible

of being constructed in this language is much larger than the area of viable and sustainable 'sentences' that can subsist as real-life buildings. However, certain architects preferred to explore precisely this uncertain ground of visual arts, texts, analysing semiotic relationships between images, texts and buildings. The disparity between unbuilt projects and those which are inherently unbuildable, like the vast superstructural bodies of *Spatial City*, *New Babylon* or *Continuous Monument*, inclines one's reading of the latter to proceed in purely iconic terms. These could take the form of evocative images, ripe with outside references, while also symbolic of debates on meta-architectural production. In this case both areas of reference are valid – the history of city-scale utopias as communicated through paper architecture projects, as well as the general discourse on urban planning prevailing at the time.

Applying such distinctions to actual buildings spawned multiple theories and interpretations presented in such studies as Robert Venturi's (co-written with Denise Scott Brown and George Izenour) *Learning from Las Vegas*. A different treatment of the subject of iconicity is attributed to Bernard Tschumi and his notation technique, namely cinegrams, in which still images sourced from various films are taken not so much for what they represent but for how they present it and thus are read as abstract diagrams of movement. Consequently they inform spatial arrangements, ground plans and choreographies. Speculative drawings are thus means to translate extrinsic forms cited from natural sciences, cinema or mechanics, while being presented as spatial constructs in prospected settings. Capitalist mass production, especially from the twentieth century's latter half and onwards, came to rely primarily on visual imagery through which such products are advertised. Regarding television as the central distribution channel, images sourced from previously inaccessible areas, be they microorganisms recorded by electronic microscope or photographs relayed by space probes, allowed researchers from different fields to gain access to a new territory, primarily through visual representation, which served as common ground or – at least – an adapter.

Back in the 1950s and 1960s spatial urbanists[9] were united in their search for an iconography that would encapsulate their ideas about unprecedented modes of habitation and infrastructural arrangements in cities. At the heart of these form-finding graphic experiments was an interest in inscribing iconic structures with immanent dynamics of active participation from users, co-opting them before inhabitation to participate in the design process and allowing them for any subsequent transformations of space. These ideas are already present in Yona Friedman's *Manifesto de l'Architecture Mobile* of 1956, echoed by the philosophy behind *New Babylon*, Chanéac's *Cellules polyvalentes* or even Paolo Soleri's *Arcologies*, not to mention Buckminster Fuller's designs which somewhat instigated the movement. Some of those designs made bold attempts at incorporating automobiles

into building's tectonics. Not only subjugating city planning to blood vessels of highways but turning the car into a mobile part of one's house, capable of reattaching itself to the structure's main body and serving as a battery that powers the building's electrical 'nervous system' (David Greene and Michael Webb's *Drive-In House* [1987–]). Another extreme example is Architecture Principe's plan to redefine urban infrastructure by 'shaking up' its 'plate tectonics'. In Claude Parent and Paul Virilio's project sidewalks are turned into skewed ramps that literally activate pedestrians in their walk around urban space, according to their concept of *The Oblique Function*. A general line of inquiry for such graphic endeavours was aiming at an embedment of greater flexibility into structures. For example, *Cushicles* and *Suitaloons* were destined to be carried around, worn as vests, instead of acting as earth-shaking upthrusts, turning urban districts into mountainsides.

... and anti-design

However, through an autobiographic, second-person narrative placed at the beginning of *Red Is Not a Color* (2012), Tschumi expresses his disappointment with traditional techniques of representation: 'You are aware that architecture uses sophisticated means of notation – elevations, axonometries, perspective views, and so on. But you soon realize that they don't tell you anything about sound, smell, touch, or the movement of bodies through spaces' (2012: 19). In speculative projects the choice of media employed is far from random. Shock value of these proposals can be even more accentuated, treading by contrasting juxtaposition of sources and techniques. In their deluding photorealism Arata Isozaki's and Hans Hollein's paper projects referred to strategies of photomontage in order to situate unlikely constructs in realistic environments. Ron Herron inserted the design for *Walking Cities* into collaged photographs of city skylines. Shared is a predilection for post-apocalyptic settings, lending projects their atmospheric and pessimistic aura. Drawings by Raimund Abraham were always set in grim, faded wastelands, envisioning simple shapes that cut violently into earth and sky. His architecture stood on the outside of time, becoming a set of archetypes for dwelling, standing upon the swathes of radiation-scorched deserts. Irrelevant of whether we look upon his series of 'cities', created in the 1960s (*Compact Cities* [1961–64], *Glacier City* [1964], *Mega Bridges* [1965]), or at his 1970s studies of desolate habitats (*Nine Houses Triptych* [1970–76], *House without Rooms* [1971–74]), the architect's

> long series of drawings [...] shows in a continuous sequence the architectural situation after a new beginning, at the dawn of time, in a barren and exposed landscape

or on other planets. The geographic location of the urban worlds and the subterraneously interconnected houses remain vague.

<div align="right">(Groihofer 2011: 8)</div>

His fellow Austrian, Walter Pichler, used to invent highly geometricized structures bearing rusty, scab-like stains, deviously evocative of mutilated corporeal art works by the Viennese Actionists. This amount of artistic expression was considered a surplus value, diverting attention from concerns regularly addressed in architectural projects. While one line of designs accentuated materiality of their images, along with the medium's attributes, others tried to reconnect to illusionist art strategies, in order to achieve a sense of ambiguity. The latter pursued what Tschumi labelled 'anti-design' – a strategy that is less concerned with form and tellingly more concerned with the operations performed by this conceptual framework.

All in all, a larger part of these proposals operates primarily on imagery, being only remotely 'attached' to concrete spaces. In particular, the projects classified as anti-design in terms of structure call upon tessellating patterns, like a network, grid or matrix, rendering them as visual supports for more established interrelationships:

> In France, the space frame would remain for some time a symbol of the new cultural potentialities of mathematics as applied to architecture; but it was also an antisymbol – the transparent infrastructure whose role was purely passive-aggressive, always ordering and directing yet never being directly perceived. The space thus created was rational and transparent yet simultaneously acted as a social catalyst for ludic activity.

<div align="right">(Busbea 2007: 142)</div>

In the works of M. C. Escher visual ambiguity was a method for activating and engaging the viewer's gaze, making him/her resolve graphic, while at the same time deludingly spatial riddles. Architectural projects conforming to artistic tactics and techniques of representation also move around this class of statements, touching upon both the represented environment and the mode of representation. What projects of the late 1960s did put forward, in comparison with their antecedents from the 1950s, was precisely a critical revision of the notion of iconicity. Structures they gave rise to, such as *The Continuous Monument* or *No-Stop City*, were envisaged in the first place as anti-icons – transparent, reflexive, plain surfaces that instead of appearing invisible deluded their users into thinking they could be rendered as such. In order to achieve their aim, images these artificial environments gave rise to were deterritorializing architecture and urban congestion. Wrapping itself around them, fracturing their order visually, multiplying false

<div align="center">94</div>

images instead of pointing at those rumoured to be real. In order to dematerialize architecture, Superstudio's or Archigram's collages needed to become inscribed with similar ambiguity, an ambiguity epitomized by – as Reyner Banham used to say – 'a whitening skeleton on the dark horizons of our recent past'.

Articulating movement

In line with the dynamics stemming from motorization, (increasingly nomadic) habitation, media and sociocultural interchanges that gradually came to inform architectural graphics, a new psychological working model of memory also had its impact on a range of projects. The Atkinson–Shiffrin three-part multi-storage model (1968) and Pierre Nora's distinction between history and memory as a dynamic process were particularly influential in this regard. A discussion on memory, in relation to city form, emerged in books by Colin Rowe and Fred Koetter (*Collage City*, 1978) and Aldo Rossi (*The Architecture of the City*, 1965), as well as in the projects by these architects (e.g. Rossi's *San Cataldo Cemetery*). Maurice Halbwachs's concept of 'collective memory' (1950) was particularly important to Rossi, who said that

> the city itself is the collective memory of its people, and like memory it is associated with objects and places. The city is the locus of the collective memory. [...] The collective memory participates in the actual transformation of space in the works of the collective, a transformation that is always conditioned by whatever material realities oppose it.
>
> (1982: 130)

From now on the city appeared as a multi-layered fabric of histories, imbued with local memories, as embodied in the tenement houses shying away from the mainstream of glass and concrete. Urban warfare, devastation and 'urbicide'[10] (as experienced in the Balkans in 1980s and during the conflict in former Yugoslavia in 1990s) comprised another set of conflict-related urban issues, involving a discussion on agreed-upon version of history, set against personal accounts and recollections of conflict. Reconstruction processes were also under suspicion, oftentimes seen as antagonistic, primarily to the historic fabric. Similar concerns included 'urban renewal' and other dynamic shifts taking place in city space, addressed successively in metaphoric terms by paper architecture. Memory's problematic status (especially when considering trauma and the process of recall) was addressed through these speculative projects, which can also be regarded as the prime site for introspective accounts in architecture.

In the wake of violent acts, applying tactics of ethnic cleansing to architectural monuments (e.g. secular architecture connected to minority groups living in the city's multi-ethnic fabric) and personal perspectives (Jean-François Lyotard's 'little narratives')[11] became even more significant and could be reconciled with modes of exploration/appropriation of our immediate surroundings and urban space.

> During the early 1980s, three architects (John Hejduk, Lebbeus Woods, Mike Webb) started to imbue architecture with a sense of memory[,] [...] a memory of things past as well as of things that were not to be because of war, life's vicissitudes or simply growing up.
>
> (Spiller 2007: 165)

Private accounts would surface in long-term projects. Accordingly, Michael Webb's *Temple Island* (1987) is a study of space in relation to speed. One that has been revised through memory, although 'filtered' through a relativist dilatation of distance. Lebbeus Woods's research of post-traumatic sites – in turn – has been envisioned through constructs that not only contest geometries of former modernist housing but are reminiscent – as one of the critics wrote – of bullet trajectories, which not so long ago inhabited Sarajevian skies. Can such events be traced onto built form, informing the shape of emerging architecture? When encoded into drawings, they already make stark political statements on the longevity of city form, playing out scenarios in which urban enclaves are pushed to extremes.

One could immediately notice that this polemics is conducted in an inherently visual area of studies on cultural texts. The projects themselves often take advantage of the iconic status of photographs, giving their author a platform upon which to form provocative statements and commentaries on contemporary life. This becomes evident in the way certain projects of the 1960s would comment on political (Claes Oldenburg's *Colossal Monument to Replace the Washington Obelisk*, 1967) and social (Gaetano Pesce's *Church of Solitude*, 1974–77) life. Many of them were site-specific to the point of *not* being realized at specified locations in the United States. Outsiders – Italian 'radicals' alongside Austrian polemicists, predominantly – apparently took great 'pleasure' in building over national sites that have already been built. Tabula rasa politics of the pre-war years in utopian projects returned in the nuclear age, with the force of the seventeenth century's *capriccios* by Salvator Rosa, or the French Renaissance painters of fantastic, 'post-apocalyptic' cityscapes of François de Nomé, or Didier Barra. Their vistas showing ruined antiquities cast long shadows on contemporary productions, emphasizing the latter's fragile nature. It is after them that the American (or rather *Usonian*[12]) urbanity came to be reduced to a template, a postcard view. Kafkaesque site was

formed for exhibiting dystopian visions, yet associated with novel technologies, resilient economy and the vector of civilizational progress. The urge to reimagine this capitalist landscape through extreme architectural 'surgeries' spawned multiple photomontages contemplating the imminent threat of empire's decay, be it New York and Sydney of Tsunehisa Kimura, or Hiroshima 're-ruined' in Arata Isozaki's photocollage (*Re-ruined Hiroshima*, 1968). In Isozaki the operation, from a cognitive point of view, is therefore two-stage, with contemplation serving as an introduction, leading up to the mental rebuilding of the evocative structure portrayed. Aside from emphasizing conflicts and contradictions, both activities focus on circumstantial, event-based aspects of the project, not simply implying an experiential value of architectural productions but capable of generating architectural planning, form, programme. All this came to be noticed even before Bernard Tschumi's *Advertisements for Architecture* (1976–77). The Swiss architect recounts how the

> issues of *notation* became fundamental: if the reading of architecture was to include the events that took place in it, it would be necessary to devise modes of notating such activities. Several modes of notation were invented to supplement the limitations of plans, sections, or axonometrics. Movement notation derived from choreography, and simultaneous scores derived from music notation were elaborated for architectural purposes.
>
> (Tschumi 1996: 147–48, original emphasis)

Events customarily invoke narratives, which order happenings into sequences. Not merely accounts of one's experience of architectural space, but flexible emanations of programme of this sort can be found in Nigel Coates's and Bernard Tschumi's notions of cross-programming. One can interpret this as an attempt to differentiate the emergent 'readings' of architectural spaces from prescribed ones. Tschumi's theoretical projects often touch upon comparable intricacies of reading and attribution, asking whether 'architectural photographs ever include runners, fighters, lovers' (1996: 123), this way suggesting that architecture in use requires this disruption of balance in precisely ordered geometries of buildings.

Tschumi himself disrupts the balance. In this he goes even further than Kimura or Isozaki as the dynamics implied in some photographs (composition) 'contaminate' the very spaces of his designs (content). Afterwards they can be exemplified by three typologies, guided by the ideas of: crossprogramming (harnessing space against its intended use), transprogramming (combining two, usually contradicting programmes, e.g. that of planetarium and a rollercoaster) and disprogramming, where one type of space becomes infested by another (Tschumi 1996: 205). Programmatic concerns can be typecast into these categories. However, what

Tschumi's model actually implies is a closer relationship of settings with chore-ographies of actions performed in them, turning architecture into narrative sequences. He also suggests interpreting our spatial surroundings in a disjunctive mode, which accords with the logic of other architectural theorists/practitioners – most notably Rem Koolhaas (*Delirious New York: A Retroactive Manifesto for Manhattan*, 1978), Colin Rowe and Fred Koetter (*Collage City*), Robert Venturi (*Complexity and Contradiction in Architecture, Learning from Las Vegas*) and fellow deconstructivists to come. Naturally, theoretical foundations call for adequate documentation, especially in the absence of concrete structures. The preferred mode of constructing stark juxtapositions is by having resurrected them along Piranesi's lines, succumbing to his illusion-making techniques, while absorbing new media; especially those already ingested on paper, as encrypted in Tschumi's cinegrams, Koolhaas's spatial montage or Venturi's sequences of stills. Aside from re-presenting, their projects would raise questions about urban circu-lations and flows, programme and its pliability, but above all, they would revisit the protocols behind architectural prospects in order for them to include task per-formance and providing solutions to a variety of occurrences – once-in-a-lifetime scenarios, touching upon politics, ecological concerns, even psychic conditions of the inhabitants.

The contradictions present in graphic collisions and collations of unrelated spaces (post-apocalyptic collages), or kinetic readings of supposedly static con-structs, do not necessarily have to cancel each other out. Speculative architec-tural projects that strive for initiating polemics in unbuildability, rather than simply exhibiting pornography of unbuilt structures, retain complexity due to their employment of strategies deriving from visual arts: ambiguity, optical illu-sion, counterpoint, figurativeness/abstractness dichotomy, intertextuality, atmos-pheric suggestiveness. Therefore, as Tschumi wrote,

> film analogies are convenient, since the world of cinema was the first to introduce discontinuity – a segmented world in which each fragment maintains its own inde-pendence, thereby permitting a multiplicity of combinations. In film, each frame (or photogram) is placed in continuous movement. Inscribing movement through rapid succession of photograms constitutes the cinegram.
>
> (1996: 196–97)

The difference between these and the early-twentieth-century uses of cinema-tography lies not in the modelling of architectural sequences after theories of montage but in recruitment of strategies and techniques deriving from film and incorporating them into the 'dictionary' of methods applicable in architectural representation.

More (is) complexity, less (is) contradiction

Let us now return to the whitening skeleton, returning to a discussion on mega-structures that transgress the 'anti-icon' status ascribed to them. In graphic form they set perspective on complexity sciences, involving thought experiments on dynamic mapping of urban space, still in a roughly inanimate form. In the post-war years – Busbea writes – having witnessed the emergence of 'spatial urbanism',

> [a]rchitects, engineers, and artists began considering space mathematically, aes-thetically, and socially. Space became so important that many designers felt the need to suppress the physical structure of architecture altogether in favour of ambience and movement. But the suppression was only perceptual. The space of spatial urbanism was not the space of void or absence but rather a space pro-jected on the terrain as a structured and structuring entity (even if it was to become invisible).
>
> (2007: 37)

The complex view of urban environment, usually projecting a field of conflicting forces, was conveyed through a myriad of 'found' images, in contrast to original and provocative architectural creations, resulting in an estranging quality of the proposals. These visual props were to highlight the composite character of new perspectives on space, transmitted by means of composited images. Megastruc-tures on paper, projects that most certainly would have been visible from the sur-face of Titan, where Salo was held up, were meant to encompass earth's dispersed urbanities, providing a unified environment wrapped in a purely utopian desire to tame the world or project a new one, devoid of chaos, onto it. These ideals quickly evaporated, leaving their dysfunctional opposites that had been hatching in the decade-long gap bridging Yona Friedman's *Spatial City* (1959) to Superstudio's *The Continuous Monument* (1969).

Moving away from radical urbanism into a far more conventional territory, in his *Architecture of the Jumping Universe* (1995) Charles Jencks recognized how latest scientific discoveries and theoretical models – coming from mathematics (fractals, chaos theory), physics, cybernetics and microbiology – have influenced architects in their designs. New concepts were introduced, focusing the lens on questions of non-linearity, contradiction in systems and a perspective on the world outside, which describes it as locked in a state of dynamic equilibrium. Archi-tecture modelled along these lines would diverge from harmony and symmetry, thus from classic qualities of architectural beauty. They have been superseded by unpredictability, complexity and ambiguity. For Venturi 'complexity represents a psychological and social advance over simplicity, an evolution of culture and

urbanism to cope *with* contradictory problems such as the conflict between the inside and outside pressures on a building' (Jencks 1997: 26), while in

> the work of the British architect Cedric Price [...] the diagrammatic approach replaced any formal apparatus of abstract geometric system with a dynamic representation of flow, force, and resistance; it disputed the aesthetic nature of architectural practice and the conventionality of its compositional practices.
>
> (Riley 2002: 92)

When arguing via architectural representation, while preserving these accounts of complexity, it becomes inevitable for the projects – retaining an entanglement of dialogical oppositions at their base – to search for new means and language codes that help to forward arguments on mobility, flux and transformation, without downgrading any of those factors in the projects themselves, to their arrested 2D spectres.

Architecture has always been a kind of reflection – synecdoche, modelled after the worldview, as it was at a given moment in history. Nowadays this architectural episteme aims at absorbing the properties of dynamic systems and probability theory. Experimental projects reflect upon this desire in an ironic manner, often displaying structures that are literally informed by symbols of this new paradigm, like fractal shapes bearing upon the appearance of 1980s deconstructivist projects. Equally influential was René Thom's Catastrophe Theory, being a study of the instances of sudden 'jumps' occurring in complex systems, when provided with heat/energy/information.[13] As a result, an unforeseen gain in the level of internal organization can be noticed, when systems are pushed out of their equilibrium, having undergone a 'phase transition'. Translating this aspect into architectural form would often spawn such figures as the fold.[14] Sudden twists and wavy lines complicate the building's skin, but not only that. For instance, Coop Himmelb(l)au's *Open House* (1983) could be considered an 'attack' on unity and structure, as well as on house typology in general.

> Organizational depth is one measure of this openness. It is interesting that similar models, or images, have recently been offered as the key to critical value: the lattice, network, labyrinth, and rhizome have become the key images of Post-Modernism, from Umberto Eco's novels to neurobiologists' neural nets.
>
> (Jencks 1997: 76)

This makes the idea of megastructure swerve into areas that incorporate such instant dynamics, bridging the gap between man-made and organic forms. Cheneac's architectural construction kit of *Cellules* (1960–63) were countered

by David Greene's *Living Pod* (1966–67) – a house suited not only for plugging into much vaster networks, but a mobile habitat, propelled by self-regulating machinery. Walking Cities replaced Spatial Cities and, just like some species of small furry mammals outliving dinosaurs, the speculative projects envisioning sustainable, smart, and portable houses (Michael Webb's *Suitaloon*, the inflatable *Villa Rosa* by Coop Himmelb(l)au), eventually displaced Metabolists' modular networks.

What this 'paradigm shift' favoured the most was contrast, collision, and counterpoint logic of architectural works, emphasizing their inner tensions. It is a case of dynamics in search of a valve. These aspects deriving from collages would mark urban discourse in the 1970s.

> The existing urban fabric and layout were privileged as the ground on which new layers were added or juxtaposed. Hence, the aesthetic of layering, ambiguity, transparency and juxtaposition which became dominant in the 1980s. Hence, Bernard Tschumi's notion of 'superimposition', making a city plan out of placing one organizational type on top of the existing ground ...
>
> (Jencks 1997: 77)

Having re-emerged as deconstructive aesthetics and design strategies, complexity made its appearance in Tschumi's designs for *Parc de la Villette* (1982). It evidenced a more tectonic approach, in Zaha Hadid's *The Peak* (1983), or the strained relationship of site and building, extorted by Peter Eisenman (*The Romeo and Juliet* project, 1986) and Nigel Coates in the latter's urban narratives (*Joyce's Garden* [1976], *Falklands Museum* [1982], *Ecstacity* [1992]). Transferring qualities of dynamic systems into theoretical projects that are executed primarily on paper and complemented by models, deprives them of possibility to be tested out by future inhabitants, workers, or other prospected users of these buildings. Charles Jencks based his polemics on formal semblance, as well as theoretical underpinnings of existent buildings and their designs. Speculative projects, which exist solely as architectural representations, can eke out 'complexities and contradictions', by employing: ambiguity in drawing conventions, visual associations, or cinematic techniques, involving arrangements/layouts of image sequences – storyboards (Superstudio), strings of still frames (Lynch and Appleyard, Scott Brown and Venturi), or scripted events, as in Tschumi's 'transcripts'. In his essays Gregg Lynn glanced back on this tendency, writing that:

> [with *Complexity and Contradiction in Architecture*, *Collage City*, and *Deconstructivist Architecture*], architects have been primarily concerned with the production of heterogeneous, fragmented and conflicting formal systems. Those

FIGURE 4.1: François Schuiten, *La Fièvre d'Urbicande* (panel), 1985. © Casterman S.A.

practices have attempted to embody the differences within and between diverse physical, cultural and social contexts through formal conflicts.

(Lynn 1998: 109)

Henceforth, these aspects became objects of visual analysis, that sought more advanced – technically, and in terms of media used – methods and technologies of representation, without reducing neither complexity nor contradictiveness in their accounts of post-relativist reality. From now on they would wrestle with 'dynamic systems' that were themselves either excessively elaborate or too elusive for a direct translation into production documents and design aesthetics. Architectural drawings, models, and, at a later time, also animations, would become prime means in recording and reflecting on the changes in society, culture, and human knowledge 'bending' under strain of scientific concepts.

Urbicande – *A case study*

If we follow Jencks's account closely, we will notice how the post-war generation of utopian architects and artists visualized systems theory in megastructural form. In turn, their arguments were put forward as drawn accusations of repeating ideals of modernist utopia under new banners, while volunteering schemes, which would be no less fixed. Two parallel lines of speculative projects – the superstructure and

the organic habitat – appeared as if interlocked in explicitly ironic theoretical designs by Italian groups UFO, Archizoom, and Superstudio. Nonetheless, a further take and development of the idea of a Modernist network or grid can be found in the second book from the Belgian series *Les Cités obscures*, created by François Schuiten (architect) and Benoît Peeters's (writer). In *The Fever of Urbicande* (*La fievre d'Urbicand*, 1985) its authors put together Antonio Sant'Elia's drawings of Città Nuova and the works of Neoclassical Revolutionary Architects. Together they are turned into a geometricized backdrop for a story on an infinitely expanding scaffold that grew out of the elongated sides of a mysterious cube. From a pocket-sized archaeological finding, the mysterious object turns into a 3D grid, growing branches from each of its vertexes, following in this Feigenbaum's fig tree pattern. Judging by its incessant progress, it will soon take over the city. The expanding entity is conscious, and, as it seems, much more intelligent than the oppositional faction, which claimed its ownership. The Network's (Réseau) growth destabilizes political order, connecting opposite banks of the river – former division line – sparking the emergence of renegade operations. For example, it allows rebels to ignore Urbicande's highly ordered and constrictive infrastructure thanks to multiple vertical pathways that emerged due to the framework's expansion. Detainees can now easily climb out of their prison cells, whereas members of the resistance encounter no obstacles, when traversing the city at any time of day or night. The superstructure also instigates new social practices around/upon it, such as construction of high lines, train platforms, farming allotments, cottages, and so on. Alas, a single flaw arising from pure chance, or initial obliviousness to the fact, disrupts the Network's 'healthy' progress. Caused by its careless placement on the main character's desk, it has been growing slightly askew. Thus, the formerly ordered Urbicande runs amok with giant scaffoldings constantly proliferating at an angle, slanted, and therefore permanently at odds with reigning rigours of urban planning.[15]

In Schuiten and Peeters's graphic novel the Network is an architectural apparatus, as for it maintains and propels its function of a supporting structure consisting of pillars and bridges, but at the same time it behaves like an organism, whose expansion escapes simple calculations (predictions) due to fluctuations in its growth rate. Behaviourwise it falls within probability theory's scope. Even in visionary designs of the late 1960s there were attempts to 'outrun' megastructures' rigid modularity, by means of modelling them after organic forms and natural processes, yet hardly any of the projects tried to either altogether abandon the Cartesian coordinate system, or stray away from Euclidean space. In these forms we are likely to recognize proliferations or distortions of Platonic solids. All the more we will notice outgrowths of fractal patterns. With the employment of complex computer algorithms, whose behaviour is modelled after processes

from biology or crystallography, the architectural structure is not designed to the very last detail, but grown. In digital morphogenesis certain forms are predetermined. Instead of being completely deterministic, morphogenetic evolution is presented as an outcome of a development that follows specific 'game rules', defined by preliminary conditions.[16] The Network of Urbicande exemplifies another age of imaging architecture, in which represented space, modelled after geometric abstraction, is revoked by an inherently dynamic, non-linear, and 'open' (in Eco's terms) space. The narrative in Schuiten and Peeters, along with its object – the architectural invention – is a 'product' of a Deleuzean rendition of the grid. The tale is evidently informed by his philosophy. Being a literal spatial mapping of modernism' ideology, it imposes itself on existing infrastructures with its rationalizing rigidity. *The Fever of Urbicande* re-imagines the Modern mindset, although in a chaotic universe, as a construct interlocked between Frei Otto's space frame and topology – the science of continuous transformations. Ultimately, Urbicande's Network, representing an apparatus for architectural inquiry, turns out to be not only unbuildable, but also unstoppable. It surveys the society, its authorities, and culture (along with ritual practices that spring around this monument). In the bigger picture it is also a 'fast-forwarded' account on how architecture, in general, affects the life of a community. Aspects of this sort are present in many other theoretical projects, both inanimate (*The Continuous Monument, Underground Berlin, The Hanging Cemetery of Baghdad*) and animated (Soki So's *Hong Kong Labyrinths*, Keiichi Matsuda's *Augmented Hyper-Reality*). Furthermore, like all speculative proposals it is a projection screen for (the historical period's) discourses and practices – reflection of (and on) its episteme.

Deconstructing the event, and the event is architecture (the Manhattan transcripts)

While the Venturis recognized a deficiency in architectural form, Bernard Tschumi began to consider how to inscribe the event 'back' into a primarily architectural setting, in a way that would not feel forced or superficial, or simply did not repeat typical programmatic concerns. Just as Venturi or Lynch intended to break down architectural 'promenades' into sequences, relying, in this area, on cinematic characteristics of rhythm, the designer of Parc de la Villette was reconsidering cinema not only through the 'acquisition' of technical strategies taken from filmmaking. By incorporating film's semantics and syntax he was able to develop his concepts. Going beyond simple records of one's traversal through space as indicative of narrative progression (Le Corbusier in *Villa Savoye*), or by breaking it down into sequences of film stills (Lynch, Appleyard, et al.), he began

to invent scripts for spatial activities and events, that even aside from extremity in the choice of crime and noir plots, or a somewhat fantastic treatment of architectural programme, brought out unusual qualities of given spaces. Cinegrams were thus employed as tools for formal interpretation of the composition, and as form generators.

> The specific purpose of the [*Manhattan*] *Transcripts* [...] is to transcribe things that are normally removed from conventional architectural representation, namely, the complex relationship between space and its use, between the set and the script, between 'type' and 'program', and object and event.
>
> (Tschumi 2012: 80)

Tschumi calls it 'counterdesign' (or *anti-design*), and while remaining critical of paper architecture, considered as a medium insufficient for containing all experiential aspects of architecture – nevertheless, a system of notation – he was convinced, that the domain should reach out to other disciplines and incorporate new design methodologies as potential aids in this quixotic endeavour.

In a similar fashion to Venturi's exercise of semiotic reading of the architectural 'syntax', the author of *Manhattan Transcripts* (1981) applied filmic vocabulary in the role of an outside support to diagramming, taken as technique of composition. Urban settings and buildings were regarded by him as loci of para-cinematic experiences. Speaking of manipulating 'devices as flashbacks, crosscuttings, close-ups, and dissolves' (Tschumi 1996: 165), he prompts one to revise baroque details as 'temporary flashbacks'.

'Renamed' as *cinegram*, this diagrammatic notation method placed action sequences at the top, plans and architectural sections in the middle, while and at the bottom of the page placed a chart detailing the choreography of people's movements through space at the bottom of the page. This form of representation aims at breaking down architectural experiences into three distinctive methods on mapping/imaging. This way the architectural situation is deconstructed precisely into three positions: space (top), movement (middle), and event (bottom) – the Tschumian triad, which became the paradigm, underlying all his subsequent designs.

> Three disjointed levels of 'reality' are presented simultaneously in the *Transcripts*: the world of objects, composed of buildings abstracted from maps, plans, photographs; the world of movements, which can be abstracted from choreography, sport, or other movement diagrams; the world of events, which is abstracted from news photographs.
>
> (Tschumi 1994: 8–9)

Thereby, Tschumi tries to include an altogether different order into modes of architectural imaging – the order of time, expressed in a purely cinematic (or musical) dissemination into moments, intervals, and sequences. He states that this hybrid methodology has been invented precisely because all means available to architects were insufficient for his ideas, touching upon time-based architectural concerns. His cinegrams – organized into episodes concerning spatial programmes in relation to: the park, the street, the tower, and the block – question an otherwise narrow scope of architecture's 'applicability', providing an uninhibited reading of discipline's key interests. In this they criticize traditional techniques, but mainly the agreed-upon conventions of representation, stressing differences between views of the same space/object. Regardless of whether we view it as axonometry, plan, or perspective. Tschumi purposefully chooses highly ambiguous situations and sites, in the same manner as Peter Eisenman would just a few years later. Eisenman employed axonometric views and diagrams as generators of form for his *Ten Houses* (1967–78), with *House E1 Even Odd* most explicitly testing the limits of axonometric projection rather than typology:

> Eisenman has embarked on an operation to convert a technique of representation which has a characteristic mode of distorting into an object which makes those 'distorted' relationships real. [...] [B]oth 'axonometric object' and the 'house object', if we can separate them for a moment, are based on the same rotated system of projection, they tend to cancel each other out in the viewer's eye, making it hard to figure out what is what, yielding integrity without clarity.
>
> (Sorkin 1991: 39)

If concurrent views perform an operation more complex than a simple rotation of the architectural object, in the process transforming also its contents – as studies of both Tschumi and Eisenman showed – then there must inevitably be some discrete, yet analogue visual 'algorithm' working in the background, which triggers this semantic reduction.

In architectural imaging convention remains intact, while methods change drastically. While not always the question of precision, it definitely remains one of adaptation and communication of spatial proposals through channels endowed with the highest 'bandwidth'. Rem Koolhaas, Robert Venturi, and Bernard Tschumi realized this, even though none of them was primarily or solely interested in strictly theoretical work. Each had decided upon a path of notational experiments that were characteristic of architectural avant-gardes,[17] while not exactly a path of least resistance. No wonder these attempts, which could not be classified as utopian, were labelled 'deconstructivist', especially when conducted via actual

correspondence with cultural theorists (Jacques Derrida, Gilles Deleuze), all of whom embarked on a 'crusade' against prevailing discourses and binary logic. Also, the theoretical aspect of their practice focused on dissection of architectural language, along with its philosophical concerns. De-structuring their own domain accelerates general 'deterritorialization' (in Deleuze and Guattari's terminology)[18] of architecture – its re-vision from the vantage point of adjacent arts.

As Mark Wigley states, 'Deconstruction is not simply architectural. Rather, it is displacement of traditional thinking about architecture' (Wigley 1993: 36), despite the usual associations with processes of destruction and rebuilding. Still, deconstruction can be elucidated as an active process, which ought to remain open-ended. Frozen in time, like still life, while simultaneously akin to an unbalancing act setting off a disjunction that emerges between systems of notation. 'Such disjunction implies a dynamic conception posed against a static definition of architecture, an excessive movement that brings architecture to its limits' (Tschumi 1994: 9). Of course, there is substantial ground for situating Tschumi's cine-architectural philosophy in context of that emerging tendency (Wigley abstains from calling it 'style') of deconstructivist architecture. The projects falling within the auspices of the 1988 MoMA exhibition (simply named 'Deconstructivist Architecture'), curated by him and Philip Johnson, call for a similar reading, as in architectural texts of other showcased architects, such as Zaha Hadid, Rem Koolhaas or Coop Himmelb(l)au, the cinematic factor is always present – as an inspiration, construction model or a methodology informing the design. Even if we boil down these qualities to aesthetic solutions, deconstructivist projects 'validated' their enterprise in theoretical terms, primarily relating to the art of 'moving pictures'.

This brings us to the second source of inspiration, which, by definition, is as much structural as it is dynamic. Jacques Derrida's concept of deconstruction[19] expects of the researcher to analyse texts of culture on the basis of the logic behind their structuring, to search for an 'unconscious' principle that underlies a given 'text' of literature, art and – by direct correspondence – architecture. As Wigley notes in his introduction to the published version of 1988's exhibition's programme,

> [D]econstruction gains all its force by challenging the very values of harmony, unity, and stability, and proposing instead a different view of structure: the view that the flaws are intrinsic to the structure. They cannot be removed without destroying it; they are, indeed, structural.
>
> (Johnson and Wigley 1988: 11)

This dynamic account of architectural text's structure, not just its shape, form or skin, is what guided compositional decisions in Tschumi's *Manhattan*

Transcripts or Koolhaas's view of Manhattanism. Strategies deriving from cinema were called upon to help determine the structure of architectural proposal, while at the same time bringing other perspectives into the equation. This is what Wigley means by calling for a deconstructivists' enterprise, searching for principles formerly deterritorialized (or 'inherent dilemmas') in modernist architecture, bringing to the forefront such attributes as (distorted) harmony, (fractured) unity and (skewed) stability, expressed through form, though more importantly – structure. Moreover, Derrida insisted on understanding deconstruction not as a product, process or activity but – instead – as an implicit characteristic that can be performed on a text.[20] The awareness of such possibility suffices to treat this reading/writing (or dismantling/building) philosophy as a cognitive shift that animates architectural form, while simultaneously escaping the deficiencies of binary logic. This notion would be addressed later, in the parametric futurism of the 1990s. Its evolved imaging tools, while performing operations that – in symbolic terms – seem somewhat contrary to deconstructive strategies of 'clashing' forms, opt for an integrated image of architecture. Greg Lynn takes note of this discrepancy in his essay.

> Deconstructivism theorized the world as a site of differences in order that architecture could represent these contradictions in form. [...] The same architects are beginning to employ urban strategies which exploit discontinuities not by representing them in formal collisions but by affiliating them with one another through continuous flexible systems.

> (1998: 114)

Conclusion

In the introduction to *Deconstructivist Architecture* exhibition catalogue Wigley suggests that the projects gathered in the publication are literally 'built theories'. They are spatial and material productions, being end results of hypothetical enquiries, which due to economic constraints have been solely limited to the drawing board. However, reading architectural works, as if they were films, brings about an inevitable conflict of expertise in terms of imposing order over space, which can progress either by means of narrative or database. While the first proceeds in a sequence, the second grants the user freedom in accessing data at random. Although primarily relating to games, software and experimental instances of cinema, Lev Manovich coined and characterized this distinction in *The Language of New Media* (2001: 214–15), primarily referring to literary theory. He focuses on the distinction between descriptive and narrative accounts on textual

'space'. 'As cultural form, the database represents the world as a list of items, and it refuses to order this list. In contrast, a narrative creates a cause-and-effects trajectory of seemingly unordered items (events)' (2001: 225). But database and narrative should not be seen as natural enemies, given the example of plotlines described in *Manhattan Transcripts*. Their 'user' is more likely to behave like a player in a RPG environment, forced to decide upon both sequence and trajectory of his/her actions. 'The "user" of a narrative is traversing a database, following links between its records as established by the database's creator' (2001: 227). Even if, as Manovich states,

> [t]he user's experience of such computerized collection is, therefore, quite distinct from reading a narrative or watching a film or navigating an architectural site. Similarly, a literary or cinematic narrative, an architectural plan, and a database each present a different model of what a world is like.
>
> (2001: 219)

With experiments regarding notation techniques this privileged 'model of the world' is contested from without the domain, thus cross-lining architectural programmes with cinematic scripts or screenplays. Architecture would have been an ideal case for database type narratives, if it were not for the fact that computer databases and their cultural appropriations had originated from a museal arrangement of exhibits in the first place. Even when 'turning tables' on the idea of programme, we will notice differences, inter alia, between the critical uses of narrative/database logic in artistic cinema,[21] excluding simple plot-driven forms of mainstream productions. Threads differentiating narrative from an index are multiple: alternative organizing principle, varying role of intertextual references and/or visual cues, and (in databases) a preference for storylines that evolve simultaneously, or branch out independently of linear action. This holds true of Tschumi's early projects, because they deconstruct filmic plotlines in a similar manner, inventing 'games' for chosen locations, with each project countering 'generic' requirements of the typology involved. He recounts, that '[a]s a series, the Screenplays were intended as an investigation of architectural concepts and techniques, exploring the relationships between events ("the program") and architectural spaces, and, additionally, transformational devices of a sequential nature' (Tschumi 2012: 66).

Learning from screenplays, storyboards, film editing, and cinematography, while employing deconstruction as strategy of critical-design, transplanted into the body of architectural theory, marks numerous projects that emerged even long after deconstructivism eventually turned out to be a style, barely a fleeting fashion. The para-cinematic aspects of certain projects would come to the fore in

periods of growing influence of cultural theory and new art 'languages'. Thanks to this marriage of previously separated fields of knowledge speculative architectural projects engage media that allow them to unfold in time, incorporate motion, subjectively reassess built environments, while surpassing conventional notation methods of plan or section. The space/time/event ensemble, taken from Tschumi's essays, acts as polarizing lenses and narrative generators for the (unmade) screenplays and visual essays of Superstudio's *The Continuous Monument*, Michael Webb's *Temple Island*, and Lebbeus Woods's *Underground Berlin*. We will see them falling into focus in the next chapter.

5

Case Studies, Part One:
'Analogue' Projects

Lebbeus Woods: Underground Berlin

Berlin of the late 1980s was a rich and politically turbulent environment, torn apart by internal conflict, yet simultaneously propelled by this split. Still supressed by the wall, it was a metropolis that – in Lebbeus Woods's script – needed to plunge deep into the earth in order to evolve in a spontaneous way, along the lines drawn by emergent youth subcultures, art scenes and a new generation of Berliners living in the shadow of the Cold War's wrath. Soon they would put an end to the political apartheid. Berlin is a city ruptured by war, though physically divided in its aftermath. The state which prevailed up till the fall of the Berlin Wall did not only give rise to frustration, but it also led to many intriguing projects sprouting in the 1980s, most prospecting accelerated construction works in the early 1990s. They aimed at revitalizing the infrastructure, bringing about a united Berlin suited for the new millennium. Interestingly enough none of them had envisioned a future which would be rid of the wall. The divide was its status quo, defining Berlin's identity as a ripe repository for acts of misplaced nostalgia. In their study, *Berlin: The Spatial Structure of a Divided City*, Elkins and Hofmeister pose a diagnosis on principal factors which sealed off the new 'walled' mentality, having written that

> [t]he sheer passage of time must also not be forgotten. Those who knew undivided Berlin forget, and death year by year reduces their numbers, while birth and migration bring in residents to whom the united city is only a part of history.
>
> (2005: 61)

Woods, by contributing to the boom of imaginative projects in the 1980s, envisioned Berlin's history as a multi-layered cake whose bottom sheet was ready to replace the topping.

FIGURE 5.1: Lebbeus Woods, *Berlin Free Zone*, 1990. Electrostatic print, colored pencil, pastel and ink on paper. © Estate of Lebbeus Woods.

Monument or model?

The year was 1988 and Berlin has just been assigned the role of the fourth cultural capital of Europe. Among a number of planned cultural events was an architectural exhibition organized by Kristin Feireiss, which brought together such luminaries as Daniel Libeskind, Zaha Hadid, Peter Cook and the studio Morphosis. This exhibition was supposed to be a shared enterprise of imagining paths that the future revitalization of Berlin – still, a partitioned capital – could take. Responding to the *Berlin – Denkmal oder Denkmodell* ('Berlin: monument or model') brief, Lebbeus Woods presented a preliminary version of his *Underground Berlin* project. The project was focused on mining the area beneath West Berlin's U-Bahn and S-Bahn lines, a nearly disused tunnel (at the time), located at the station of Stadtmitte. While the first one of the two lines linked up Checkpoint Charlie with the Friedrichstraße station, the second route connected Potsdamer Platz and Alexanderplatz, thus joining the dots that outlined the wall's dividing line. The apportionment imposed in 1961 was superficially plotted and imposed by force; thus, during daily commute, passengers from West Berlin would still see people crowding on platforms in the disadvantaged stations in the Eastern Bloc, watching as trains passed by. Volker Welter evoked such scenes in his essay, painting a vivid scene.

> The speed slowed down to almost walking pace, the intercom crackled 'Last station in Berlin-West', and the trains traversed dimly lit ghost-stations like, for example,

Potsdamer Platz and Unter den Linden; names that where from a past as distant as the Gothic script was old-fashioned that announced them on pale wall tiles.

(2008: 1)

Woods was definitely with the agitators, who called for tearing down the wall. But his own revolt had to be thoughtful, administered slowly, by means of an underground landscape of corridors, tunnels and caverns. A buried counterpart for Berlin above would have been a perfect resolution, making use of two concepts haunting his opus. First one was the 'heterarchy'; the second, 'freespaces'. As previously stated, the programme of freespaces is expected to come forth spontaneously, in the course of habitation. While this concept has always been 'up in the air', when digging through Woods's late 1980s works, it erupted full scale in *Berlin/Zagreb Free Zone* (1991), and then his later projects for the rebuilding of Sarajevo.

'Space is essentially a mental construct. We imagine space to be there, even if we experience it as a void, an absence we cannot perceive,' writes Woods on his blog (*The Question of Space*, 2009). The physical construct of freespace is a territory, uninscribed by mental templates, standardized rooms and interiors shaped like cubes and cuboids. It is a daring venture into oblique, trapezoidal and non-regular, that is, polyhedral forms, defying its users' expectations towards built environment. Freespaces can be injected into existing structures. They should, conceived as instruments of immediate social and habitual change. Like 'rescue kits', they were prepared for application in the aftermath of natural disasters and wars that reshape, if not completely damage, habitual modes of living. If we revise architectural history from the vantage point of failed planning schemes, akin to mass scale modernist projects epitomized by the 'parable' of Minoru Yamasaki's *Pruitt-Igoe* housing scheme in Saint Louis,[1] it is they themselves that could be viewed as a disaster, which forcefully reshapes the structure of local communities and its social life and imposes a highly politicized mission of urban planners. This concurs with Lebbeus Woods's critique of haphazard post-war reconstruction, which he views as causing just as much damage with its quest for restoring past as the disaster itself. Freespaces are meant to prevent such pitfalls, due to their bottom-up organization scheme, engagement of inhabitants, as well as thriving on their prolonged incubation – deliberate and necessary in order to synch up with the pace of post-traumatic living: stabilization, remembrance and reconnection – recovery and healing. Woods divided his architectural psychotherapy into phases, which assume gradual mutation of living space by means of transforming hollowed-out sections of the building. First, by filling them with an injection, which over time turns into a scab, subsequently solidifying into a scar and eventually re-emerging as new tissue. In the latter stage the addition becomes a permanent element of the

structure. Most important of all, the emphasis is on evolution of these indeterminate spaces, and therefore Woods's plan assumes anything but an immediate architectural intervention.

What this metabolism of freespaces additionally implies is an alternate – horizontal, rather than vertical – method of (self)governance and organization. A heterarchy acts as a force of resistance, regardless of whether we speak of the violence of urban renewal or the simulacrum of architectural restoration, which – as Woods writes – preys on nostalgia for the pre-war past and a sense of loss in societies, which in turn tend to instate new official authorities as restorers.

> The hierarchical surface city is met by the heterarchical subterranean city in structures built to break the physical and ideological barrier between them. The projection towers are architectural weapons par excellence. They have every intention of disrupting, of leaving the fabric of the surface city and its way of life. Staging the political and cultural energies of Underground Berlin, they are instruments of a wider transformation to come.
>
> (Woods 1992: 51)

One is able to find an answer to this question, formulated in the 1988 exhibition's title, in a book published a few years after the Berlin projects. *War and Architecture* (1993) focuses on the atrocities of Balkan War and the siege of Sarajevo, outlining a manifesto of 'radical reconstruction' – a different kind of spatio-temporal clash between space and politics that elaborates upon the flexibility in *Underground Berlin*'s urban regeneration prospects. Woods writes:

> [W]hen society can no longer define itself in classically deterministic objective terms, but only in terms of continuously shifting, fluid-dynamical fields of activity, then architecture must forsake the monumental, because there is no hierarchy to valorise, no fixed authority or body of knowledge external to human experience to codify.
>
> (1993: 6)

In this Woods was deeply empathetic with a Virilian account of technology's influence on our daily habits and living in general. Freespaces were therefore endowed with a range of electronic instruments, seen – in contrast to Virilio's writings[2] – as a way to bypass hierarchy through creative play and implementation of counter-authoritarian forms of economic, informational and cultural exchange. The American architect recognized this mode of existence as natural for towns and cities of bygone days, gaining organizational density over time. In his argument he gives privilege to the complexity characteristic of historic (Rossi) and/or collage (Rowe/Koetter) cities, as opposed to modernism's functionalist urbanism. Their

infrastructural chaos was not necessarily a bad thing – he concludes. Certainly not, if we define it in relativist terms as a 'complex and nonlinear form of order' (1993: 8) – the property of systems that are about to jump onto a higher level of organization. And it does leap far, when we consider how the project's underground spatial arrangement parallels that of the 'Berlin above', privileging and facilitating new modes of habitation, transformation and city-making that contradict former social orders. In Woods's pessimistic scenario order is stillness, and stillness means constraint, which inevitably leads up to legislating oppressive systems.

Underground city

Given these conditions, founders of the discrete city in *Underground Berlin* decided to seek independence below ground. In turn they found dynamic forces of seismic winds and electromagnetic fluxes – Woods narrates this subterranean 'odyssey' in *OneFiveFour* (1989). Exploring the interiors of Underground Berlin, we discover that they appear as if covered with salvaged metallic sheets – the classic 'Lebbeus look' of ragged, twisted and jagged hi-tech, in line with deconstructivist plane crashes of Eric Owen Moss, combined with the tarnished surfaces straight out of Raimund Abraham's drawings. With their audacious forms they contest architectural landscapes of the city above with their new geometries hatched closer to the earth's core. When we scrutinize the drawings and models made for the project, while remaining cautious not to swerve towards Woods's previous works (*Einstein Tomb*, *Four Cities*, *Timesquare*, *Centricity*), we may find close resemblance to expressionist architecture of the 1920s, particularly Bruno Taut's crystalline forms adopted by his 'alpine architecture'. Expressionist Architecture was only a short period in the history of Weimar Republic. Along with its dissolution – first in favour of ascendant socialist agendas of the Neues Bauen (New Objectivity) movement, then by neoclassicist leanings of the Nazi party – the period came to be regarded as a 'lost generation' of projects in the history of architectural theory. Conjuring up architectural styles, which during the Third Reich were regarded as 'degenerate', is just another way of playing out the conflict between authoritarian urbanism and guerrilla reappropriation/occupation of space. Woods's discrete urbanism, a city hidden underneath a meshwork of U-Bahn lines, plunging hundreds of meters below actual infrastructure, is in fact a vital and creative commune. Halfway between a squat and thriving *arcology*[3] that was unable to find its safe harbour in the ruptured capital.

What is being recalled here is a similar disparity that arose between official and 'unauthorized' cultural politics in 1930s' Berlin. But interpreting the city's art scene via Cold War–era West Berlin's 'street customs' impelled him to design a suitable

container for this new cultural climate. When taken symbolically, as an excavation project, it evidently embarks at a recovery of the German capital's troubled past. Viewed along these lines, his project becomes a statement on the politics of memory or obliteration. Keeping in mind the Freudian collation of psychological repression mechanism with burial, Gaetano Pesce's *Church of Solitude Project for New York* (1974–77) reveals itself as a foray into similar territory. By means of architectural design it maps out the collective unconscious, addressing such issues as individual's desolation in modern society. The cavernous, underground space of Pesce's project resembles an archaeological site, opening up to the surface city.

Among Woods's drawings prepared for *Underground Berlin* there is one that shows a spiky, deconstructivist stalagmite tower, bursting through the middle of Alexanderplatz, like a deadly fungus through an ant's drained skull. It is only the tip of a metal sheet iceberg that proliferated underneath into a gamut of unevenly shaped rooms and halls, spreading along zones both private and public, accessible and off-limits. Underground Berlin was meant to overcome the physical, political and cultural boundary posed by the wall, subverting it (symbolically, through activities and non-programmes reinscribed into the subterranean fabric) from beneath ground. Underground canals, cellars, sewage systems, networks located below street level have always been the locus of organizational infrastructures in invaded cities. Be it French or Polish (underground) Resistance, each had to adapt the sewers or metro lines into a surrogate for a functioning city organism. Thriving on the idea of a permanent rebellion, *Underground Berlin* offers spaces that conform to this new mode of habitation, without reproducing urban developments above, along with their hostile infrastructures. With the fall of Berlin Wall in November of 1989, and the political and economic fusion well underway, the mission statement of 1988's Berlin exhibition might have sounded a little outdated, even if the new political leaders were not planning to introduce any of the ideas presented there. For the architect Berlin 'after the wall' seemed to be lacking 'prohibition' period's danger zones, let alone the zeal of genius dilettantes. If city is a breathing fabric, Woods intended to clothe his 1988 project's structure in a deconstructivist robe of the excavated underworld. His snapshot of the emergent youth culture was a mixture of rave party scene provided with an actual stage, punk DIY tactics, coming to inhabit a military complex with the rumoured 'space' taken up by Third Reich–era secret laboratories. The American architect called for reclaiming these symbolically forgotten, restricted or makeshift facilities in one of his essays, asking: 'Where will the empty, haunted, elegiac spaces be in the super-controlled New Berlin? The nightclubs, afterhours bars, the underworlds and overworlds that make a city vital, creative, dangerous, exciting, and potential?' (Woods 2004). As the new authorities were taking hold of every corner and gap in the city space, this artistic activity, which has to be seen as a self-generated force in

transforming the city,[4] found itself at risk of being relegated, compartmentalized or harnessed by commerce. In the context of Lebbeus Woods's projects, precisely that scenario would have been most harmful of them all, because his freespaces ideologically, if not viscerally, defy the consumerist inertia.

How to overturn urban space through architectural violence

In the light of rapid unification the 'unitary'[5] proposal for Berlin had to evolve in a different direction. After embarking on a small tour around Europe as part of a travelling exhibition, the project was subsequently revised by Woods and turned into a film script, treatment for which surfaced years later on the architect's official blog (its storyline will be described later on). Written from the standpoint of locations and spatial constructs inhabited by subterranean Berliners, its narrative served as an investigative tool to explore the city's 'repressed' spatial alter-ego, a theme suited perfectly for a time of historical revisionism. We should not call it a sequel; more of a development of the project into an altogether different medium whose basic premise is storytelling.

On his website Mark Lamster describes it in terms of cinematic classics, which resembled the project visually, thematically or structurally. A 'distillation of design philosophy into narrative form', it is said to recall a cross between Chris Marker's *La Jetée* (1962), Stanley Kubrick's *Dr. Strangelove or: How I Learned to Stop Worrying and Love the Bomb* (1964) and Lang's *Metropolis* (Lamster 2009). Comparisons to *Metropolis* seem to be echoed in the theme of revolt of the inhabitants of city's lowest sectors and – to a lesser extent – in its narrative structure. With both scripts organized around exploration, each hails architectural space as the main conveyor of the plot. Contrary to Lang Woods refrains from leaving his audience with clichés that interconnect the hand and the head by a detour of the heart. Instead, in the script's final scenes his 'suppressed' city burst out with the ripeness of underground infrastructures that stood as archives to Germany's muted past – an architectural defence mechanism against Konrad Adenauer's politics of suppression.[6] Lebbeus Woods's project is therefore a study of memory and history, in which these inseparable domains are rendered as a sociopolitical function of urban habitats. Given the example of Underground Berlin this symbiosis can result in a harmful split, between official and actual discourses on urban space.

Going back to *Berlin Free Zone*, we can see the project as a notable shift in Woods's reflection on artificially divided cities, relocating subversive structures from subterranean levels to interiors of buildings. This architectural intervention also utilizes freespaces. Behaving like parasites, they seem to have devoured segments of floors, even entire flats, developing in their place an

irregular architectural growth. In his monograph (*Anarchitecture: Architecture Is a Political Act*) we will find an erratum on that project, which is anything but surprising, as – in the meantime – Berlin overcame the political division. Still, a spatial interpretation of collective unconscious cannot simply be disposed of. Instead of manifesting itself as exiled, it materializes as hidden 'force', underlying seemingly unchanged surfaces. A theme familiar to science-fiction writing resurfaces here as the projection of the characters' inner world onto their surroundings. Traumas, anxieties and unconscious drives become main interpretive apparatuses for actual architecture presented in novels. Such literary psychasthenia is what drew the attention of architectural circles to the works of James Graham Ballard. Consider the habitation unit in *High Rise* (1975), enclosed holiday destinations in *Super-Cannes* (2000) or the shopping mall in *Kingdom Come* (2006). Recall the desolate isle in an entanglement of flyovers in *Concrete Island* (1974) – each of these envelops the aforementioned spaces with its narrative, analysing infrastructures of office buildings, domestic settings, luxury spas, alongside other urban fragments and architectural complexes which Ballard's protagonists temporarily inhabit. They are not machines for living (in), but for transformation. They are midwives assisting the characters' regress into a primordial swamp of drives and urges, which had been repressed by social conditioning. Let us call upon characters such as Dr Alan Bodkin from *The Drowned World* (1962), enthralled by the apocalyptic flood, embracing landscapes remoulded beyond what he is able to apprehend, yet representative of his unconscious urges.

A similar release mechanism must have been installed in the cavernous architecture of Underground Berlin; in the protagonists exploring its tectonics, recovering modern history, both tormented and vile – a necessary step in terms of psychoanalytical reconciliation of 'split personalities' of East and West Berlin. If city form is a manifestation of knowledge, then it should be possible to map out collective memory by its public squares and avenues. The two cities narrated in *Underground Berlin*, and then in *Berlin Free Zone*, become settings for journeys in remembrance. The one underneath reflects a vibrant new culture, as well as an inconstancy in accounting of the past. The one above acts like its rectified sibling, submerging history in concrete (or, simply, being representative of *history* – in Nora's terms), causing obliteration of any activity which cannot be defined as knowledge. Woods stated in his essay *Walls* that 'zones of crisis are the only places where actualities of the dominant culture are confronted, and from which new ideas essential to the growth of a new culture can emerge' (1992: 13). Unsurprisingly the hidden city's deconstructed, oblique architecture ruptures Berlin's crust, invading its infrastructures and devouring urban voids. Among them is Alexanderplatz. The city-machine pierces it at its centre.[7]

118

Dust jacket design: The SF vernacular

At the time of *Underground Berlin* Woods already had some experience in constructing dystopian scenarios, serving as an illustrator for two publications – *A Dark Travelling* (1987) by Roger Zelazny, and a collection of short stories by Arthur C. Clarke, entitled *The Sentinel* (1983). Both bear more than just slight resemblance to the projects he pursued at that time. For example, one of the monochrome drawings accompanying Clarke's short story 'Jupiter V' resembles a panel from the *Centricity* project. In 1992 Woods had also revisited classic SF with an illustrated adaptation of Ray Bradbury's *There Will Come Soft Rains* (1950), published in the third issue of *Ray Bradbury Chronicles* comic book series. Even though he was used to narrating his illustrations, with Bradbury's short story he had to do the opposite. It is the narrative that had to be coated with a fitting graphic interpretation.[8] Illustrations Lebbeus Woods created for this project display a genuinely constructivist dynamics. These are force fields of colour, jumbles of shapes, which depict a domestic variant of the post-apocalyptic genre by submerging the reader in a sea of unfamiliar spaces and forms. In essence they fulfil tasks, which are assigned to freespaces, although employing purely graphic strategies. Comic books are not necessarily the prime site, in which we encounter clashes of figurative art with its abstract sibling. Neither are they the medium to initiate any kind of discussion in, especially one concerning drawing conventions[9] and technical aspects of representation. And yet, with artists like Moebius (Jean Giraud) or François Schuiten (both of whom were deeply appreciated by Woods), these issues are addressed and discussed at length.

Returning to Bradbury's short story, this device is precisely at draughtsman's disposal. All in all, the illustrations are meant to accompany a scenario, which finds our world devoid of humans, hence not exactly ours anymore. It is consistent, therefore, in completely disposing of the need to anthropomorphize either events, actions or entities and objects presented, let alone subjugating artworks to figurative modes of depiction.[10] This alienating aspect of architectural spaces, which has been brought out in *There Will Come Soft Rains*, is also present in *Underground Berlin*, where the composition of underground tunnels and halls seems at odds with the few forms that could be noticed in the surface city. Additionally, the 'shooting' angles chosen by Woods, as well as perspective projections employed, are not even close to translating the human point of view. They appear, as if they belonged to an insect – the proverbial cockroach, which survived the apocalypse. Views are highly distorted, low angle, rendering household objects – a table, a toy or a sink – monstrous. Communicated here is a statement on architecture that interprets it as an apparatus irrevocably bound and attributed to the function of sight, whereas seeing denotes an active process – the act of cognition and thus recognition of objects,

FIGURE 5.2: Lebbeus Woods, *Underground Berlin 19, Elevation view*, 1988. Graphite and pastel on paper. © Estate of Lebbeus Woods.

spaces and forms. Architecture of Lebbeus Woods had always been a visualization of temporary, imperceptible and elusively dynamic aspects of reality, along with their translation into built form. Houses modelled after bullet trajectories, shelters resembling collisions of tectonic plates, captured as if in the aftermath of an earthquake. With *Underground Berlin* a whole subterranean urbanism of crystalline environments is evoked, which offers a refuge inside a dream of an architectural expressionist. The architect's mission was to conceptualize the kind of building practice that would be forced to evolve under extreme strain of circumstances, such as natural disasters and war destruction. Architecture designed by Woods is the architecture of the threshold. If forces and relationships subjected to mapping are dynamic, then the method in which they are mapped should also involve vocabularies that evidence equal degree of kineticism. Woods elucidated this idea in his *Radical Reconstruction* book, conceiving of a post-relativist society in the example of *Berlin Free Zone*, in which 'the classical distinction between art and life disappears. Art and life flow together, inseparable. Architecture then concerns itself with dynamic structures: tissues, networks, matrices, heterarchies' (1997: 14). This border is as much conceptual as it is graphic. Not only in terms of composition but also in the choice of techniques and media that inform it. Attributing to images an altogether different level of ambiguity, in style or in the layout of panels

on each page, can offer up alternative modes of reading the story. Given his experience with graphic novels, Woods could easily have conveyed a more insightful and broad account of the *Underground Berlin* project, helping himself with comic book form. However, acknowledging the study originating in the 1988 exhibition (while also encompassing the 1990's *Berlin Free Zone* proposal) as a work-in-progress, he decided upon turning it into a film script. In this he was no novice either. In late 1980s Woods was involved in the pre-production of *Alien*[3], at the time when Vincent Ward was still assigned as the movie's director. Among pieces of concept art prepared for that third instalment of the *Aliens* franchise, one could find settings resembling a medieval wooden monastery, rather than a post-industrial penal colony, in which we are stranded alongside Ellen Ripley in David Fincher's film.

Launching the architectural machine

Following his experience on a big budget movie production, having faced the toils of being a film set designer, after the director left with most of his collaborators, Woods was also dropped from the payroll. In a few years' time he will write a script of his own – one in which architecture would not be relegated to the role of a seedy backdrop, but where settings would be driving the plot, enriching it conceptually. *Underground Berlin* made a comeback as a movie script, co-authored with Olive Brown, only to fade again into obscurity not much later, as its production never came to fruition. Over a decade onwards Woods posted on his blog a film treatment, together with a handful of sketches intended as storyboards.

The story follows Amelia, an American architect, in her search for a lost brother – abducted in childhood by their father. She arrives in Berlin of the near future, which is presented as a city unable to come to terms with its own past(s) – the atrocities of the Second World War as well as the political separation that lasted throughout the Cold War. This ambiguous relationship is encapsulated in the character of Amelia's father, a former Nazi collaborator, now a renowned geologist, still valuable to the state, apparently, being a member of a

FIGURES 5.3–5.5: Lebbeus Woods, *Underground Berlin, the film treatment*, 1990. Drawing (modified reproduction).

secret government project. He has been declared dead, while in fact he works in a facility hidden beneath the centre of Berlin. After arriving in the city, with the help of Leo – a Yugoslavian physicist – Amelia finds the entrance to the underground compound, beyond the reach of German authorities, who are neither supportive of nor content with her quest. Descending into the city's subterranea, she meets up with her father's former working partners – Sarah, a scientist working in the complex, and Christian, the administrator of the Underground Research Station. What comes as a surprise is the fact that underneath the official research station, there is yet another one, constructed in the times of the Third Reich. Throughout the war, and then in its aftermath, it has been inhabited by families and descendants of the scientists, who were relocated there. The original team of researchers had severed their connection to the Nazi government, working independently of their supervisors above. Much like Hitler's followers, however, they sought aid in the occult. Their creed was a 'product' of the world they came to inhabit – the harsh subterranean environment of magnetic currents and seismic activity, imposing its rule of primordial earth forces that embody a knowledge far superior to the one causing temporary turmoil upon the lithosphere. Several generations later, after the fall of the Berlin Wall, their descendants could return to the surface, leaving sprawling underground labs and uniquely shaped spaces behind them.

As always, there is a fatal flaw to this utopia. The government in Woods's script leans towards authoritarian, if not outright fascist rule, ordering a series of nuclear weapons tests to be carried out underground. Getting rid of the hidden facility, whose existence threatens the order established above, is a logical choice and an operational defence mechanism at that. Especially as the complex has a long history of being inhabited by subversive elements. Each of the main characters is typecast as a potential revolutionary, in accordance with their occupations. These are the people giving shape to society, responsible for addressing its ails, nevertheless regarded as squatters. But collective mindset is not unanimous, which probably best distinguishes Woods's script from a piece of positivistic propaganda. Even among revolutionaries Christian is a true radical, an

FIGURES 5.6–5.8: Lebbeus Woods, *Underground Berlin, the film treatment*, 1990. Drawing (modified reproduction).

anarchist, who sets out to overthrow the authorities. Eventually he turns out to be more interested in changing the individual in charge, rather than overturning the system as such. Unlike Amelia or Sarah, who prefer to implement changes gradually, he opts for upheaval rather than 'evolution'. When the officials order to carry out the underground weapons tests – by this act evidently resuming their politics of obliteration and severance from a cumbersome past – Christian welcomes the news, seeing in these actions a justification for (as well as an opportunity to) putting his plan to work. Probably none of the characters, except for him, realize that the second underground complex can be set in motion, literally. Not a proper Walking City, but an apparatus of destruction that attacks other urban structures, contaminating them by means of freespace 'spores', which take control over infested hosts. The film's climax scene evidences this scenario. Set in Alexanderplatz, it pictures the public square penetrated by a Projection Tower, driven by Christian. Riding the underground machine to the surface, he supervises this hostile intrusion into urban fabric. 'It will release aerial machines, called aero-living labs, into the skies above Berlin, where they can escape the devastating effects of the coming geological cataclysm' (Woods 2009). As soon as that happens, 'spores' take the invasion to the terminal stage. In fact, spores are inhabitable aerial machines that use the earth's ambient magnetic field like air currents to sustain themselves up in the air. Akin to freespaces they are yet another means to colonize the medium too thin and inconstant to even remotely be considered liveable, harnessing gravitational pull. Finally, Amelia and Leo are able to escape in one of the aero-living labs, while the unstable tower collapses, burying Christian and Sarah along with it, the minute before nuclear blasts go off.

Subterranea, or, definitely a model …

While *Underground Berlin* has a rather conventional action film structure – which, at least partially mimics relationships between characters at play in Ward's version of *Alien*[3] – Woods's script manages to highlight discussions and sequences concerning urban form as those elements that are crucial to the plot. Same emphasis is placed on the role architecture performs in shaping societies and the entanglement of built environment and politics. In film it is manifested by placing it in context of historical styles and aesthetic preoccupations. Even though his screenplay's seismic architectures are supposedly Nazi-era structures, in no aspect do they recall the neoclassical grandeur of Albert Speer. Evocative of architecture of political resistance, Woods's deconstructivist voids and fractured lines fit in perfectly. They are lightweight, unattractive by design, taking after the poor theatre aesthetics

formulated by Jerzy Grotowski and Peter Brook;[11] alternatively, recalling Tadeusz Kantor's notion of the catastrophe:

> This catastrophe, in Kantor's vocabulary, was the process of annexing reality – that reality that could no longer be appropriated by a hegemonic constellation. Within this reality, he sought his places of the lowest rank – a bombed room, a café, a wardrobe, a poorhouse, a cloakroom – which depreciated the value of reality through exploring degraded objects, matter, marginalized objects.
>
> (Kobiałka 2009: xi–xii)

Either way they clearly employ the stylistics of poverty and degradation as counterstrategy to those of totalitarian propaganda and the cult of classicist tastes (as a neo-historical reappropriation of the Greco-Roman model), which hailed proportion, symmetry and decorum as the paradigm of architectural order. Spaces proposed by Woods would have been deemed 'degenerate' by the Third Reich, just like Kurt Schwitters's Merzbau proto-installations.[12] Poverty, regarded as cultural tactics, rejects stale, pre-twentieth-century notions of art. In *Underground Berlin* (among multiple others of his design), it is depicted as a renegade force that propels social change and reflects the 'living tissue' of cultural production.

After aesthetics, another way of exploring urbanity's underside is through generic modes and settings. In this respect both, the divided Berlin's and post-apocalyptic Philadelphia's undergrounds, stand out as examples of the so-called subterranean fictions literary genre. This type of literature describes alternate, utopian or Arcadian communities living below the earth's crust, although not portraying them as arrested in development. Just like small furry mammals, which survived harsh climate changes that drove dinosaurs to extinction, Woods's spatial models represent forms of compacted living, that could 'hatch' only in warm subterranean regions, way below street level. Both acquire longevity through a system of electronic communication, though in *Underground Berlin* specifically this fact is perceived as an opportunity for heterarchical organization. Reaching further back into the past, one would find a similar spatial pattern in Edward Morgan Forster's *The Machine Stops* (1909), where it gives rise to a dystopian narrative, which informs a large part of Lebbeus Woods's project. With his film script the architect descends further into Germany's history, precisely by descending to the literal underworld – a nonstandardized space, suited for carving out and inscribing it over with his concept of 'radical reconstruction'. An anti-establishment practice, freespaces should be read as an attempt to reconstitute power relations in the city. 'For Woods, politics is ambient. As a manifestation of culture, the political accretes all the styles of knowledge and media of expression that surround it' (Sorkin 2011: 177). *Underground Berlin* brings together a handful of projects realized at the time, adding

them to a Lebbeusean mythopoeia, which, aside from the aforementioned Berlin projects, encompasses *Aerial Paris* of 1989 (flying labs), and *Centricity*. The latter one, with its infamous 'chair' plagiarized by the creators of *12 Monkeys* (Terry Gilliam, 1995), originally from the (Upper) Chamber drawing, can also be spotted in a few sketches included in the storyboard.

In literary theory researchers like Northrop Frye exploited their critical method for the benefit of establishing relationships between texts, which would characterize and distinguish narrative archetypes shared by them. They would point to a set of basic myths repeated in subsequent iterations throughout history. Frye wrote in the third one of his essays, included in the collection (*Anatomy of Criticism*, 1957), that '[t]he structural principles of literature, [...] are to be derived from archetypal and anagogic criticism, the only kinds that assume a larger context of literature as a whole' (Frye 1973: 134). Structuralist discourse came to influence numerous experimental variants of novel form. One of the strategies involved purposefully keeps the storyline in a schematic, if not embryonic, form, in order to emphasize narrative intricacies. The focus would often lie on strategies employed by writers; on specific modes, structures, and devices they use or invent, instead of strictly following the course of events. For example, Alain Robbe-Grillet's type of the 'anti-novel' (although such terms as post-modernist fiction, experimental novel, or 'metafiction'[13] share similar characteristics), made use of stereotypes and conventional storylines, for the benefit of complex and ambiguous structures given rise to in his writings. His primary interest could be distilled to a preoccupation with constructing a highly sophisticated – while at the same time distorted – model of time.[14] Keeping his plots underdeveloped, the author of *Jealousy* (1957) could manipulate descriptive segments of his books, presenting ambiguities of temporal and spatial nature; relativist concepts that would facilitate communicating to the reader the aforementioned issues of representation – the act of writing/constructing a novel. These strategies were focused on making readers aware of the novels' non-narrative content, differentiating the container (structure) from the contained.

Writing a film script from the perspective of architecture, could be considered an enterprise akin to Robbe-Grillet's. Even if its outcome may reveal resemblance to any other script, integrity of depicted environments, as well as primary preoccupation with an architectural anchoring of the storyline, it renders the text an extension, in Woods's case, of *Underground Berlin*'s speculative proposal. Pursuing his idea(s) in other media of representation, the architect did not only turn to convention of film/screenplay – attempting to merge his drawings into linear sequences – but also illustrated them with a narrative deriving from fiction writing, enriching the 'genre' of typical project briefs. Because of this his script is at once a discussion on space, considered as a function of urban politics, and a 'dry run' for the kinetic aspects of his projects in along the likes of aero-living

labs, Projection Towers, or Slip Houses (the last one in response to the San Francisco earthquake of 1994). Despite protests from its creator, who had sued the copyright infringing creators of *12 Monkeys*, even the elevated chair in a desolate 'translation' of Woods's Neomechanical Tower makes a considerable impact on viewers' imagination.[15] It assigns a clearly formulated function (programme), atmosphere, and context for the scene, in what has formerly been an evocative and equivocal inanimate drawing. Unfortunately, Gilliam's interpretation of the seat's purpose has only reinforced its totalitarian connotation (interrogation chamber), which goes against the architect's own. In the sketches accompanying the treatment for *Underground Berlin* the chair is inserted into the Projection Tower's cockpit. This might be the greatest threat that moving images carry with them – making imagery clear-cut to the point of rendering it 'flat', unambiguous – less susceptible to interpretation (as strange as it may sound), though persistent with the illusion of 3D space.

Michael Webb: Temple Island

Imagine 'the volume of air, land and water enclosed by a perspectival cone of vision whose axis is parallel to the plane of the river and whose apex is in the Cyclopean eye of the beholder' (Webb 2014: 61), making a section cut in the landscape from one's memory, a section through a particular space-time frame of reminisced regatta races, as mediated through the act of recollection, in turn, distorted by its faulty mechanism that turns the snapshot into a compressed 3D image, which now appears as composed of trees, green fields, bystanders watching the relay, while inspecting a swath of the River Thames. Complete with predigital artefacts, which occlude portions of it, like shadows that erase the land already surveyed, the very moment you revert your gaze. Dark shadows are cast by objects. White ones, which have eaten away even vaster strips of that English landscape, come together in a view from the hill that you had a hard time recalling. All this is an orthographic projection of a 'palette' of glimpses and impressions, which are too elusive to grasp, pinpoint or assign to them any precise measurements, unlike any other material constructs. This small plot of memory is solidified, along with shimmers of light in the trees, whimsical weather and a sense of agitation hanging in the air. It has been preserved as a snapshot, immersed in a medium that could remind one of frozen aspic. In these preliminary conditions the project embarked on by Michael Webb some forty years ago outlines a nostalgic background for the proper architectural intervention.

This is not about space but one's perception of it. Perspective projection becomes the site of intervention for the *Temple Island* project. Its preoccupations

are with projective tools and drawing techniques at architect's disposal – and their limitations, when reconsidered under scrutiny of general relativity theory. Representational methods involved in the architect's inquiry also serve as ephemera evocative of romanticism, like Claude Lorrain's 'black mirror',[16] rather than any particular building design with a material basis. Instead of supplying the site with another building, Webb

> conceiv[ed] of an epic journey from the observer to the vanishing point. Let it be assumed that the beginning point of the journey is the location of the camera lens, and that the vanishing point occupying the centre of its visual field is the end point.
>
> (Webb 2014: 65)

Insides of a cone of vision turn into the itinerary of his voyage. In his 2014 article for *Architectural Design* Webb suggested undertaking a double trip. In the first one, the image should be treated as a perspectival projection of the site it represents. The second was meant to proceed along the surface of a 1930s photograph of the regatta race, revealing a perspective with its vantage point located in the left upper corner, as if, as beholders, we were tracing a line joining two points on the surface covered by emulsion. While in the second instance movement is executed at a constant velocity, in the first one the observer accelerates. The same composition can either be read either as elevation or as a perspective. Both methods of representation – as Webb's investigation reveals – are rather customary to the picture's content, rather than implied by it.

The submersible and the distorted image

We can see how the project discussed previously relied on a precisely defined timeframe, a historical turning point and a politically neuralgic period, over the course of which architectural proposal was an actual statement, reassessing what media or sociologists were not able to grasp. From there we depart to an event, which is extended in both time and space. This journey is deeply personal. Henley Royal Regatta, held annually in Webb's hometown of Henley-on-Thames, has been a preoccupation of the architect, since his pre-Archigram years, back when he was only an attentive observer, accompanying his father in accounting duties. *The Temple Island*, an ongoing study, appears as a kind of romantic undertaking meant to recover childhood memories with the help of orthographic projections and quantum mechanics. It congeals the perceived landscape in a cone of vision, while the mobile observer, located in a submersible, advances towards the little islet topped with James Wyatt's fishing lodge – perceived as a dot on an ever-receding

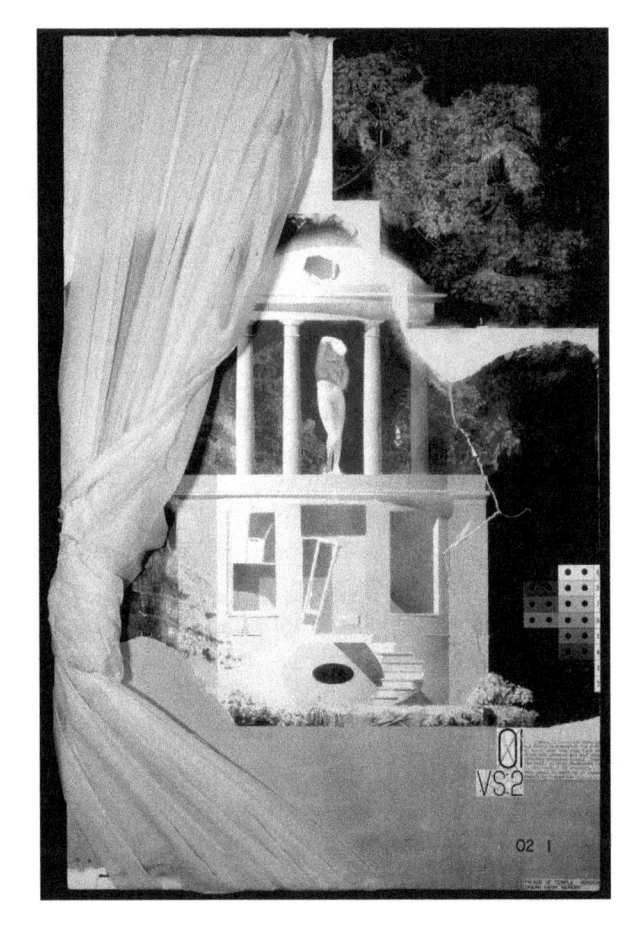

FIGURE 5.9: Façade of the *Real Temple* partly unveiled, Michael Webb © Archigram 1966–84.

horizon. Although commenced in 1977, even ten years later – when the project saw its first major presentation/exhibition at the Architectural Association in London, accompanied by its publication, *Temple Island: A Study* (1987) – this instance of paper architecture has not even neared its completion. Similarly to parallel lines supposed to converge at infinity, the race towards an imaginary Temple Island – one distilled from memory, only vaguely coming in terms with the material – will never reach its destination.

Scouring Archigram Archives, there is at least half as many drawings, photographs, and prints created as extensions of the study, always in dialogue with the initial 'backstory' featured in *Temple Island: A Study* (1987). Presented in the form of a journal that gives off information about date, hour, temperature,

and weather, as any proper sailing log would, it complements Webb's metaphoric summaries of the idea, while accounting for its evolution from a passing reflection on fading memory, to an architectural statement on Virilian *dromology* and Lorentz transformation. It would have felt forced, to search for clear cinematic allusions in this projects, because what genuinely is shared with the art of moving pictures, is an interest in spatiality considered as a function of (the camera's) movement. Webb's observer, or the 'tripper' – as the dreaming submarine's captain is called in the text – operates a kind of *camera obscura*, equipped with a light source (floodlight) that dollies in on distant objects located across from him/her. Both, the setting and present-day rules of the regatta, with its Straight Course and distance of 2,112 metres, arrange fixed conditions for Webb's thought experiment. They stand as survey data to 'ground' this theoretical project in numbers.

In a video recording of a lecture, given back in 1987 at the AA Exhibition Gallery, Webb shows a drawing, which has brightly lit edges around a black pool of light. By describing it as a an axonometric projection, although interpreted through (and limited by) data which are available – concurrently with those that are not – to an on-ground observer (located in the lower left part of the picture), the readers of this drawing are denied scientific impartiality. As trees and islets occlude the landscape beyond the horizon, what we see in the aerial perspective are white shadows cast by figures, superimposed on swathes of land, or, more probably, bodies of water. Areas of the picture-terrain like these, are ones which the accelerating submariner cannot visually access. *The Temple Island* drawings collected on the Archigram Archival Project website (*Temple Island*) reveal plans and sections through the cone of vision, where we can notice these white shadows cast into infinity. A painting of his, titled *Solidified Air Mass Around The Regatta Course* (2002), visualizes these iterated volumes of occlusion, as if they were literal and, thus graphic limits of the projected world. Of a world that has been created in a medium akin to the cinematic one – equally daunting, even when considered as mere reflection of the profilmic scenery. Like an image projected by an approaching floodlight, from an observer's mobile vantage point the Temple is a constellation of dots, which can be interpreted at the same time as a real building and display errors. Upon arrival, as the submersible pulls on shore, the building does not appear any more material than it did when viewed through the periscope. Having disembarked from the vessel, the traveller tries to experience the building, take a look around and beyond its structure. But he cannot see any further, as there is no 'beyond'. Nothing but white shadows of objects constricted by the sleeper's cone of vision, which are inaccessible to us, pretty much like our own memory landscapes, ever more contracted by the focus of equally nostalgic journeys we make.

Site of representation

From there on representational conundrums start to amass with each subsequent drawing by Webb, which presents us with spatial complexities, like orthographic projections of grid lines, fading towards the horizon. They are not superimposed on material space. Instead, they stand for space, providing an unlikely site for the project. In each instance, they highlight the importance of a rephrased version of the 'observer effect'. It postulates that the way we choose to view a concrete object always affects the content of our perception. With *Temple Island* this distortion becomes extreme and apparent, being a consequence of acceleration, an afterimage, affected both by selectiveness of sight (pyramid of vision), and equipment's malfunctioning, as for 'the accompanying images of the study should be understood as light photons received by the retina emanating not from the landscape itself but from a computer screen of the landscape' (*Temple Island*).

Paraphrasing Michael Webb from his 2011 lecture given at Bartlett School of Architecture, initially there was an overriding desire to create a set of drawings that paid homage to the regatta races of his childhood years and their picturesque site. Not the ones captured in numerous postcard views of the period, but experienced by rowing teams, rushing towards the island (in *Temple Island* start and finish lines were reversed). The vessel's acceleration at a constant rate results in two interesting characteristics. First one is an observable contraction of the objects perceived by the moving observer in relation to the landscape; second is the electronic interference, or a technical error we would likely get when using digital technology as a mediator between the oarsmen and riverbank flora, though, more importantly, between the vanishing point on the horizon – the eponymous Temple Island – and a periscopic projection of that area, limiting the field of vision to a circle. Moreover, the vista is relayed by a dot matrix, as if we were beholding an ink jet printout of the scenery, or inspecting it in details at maximal zoom, forcing the optical device to expose limits of the electronic equipment's resolution. Additionally, regarding the style of its presentation, Webb's Henley regatta landscape has a slightly romantic aura. On the one hand, it conjures up an image of a golden afternoon, and on the other – it chooses a serene Sebaldian subject, 'portrayed' in an English countryside, displaying a fixation on the desolate tempietto located on the island. But instead of putting the temple in focus, we should reconsider the technology engaged in this task. Serving as a focal point in itself, the temple is already a ruin, susceptible to digital glitches distorting any sublime views we were expecting to receive through the periscope.

Traces of the *Temple Island*'s theme can be found in Webb's past detours. *Drive-In Housing* (1975), for instance, lends the project its idea of integrating a mobile vehicle with building's infrastructure, a car's body slipping into architectural skin. We will notice this in a symbiotic relationship between two of the submersible's

parts – one that falls away, and that which is transformed into a liveable capsule, hosting a bedroom for the tired traveller. *Cushicle* (1966), installed within a *Suitaloon* (1966), provides for the other example, reflecting on the way user can become integrated with his home or room, which, in turn, cocoons its inhabitant in a reclined position within an artificial womb, just like *Temple Island*'s submarine bedroom does. Especially the first of these coaxes us to think in terms of adjacent shapes, curvatures, and elements that could be fitted into, plugged in, connected to a larger body. A megastructure, perhaps? Webb describes this modularity in terms of a 'longing for the perfection of contour achievable in a car body and its likewise extension of that perfection into the architecture of the house it serves' (Webb 2014: 65). Integrating different technologies into a compatible network of electronic appliances, that which would work in unison, was already a concern for visionary architects from the Archigram group, back in the 1960s. With *Temple Island*'s screened images and technological noise altering the perceived environment, the actual point of entry for a discussion on technology can be located in its feedback coupling of vision and motion. The moving observer of/in Temple Island triggers not only triggers the vessel, which is destined to carry him towards the vantage point, but also 'activates' the landscape conveyed through orthographic projection. Acceleration starts to blur his perception of objects, distorting shapes, while an 'apparatus' of calculated occlusions erases portions of the scenery through volumes of white shadows.

But the vessel too becomes an element of this projected landscape's 'tissue', tailored with the beam of its reflector to the temple's façade – notes Webb, exploring signification of shapes cast by it. 'In its journey from FL_0 to FL_n the floodlight creates a pool of light of changing shape as it moves across the surface of the dome. These shapes, when viewed in orthographic projection comprise the waterlines of the submersible' (Webb 1987: 13). Thus, the submersible-temple setup, while incorporating the medium (of either water or photographic emulsion), through which the former travels in order to reach the latter (regarded as a solidified mass of water, air, and land frozen inside the cone of vision) – is at once the site of the architect's intervention, and an intervention itself. In general, it remains a dynamic account of space traversed and thereby created by this act, as the temple fades into and is recalled back from oblivion by a beam of light. They ought to be analysed separately, first, and then, in tandem – from the perspective of what action does each of them performs in this setting.

Separately #1: The temple

Fawley Temple, the destination of a journey undertaken by Webb's narrative's own Little Nemo, is – in the end – insignificant. Its appearance could be determined

only by speeding towards it. The building is set in motion. Unlike Archigram's mobile constructs of their early projects – *Walking Cities* (Ron Herron) and their gypsy relatives of *Instant Cities* (Peter Cook) – the temple's apparent movement is measured always in relation to an observer approaching the structure in a little submarine. 'Both in memory and upon an islet in the Thames at Henley reposes a temple: i.e. the incorporeal and the real (one), and though the site of each remains intact, the incorporeal temple is fading' (Webb 1987: 18). The temple in question is a neoclassical fishing lodge built in 1771 by James Wyatt, located in Henley, on an islet in the river Thames. Webb has retouched its dome, piercing holes for light to come through, while 'conducting' refurbishment works by adding a double staircase. As seen in the *Façade of The Real Temple, Shown Partially Unveiled* drawing (1984), he represents the lodge as a long-deserted ruin,[17] double-exposed on the landscape behind it, with empty sockets for windows and a partially folded curtain. One could be reminded of a Surrealist postcard upon viewing it, as it gives off an illusionist impression of being slightly lifted, in order to reveal a tarnished photograph or a sepia painting. All these artistic measures make us refrain from considering this part of the project as an example of historic restoration, rendering the temple as an imaginary construct. Retrieved from memory, but immaterial. Even during factual restoration works in 1989 the statue underneath the cupola was eventually replaced. Unlike the partially destroyed original – though also placed there only after the Second World War – it represents a nymph. Beaconing siren song comparisons are needless here, for the figure on a printed invitation to the AA exhibition (1987) is, in fact, the image of an absent object, making this Flatland[18] 'harbour' all the more beaconing.

Separately #2: The submersible

And now for the submarine. Its hull and the cupola have identically shaped orifices, while the boat's waterline has been modelled after the floodlight's ellipse. What is the purpose of such pairings, whose presence could be observed on numerous drawings and texts accompanying the project? Clearly, the introductory text only stirs up confusion. Concerning similarity between: the drawings of statue's 'filmy toga', 'folds of the veil' that partly obscure the drawing, and the way in which a map of the regatta course is blurred by a filter of swirling clouds, each of these elements reveals a pattern that has been iterated at different scales (again, somewhat reminiscent of Sebald's narrative in *The Rings of Saturn* [1995]). Not just activating an analogue archetype of a pattern recognition algorithm, but recognizing the objects and buildings in *Temple Island* as fitting machine parts, this way setting this drawn thought experiment in 'motion'. The

submersible makes a journey, reversing the original regatta course (1839–85). Aside from accelerating, it casts a beam of light that hits the temple's façade, and – over the course of time – allows a brightened circle/ellipse to slide down its surface and slip into the interior through cracks in the cupola. Actually, by perforating the temple's damaged dome Webb created an interesting light show governed by laws of quantum mechanics, applied to bodies moving at close-to-light speed velocities. There are four vantage points at which the lethargic traveller glances through his periscope, each time seeing a digitally distorted array of dots (beginning with a bright white eclipse of his vista, at the position of the former 'finish' line). The closer he gets, the more visual anomalies he encounters. The last of his observations takes place on the islet, where the vehicle splits into two halves, with the front part lifted by a crane. Alas, even at destination point he is unable to behold the view in its entirety, haunted by white shadows. Had the temple – which could be perceived only at precisely defined points of his journey – been an illusion all along? Was this only a visual glitch in his electronic lens, acceleration's side effect?[19] Regarding the austerity of details and incompleteness of the world he surveys, is this still Henley, or its orthographic projection transposed on a cartographic grid? Whether the journey has been made at all is also unknown. When coming across passages such as the following, one might have second thoughts: 'As the tripper looks back over the distance covered, the cones of vision whose vertices are SPL and SPR (located inside his/her lens) transmute into solids, leaving kneecap-shape holes as the only evidence of the tripper's presence' (Webb 1987: 38).

In tandem

Raising more questions than providing answers, Webb even undermines the certainty of architectural objects. It conveys the *Temple Island*'s message through a breadth of imaging techniques, most of which predate computer model making, simulations and calculations. Digital recreations would have resulted in similar, if not identical, projections. By acknowledging that '[t]he journey may be understood either as a venturing into the implied 3D space of the pyramid of vision or as the actual traversal of the two-dimensional surface of the photographic emulsion depicting the pyramid' (Webb 2014: 65), the Prospero of *Temple Island* suggests reading the project as an investigation into systems of architectural imaging, which are by default rendered invisible. Here, they are closely examined, imposed over one another, and 'put to work' in extreme conditions, that is, cases, which concern neither purely concrete space nor actual geographic location, but which target the mechanism of vision, interpreting it from an architectural standpoint.

In his introductory essay Michael Sorkin wrote that *Temple Island* is a thought experiment. One that progresses along architectural lines, though calling upon Heisenberg's uncertainty principle and Lorentz transformation to chart the acceleration of a vessel's body between the 'line of departure' at camera's lens and the temple's vanishing point. At the same time Webb constructs a nostalgic narrative around the regatta race and collates fading memory with fluvial itinerary. This is because, in essence, the submersible's trip is not unlike that of a light travelling from a distant star, a voyage in spacetime. One's cone of vision, with its uninterrupted fling along the river, could be plotted on a graph, giving as a result the future light cone of Minkowski diagram.[20] It illustrates the behaviour of objects moving at the speed of light, that which could also be considered as a 2D translation of the light's pathway, emanating from an event in T_0. Webb's method of presentation graphically interprets time dilation and contraction of length according to special theory of relativity, which would inevitably result from submarine's acceleration. What is worth mentioning is that this method of representation equates spatial progression with the temporal one (also measured in c per second), which gives (presumably) a significantly different meaning to the regatta course as portrayed in *Temple Island*. This interpretation ascribes temporal characteristics to objects in Webb's rudimentary, even algorithmic narrative, forcing us to consider them as events, not just purely spatial phenomena. This is also true of the four observations made, as well as of the pilot's final glancing back straight into the 'lens' of two frozen light cones – a reminiscence of the primary conditions. They predate future materialization of the temple, summoned from its spectral appearance as a hypothetical vanishing point, and subsequently as an image received through the submersible's electronic apparatus.

Surfing on sine waves

One other text, deriving from a tradition of structuralist film-making of the 1960s and 1970s, at once establishes perspective projection as a framework and point of departure for a journey towards an object that is infinitely removed, located on the apparent 'horizon'. In Michael Snow's *Wavelength* (1967) we look at the interior of a studio loft. This is pretty much everything we are watching for the next 45 minutes of the film's duration. The camera is immobile, fixed at a slightly oblique angle, this way upsetting one-point Renaissance (linear) perspective. Instead, it offers the viewer a continuous zoom in, progressing at glacial pace towards a point located on the opposite wall. The point in question is a photograph representing waves upon a ruffled sea – a likely accomplice for multiple wordplays that bring up oscillations like the sine wave of ascending frequency (contraction of cycles)

FIGURE 5.10: Section through cone of vision, circular image, Michael Webb © Archigram 1966–95.

in film's soundtrack, a variety of optical distortion filters allowing the camera to register light rays of different wavelengths, or the play upon the 'fluctuation' of events taking place in the loft space, which unfold and fade somewhere 'on the margin' of this dispassionate close up. Snow, very much like Webb, is interested in transformations that allow the viewer to 'transgress' from a 3D to a 2D systems of representation, highlighting the fact that both are optical illusions. Thus any potential difference must reside in the cognitive act; in the way we read the image, as well as in graphic techniques that either reinforce this illusion, or try to restore our impression of a two- dimensional surface.

> Like any zoom-in, *Wavelength*'s zoom does three different things at the same time. It narrows the camera's angle of vision; it 'flattens' the 'illusory space' perceived on the screen; and it keeps whatever is in the centre of the frame when the zoom begins, exactly in the centre for the full duration of the zoom.
>
> (Wees 1992: 156)

Along with narrative progression, filmic space gains in flatness. This does not happen solely due to our zooming in on a 2D picture, but because of increasing the camera's focal length. Narrowing the viewing angle causes loss of depth in the image. Even though the far-off print grows in size to a point of filling up the whole picture frame, the apparent sense of perspective is practically absent, though superseded by represented space in the photograph.

While initial camera setting exaggerated distance, at close to 45 minutes into the film, the apparent distance is collapsed, just like the swathes of Thames in *Temple Island*, which become solidified in form of past cones of vision encompassing the distance traversed. In turn, if we zoom into the 1930s photograph of the Henley regatta, which Webb never ceases to return to, both *Wavelength* and *Temple Island* seem to focus in their 'journeys' on the intricacies of mechanistic vision and visualization, despite any differences between the two texts, in regards to the speed of movement and their optical/physical disparity. It is because the latter introduces issues of representation and illusory space, as either caused either by changes in focal length, or by a 'Lorentzian-like' transformation of data extracted from submersible's progress and the dot-matrix patterns received. In Webb's storyline – organized along a string of consecutive actions (on 'sleeper's' part) and events (the observations made)[21] – the landscape, which hosts his game,[22] appears as a 'substance' already mediated by the inquisitive gaze, as well as co-authored by the traveller's imaginative recollection. *Temple Island* is ripe with paradoxes, starting from those concerning distance between the observer and the vanishing point. In plan projection they are rendered far apart, whereas perspective projection renders them coincident (Webb 2014: 62). The regatta landscape is partially obscured, not only by a cover of clouds but by white shadows hidden away from the scrutinizing floodlight of the cone of vision. What cannot be seen in the photograph does not exist. Finally, Webb formulates a question probably most relevant to this study, wondering whether the space of the drawing – or any other medium of visual representation, for that matter – might not already be the best possible 'site' for architectural reflection. He adds that what act of drawing gives rise to is a dynamic activity of reconsideration, formulation and 'sketching out'. It should not be labelled incomplete or prosthetic.

In line with previous efforts that could easily be classified as speculative projects, *Temple Island* resembles an assembly kit with incongruent parts. Its

methodologies seem excessive, while descriptions of the intended construction, as well as its spatial implications, are scarce. But this is not one of those projects which are prospected to be built anytime soon. At least not in unaugmented, if not contracted, reality. Rather, it is a series of 'unfortunate events' related to both analogue and binary equipment inside the submersible. The somnambulic explorer is unaware of the failures, even though his vision/concept of the world outside relies on nothing else but the apparatus on board. In consequence, he is a slave to machine efficiency, inhabiting a world that is a (mathematical) function of the mechanistic visual system, constituting a personalized architectural/ memory space. Similar researches concerning architectural space as an extension of user's lines of sight and visual imagination were rather infrequent in architectural history.[23] With the advent of electronic communication, although mainly in recent years, this area began to be explored by Frederick Kiesler's 'descendants', not to mention those who followed in Michael Webb's footsteps. Whereas Kiesler created plans for a *Vision Machine* that interrogates the process of visual perception – interpreting it as a dynamic, active process, in place of a 'simple' mechanistic reproduction of the image – the latter's *Temple Island* veiled itself from complete occlusion.[24] First, he is being fooled by the computerized display, which feeds him with increasingly detailed pixels (although they are not named as such in the text). Then, he is forced to perceive visual data, as if his electronic eye was covered by a cataract. Finally, upon arrival, he realizes that the temple's image he constantly looked at through the periscope is placed behind the actual building. Amidst this confusion we realize that the storyline, survey data, and methods of representation involved are there to convince us that – like in Duchamp's *Étant donnés* – there could be no architecture without the 'visual machine'.

Such a 'flock' of glitches, arranged as consecutive events/locations, only accentuates the protagonist's reliance on techniques of architectural (here, simply spatial) imaging, consequences of which he witnesses throughout his/her journey. Webb puts the architectural status of these modes of representation (architectural imaging) at stake, when he plays around the notion of manifold reading – filtering the image through diverse modes of representation. This converges with interests of structuralist filmmakers. While Snow's camera inevitably flattens space at the point of the narrative's destination, Webb's 'vision machine' preserves it in a virtual state; one which retains only the initial vantage point, a glimpse 'left' on the finish line at Phyllis Court. Additionally, in *Wavelength* the actions perceived on screen are injected into a space, which remains unchanged, without diverting our attention. They unfold and then momentarily fade in the course of an uninterrupted zoom, which ends with an extreme close-up on the photograph of sea waves. The 2D framed picture, we encounter at the end, is there to remind us, that this journey too was made in a series of 2D perspective projections. But does not

Webb's experiment also take us on a trip via a series of cross-sections through the cone of vision, distorted by an electronic relay system?

The scope of uncertainty

Werner Heisenberg, quoted in Webb's book, said that: 'In science, also, the object of research is no longer nature in itself but rather nature exposed to man's questioning, and to this extent man here also meets himself' (Heisenberg 1958: 105), this way unconsciously defining *Island*'s guiding rule. When making statements on built environment, we are in fact – following the rhetoric of *Temple Island* – only making suppositions about the appropriability of tools we have chosen, as well as regarding limits of their application. This idea is reflected in the temple's indeterminate status, conceived of as an object of architectural investigation that emerges from a site in an act of an inquisitive ... introspection – the traveller would probably add. The world appears to him (the traveller) as pre-digested, already interpreted, either by analogue or electronic apparatuses. Each one with a malfunctioning interface, communicating a distorted sense of distance covered (here, river section), or of architecture that is expected to be viewed upon arrival. If the cone of vision, an artificial support for perspective projection, is turned into an object, then Webb presents us with a whole dictionary of architectural imaging methods. Some of them are even stranger than axonometries of perspective projections, employed by the creator to interpret each other, moving away from any firm theoretical basis. 'On' *Temple Island* architecture becomes a thought experiment for optics. Furthermore, Webb provokingly asserts that the journey is a foray into the space of representation, unleashing his complicated plot, which stands against a dogmatic application of imaging methods. In this world we are free to wander, like *The Rings of Saturn*'s narrator – simultaneously in our imagination, in memories, and in landscape. Treating imagination as a locus is important. It privileges and validates the emergence of a stipulated, psychological space, while allowing it to remain heterogeneous, encapsulated in the form of an open research project for understanding relativist paradoxes, which we are likely to encounter at velocities approaching that of the speed of light.

When in the early twentieth century general relativity theory seemed to contradict every theorem postulated by classical mechanics, Lorentz transformations came up as a method to reconcile those presumably disparate systems. Webb's *Temple Island* poses important, though enigmatic, questions, looking back at the history of architecture through space-time lens, noting that methods of description available to us more often than not downscale the 'bigger picture'. Calculations, drawings, photographs, various rendering and projection techniques, and finally

FIGURES 5.11–5.21: Michael Snow, *Wavelength*, 1967. Film still: self-produced (Canada, USA).

narratives – all of them are in fact unable to fully explain the nature of new, intangible spaces, which can be generated with the aid of digital imaging technologies. Neither are they fully capable of elucidating architecture's future applications, along with the limits of its representation capabilities. Therefore, when glancing over his shoulder, having just emerged from the vessel, the sleeper is inclined to understand more than can be seen in the 'frozen' cones of vision. These are material(ized) evidence of a hypothetical journey, being anything but at odds with contemporary excursions in both augmented and electronic spaces. Architecture has already begun to dematerialize into photon streams and images on display

screens, which comprise our most immediate surroundings. If all these are but spatial arrangements of information, why not employ architectural imaging to areas previously inaccessible to constructors, intangible and ephemeral? If the future of architectural production appears to us under the guise of spectral constructions flickering on Temple Island – that is mediated through electronic visors – maybe it is better to evaluate it by the criteria of evolutionary longevity. Not merely the volume it takes up, both on the page and rendered in perspective projection.

Superstudio: The Continuous Monument

The term 'radical architecture' first appeared on the pages of the Italian architectural journal *Casabella*. Notwithstanding later comparisons with other 'avant-garde', 'visionary', and 'experimental' labels, it was suitable enough to convey general ferment and demeanour present in architectural circles of the time. Such conditions brought about a surge of experimental designs and theoretical projects emerging throughout the 1960s. If architecture was to be considered a language, then not every question needs to be indicative, whereas formulating complex questions is a substantially better creative stimulus than providing banal answers in built form. But first, a well-wrought graphic provocation, usually employing a technique of representation that matches the proposal in its ground-breaking character, has to be paired with an ear-catching band name. The one formed in Florence in 1966, established by Adolfo Natalini, Cristiano Toraldo di Francia, Gian Piero Frassinelli, Roberto Magris, Alessandro Magris, and Alessando Poli, was christened Superstudio – a name that indicated conceptual prowess, but at the same time a tripartiteness of its endeavour, which concentrated on issues of monumentality, architectural image, and – predominantly – image's role in discourses on pop art and mass-produced objects. 'Natalini proposed the title Superarchitettura: promoted to be "the architecture of superproduction; superconsumption; superinduction to superconsumption; the supermarket, superman and super gas"' (Lang and Menking 2003: 13). Their path of counter-consumerist statements comprised of a conceptualized series based on infinite expansion of the perspective grid, rendered as an architectural object, cutting into, and wrapping up the landscape like a cooking chef.

Life without buildings

But Superstudio's effort goes beyond plain rendering skills. Confronting viewers with images of over-rationalized reality, in which every environment is turned

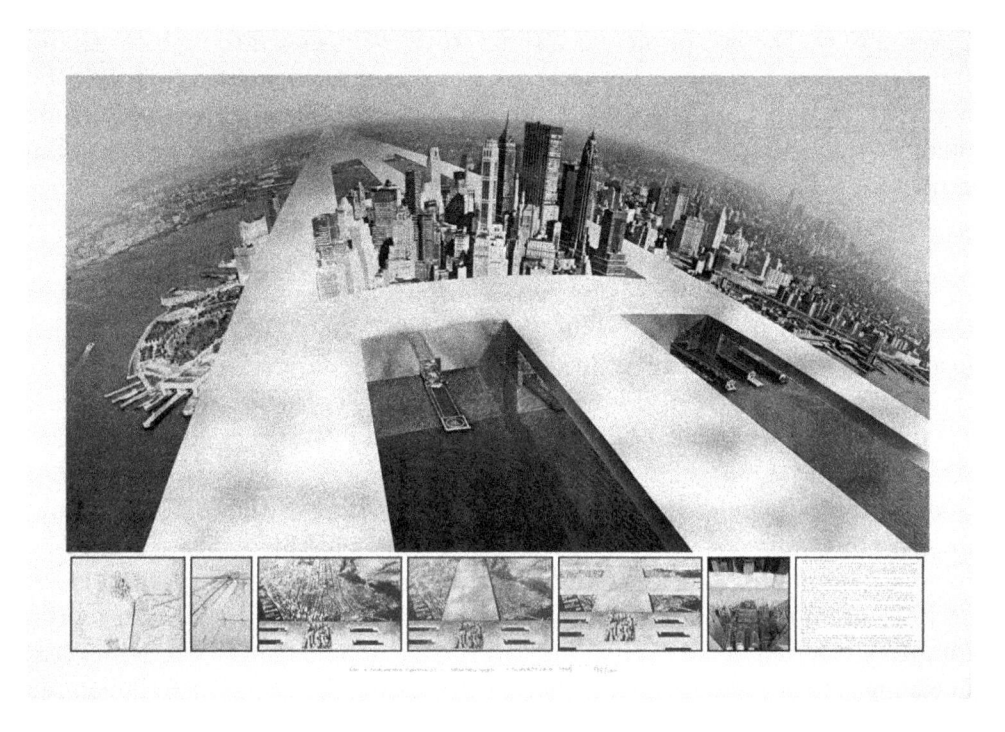

FIGURE 5.22: Superstudio (Gian Piero Frassinelli, Alessandro Magris, Roberto Magris, Adolfo Natalini, Cristiano Toraldo di Francia, Alessandro Poli), *The Continuous Monument: New New York*, project (1969). MAXXI Museo nazionale delle arti del XXI secolo, Roma. Collezione MAXXI Architettura, Archivio SUPERSTUDIO.

into an artificial setting, the dissolution of architecture is performed through blurring distinctions between Nature and civilization, epitomized by the image of the city. From object design to urban planning, conversely, the histogram – as Superstudio titled their series based on programmatic tessellation of the smallest unit of graph paper, the square – is turned into an expanded Cartesian grid of *The Continuous Monument* (1969). Nothing can stop the grid from taking over the planet. Superstudio's most famous graphic statement is that of a unified architectural superstructure, proliferating from simple geometric shapes. This 'model for total urbanisation' encapsulates cities. It turns them into images by mirroring their architecture in the surfaces of its walls. It mimics building typologies and invades natural environments with the force of rationalizing regularity. As Gian Piero Frassinelli remarked in retrospect (Frassinelli 2003: 80), group's subsequent projects were intended as evolutionary stages of this initial 'histogrammatic' idea, this way bringing together *The Continuous Monument* series (1969), *Architectural Histograms* (1969–70), as well as *The Twelve Ideal*

Cities (1971). The last of them is a short story cycle, meant to narrate group's static imagery. Actually, each of these projects was concocted as a didactic narrative, mainly cantilevered by cinematic strategies of juxtaposing moving imagery with sound – an idea already underwriting their first animated film production, *Interplanetary Architecture* (1967). It is impossible not to notice the way it *Interplanetary Architecture* references Stanley Kubrick's *2001: A Space Odyssey* (1968), to which their numerous subsequent collages will refer to; evoking its production design, even quoting specific scenes, that is, by the choreographed camera movements and astronaut's slow ballet. Although here, instead of Johann Strauss, the slow-motion dance is made eerie due to a sound-track comprising of tribal drums and folk music, giving the scene an ethnic, if not outright archetypal feel. The fact that Superstudio's most important projects were conceived in storyboard form can be explained not only by group's interest in expanding the language of architectural imaging. Envisioning their output in transgressive terms, they employ the rhetorical mode of inquiries in drawing to envision both the future shape, and rumoured origins of architecture. Here, architecture is (again) a ritualistic practice, meant to give form to human activities. In a way similar to Archigram's, the prime of Superstudio's activities was in waging a 'war' that has already been lost, battling the inertia of architecture's absorption into commercialism and consumer economy. Rendered this way, the group's architecture could have resembled 'unisex' containers, like *The Continuous Monument*, that bring solutions to problems, let alone those raised by architecture in the first place.

Superstudio's ideal of architectural discourse involves living considered as space-making practice. They called for a nomadic lifestyle, increased mobility, and lesser dependence on commercial goods. Unlike the 'Summer of Love' utopia of parked vans, wigwams, and queues at rock festivals, the so-called SuperSurface could have only come to exist in communities organized around communication nods, because it hosts nests of electric cables and media providers, plotted around the artificial landscape in a fashion typical of projects predating the era of the wireless. As Natalini once remarked, the dissolution of objects was a manifesto targeted at objects regarded as denominators of power and status. Material commodities and our most immediate surroundings – in Superstudio's perspective – were shaped by the same force of commerce. Life without buildings was thus a nomadic, and communal vision conducted on a supporting frame of an immobile, sterile, and invasive structure of *The Continuous Monument*, which embodied Modernism's oppressive leanings gone rampage on the world. Given the subversiveness of group's collaged perspectives, we quickly notice, either in *The Continuous Monument*, or in *Twelve Ideal Cities*, that each envisages

a 'moderate utopia' to imagine near future in which all architecture will be created with a single act, from a single design capable of clarifying once and for all the motives which have induced men to build dolmens, menhirs, pyramids, and lastly to trace (*ultima ratio*) a white line on the desert.

<div align="right">(as quoted in Lang and Menking 2003: 11)</div>

In this boundary-defying effort, Superstudio's projects were joining two faraway ends of the scale: micro- (object and furniture design) and macroscopic (architecture, urbanism), struggling – by means of unwieldy, fantastic images – to conceptualize man's interventionism and the human drive towards creation of artificial environments. Independently, whether we take cities, or living rooms, in their histograms series, Superstudio was taunting mass-scale, instant, tabula rasa solutions to urban ailments. Their architecture was everywhere, and at the same time nowhere. *The Continuous Monument* aimed at dissolving one's settings in the process of 'total urbanization', very much like the 1978 Venice Biennale installation (*The Wife of Lot*), in which dripping water slowly eroded salt models of famous buildings, with Le Corbusier's *Pavillon of the Esprit Nouveau* and *Palace of Versailles* among them. Beginning in 1966, and grinding to a halt about 1978, the group's activity focused on artifice and edifice, both pursued with the aid of collaged imagery, opening up to a range of influences from outside arts. 'The architecture of the image provoked an extensive visual experimentation into techniques and appliqués, appropriating from diverse sources, such as collage, pop art, cinema and dada' (Lang and Menking 2003: 16). In the end, it turned out to be cinema that best approximated Superstudio's idea of total urbanization, capturing the irony behind it.

Scripting total urbanization

Unsurprisingly, the narrative of *Five Fundamental Acts* (1972–73), a quintet of short films illustrating main aspects of super-existence, was scripted as an educational documentary explaining every intricacy of living your life upon the SuperSurface. A generic place, which can be located either on the inside, over or in the neighbourhood of *The Continuous Monument*. From the five fifteen-minute films planned – *Life (SuperSurface)*, *Education*, *Ceremony*, *Love* and *Death* – only two instalments were eventually realized at the time (*Life*, *Ceremony*). The rest were animated a few decades afterwards, in the form of narrated slide shows. *The Continuous Monument* itself had been devised, in the first place, as a series of storyboards, complementing a script that, only now, on the occasion of Superstudio's retrospective held at the Museo Nazionale Delle Arti del XXI Secolo in Rome

('SUPERSTUDIO 50'), was turned into a proper film. Illustrated storyboards, taken as technique of composition, served as a 'map for orientation' – a way of bringing context to the forefront of the presentation, precisely because no landscape raided by the Monument escapes becoming reflected and diffracted by its surfaces. 'Not a technologically determined mega-structure, but instead a sort of neutralizing living architectural volume that could be laid across finite or infinite space' (Lang and Menking 2003: 20). In the first instalment of the partially realized *Five Fundamental Acts* the narrator offers us a glimpse into a gridded landscape that would have stretched beyond the horizon, if it were not for a mountain range occluding the view. But then again, are mountains a true barrier or just a ruckle in an endless plane of orthographic projection?

'The *Five Fundamental Acts* represented a thesis on the metamorphosis of architecture into life, calling for architects to abandon their callings and express themselves by living architecture' (Lang and Menking 2003: 175). In a similar way to the sequence of still images in the *Continuous Monument* project, in *Five* it becomes translated into a set of instructions, schemes and collages – zoomed in and out. The film combines live-action footage with animated organization schemes, each illustrating the story's central argument. The final sequence of *Life (Supersurface)* follows a happy couple in a rural landscape, who sit by an electronic board of the SuperSurface. A few scenes earlier, the narrator was explaining the history of SuperSurface's formation helping himself with animated panels in which perspective grid lines are drawn over a docile terrain, embellished with 1950s-style 'kitchen sink' adverts. In the narrative a typical laudation for the product is substituted by an instant solution commercial, courtesy of Superstudio. The filmmakers have been following a similar strategy to the one employed in their collages. In regards to photographic material and draughtsman's interventions, their strategy is therefore a 'process of extracting "ready-mades" and considering potential relationships and juxtapositions precisely defines collage-making, revealing Superstudio's design process to be one illustrative of a collage mentality' (Shields 2013: 108).

An intrinsic aspect to the collages created by Superstudio is their dependence on principles of perspective drawing, with the grid and pure geometrical shapes of the *Continuous Monument* partitioning, arranging and ordering the space of representation. Springing up in front of buildings and infrastructures, which display their indexical quality indicative of real-life contexts, the *SuperSurface*s of group's inventions appear as forceful impositions of a perfectly translucent grid over the land. If, as members of Superstudio argue, architecture is the ultimate way of imposing cosmic order on earth, then implementing architectural solutions as sole backdrop for action deliberately unmasks their 'remedy' as highly ambiguous and self-sabotaging. Superstudio's activity was symptomatic of a general backlash

to previous, more 'positivist' utopias that were used to envision future as something that effloresces in the crevices of a heroic megastructure. Radical architecture marks a point in history when 'spatial cities', along with other instances of 'spatial urbanism', ceased to be taken at face value. Superstudio's proposals were critical, ironic. They presented the absurdity of domestic situations that unravelled on endless planes of misfortune – sterile surfaces that do not bear any marks of habitation. They gave infinite freedom, but at the same time confronted their users with settings made out of obtrusive geometry, discomfortably right angles and parallel lines that would colonize space, replacing untamed flights of imagination with graph paper templates. They are like cut-outs for Cartesian minds (ages 1637–1972).

Collaging the continuous city

Taking 'architecture of the image' as one of three main lines of inquiry, the group polemized not so much with the discourse of paper architecture as with a commercialized notion of imageability. Superstudio decided upon a strategy of graphic provocations that shy away from the exploded technical views characteristic of Archigram's designs. It relied on visual 'conflicts' arising between the sources of elements 'cited' in their collages/drawings. This way their productions clearly bear marks of two disparate graphic registers – the first one detailed, due to the grainy quality of photographic quotations from, for example, the New York skyline; the second remaining a hypothetical construct, devoid of distinctive features, scratches or specks of dust. Jennifer A. E. Shields wrote in her *Collage and Architecture* that

> [the] *Architecture of the Image* led to experiments in graphic representation that included collage-drawings: architectural line drawings integrated with and juxtaposed photomontage elements. The speculative projects illustrated through collage-drawing were frequently published in architecture magazines including *Domus*, *Casabella*, and *Architectural Design*.
>
> (2013: 106)

But images submitted to magazines and exhibitions were never merely plausible, drawing much of their evocative power from the technique of collision. This subversion of architectural conventions from within has been noticed by Peter Lang, who writes:

> SUPERSTUDIO effectively campaigned to destabilize modern architecture while remaining within the enlightenment language of perspectival space or, through

their filmmaking, operating within the Cartesian construct of the *camera obscura*. SUPERSTUDIO therefore did not so much seek to challenge the conventions of representation, or what Martin Jay classified as 'Cartesian perspectivism', the projection of the two-dimensional single ocular perspective, as they sought to operate to subvert the principles of architecture within this convention.

<div align="right">(Lang 2003: 44)</div>

And what if the site of intervention is at the same time representational space, as in the case of Michael Webb's project? The space in which the viewer is supposed to immerse? To rival the convention from within is to test out limits of a given method, rendering construction process visible. One method involves depicting objects that could be read as illusion-reinforcing 'props', not unlike painted frames, curtains or flies that ostensibly took a few moments' rest on the surface of a Baroque painting. In architectural terms this would translate into objects and patterns that echo the technique used in achieving a specific type of projection. For instance, Webb's perspective grid cast by the moving observer's range of vision overlapped with constructed 'guidelines' in the drawing. Furthermore, it introduced ambiguity to the composition by means of axonometric projections of vision cones and perspective projections of grid's latticework.[25] On the surface Superstudio seems to be less radical. They too invent urban/architectural constructs that reappropriate space, along with the horizon and its vanishing point. In their most famous project they break up the picture plane by means of a Cartesian object, which reflects immediate surroundings in its texture, as in the example to follow. Among the more evocative compositions in the *Continuous Monument* series, there is a collage showing a segment of the superstructure placed around a waterfall. Because it is translucent, we only notice its edges, being contours of the monument's shape. The colossal object's 'contents' appear to the viewer as mirror images – fractured areas of the environment, which diffract its surroundings, like a glass of water diffracts a beam of light. Therefore, we instantly read this landscape as itself as a kind of contorted mirror reflection, not really rationalized or ordered by the architecture at its centre, but reconfigured into a constructivist riddle.

The second film out of the five planned, *Ceremony*, is also mostly live action. If *Five Fundamental Acts* can be regarded as a single cinematic text, then *Ceremony* feels like the Book of Exodus in terms of its subject and position in the overall structure. Exodus: A Remake, perhaps, for when in film's exposition people leave their underground concrete dwellings, they immediately replace their forsaken home with a performative gesture – namely, a set of rituals that define a typical household. In the opening scenes humans emerge from an orifice in the ground, while the narrator off-screen describes this event as an archetypal paradigm shift. This way a shift from a traditional former concept of dwelling as shelter to a 'dwelling' – as

an intransitive verb, better adjusted to the nomadic traits of their inhabitants – is being accentuated. Instead of Cushicles, however, we see furniture-enclosures extracted from an infinite histogrammatic plane, devoid of household objects. This necessary relocation is meant to encompass commodity-based perception of one's shelter. The new house heralds a dissolution of the old house – his narrative lingers on. The 'future' arrives in the shape of an open house, or an inhabitable area of SuperSurface's artificial 'grassland'. The aforementioned architectural 'gesture' could be read as an act of recognizing the discipline as primarily dedicated to place-making, but simultaneously – given the ironic twist in each of Superstudio's projects – it is a Jean Tinguely type of apparatus that administers its own decomposition. As Spiller wrote in his *Visionary Architecture*, 'Here was an attempt to create architectures that simply and suddenly sorted themselves out, that could be applied to any scale, from furniture to city, and that could be used in any way the user wished' (2007: 86–87), wrote Spiller in his *Visionary Architecture*, being in accord with statements in Superstudio's film, hastily adding that the next step would have been to conceive of buildings for yet unknown ceremonies.

Both, the demonstrative parable of *Ceremony*, and the 'guidebook' readout of *Life (Supersurface)*, have been conceived as segments of a symbolic journey meant to re-establish new connections between fundamental 'programs' of one's existence. Short parables and illustrated lectures of: *Life*, *Education*, *Ceremony*, *Love*, *Death*, look into these eternal aspects of being human, considering them as prime movers for the design process. As such they are better exposed due to a rumoured neutrality of architectural settings. In her book Jennifer Shields emphasized the fact that in Superstudio's collages the graphical motif of the grid is imposed at various scales and contexts, from interplanetary to domestic one. The projects by the Italian studio seem to privilege ratio over precise measurements, along with the ascalar qualities of depicted objects, which can be translated as a method of abstracting data and indexical referents. Total urbanization, as laid out in their models, does not concern any single city, even though we are convinced to have recognized New York in some of the collages. To an even greater extent this synecdochical New York resounds throughout *Twelve Ideal Cities*, where any indexical comparisons should be withheld in favour of allegorical ones. Recognizing concepts, like the Functionalist City, or Mass Social Housing Projects, is more important than name-dropping specific metropolises.

SuperFilm

Arriving quite late into the game, Radical Architects countered purely formal proposals of the 1950s 'spatial urbanism', employing a performative angle in their

argumentation, and supporting their projects on (visual) storytelling. As Lang observes,

> [SUPERSTUDIO] films [...] retain basic narrative structures and follow largely rational progressions through space and time, but use the medium instead to call into question the meaning of architecture itself. From the beginning SUPERSTUDIO built its projects using the narrative vehicle of the storyboard.
>
> (Lang and Menking 2003: 45).

Underlying all this is Superstudio's attempt to base stories on their evolutionary proposals. Recognizing them for what they are – namely, critical pieces belonging to the realm of paper architecture. They organize their spatial ideas around specific themes, which are presented in a genre of educational films (narrative mode, rhetoric), although exhibiting a wide range of references, and openly flirting with science-fiction mode of storytelling. As previously noted, Kubrick's *2001* lends the entire structure of its chapters – devised as giant leaps in the evolution of mankind, towards its goal in space travel and extra-terrestrial exploration – to Superstudio's *Continuous Monument* storyboard. Moreover, that film's visual language becomes recognizable also in numerous other projects, including the slide show reconstructions of the studio's unmade films.

The storyboard for a film based on the *Continuous Monument* project has first been serialized, beginning with the 1971 issue of *Casabella* (no. 358). Already in the initial frames, conjuring up verses from Genesis and Revelation, one can find allegorical overtones of Superstudio's narrative, touching upon the morphology of architectural forms. And the forms follow through, from their rumoured mythical origin to a commodity-free future. Even in the soundtrack it is stated that 'all history lies between chaos and architecture'.[26] They unveil humankind's desire to encapsulate the world through description, to seal its conquest by means of measurements. *2001*'s chaptered structure[27] informs the narrative's progression, as well as its tone. 'Our story is just a parable of formalization', they state in the exposition, explaining that 'it is a story of deserts, both natural and artificial, deserts where clouds may come to earth or where clouds are born, then to generate geometrical, long-awaited apparitions' (Superstudio 1971: 20). In the panels ns. 18–20 seismic tremors uncover a Platonic solid buried in the desert; a mythical – and probably just as mystical – origin of architecture. Image of a perfect cube will return in the *New York of Brains* (*12 Tales for Christmas*), or visible in the collage depicting a vacant lot or wasteland dwarfed by a monolith. 'Thus geometry appears, the first character in our parable. The square block is the first and last act in the history of architectural ideas, as the intersection of the relationships between technology/sacredness/ultimatism, between man

FIGURES 5.23–5.26: Superstudio, *The Continuous Monument* (*Il monumento continuo*) (storyboard), 1969, published in *Casabella*, n. 358, XXXV (November 1971), pp. 19–22.

FIGURES 5.23–5.26 (continued)

FIGURES 5.23–5.26 (continued)

FIGURES 5.23–5.26 (continued)

machine rational structures of history' (1971: 21). In subsequent frames the block undergoes a series of transformations with the first of them being mitosis, while the last one – dispersion into a handful of architectural seeds, encumbered with their ideal form.

After this ontogenesis the story's narrative mode changes to a guided tour around a 'drive-in museum of architecture', which takes us from an image of the art object representing two black marble prisms joined by a neon rainbow, to various utterances of 'dream architecture,' peopled with inhabitants, looking, as if they were extracted from tourist brochures. Nonetheless, the journey is highly educational. We are reminded of the works created by great visionaries of the past, both material and unbuilt, from Joseph Paxton's Crystal Palace to *Ville Radieuse* to Boullée's *Cenotaph for Newton*. Is this a fatamorgana, or merely a montage of images projected by the neon tube? Again, we experience a change of scenery, being carried now to an unspecified post-apocalyptic future – a *dawn of man* sequence, although set in the desert, where a gateway looms on the horizon, composed of black cuboid shapes. The camera pulls back, and the shot reveals an entry to the crystal cube. Among multiple apparitions this has only been the first one. Architectural elements detach themselves from their original context. Next in line is the door, the corridor, stone (foundation), and the wall. While the U-shaped structure hides a tall thin corridor from which three airplanes fly out, startling the audience, the Stone, like *2001*'s black monolith, begins to hover above the surface. 'It contains the distorted image of the city, the great technological circus. The black mirror in the sky is intelligent and immobile' (Superstudio 1971: 22). In subsequent scenes the stone lands on top of the walls standing opposite each other, so that it serves the function of a roof. We notice a man traversing the space in between these walls, who – by the above-described act – finds himself trapped in a dark long and dark tunnel. When he is about to reach its end, a bright light suddenly blinds him, revealing yet another structure born out of these topological metamorphoses – the Continuous Monument. 'Envisaging the progressive impoverishment of the earth and the now nearby prospect of << standing room only >> we can imagine a single architectural construction with which to occupy the optimal living zones, leaving the others free' (1971: 22).

A single vast body of architecture offers solution to the shortage of living space, but it also performs a solipsistic task of paying a homage to architectural inventiveness. It is an unalterable image that dwells on its own 'non-site specificity'. Otherwise, it is a monument for serene longing and contemplation, dedicated to the human urge to leave a mark upon the face of the earth. A genuine 'monument to end all monuments' – noted Salo in his journey log. An excerpt from the storyboard's initial frames explains the rationale that brought this megastructure to life.

Then, when human signs are not elementary solids, they are long continuous lines, a theory of elements, the expression of the same will to sign and measure. Bridges, Chinese walls, or aqueducts are still continuous monuments, also lying full length to embrace the earth.

<div style="text-align: right">(Superstudio 1971: 20)</div>

In consecutive scenes we see ancient monuments either protected or partially swallowed by the Monument. Alongside lie wonders of modern architecture, like the nameless ring junction reminiscent of Rome's *Grande Raccordo Anulare*; although here it is labelled as one among multiple precursors to the Continuous Monument. The Monument in itself (and within itself) preserves significant sites. Central Park, for example, stands the test of time next to its fossilized kin, submerged in resin, solidified into amber. It keeps a record of the 'memory of a time, when cities were built with no single plan' (1971: 23). By rendering the status quo obsolete, it silently promotes itself as ultimate solution to problems concerning a 'domestication' of space. Presented in this manner, the storyboard for *The Continuous Monument* follows mankind's struggles with meaning as inscribed in built form, and expressed by programmatic and typological concerns. Recognizing whether architecture communicates shelter rather than commemoration. In other words, 'Hello, Tralfamadore – Salo sends his greetings.'

While the project – a series of collages – remains a provocation encoded in architectural form, *The Continuous Monument* – as storyboard – is more of a primer to Superstudio's vision of architecture's symbolic purpose. Whereas Superstudio's decision to put across their ideas in sequential form should be read as anything but a didactic detour, the group's script emphasizes the role of temporal development in transformations of depicted forms. Their evolutionary character conjoins basic shapes with complex configurations, against the backdrop of rituals and symbolic practices. It cannot be narrowed down to the eye-catching imagery of their collages, and makes sense only in the context of *The Continuous Monument*'s epic storyline that discusses archetypal forms and typologies. Film form makes transitions important, just like its profilmic – or in this case drawn – content, while stressing the importance of specific juxtapositions (concepts, symbolic objects, actions presented). The sequence depicting movements and changing configurations of cuboids on plane establishes a connection between building typologies and the transitiveness of single elements contributing to the architectural organism, or building (the narrow way/corridor scene). Superstudio's film project examines primal acts that contribute to the 'creation of architecture', simultaneously perpetuating this modus operandi in an age of integrated design, increased mobility, even nomadism. It also prefigures the dissolution of artificial environments by intelligent technologies

FIGURES 5.27–5.32: Superstudio, *Supersurface: An alternative model for life on Earth*, 1972. Film still: Marchi Produzioni, Italy.

that turn designs into extensions of a gesture. In an ironic manner Superstudio shows that Utopia – if it were to arrive at all – cannot be inscribed with any preconceived modes of habitation. Not unless one stops misreading optimal as universal.

Caution! Urbanism at work

In recent years Gian Piero Frassinelli's collection of short stories has been turned by its author into an essay film composed out of slides Frassinelli writes:

> [While] Adolfo [Natalini], on a trip to the United States, discovered primeval forms in a meteoric crater, in Arizona, I 'improved', in my terms, *The Continuous Monument*, striving to explore the abysses of imbecility and horror that produce our beloved Ideal Cities.
>
> (2003: 80)

Preceding the Italian language version by months, this collection of inter-related short stories was first published in the December issue of *Architectural Design* (1971). Each of the twelve 'ideal' cities poses before the reader a similar question. Every city-story is centred around the idea of an inhuman metropolis, which exploits its inhabitants, reducing them to anonymous strings of data fed

FIGURES 5.33–5.38: Superstudio, *Ceremony*, 1972. Film still: Marchi Produzioni, Italy.

to the machine. Previously, in the case study of *The Continuous Monument*, we were looking into a storyboard complemented with fragmentary narratives. With *Twelve Tales for Christmas* we will encounter the opposite, for each parable is accompanied by schemes, diagrams, and perspectives of the cities described. Most of them are quite meticulous due to the inclusion of precise measurements and dimension ratios. In other aspects Frassinelli's cautionary tale draws on a wide range of literary influences, including hard-boiled science-fiction parallels, partially listed in Daniela N. Prina's academic paper, published in *Writing Visual Culture* journal, namely Jack Vance's *The Houses of Iszm* (1954), Robert Silverberg's *The Man in the Maze* (1969), Arthur C. Clarke's *The City and the Stars* (1956), or Frederick Pohl and Cyril M. Kornbluth's *The Space Merchants* (1952) (Prina 2015: 6). As each of these novels was issued in Italy as an instalment in the thematic series called *Urania*, speaking of a 'direct influence' in terms of content would have been misdirected. Issues of *Urania* were always accompanied by extravagant and surrealistic cover art. As a potential reference it also made its way into several of Superstudio's collages.[28]

With visual and textual 'storylines', which are equally important to the project, Frassinelli's cities are demonic extrapolations of contemporary trends and biases in urban planning, also addressed by the aforementioned authors.[29] Superstudio/Frassinelli's cautionary tales present a nightmarish vision of cities that constrain freedom, instead of channelling it. Generically, they are symptomatic of the dystopian turn of the 1950–60s, preceding 'hard-boiled' works of Philip K. Dick and

156

J. G. Ballard.[30] Although Frassinelli's short stories have been written in a 'dryly' instructive tone, their focus lies on an individual's existential 'pathway' through city's 'peristaltic' system. Each of them exemplifies the ultimate form of governance and biopolitics, administrating/engineering their citizens' lifespan, living conditions, occupation, and position in social hierarchy. In each case we are presented with detailed descriptions, as well as spatial layout of the structures. Unsurprisingly, one mirrors the other as similar features are shared. Most of the cities are capsular, often confined to simple geometric forms, appearing to citizens as enclosed systems governed by obscure, non-negotiable rules, which prevent any freedom or possibility of change. Welcome to *Brazil*.

And so, the *2000 Ton City* suppresses revolutionary defiance with the help of a massive ceiling generating pressure of eponymous weight. In terms of plan it is a single enclosure, divided into parcels of equal measure, serving as a surrogate environment feeding its inhabitants 3D images, sounds, and smells emitted from walls – a 'trace' left by E. M. Forster's *The Machine Stops*. Permanent surveillance is maintained with severity. The tone of Frassinelli's descriptions evokes sacred texts could not get more oracular, when bringing up 'cubics' as the unit of measure. In an adaptation of this tale into a slideshow, created by Frassinelli decades after, we' will see images quoted from *2001* accompanying the narrative. One of them displays HAL's interiors and astronaut David Bowman attempting to shut down the malicious computer from within. Other Frassinelli's stories are built around similar quotes from cinema and visual references to gargantuous, enclosed systems of city-states, which go as far as to 'grow' their citizens, and dispose of them, when their 'expiration date' comes (*Spaceship City, Continuous Production Conveyor Belt City, Temporal Cochlea-City*). Some of them promote social struggle, like such as the *Conical Terraced City*. Narrated in a Borgesian manner, the story resembles an instruction for an ancient rite, this way bringing out the text's allegorical nature.

While focusing on the cyclical character of city-systems, any sense of specific time and place becomes blurred, which makes distant future – of a nuclear winter scenario – resemble primordial past. Among the exceptions there are also direct references to existing agglomerations, as in the *New York of Brains*, set on a post-apocalyptic 'day after'. In this scenario mankind has been exterminated by a pandemic. In an attempt to salvage its remnants surviving disembodied brains were put inside a silver cube, 180 by 180 feet in length. Each brain is stored in a little box and kept in suspended animation by the machinery located at the cube's base. Even among debris and ruin rational organization is bound to emerge, even if reduced to its capsular form. What is substantial in all these short stories is their temporal dimension. Urban infrastructures and architecture is collated with narrative's exploratory mode. Of great importance is also their connection to utopian literature. In each tale precedence is given to spatial 'mapping' of the authoritarian system, primarily through

the oppressive dimension of architectural structures. This dimension manifests itself in the perfect cube of the repository/cemetery for citizen's conscious remains; the 'social ladder' layering of the *Conical Terraced City*; or the centrifugal arrangement of cells that undergo a 80-year cycle in *Spaceship City*.

The second narrative – *Temporal Cochlea-City* – is no different. In fact, it best exemplifies how a description of spatial arrangement serves as the carrier of architectural meaning. Viewed against the framework of society, the life of its inhabitants – cycles of birth and stages of ageing – is cast into an image of a gigantic screw, 4,5 km in diameter, driven into the lithosphere. Through a horizontal cross-section a concentric array of cells is revealed. The machine maintains a steady pace of one revolution per year. While digging deeper, in the direction of the earth's core, it leaves behind levels of built-over structures, that go up to the surface. They retain the screw's spiral shape, along with its circular highways. These radial roads connect the surface to the level at which the city is located at a given time, yet they are closed off near the exit by an automatic building site.

> The city is composed of living-cells arranged in a double row of concentric circles. Between the two contiguous circles of cells runs a roadway. [...] Materials used for building the city remain unaltered for a century, without maintenance; then they begin to degenerate; this is also true of the equipment and machinery.
>
> (Frassinelli 1971: 737)

Birth and death cycles are embodied in the tale with the 'vibrating building site', and the 'zone of extreme old age', with the latter located near the 'spirals of decay and putrefaction of things', deep down below. Citizens are free to live as they please, except for straying outside of the designated area. Still, they are lured to the closed-off sectors, where new life is formed.[31] Besides, burial grounds are located far away from the active construction zone – the noise of revitalization.

In the *Cochlea City* segment of the *Twelve Ideal Cities* slideshow we see museal mummies, associated with those parts of the story that touch upon Cochlea City's resemblance to a necropolis. Some of Frassinelli's descriptions stress the role of such factors in its organization as the immobilization of citizens, confined to their enclosures; or the fact of experiencing the world indirectly, through televised images, tubes, electrodes planted into one's brain. *City of the Hemispheres* is yet another example of this 'descriptive mimicry', as its spatial layout reminds one of a field filled with transparent coffins. Each of its cryogenic vampires is connected to a system providing media and feeding tubes. The city's 'CPU' not only controls thoughts but also exercises a scenario repeated, for example, in *The Matrix* franchise by The Wachowskis (*The Matrix*, 1999; *The Matrix Reloaded*, 2003; *The Matrix Revolutions*, 2003; *The Matrix Resurrections*, 2021). The city allows its inhabitants to navigate their

'avatars', which look like 'hemispheres' hovering directly above their pilots, resembling globules in René Magritte's painting *The Voice of Space* (1928).

Literary dystopias link Frassinelli's work to the *Continuous Monument*'s persistent image, which, in turn, is an antecedent of the perspective interior 'views' presented in group's 'cautionary tales'. In them, human lifecycle is often linked to the working cycle of a machine, reinforcing a mechanical reading of these urban realities. The Grand Factory in the *Continuous Production Conveyor Belt City* is responsible for producing new housing units, maintaining a cycle linked to their use and to a practice of forsaking old ones as they fall apart. It is a moving city, although resembling a glacier, rather than Herron's insectoids. Like a glacier, it leaves behind a trail of outdated scraps, desolate houses, ruins – a 'detritus' inhabited by 'lunatics', who dare oppose the housing lifecycle, thus defying market economy as well. As Superstudio's narratives imply, such rebelliousness should underlie every 'smart' act of 'intelligent' city-making.

Conclusion

The Continuous Monument and *Twelve Ideal Cities* employ alternative modes of storytelling, in order to construct a visual and textual critique on urban planning *c.*1960s. They attack the concept of a Functionalist City, along with failed urban renewal, housing and planning schemes. On the other hand, Superstudio's narratives ridiculed automatization in relation to architecture and mass media, often hijacking the language of pop art in their collages or techniques of moving imagery, not to mention an ironic strain, attained through collage and film techniques. In her paper Prina highlights yet another factor that places Superstudio among experimental art movements, as they express their points with a wide range of representational strategies.

> Italian Radical operators therefore resorted to old and new avant-gardes' expressive stratagems (such as manifestos, performances, etc.), pushed architectural practice beyond its concrete applications and widened it conceptually, into the sphere of a sort of architectural criticism, exploiting the possibilities offered by the intersection of visual and literary artifices.
>
> (2015: 4)

Instead of inventing architectural representations as straightforward solutions, architects, like members of Superstudio, extended their analyses so as to encompass both actual and imaginary/represented space. Not unlike the propositions by Lebbeus Woods, or Michael Webb, which question the 'sustainable grounds'

FIGURE 5.39: Superstudio (Gian Piero Frassinelli), *Twelve Cautionary Tales for Christmas (12 Ideal Cities),* six illustrations for the cycle of short stories. Courtesy of Gian Piero Frassinelli; (upper left to bottom right): *Continuous Production Conveyor Belt City*; *Conical Terraced City*; the *Ville-Machine Habitee*; *City of Order*; *City of the Splendid Houses*; and *City of the Book*.

for utopian thought, while visually directing a similar question at the choice and application of concrete techniques of architectural representation. Specifically, speculative projects like *The Continuous Monument* are bound to polemicize with megastructure concept – with architecture extended into urbanist proportions. At the same time they ask relevant questions about human urge to describe, define and encapsulate the world at large, doing so from within the Cartesian coordinate system, symbolized by an image of the modernist/graph paper grid.

We have seen how the idea behind a project can progress from eye-catching collages to the historical analysis of architecture's mythical origins. But when supplementing this narrative with that of the equally expansive, rigid and oppressive *Twelve Cities*, it is possible to notice a purely educational documentary mode of storytelling developed into science-fiction genre text. With contemporary developments in film-architectural projects, larval ideas can serve as a basis for viable filmic texts, which complement purely visual, though essentially spatial ideas. With the dramaturgy of sound, movement and narrative a variety of concepts, too dynamic to be contained, can be explored and fully formed, harnessing the strengths of a different medium. Questions of containment, formal expression and limits of scientific cognition are echoed in the projects discussed here. Often they become experts in pointing out an absence at the heart of representation, harnessing the (dis)advantages of analogue, static media, so as to speculate on project's transitioning into

the 'fourth dimension'. In spite of this, they retain their primary niche, in which they are classified as facsimiles of work-in-progress, research documentation, as architectural constructions on paper. Speculative animated films, which will be studied in the final chapter, are heirs to some of the research questions discussed here. Additionally, they are texts that introduce new themes, shifting attention to digital modes of depiction and simulation. All of them are inherent components of augmented reality, which architecture only now begins to be subdued.

6

Digitalia

Picking up the 2013 issue of *Architectural Design* devoted to architectural drawing – guest edited by Neil Spiller – one might be overwhelmed by the range and level of art-architectural transformations undertaken by Bryan Cantley, Tobias Klein, Marjan Colletti, among other post-digital architects, speaking out 'on behalf' of the 'augmented' drawing board. On the other hand, animated filmic texts (fly-through presentations), meant to 'explain' intricacies of design, did not only take over from model-making but evolved into an independent 'site' for visionary architectural production. In his essay from 1993, *Architectural Curvilinearity: The Folded, the Pliant and the Supple* (Lynn 1998: 109–33), Greg Lynn characterizes deconstructivism as a philosophy that conceptualizes the world as a site of differences. Parametricism invests them with digital fluidity, 'stitching' them together into a 'continuous flexible system' (Lynn 1998: 114). The digital turn appears thus as an update, or a turn deduced from (and being an extension of) design strategies explored by Coop Himmelb(l)au, Daniel Libeskind or Eric Owen Moss, which left the scene intrinsically metamorphosed.

Welcome to the fold

'Inspired by the baroque thinking of Leibniz, Bergson and Deleuze, Lynn is trying to discover a different geometry; one that is no longer tied to a transcendent value system, but is an adequate expression of contemporary secular system' (Bouman 1998: 10). Arguing for the diminution of past compositional standards of beauty, like proportion or symmetry, Lynn introduced a new ontology of forms. Innovative form-generating methods, which he discussed, would soon (from the standpoint of the early 1990s) result in an efflorescence of near to natural shapes and structures, remaining in stark contrast to the modernist geometries that still presided over the urban landscape. But this emergent methodology cannot be boiled down to pure

aesthetics. With the apparent fluidity and flexibility in attainable forms, Lynn created a point of entry to a non-Euclidean universe. In general terms, his *blobitectural* paradigm could be defined as a method of assembling parts that facilitates incongruent objects, while smoothing out potential transitions between them, in place of clashes between contorted shapes in deconstructivism. Not unlike his conceptual predecessors, the founder of FORM also flirted with cinema, mainly by sharing software he used with the film industry, especially dedicated to its newfound field of digital special effects. Comparisons to the Hollywood-type mainstream cinema, appearing in Lynn's essays – written from the vantage point of mid-1990s – were definitely connoting a range of special effects-driven box office hits. Films of this sort made audiences wonder about future applications of computer graphics in moviemaking – creation of entirely artificial worlds, resurrecting actors as binary holograms, amending reality ... any former impossibility seemed at hand. At that time digital graphics workstations were potent enough to revive the dinosaurs in *Jurassic Park* (Spielberg 1993) or breathe life into a translucent robotic assassin in *Terminator 2: Judgement Day* (Cameron 1991); in the non-feature-length format it allowed for Michael Jackson's incessant mutations – bypassing constraints of race, skin colour or stature – in the video clip for his song 'Black or White' (Landis 1991). As that title implies, profilmic differences were becoming irrelevant.

Lynn's parallel is clear enough. Just like architecture came to favour smooth, round-edged shapes, so has cinema become infatuated with smooth transitions, 'liquid' camera movements, CGI and special effects that nearly breach the credibility protocol. This turn has gradually introduced tools for undetectable manipulation of filmic imagery. Even if they are allowed to advance to the forefront in spectacular FX-driven scenes, these digital creations ought to remain 'masked', because detection – according to the logic behind Hollywood 'showcase' sequences – equals failure. Stark contrasts and sharp juxtapositions of traditional editing – while usually performed at an accelerated rate in post-modern cinematic productions – would not entirely be giving way to the aesthetics of 'smoothing out'. In architecture, a similar turn was already in the works. With the fashion for deconstructivism in decline, architectural design witnessed the rise of what Lynn nicknamed *blobitecture* – in part a homage to cinema's cult classic (*The Blob* [Yeaworth Jr. 1958]), in part an acronym for binary large object(s). This invader did not come from outer space, though, but from parametric design software. 'Both Venturi and Wigley argue for the deployment of discontinuous, fragmented, heterogeneous and diagonal formal strategies based on the incongruities, juxtapositions and oppositions within specific sites and programmes' (Lynn 1998: 29), stressing the seamless nature of the nascent computer-aided productions.

If we take a single frame out of the continuous process of designing a 3D model, rotating and assessing it from each side, it will appear to us as a section cut through

time; freeze frame of an object locked in the transitory phase of a continuous transformation, especially when viewed against a potentially limitless array of alternative design solutions. Architects like Cantley or Ricardo de Ostos explored this arrested potentiality in digital objects – the possibility to deconstruct modelled objects into layers and the coexistence of project's multiple versions, accessible at a random stage of production. What is of real interest here is the proximity of CAD methods to the making of computer-animated films. Reconsidering this quality from the perspective of the images' ontological condition, we may find ourselves close to Gilles Deleuze's distinction between movement-images[1] and time-images,[2] which urges one to consider the abstract composition of a cinematic frame not as a photographic still. In turn, it becomes either a 'section cut' of movement through time (movement-image), or – alternatively – we may read the scene as a 'zone' subjected to Bergsonian Duration – a sense of time distorted through character's subjectivity (time-image). This understanding conjures up previous discussion on the model of time in Robbe-Grillet's experimental fictions, while simultaneously recalling a famous quote from Norman McLaren, who pioneered in numerous types of animation, responsible for establishing the reputation of the National Film Board of Canada. In his opinion, animated film is not a series of moving drawings but a sequence of movements which are drawn.[3] This significant distinction, which might appear as a perverse play on words, clearly delineates the mindset for approaching such subjects as 'animated architecture', which is at odds with 'architectural animation' – to conjure up the title of Neil Spiller's essay – as the latter 'often negates the enigma in architecture; everything has to be known in detail before it can be pushed into the virtual' (Spiller 2000: 85). His diatribe focuses on the reckless employment of animation techniques in showcase presentations, usually meant to razzle and dazzle the client, far from provoking any serious thoughts on the subject or design practice in general. Moreover, it favours digital 'body-building', forcing more imaginative graphic explorations and experiments to wither, even atrophy for the advantage of standardized, if not template-inspired outcomes of architectural image-making.

If architectural form is generated in a process of endless iteration of the designer's decisions, both additive and subtractive, then animation – as the medium most intuitive for temporal transformations – could be regarded as the final expression of the designer's intent. A genuinely interesting turn of events for a domain which harbours immobilized spatial constructs. In their case, the fourth dimension becomes a point of departure for projects that focus on architecture's temporal performance, durability, use, deterioration, decay and potential transformation. Proposals of this kind explore paradoxes of time and space, often foraying into science-fiction territory for suitable context. Unsurprisingly, in the works of Tobias Klein, Marcos Novak, Dan Farmer, Paul Nicholls and Soki So, architecture becomes something 'other' – an entirely different object, attuned to performative, cultural, cybernetic,

phenomenological or neuroscientific accounts of space. Provided that it perpetuates its material form, while not dissolving into streams of data, intangible interfaces or organisms equipped with their own intelligence.

While still 'preserved' in the graphic software, or the medium of animated film, architecture gains the status of a dynamic object, both a code that preconditions the image's appearance and the code's execution – namely, imagery as such. What follows is a historical account of the speculative architectural projects' emergence, according to which the art of moving pictures is not simply a communication platform but which are themselves 'pictures on the move'. Animation, in this context, has always been a 'test run' for building's performance. In this case, however, the medium's site often hosts a utopian guided tour, or a capsular dystopian plot. Frequently, the method of (re)presentation overlaps with the represented object; spatial events blur in event spaces. Tschumi defined architecture as susceptible to the compositional factor of events. In the digitally enhanced space of animated film architecture has already become an event.

Like architecture, but animated

Primarily, '[t]here are at least two opportunities for animation to be used as part of the development and representation of ideas', writes Mark Burry,

> firstly as architecture considered and represented through animated treatment of 'real buildings'; and secondly at a conceptual level where animation is used as a device in architectural design, most usually as part of an iterative design generation or as an evaluation procedure.
>
> (2001: 7)

Investigating this issue further, a line needs to be drawn between presentations made for clients and genuine explorations of cinematic language, engaging in complex narratives, effects and uncanny subjects, few of which could ever be narrowed down to building proposals. Animation – at the same time a technique of architectural imaging and a mode of artistic production – constitutes two different 'beasts'. While the first bears marks of the profession's state, as it used to be in the late 1980s, with animation software considered mainly as visualization aid, the second ought to be traced back to the origins of cinema. First, with comic strips adaptations turned into prototypes of drawn animation and early cartoons, and then with stop-motion trick effects, comprising of 'animated' segments inserted into feature films.

Only the latest chapter in a more than a hundred-year-long evolution of personal styles, methods and approaches is relevant to the architectural side of the story. At present 3D computer animation grew large enough to dominate the market,

becoming the principal technique employed by large animation studios. Nonetheless, its beginnings were modest, constricted to short films created by John Lasseter under the aegis of Pixar Animation Studios (back then, only a division of the Graphics Group of Lucasfilm Computer Division), still in its formative stage. These productions display only the most recent, 'anthropomorphic' phase of animated film's development. Experimental animated works were created with primitive, post–Second World War computer languages or 'reincarnated' from the software written especially for them. Unlike their contemporary descendants, the films in question were abstract choreographies of geometric shapes, visual symphonies and exercises in op-art, exploring kinetic, technical and purely formal aspects of filmmaking. With such harbingers of the digital revolution as John Whitney's *Catalog* (1961) and *Permutations* (1968), Ken Knowlton and Stan VanDerBeek's *Poem Field* series (1964–67) or Peter Kamnitzer's *CityScape* (1970),[4] the narratives ranging from topological dances of 'transformation algorithms' to transpositions of graphs' temporal development often draw a line between digital and analogue productions. Although such a line is barely visible. For example, James Whitney's analogue abstract films, being instances of his mandalic cinema,[5] would usually also be counted among early attempts at computer animations. Numerous others employed the technique of placing camera directly against a cathode ray tube, directly filming images arising on the monitor screen, generated by the programme executed on a processing unit. Paradoxically – due to the zeroth level of integration of digital and photographic materials – one could name these productions documentaries, if not simple recordings, more akin in their intent to Georges Méliès's spectacles acted out in front of the lens. Only in the 1980s, at the Industrial Light & Magic stage of this technical evolution, have computer programmers/artists begun creating films directly in digital environment.[6] From a narrative point of view, each of them engages with the transformation/morphing paradigm, displaying numerous 'phase transitions' of the object, incorporated into the plot and exercised as visual special effect.

Unsurprisingly, non-figurative films created by artists of the American West Coast movement, who are considered early pioneers of computer animation (such as John Whitney), strictly dissociated themselves from what was generally acknowledged as commercial cinema or mainstream animated film – regarding the latter as inherently bound to Disney's figurative hyperrealism. Rather, they associated themselves with the Great Avant-Gardes of the 1920s, along with its kinetic visual explorations, which sought to discover – in filmic medium – a new ground for dynamic explorations led in modern painting and sculpture. In his article 'Animated Techniques: Time and the Technological Acquiescence of Animation', Gregory More recounts how the early-twentieth-century crisis in visual arts propelled a branching out of researches in 'visualizing motion'. 'The crisis occurred when visual artists, predominately painters, explored creative form relative to

time' (More 2001: 22). He argues that the previously unavailable factor of 'time' made possible a qualitative and quantitative change in the architectural object. Many of these attempts, however, focused on emancipating film from its debt to other art forms; above all, theatre and painting. This path – as it was soon to be proved by the likes of Hans Richter, Viking Eggeling or Fernand Léger – was regarded as a continuation of their explorations led in abstract painting, while shifting the interest to rhythm, light play and motion. Artists like Man Ray or Marcel Duchamp kindled an interest in film, precisely due to its motion-based characteristics. These could be suggested only by the paintings' style or content.

> The makers of Absolute Film proposed to reconfigure film so as to highlight the film's innermost dynamics – thereby they would release cinematic form from representation. Light and time, they insisted, were the cinema's true materials – the artists engaged in the creation of the Absolute Film shared an interest in light and time with makers of light sculptures and Lichtspiele.
>
> (Elder 2007: 22)

In cinema motion is not just apparent, as in Op Art, but inherently mechanic, inscribed into the medium's inner workings. While a 'canvas' remains static, animated film can put abstract ideas in motion, arranging them rhythmically, turning lighting effects, music or morphing of images into a narrative baseline for the piece. With *Anemic Cinema* (Duchamp 1926), *Le Retour a la Raison* (Ray 1923), *Ballet Mécanique* (Leger 1924) and most of all Hans Richter's *Rhythmus 21* (1921), this emergent art form can be considered prototypical among the studies of filmic space (in parallel to the *city symphony* film genre), negotiating between abstract shapes and spatial cues. For example, 'Richter's *Rhythmus 21* (1921) uses techniques by which the filmic illusion of space and especially depth is creatively explored' (2007: 13). In that sense animated film did not only evolve along the same lines as studies of optical illusions in graphic arts but – due to their embedment in a medium that handles a synthesis of the temporal and the visual – it recontextualizes perception as a dynamic, active and procedural act.

Motion in digitally reimagined architectural spaces

This aspect of early experimental animations is also present in architectural filmmaking, primarily in the poetic recreations of real spaces. A genre which seems to stand on its own, as for its narrative mode can be discerned in many architectural shorts shown at architectural animation festivals. It is no different with Alex Roman's *The Third & The Seventh* (2009). In slow tracking shots we glance at

digitally enhanced interiors of Louis Kahn's Phillips Exeter Academy Library and the house of the Parliament of Bangladesh, among multiple other architectural milestones. One particularly stunning sequence features Frank Gehry's Walt Disney Concert Hall. Its reflexive surfaces trace sunbeams, while a silhouette of a passing jet plane follows suit. Roman's film leans towards the abstract, because walls and surfaces lack any reference points or human figures to be counterbalanced by. They are textures (or, as Giuliana Bruno would have preferred, *architextures*[7]) convex at times, concave at others, letting the building's curved lines guide our sight substituted by the camera. Atrium space is shown from top to the bottom. At first, we can only recognize an ultramarine square of the evening sky, rotated counterclockwise, together with adjacent lit-up corridor segments, taken from the consecutive floors of the BCN Auditorium, designed by Rafael Moneo. This setting returns at about ten minutes into the film, this time reinforced by a pack of CG reflective globules – an additional light dispersion and water surface effect, metamorphosing architecture into a shrunk and reversed image of itself. It adds yet another mediator to the battery of optical recording devices (various cameras), seen at different segments of Roman's short, each time being 'caught' in the act of mediating our view (reflected in surfaces of marble walls, water pools, structural glass, etc.). The view we receive is already mediated and digitally altered – 'prepacked', so we could scrutinize it on screen.

When interpreting space on screen as a virtual site, we are likely to treat it as any other environment we are likely to encounter in real life. Roman's film makes this fact apparent, though it does not repeat banal statements, because it focuses on the act of perceiving. The space is revealed gradually and instantly reflected by means of a variety of apparatuses. An act that unmasks filmic space, in this regard, as a brilliant illusion. Even though we are denied immediate access to the mirage, films are prone to emphasize such illusions, rendering them all the more convincing with a palette of depth cues and photorealistic effects, whose purpose is to obscure the view, visualizing motion blurs, darkening the landscape removed apparently too far away to be inspected by the viewers in detail. All this is undertaken for the sake of confronting us with a 'space' that supposedly arrives already interpreted by one's visual apparatus. Each time the camera's focus is being set, or lens adjusted to capture elements located either very close or in the background, we can notice that

> [p]erception is not something that happens to us, or in us. It is something we do. [...] *What we perceive* is determined by *what we do* (or what we know how to do): [...] we *enact* our perceptual experience; we act it out.
>
> (Noë 2004: 1, original emphasis)

This is because what beholding a scene actually means 'is to understand, implicitly, the effects of movement on sensory stimulation' (2004: 1). Filmed architecture

actuates this movement directed at spatial cognition. *The Third & the Seventh* contributes to the illusionistic lineage of cinematographic endeavours by subordinating film's narrative to an exploration of both the buildings' interiors/exteriors, and the (digital) camera's processing/rendition of these spaces, each enhanced by CGI.

In fulfilling this task light becomes an accomplice in exposing the digital textures we look at. It proceeds in a manner not so far removed from the role light plays in the 'visual poems' of Eggeling, Ruttman or Richter. Thus, in the 'finale' of *The Third & the Seventh*, we can see ripples of light 'dancing' on the wall, and the scenery deformed in extra-large droplets. Before eventually noticing that these are in fact patterns of light reflected off the globules' surfaces, we behold a spectacle staged on glass panels. As Simon Unwin writes,

> Light can make the fabric of a building seem to dematerialise. A well-lit, completely smooth, surface (of a wall, or a dome, for example), of which one perhaps cannot see the edges, can appear to lose its substance and become like air.
>
> (2009: 28)

But in Roman's film the opposite happens, as the light falling upon water gives shimmering effects, crawling down the walls and objects, dressing up interior surfaces with wrinkles. Revisited as a visual effect, this *lichtspiele* is meant to probe spaces represented/simulated on screen. Assuming the immobility of spectators during screening, this reflection effect acts as a surrogate to spatial experiences of one's movements about the location.

> [P]erceivers continuously move about and modify their relationship to the environment. They do this in order to get better vantage points and to bring themselves into contact with the relevant detail that is of interest. […] Perceivers have an implicit, practical understanding of the way movements produce changes in sensory stimulation.
>
> (Noë 2004: 66)

These kinaesthetic aspects of spatial cognition are followed through, primarily in the way cinematic space is constructed and graphically enhanced by CGI and digital post-production. Architectural structures are rebuilt (to some extent) with CGI, entwining footage with objects that are convincing in 'inhabiting' the scene. Ali Rahim, quoted in Peter Cook's book, discusses such developments heading towards replacing and emulating material qualities of objects.

> The key breakthrough has been advanced software that enables the control of light and color in very precise ways and in real time within the digital. […] Now there

are so many more factors that we can control and adjust in real time that the representations become linked with form and material in real time.

(2008: 213–14)

This important characteristic of the computer-immersed working environments can be considered a game changer. With the ubiquity of animated presentation films, employed for seducing clients, many young architects constantly address the fact that architecture and its mode of presentation have started to become 'codependent'. As Patrick Maynard writes on what had formerly been considered a dualism of form and content, this separation is rather dubious with a number of artists, especially when reading the image by its communicative allocation.

> In architecture, landscaping, and other kinds of design, the overall form, contour, texture, and shadow modelling of an artefact can assist or baffle our perception of its form; indeed they can also appear to have been produced for the purpose of guiding our perception along such ways.
>
> (2005: 225)

In order to highlight their perspective, they often depict architectures, which come into existence – but also disperse – under user's gaze. Only in speculative proposals can this erasure of boundaries, between the subjective and 'experientially shared', be expressed and pondered over in full. With immaterial constructs they touch upon a broader range of subjects. These might encompass issues regarding the purpose and course of architectural production in times when digital media thoroughly permeate social space. Cognitive accounts of urban and private spaces could similarly be reconsidered from this vantage point, focusing on the progressive mediation of events. These questions also pertain to a deeper crisis, concerning the architect's role as a creator of – predominantly – imagery. On the one hand, this has been a prevailing condition in the practice, sustained and resounded ever since the Renaissance; on the other, this turn epitomizes architecture's expanded field of application, which now came to include creating viable architectural supports for film directors, graphic artists, book illustrators and game programmers.

Mediatization as crisis

But can the origins of this 'crisis' of deepening dematerialization be found anywhere else but in visual arts? Along with the emergence of film (form) as a medium capable of creating convincing impressions of 3D space, we seem to be repeatedly asking ourselves whether 'we [are] dealing with a surface or a space for instance? This is

FIGURES 6.1–6.6: Alex Roman, *The Third & the Seventh*, 2009. Film still: self-produced. Spain.

a problem endemic to abstract painting. While these films are sometimes placed in what is called the anti-illusory tradition, they deal fundamentally with perceptual illusions' (Elder 2007: 14). Otherwise, we could try to locate the precise moment of this split, by looking into circulation of architectural imagery in mass media – commercial photographs, designs, but also exhibition catalogues. In *Privacy and Publicity: Modern Architecture as Mass Media* (1998) Beatriz Colomina argues that the beginning of the twentieth century witnessed a progressing dematerialization of architectural production. Architecture's popularization and distribution over media platforms (press, architectural periodicals) revved up the production of photographs and imagery but also created an outlet for project documentation. Writing about Adolf Loos and Le Corbusier, she pointed to a tendency, which would intensify with the proliferation of media of mass communication. This profound change relates to 'a transformation of the site of architectural production – no longer exclusively

located on the construction site, but more and more displaced into the rather immaterial sites of architectural publications, exhibitions, journals' (Colomina 1998: 14–15). Among other examples discussed in her book, the rise of International Style has been artificially propelled – if not primarily initiated – by means of mass communication involving press, monographs and exhibitions (1998: 202–03).

The emergence of distribution outlets, which conflate architecture to the status of photographs, drawings, collages, all in servitude to advertising – not just for future buildings, but entire unprecedented realities brought to life by means of seductive imagery[8] – opens up new institutional space for what has formerly been marginal to the practice. What might seem like a reversal of the traditional trajectory of architectural production is in fact its segmentation and liberation of its subsequent production stages: inscription (sketches, diagrams, ideation phase notes), codification and representation (photographs). Visionary renderings of 'utopian practicality' could now adjoin blueprints and perspectives on magazine covers, while earning heightened attention due to their pictorial seductiveness. If this is crisis, then certainly a valuable one, making architects revert to other art forms. Their ideas could now be propagated through publications, given extensive media exposure. Exhibitions and publications are as prone to distributing imagery of actual buildings as they are to treating their speculative counterparts and futuristic visions in the same manner, conjured up by concept artists and illustrators such as Syd Mead, John Harris or François Schuiten.

> Publishing, like ornament, by absorbing architecture into the universe of merchandise, by fetishizing it, destroys the possibility of transcendence. Architectural magazines, with their graphic and photographic artillery, transform architecture into an article of consumption, making it circulate around the world as if it had suddenly lost mass and volume, and in this way they also consume it.
>
> (Colomina 1998: 43)

Still, this conflation prolongs their dematerialized lifespan. Given the current transition into augmented realities, speculative instances of paper architecture are likely to harness the media in which they are distributed, bringing out seductiveness, extravagance and unfamiliarity to the forefront of the presentation.

Animating discussion

With two crises in plain sight, we might as well expect a third one approaching from the side of computer graphics. Essentially, it reinforced the status of representation

as something separate from the denoted object – the project executed as building – while rendering it as a twofold entity, comprising of the construct and that which informs the construct. The history of computer animation, before being pigeon-holed as either architectural designer's aid or a tool in service to special effects artists, confirms an evolution towards greater photographic verisimilitude whose present outcomes pervade nearly every contemporary feature film.

> On the day when real exteriors were introduced into film, the future of the film set was virtually decided. Rather than clash with the rest of the film, the set now had to succeed in re-creating a framework equivalent to reality.
>
> (Barsacq 1976: 4)

We can definitely envisage a total replacement of material objects with their CGI props, without immediately detectable differences. Numerous times this has been done in films such as *Gravity* or *Birdman (The Unexpected Virtue of Ignorance)* (Iñárritu 2014). What we take at face value is usually a rendered texture. It is the latest phase of a process that began with wireframe models, incorporating such image-making techniques and filters as anti-aliasing (Frank Crow), texture map-ping (Ed Catmull) and bump mapping (Jim Blinn), each discretely hidden away, by being woven into the final image. An entire history of animated endeavours (mainly, short films), intertwining with a similar narrative on digital visual special effects, might be recounted from the standpoint of specific algorithms enhancing the verisimilitude in the appearance of things, traced back to such films as: *Vertigo* (Hitchcock 1958) – the first computer animated title sequence, created by John Whitney Sr; *TRON* (Lisberger 1982) – which came forth as the first promoter of gaming environment imagery and 'cyberculture', even though its backdrops were mostly painted impressions of vector graphics, rather than actual CGI; or *Willow* (Howard 1988) – evidencing the first use of morphing effect in a feature-length film.

Features reigning over the marketplace in the 1990s would contribute just as much to the advancements in reproduction of skin textures, being fur-rowed with: reptile scales (*Jurassic Park* [Spielberg 1993]), fur (*Monsters, Inc.* [Docter 2001]) or hair (*Final Fantasy: The Spirits Within* [Sakaguchi 2001]). Although the last one is regarded as a failed experiment, because of its expres-sionless china dolls standing in for human beings – a typical reaction on the part of the audience attributed to the so-called uncanny valley effect. Tom Sito sums up this development in his *Moving Innovation: A History of Computer Anima-tion*, calling it a creative strategy and recounting that

> as computer technology slowly improved, Lasseter devised ways to work around the medium's limitations. Computer animation looks hard and mechanical? So make

films about toys and bugs. Computer animation has problems portraying weight? Make a film about fish, which float around. It wasn't until *The Incredibles* (2004) that Pixar found the right formula for stylization to do credible human characters that kept the verve and energy of traditional animation.

(2013: 245)

Innovations in this field are still treated with great reverence. Short animated films were winning awards at animation festivals, such as the annual SIGGRAPH (Special Interest Group on GRAPHics and Interactive Techniques) conference, later to be discovered by large production companies and used as special effect segments in films, or even themselves developed into feature-length features. For example, in Michael Crichton's *Westworld* (1973) a two-minute sequence envisioned the action from an android's point of view, deconstructing images perceived into a wireframe model of the scene. Raising the bar for its sequel, *Futureworld* (Heffron 1976), the creators bought Ed Catmull's student film, *A Computer Animated Hand*, and Frederic Parke's animation of human face (created as the latter's master's thesis) not merely to rival but to exceed their previous film's novelty (2013: 154). A similar path marked the career of Loren Carpenter, picked right off his presentation at the 1980 SIGGRAPH conference, where he showed a two-minute animation titled *Vol Libre* – a fly over terrains generated by stochastic algorithms, namely fractal landscapes. Hired at Lucasfilm's Computer Division, a company that was soon to become Pixar Animation Studios, his original idea was redirected at displaying the terraforming power of the Genesis Device in *Star Trek II: The Wrath of Khan* (Meyer 1982). What had begun as laboratory experiment,[9] or a government-supervised programme,[10] was eventually turned into industry standard. Even if these student films and visualization efforts sprung independently of the West Coast experimental film movement (Hy Hirsh, Harry Smith, Jordan Belson, the Whitney brothers), itself indebted to émigré artists of the 1930s, like Oskar Fischinger, they were the first to establish a connection between abstract imagery and transmutable Platonic solids, as conveyed in the form of vector graphics, along with their gradual remodelling into anthropomorphic, or at least zoomorphic polygon-based 'lifeforms', invested with increasing photo-realism.

Digital imagery succumbs to rules best played out in animated cinema, regardless of whether we contemplate them in the context of live-action or animation. For the better part, cartoons made a praiseworthy tradition out of abusing laws of physics, corporeal constraints, and common reason. In his books Paul Wells discussed multiple attributes of such productions, combining cinematic and painterly modes of image creation, taking advantage of the ambiguity, non-materiality, or stylistic convention.[11] If cinematic architecture was to be built around, or follow

similar pathways (as it did) though photorealistic environments, distant 2.5D mattes, cyberspaces of *Johnny Mnemonic* (Longo 1995) or virtual set extensions of *Gone Girl* (Fincher 2014), it would have testified to a far-reaching conspiracy against filmic space, its dematerialization and substitution with a mirror image. Outlining a history of spatial concepts, Anthony Vidler takes note of the increase in artistic practices that express themselves by projecting our internal sphere of psychic anxieties onto the urban environment – notably those, who express themselves in architecture, film and urban interventions. He sees this psychasthenia as the defining condition of modern life, which now resurfaces as digitally induced deterritorialization of social space. Vidler recounts, how

> [b]etween the 1960s and now, however, there has emerged the great divide of the digital, which, I would argue, has had results that go beyond a simple change in representational techniques, to imply a profound shift in the nature of our subjectivity with regard to architectural space. Here I am not only speaking of the way in which digital software has allowed us to re-represent things in the same way we used to represent them: the enormous efforts of CAD, for example to replicate perspective, or that of so-called virtual reality simulators to throw this perspective into a felt three dimensions.
>
> (2000: 45)

Rephrasing his point, it is inevitable to eventually abandon the phase of mimicry and replication of ideas anterior to parametricism, computer-aided design and CGI, instead coming up with visionary projects that frame architecture in altogether different terms. Deconstructivist architecture devised a syntax of strenuous shapes, akin to the wireframe models of computer modelling software. After a 'round of trails' with vocabularies of natural forms that informed protocols of early parametric designs in the 1990s, there came a time to critically reassess the overt admiration for smooth casings of the biomorphic typologies. Derivative of aircraft design software, capable of achieving Bézier curves for aerodynamic bodies, parametricism quickly oversaturated the architectural discourse. To move on meant to incorporate alternate (i.e. analogue) techniques into its binary mainstream, searching for 'unprescribed' methodologies of form generation.[12] Animating design in these terms, opens up architectural animation to a range of options, setting in motion not only the observer – in fantastic fly-through sequences – but also the building. It reframes previous concepts of architectural objects, developing them along the lines of Archigram's mobility in built forms. In terms of representational techniques we have entered the post-digital stage. In this light visionary projects appear all the more interesting, because they employ non-standard narrative modes

(parable, utopian literature), or to great extent make use of motion (film, animation), engage with heterogeneity (in their choice of diverse art forms to best communicate a given project), and experiment – the intentional artistic 'noise' injected into the formal system.

Emergent representational techniques: Animation

Critical readings of CGI have already been the focus of scholars in the field of film studies (Purse, Prince, Whissel), while their colleagues from animation departments furthered those observations (Wells), applying theories from pictorial arts to filmic environments and architecture, for example, reading

> [t]he curves and soft edges of this technological city [in *Minority Report*] [,] [noticing, that it] point[s] towards circulatory and spatial enclosure; [while] their very *seamlessness* (one of the often observed characteristics of digital photorealism) begins to signify the impossibility of escape, physical entrapment and a denial of freedom of movement.
>
> (Purse 2013: 42, original emphasis)

Similar CG settings, when under close inspection – that is, remote in hand, extras section loaded on a Blu-ray disc's menu – make the spectator pay attention to the nature and technique employed in their creation. For example, *Minority Report*'s set design brought up connotations with a digitalized flux and impermeability, due to future Washington, D.C.'s enclosed *blobitectural* settings. Further on, especially in architectural animations, this aspect of the represented environments would become even more defining in narrative terms.

Applying such genetic, contextual, and stylistic readings to the speculative projects of post-digital architects, can bring out substantial characteristics of these emerging designs, some of which can directly be traced back to kine-/cinematic roots. To a greater (experimental filmmaking, advent of CGI), or lesser (media publishing) extent, in each of these cases there is an irreducible temporal component 'built-in' through animated form and visualization techniques.

> Change in architectural form becomes defined relative to frames of animation and time is treated as an applied dimension that is readily removed for the procurement of physical form: the freeze frame. The technologies of parametric design diverge from the cinematic treatment of time, and they in turn require a consideration of what this divergence means within the discipline of architecture.
>
> (Purse 2013: 27)

Seamless space

These days digitally-enhanced mainstream feature films give off a sense of uninter-ruptedness in the sense of transitions between scenes. Instead of traditional continuity editing, single shots are now seamlessly conjoined into sequences, while sequences are stitched together into long takes. Rapid-fire montage cuts in action sequences could not have been better, yet now they are more often substituted for zoom-ins alternating with pull backs, making sense of the entire composition, without resorting to hard cuts. The spectacular outcome resembles beholding a Bruegelian canvas, by repeatedly magnifying, and then minimizing detail after detail in *Children's Games* (1560) or *The Procession to Calvary* (1564). A logical extension of these CG transition effects is the ability to conjoin distant locations; sometimes, regardless of whether they are essentially spatial or temporal in nature. Following a discussion on filmic-deconstructivist connotations, it is inevitable to move on to an outline of how technological shifts in image production, presum-ably CAD methods in architecture, and the introduction of CGI to filmmaking, have reframed the former acquaintance of the two. Both now and before special effects were considered as being in service of the photorealist principle. Even the dinosaurs shaped by Ray Harryhausen, slightly before the ones resurrected in Steven Spielberg's movie, would try to blend into the live-action footage, as unob-trusively as possible for Mesozoic reptiles.

> The seamless use of effects is continuous with Invisible usage, but seamless effects are discernible if subjected to scrutiny and consideration. In this category effects also draw from across the range of techniques and, as with the invisible category, seek to pass unnoticed. The distinction between these and invisible uses is made on the basis that given reasonable consideration, their usage is detectable.
>
> (McClean 2007: 78)

Only recently have special effects sequences begun to grow considerably into show-cases of digital virtuosity, although at times one can argue, whether if Hollywood blockbuster plots are driven by anything else other than a desire to showcase Vfx prowess.

Shilo McClean distinguished eight categories of special effects, distinguished accordingly to their exposure (or visibility) on screen. She writes about 'the narrative and stylistic uses of DVFx [...] [dividing them into such categories as]: Documen-tary, Invisible, Seamless, Exaggerated, Fantastical, Surrealist, New Traditionalist, and Hyper Realist' (McClean 2007: 73). Leaving the context of box office hits, we will find a similar stance in the convention of architectural presentations. Precisely due to the genre's quick solidification into a standardized and strictly revealing

mode of visualization, some architects made their best effort to undermine this scheme, making it more cinematic, less obvious. 'Architects modelling buildings and making "walk-throughs" and other visualizations and presentations require the traditional skills of moving image communication (including fiction, drama and music) to "narrate" architectural space – especially populated space – through DV, mixed media and 3D animations' (Penz 2003: viii). While showcase fly-through sequences enable optimal views of the design, they hardly amount to anything other than either an advertisement for a product, or a binary doppelganger of the building's model for presentation.

Instead of 'helping' their students adapt to market economy, academics from institutions like the Bartlett School of Architecture made use of para-cinematic visualization methods, repurposing them as aids for design and ideation stages, turning animation into a medium, which can be used to convey an outcome of one's work, just as much as help in the project's formulation – more of a sketchpad than a provider of templates. Cinema, video art, and other adjacent kinetic art forms needed to be rediscovered and consulted. They became potential sources of techniques and strategies, as well as providers of outer-architectural 'languages'. After a period of novelty in the 1990s, the new millennium welcomed a nascent phase, in which through architectural experiments with 'cyberspace' architects sought to utilize the ideas of the second-order cybernetics, as they considered the mutual relationship of the system and the observer.[13] Issues of architectural space and its user/explorer's visual apparatus, closely-coupled, were pushed into the spotlight, becoming pivotal to a number of projects taken on by the students.

> Against the backdrop of the wider proliferation of digital technologies, media and communication networks, digital and digitised practices have found their way into almost every aspect of filmmaking, including sequence pre-visualisation, blue and green screen shooting, face and body motion capture, compositing of image elements and digital rotoscoping, non-linear editing and sound mixing.
>
> (Purse 2013: 2)

This way filmic space has been ontologically transformed. Formerly a composite of disparate profilmic elements and graphic alterations (optical printing), in digital age represented space achieved an unprecedented level of photographic verisimilitude, with CGI artists capable of generating 3D objects, but also seamlessly integrating them with the footage (digital compositing, match moving), or extracting spatial information from 2D images/photographs (photogrammetry). As a result the acquired filmic image that we see in most mainstream action cinema is ripe with purely visual props, mostly indistinguishable from their real-life counterparts. There are CG set extensions and photographic backgrounds enhanced

through photogrammetric analysis into 2.5D lookalikes of actual depth cues. Cinema had always been a test bed for optical illusions, yet with the advent of 3D cinema, stereoscopy, and HD technology, the standard palette of 'tricks' has been upgraded to pass the test of photographic truthfulness.

Despite Greg Lynn's acclaim for digital innovations in cinema, when looking back at the cinema of the 1990s, we can notice how actual screen time taken up by CG effects has been strictly limited due to the technical restrictions of 'rendering farms' and the costs of processing filmed images. Additionally, an older, but a very convincing adversary in the high-quality effects achievable by mechatronics, traditional sets, and painted mattes, was still in reign, which is not that surprising, when compared to the glossy, yet 'bare-boned' look of early CG visuals. This gave the creators sustainable reasons for labelling digital interventions as a flashy excess, pigeonholing them as applicable solely to fantastic subjects, whose on-screen representations could not be debunked by photographic evidence from real life. Thus, the dinosaurs we see in for the most of *Jurassic Park* (1993) are in fact mechanically controlled, while their CG colleagues are relegated to a few minutes of screen time in total. Likewise, the main use of CgFX in *Terminator 2: Judgement Day* (James Cameron 1991) is to be spotted in the animation of T-1000's translucent body, in the action sequences that deliberately question its digital composure. However, the type of cinema anticipated by Lynn's praise is best embodied by the recent superhero and science-fiction movies. Here the final image is a composite far more advanced than their ancestors 'encrusted' with painted elements. The filmic image is digitally modified, but not just for 'showcase' scenes. Instead, films evidence a holistic approach in the multi-layering of digitally enhanced photographic imagery. This confuses any previous understanding of the term 'special effects sequence', as these are neither special effects (but complete makeovers of the picture), nor sequences (as, according to contemporary logic, no frame is to be left unaltered). In turn, the latter are rendered non-abstractable from the filmic body. The products and tools of silicon graphics permeate nearly every stage of production. They step in not only as retouching tools, but as a design aid (*animatics* – the animated storyboard), or previsualization technique that helps in planning out the final cut, even before the shooting commences. This was common practice in animated films, yet – given the example of *Gravity* (Cuarón 2013) – nowadays, not only there.

This 'second phase' of digital interventions has found its prime 'site' in continuity editing. Mainly in favour of creating plausibly immersible environments in stereoscopic cinema, such techniques as match moving allowed for seamless compositing of the footage. Oftentimes this means putting reality principle to the test, while also altering the logic of transitions between shots and applying morphing techniques to what would have formerly been arranged through sequences of hard

cuts. This did not necessarily make classical continuity editing (or montage as such) obsolete, though. Only now, physical settings can be reconstituted in computer environment, supplemented with digital set extensions, or generated artificially, ex nihilo. In an age when mechatronic monsters were being banished from the silver screen, and gradually replaced by equally savage BLOBs (CG silicone-based 'lifeforms'), film directors began to overcome the obstacles in serializing detailed close-ups, or 'jumps' between shots, when zooming in on the action. Recalling previous discussions regarding the shift from deconstructivist to *blobitectural* compositing strategies, a parallel transformation has to be characterized, this one pertaining to the method of assembling cinematic images; determining, whether it operates on the deconstructivist (many fast hard cuts), or on the BLOB principle (sustaining the illusion of single long takes, when stitching together multiple scenes). This distinction becomes evident, when we juxtapose the hectic pace of post-modern films, abundant in cuts and Eisensteinian collisions of meanings, with equally hyperactive propulsion in the films of the 'golden' age of CGI. They replace hard cuts with rapid 'within the frame montage', incorporating sudden zoom ins and pull back dolly shots, 360-degree panoramas, extreme close-ups and whip pans, complete with 'real time' adjustments of camera focus, some of them executed in the midst of a movement (dolly zoom). Such parlour tricks are always present in films overflowing with choreographed sky battles, like the ones in the *Avengers* series: *The Avengers* (Joss Whedon 2012), and *Avengers: Age of Ultron* (Joss Whedon 2015).

Planning out a sequence in advance, subjugating it to the logic of digital match moving and CG 3D environments, can distinguish a surficial use of CGI as a special effects mask or tint, from ones that rearrange the structure at a deeper level. In such cases either smoothing out or highlighting the clashes, takes up a profound meaning beyond purely aesthetic concerns. With this we are entering a semi-philosophical territory, in which (filmic) space is put under scrutiny and re-examined on the account of its image-based status. In consequence, image-based environments are viewed through the lens of a subjective construct mediated through memory and perception. One can discern such readings in two special effects-driven blockbusters: *Inception* (Nolan 2010) and the aforementioned *Gravity*, both linking up a specific range and area of CGI's application to the 'tectonic' concept that underlies each film. *Inception*'s structure relies on classic montage theories, translating inevitable cuts into dream levels in the narrative. Hard cuts are evidently made to highlight – rather than masking – the transitions between planes of action. In other segments of the film digital special effects are employed in a manner akin to an illusionist's use of magic tricks – to astound the viewer with unrestrained possibilities of this oneiric kingdom. *Gravity*, on the other hand, takes place in an environment, which is seamless. Furthermore, the history of its portrayals in media is an

account conveyed by uncut long takes that emphasize a single-point perspective. No wonder that a film about an astronaut stranded in outer space would hold so tightly to the concept of an uninterrupted single shot, which spans the first 30 minutes of the film. Filmmakers actually exceeded such premise, dematerializing the strandees, along with objects locked in the earth's orbit. Impossible camera moves were part of the 'arrangement', like the one in which virtual camera penetrates not only through the main character's space suit, but positions itself in Dr. Ryan Stone's perspective. All these cinematographic enhancements are there to mimic some of the errors, we are likely to encounter in computer game environments, although here their purpose is definitely directed at communicating an ultimate sense of immersion into the fabric of unfolding events, at the expense of physical realism.

Promise of the ubiquitous consistence, acquired by any formerly disjointed/fractured sequences of images, grants the filmmaker the ability to not only sustain not only an illusion of a single long take, but also erase any borders that would have normally been posed by material objects – be it props, decorated sets or actors. The same applies to actors' bodies, substituted for their CG doubles. They too no longer pose any barrier to the camera's gaze. Boundaries formerly impenetrable, like the ones between inner and outer space (*Gravity*), have been relegated to the status of digital wild walls. Digital image processing allows artists to 'retouch the brushstrokes', although with a significant 'side effect', which altered the way in which we perceive space represented on screen. What had formerly been a montage of fragments, at present turns into a homogeneous environment, where architectures of the material and the CG illusory converge. Filmic space, the space we see on screen, has always been a graphical (in terms of arrangements of objects within the frame), and temporal (editing) composite, created from imagery, that has been taken out of different sources: profilmic space, stage sets, scale models and, matte paintings. With the introduction of computers into filmmaking the spectrum of tools enabling image processing grew considerably, making modifications easier, more in-depth, while leaving the digitally composited image – unlike even most careful optical printing treatments – pristine. No conspicuous traces of past incisions are to be found.

Virtual sets and malleable spaces

After a long period of shooting outdoors, commenced by post-war film movements, such as Italian neorealism, filmmaking eventually moved back in to the sound stage. This time taking a photographic simulacrum of the world outside along with it, recapturing its physics, texture, and behaviour.[14] Contemporary live-action feature sets rely almost entirely on digital techniques of creating filmic

space. Architects have been most helpful in this backstage revolution, for instance, introducing a new approach to digital design technologies. Newcomers, like such as Tino Schaedler, take note of the extent to which, for production design department, 'visualizing backgrounds, like cityscapes, was new territory, but art departments in those days didn't know the CG side of design, so the artists weren't building with 3D tools' (Schaedler 2015: 6). The nascent cinematic field of computer graphics has incrementally made production designers, and generally film crews conceive of filmic space in terms of a rendered map – a traversable 3D environment.

> Thinking in 360 degrees is another tool that arch-viz artists use constantly in environmental designs. Spaces change as you move through them – light changes, perspective changes. An issue common to the film-centric VR method is the 'movie screen' dilemma. Most film artists are only taught to think in terms of where the camera is pointing.
>
> (Nichols 2016: 8)

By regarding CG space as something that exists – in ontological terms – in stark contrast to regular profilmic space, new threats were posed (initially, budget concerns; the amount of rendering time required) and opportunities created (the degree of manipulation possible) to the art department.

Implications of this turn can be understood by reverting to animated film productions, where a number of these aspects are seen as industry standards. Issues with convention, style, representation, context, and realism, have been raised there, and resolved, long before live-action cinema was forced to do so, consulting its 'cartoonish sibling'. Among Paul Wells's features characterizing the medium of animated film, I find three most compelling to the formative line of CG filmmaking, although some of them fit both live-action film and animated productions (synecdoche, symbolism). 'Ambiguity', 'metamorphosis', and 'penetration' found fertile ground in digitally modified 'pictures', in turn developing an altogether new meaning for the terminology, redefining photographic (indexical) content of the imagery. Wells points to 'ambiguity', which has been present in moving drawings, ever since their inception: '[A]nimation works best as an abstract form, where it fully demonstrates its intrinsic capability of moving non-representational lines and materials which fall outside the orthodox domains of "realist" constructions and agendas' (Wells 1998: 29). He stresses the fact that animated medium cannot retain its objectivity – nevertheless, an important issue in relation to the (animated) documentary genre. It becomes particularly difficult to hold on to the same line of argument, upon discussing CGI. On the one hand, it succumbs to laws of 3D animated films, according to which artists refrain from mimicking

objects' textures, reconstructing them in the form of wrappings for polygon mesh. On the other, photographic authenticity is reinstated as the prevailing paradigm of such productions.

In essence, Wells deems the medium suspect, highly subjective and supporting itself on agreed-upon conventions, which engage with our visual literacy, when reading/interpreting paintings. In the first example, we can assume that the style chosen by the artist, as well as the subject, convention of representation, along with specific traits and cues used in imagemaking, can suggest a double reading – as either an image of the object, or an abstract composition.[15] When considering space in paintings, particularly in anamorphism or illusionism, this issue comes to the forefront, as such techniques are at play with observer's habits, preconceptions, and stereotypes. Ernst Gombrich reminds us, that it is impossible to simultaneously *see* both the abstract and the concrete. Unwittingly, we decide upon a reading, after undergoing an initial 'reconnaissance' – conducting a series of guesses and observations, either confirming our intuition of the pattern perceived, or contradicting it. 'It is through the act of "switching" that we find out that different shapes can be projected into the same outline. We can train ourselves to switch more rapidly, indeed to oscillate between readings, but we cannot hold conflicting interpretations' (Gombrich 1984: 188).

This ambiguity lying at the heart of each animated drawing can be emphasized through narrative use of the device of metamorphosis. In addition, it can be accentuated by the subject's proneness to interchange it with metaphor, suggestion or conjoin it with character's movement. In his book Wells links this strategy to a technique developed in Winsor McCay's *Little Nemo* cartoons, and subsequently in his shorts from the *Dream of a Rarebit Fiend* series: *How a Mosquito Operates* (1912), *Bug Vaudeville* (1921), *The Pet* (1921), *The Flying House* (1921). We could 'lay the blame' upon a general inclination of the cartoon genre to impose numerous dreamlike transformations on its characters, thus presenting viewers – as in the example of McCay's narratives – with an intrinsic characteristic of the medium (as the story recounts night escapades, we could call it oneiric plasticity), as well as the techniques it regularly employs (transformation, mutability, inconstancy of the character's form). Sergei Eisenstein called it *plasmaticness*, even though, upon finally meeting Disney in person in the early 1930s, most of the studio's 'plasma' had already evaporated.[16] The company appeared as more interested with forced impressions of authenticity, namely hyperrealism. In the late 1930s Disney altogether abandoned the playful transformations of their characters' elastic bodies, still at work in classics such as *Steamboat Willie* (Walt Disney and Ub Iwerks 1928), in favour of anthropomorphism, physiognomy and gravity (or even *gravitas*, if one remembers *Bambi* [James Algar et al. 1942]) of the studio's feature-length films. Essentially, this new direction evades mutability and

ambiguity, posed by that convention. Metamorphosis is what we would normally link up to digital morphing technique. Regarded as a narrative device,

> [t]he ability to metamorphose images means that it is possible to create a fluid linkage of images through the process of animation itself rather than through editing, although, of course, editing may also be employed in the same film. Metamorphosis in animation achieves the highest degree of economy in narrative continuity, and adds a dimension to the visual style of the animated film in defining the fluid *abstract* stage between the fixed properties of the images before and after transition. Metamorphosis also legitimises the process of connecting apparently unrelated images, forging original relationships between lines, objects etc., and disrupting established notions of classical story-telling. [...] In enabling the collapse of the illusion of physical space, metamorphosis destabilises the image, conflating horror and humour, dream and reality, certainly and speculation.
>
> (Wells 1998: 69, original emphasis)

The third characteristic, which so willingly migrates into CGI-enhanced cinematic productions, is what Wells calls 'penetration' (1998: 122), being a device which grants us an insight into spaces previously inaccessible, from visceral cavities to abstract concepts.

> Penetration is essentially a *revelatory* tool, used to reveal conditions or principles which are hidden or beyond comprehension of the viewer. Instead of transforming materials or symbolising particular ideas, penetration enables animation to operate beyond the dominant modes of representation to characterise a condition or principle *in itself*, without recourse to exaggeration or comparison.
>
> (1998: 122, original emphasis)

What arises from merging together two last strategies has been discussed before, in the example of *Gravity*. Harnessing the two, specifically in order to transform the space of representation, might take us to a place nearest to 'parametricism', that is, directly to the topological philosophy of Deleuzean folds.

Elusiveness of architectural space in traditional animations

Far from reading these three singled-out aspects into the digitally transformed incarnation of animated films, metamorphosis, penetration and ambiguity of style have maintained their position in the history of animated cinema, strengthening

their relationship with experimental/abstract films. Apart from considering them, on the ground of comic effects deployed in cartoons, as an extreme form of physical comedy (i.e. the so-called squash-n-stretch effect), a range of techniques deployed in animated films incorporate them because of their production history. For example, the stop-motion technique engages materials like plasticine (*claymation*), whose incremental transformations are turned into consecutive film frames. Alternatively, in the animation of granular materials – sand, salt, beads and so on – any kind of solid arrangement is always regarded as temporary; permanently on the verge of instant dispersion into an altogether different 'image'. Drawn animated films are regarded as heirs to Disney's 'hyperrealist' tradition, somehow forgetting about the works of Otto Messmer, Max Fleischer or Winsor McCay, all of whom regarded plasticity of their characters and backgrounds as the distinctive asset of animated film form. CGI 'braided' into the footage – that is, on the retouched *cels* – brought about the possibility of rekindling medium's predilection to transformation, although initially deployed in an entirely different area. Digitally choreographed scenes facilitated complex camera movements and transitions, like in the famous ballroom scene in *Beauty and the Beast* (Gary Trousdale and Kirk Wise 1991). Special effects allowed the camera to sweep across space and twirl along with the dancing couple.

In such company Japanese productions usually stood out as innovative, balancing on a tightrope between a representational stereotype and narrative surrealism of offbeat drawing conventions. Even before the advent of CGI, filmmakers such as Mamoru Oshii, Hideaki Anno, Katsuhiro Otomo and Satoshi Kon embraced this technology with caution, scrutinizing it thematically as well. Films such as *Angel's Egg* (Mamoru Oshii 1985), *Paprika* (Satoshi Kon 2006) or *The End of Evangelion* (Hideaki Anno and Kazuya Tsurumaki 1997) employ visual strategies to deconstruct the filmic image. We are likely to automatically interpret settings in these films, especially those of Mamoru Oshii, as projections of 3D experiential space, following Gombrich's observation that '[w]e are so trained in assigning to each image its potential living space that we have no difficulty whatever in adjusting our reading to a configuration in which each figure is surrounded by its own particular aura' (1984: 183). Our reading of represented space, primarily through stereotypes and categorical frames, becomes, in this instance, the manipulated object. In this visual cues and illusionistic effects act as probing devices. Results are often surreal, as well as distortive of our initial ideas about the reality depicted. They challenge our assumptions about artist's drawing style, questioning its instantaneous validation as indicative of the reality on screen.

Each of the directors listed above tinkered with the ambiguity in terms of drawing style, pictorial convention of *anime* genre or with figurative/abstract cues that establish the dominant mode of image's interpretation. Naturally, these explorations,

which were always entangled in the storyline – thus supplying crucial clues to the plot – now come as enveloped in computer graphics, repurposing their surficial ('the CG look') and structural smoothness,[17] along with flexibility, to a narrative allocation. The examples below involve manipulation of represented spaces, in most cases merging characters and backgrounds with other elements of the composited image. Shattering our illusion of depth or any presumptions about 2D space we might keep, switching from figurativeness to abstract, or playing on specific visual cues that echo our perceptual apparatus, usually upsetting certitude that comes before the 'guessing game'. Even when it is delivered with an illusionist's cheerful wink.

Test sample #1: *Twilight Q: Mystery Article File 538* (Oshii 1987)

The plot of the second and – sadly – the last episode of *Twilight Q* revolves around a series of mysterious vanishings of commercial air flights. A private detective, its main character, plunges his knife into an animal's belly, performing a quick cut. Up in the sky, an airplane's underbelly suddenly rips open, sucking passengers out of the cabin, along with their carry-ons and seats. Seconds before that we see the plane peacefully 'swimming' in a cloudless sky. Suddenly, the machine grows scales and gills, twitching like a genuine fish. The 'camera' is pointed at the sun, visual contrasts set to maximum. As if we were standing there at noon,

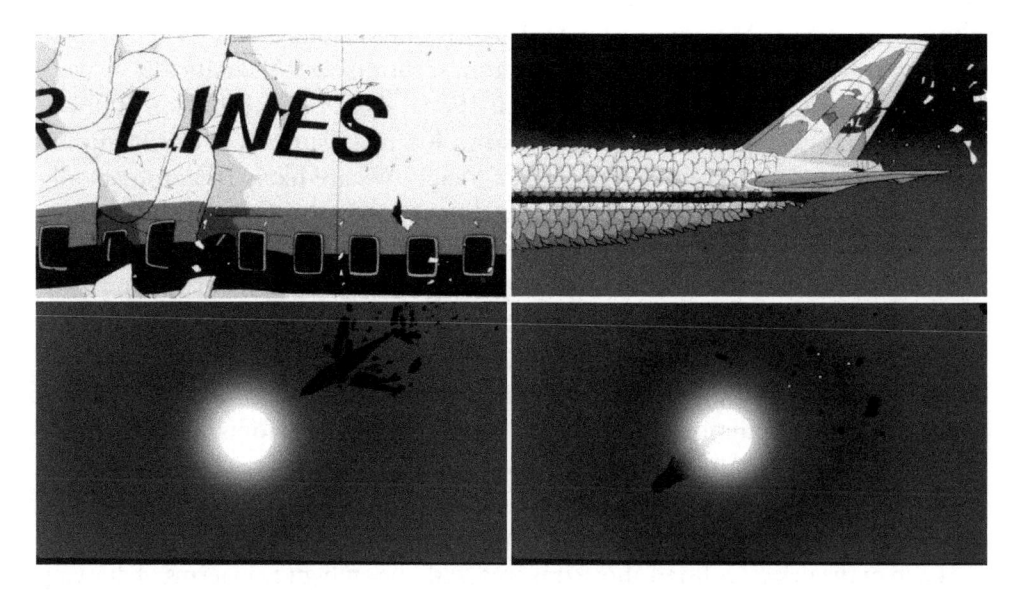

FIGURES 6.7–6.10: Mamoru Oshii, *Twilight Q: Mystery Article File 538*, 1987. Film still: Network Frontier. Japan.

on a summer's day, or beholding a shadow play. The transformation is complete. Against the background of a bright circle located in the middle of the screen, every object resembles a shadow. So does the plane. Crossing the point of conjunction, it swiftly emerges from the other side, 'dressed' in a carp's silhouette. The use of metaphor and suggestiveness in Mamoru Oshii's film spawns dream-like sequences like this one, not only comparing the 'medium' to shadow theatre but also playing out the characteristics of mutability, both in narrative and formal terms. In the representational layer, *Twilight Q* makes a subtle substitution, exchanging air for water. The difference between these elements, when committed to tape, thrives on their photographic, light-distorting qualities (live-action), if not solely on the drawing convention (animation).

Test sample #2: *Ghost in the Shell* (Oshii 1995)

Ghost in the Shell, made some eight years later, sees this envelope of Oshii's pictorial polysemy pushed even further. About halfway into the movie, its main characters take some time off from the investigation, going 'scuba' diving in the bay. As Major Kusanagi floats towards the water's surface, we see her perfectly reflected in the screen's upper right corner. Cut to the frame divided by the water line – we see the character approaching what seems to be her double. The scene takes place underwater, but even when equipped with this knowledge, our confusion persists,

FIGURES 6.11–6.14: Mamoru Oshii, *Ghost in the Shell*, 1995. Film still: Production I.G, Bandai Visual, Manga Entertainment. Japan, UK.

precisely due to the depiction style. No other indications – like the water's blue hue, wavy alteration of the drawing or lack of focus – are given in regards to the medium, in which Kusanagi is contained. Yet this confusion deepens even more, because at this point we are watching two identical characters floating towards each other, while the viewer is given no indication about which of them is Motoko and which her reflection. In fact, both are representations, as there was no 'material prototype' to begin with. Oshii frequently plays upon pictorial conventions, creating equivocal 2D settings. Depicting them at fixed angles, which only reinforce optical illusions, which would have been shattered in stereoscopy. Water's unwrinkled surface, when presented in painting, can be indistinguishable from a mirror or chromed metal. By painting panes of glass and water's surfaces, Oshii stretches the limits of representation, demonstrating how images allure and imply instead of merely 'standing for'.

Test sample #3: *Paprika* (Kon 2006)

In spite of his premature death, Kon managed to establish his position as the master of animated illusionism, weaving together scenes from dreams and nightmares with those depicting waking life. Untraceable for most of their screen time, due to the manner in which the director conceived his storylines, hiding cues and subliminal suggestions on the brim of viewer's attention. In *Paprika*, an adaptation of Yasutaka Tsutsui's science-fiction novel of the same name (1993), the

FIGURES 6.15–6.18: Satoshi Kon, *Paprika*, 2006. Film still: Madhouse. Japan.

ambiguity at play concerns gradual intrusion of the dream world into concrete reality. Kon's team uses digital effects of morphing and transitioning in order to mark the transgressions from dreaming life to waking one – jaunts that Paprika, the film's main character, makes on a regular basis. About eighteen minutes into the movie, Chiba, Paprika's waking life alter ego, searches through her colleague's (a former programmer) apartment. When descending to the basement, she finds herself having entered a huge amusement park. Noticing a doll, which bears slight resemblance to the missing colleague, she approaches it, jumping over the fence between her and the puppet. The fence, however, suddenly becomes distorted, like a water reflection. It vanishes, and Chiba freezes in mid-air on the apartment's balcony, several floors above the pavement. Film's digital 'embroidery' makes the drawing undulate, morphing a safe, kindergarten-like space of the fairground into a towering vertigo. Farther on, Kon nullifies differences between the images shown, as Paprika easily accesses places televised or represented on billboards and photographs, as if these were gateways.

The scenes 'sampled' above reveal great ambivalence in terms of the technique employed in depicting real, simulated and augmented environments. Moreover, they are far from animated film's tradition of acting out its solid and static nature, consistency and physical firmness (as in Disney's hyperrealist productions), giving an impression of regular film footage 'shot' in actual space. In animation an artist's style often serves as a masking 'tool', preying on the viewer's habit to sep-arate moving characters from static backgrounds, as if they were actors in actual spaces. However, this has never been a prerequisite for the aforementioned ani-mators. Instead, in Kon and Oshii the viewer is prompted to discredit this 'reality principle', scrutinizing it as a construct, regardless of how convincing it looks and how engaging the plot might be. Migrating into live-action or evolving into stand-alone computer-animated films, these aspects flourished into catalysts for the narrative.

As architectural animations grew independent of their commercial application and the intent of visually communicating the project, swerving into advertising, animated film festival competitions and para-cinematic productions (opening credits sequences, film CgFx, music videos), the aspects of metamorphosis and ambiguity were being revived and revised. Reread from the perspective of imagery's spatial features – the new model of architectural space they imply. In animated film attributes of material objects and physical laws have to be implied vicariously, informing the viewer about such qualities as texture or weight through the play of light, or the way characters interact with objects and settings. Dematerializing in live-action cinema – as is the case of actors placed in blue screen environments – pares them down to the status borne by any other image. In consequence, the film's 'fabric' appears as a coherent and seamless whole, equating the pro-filmic with

the virtual, that is, virtual camera's movements, CG surrogates of actors, digital set extensions, 2.5D and 3D matte paintings.

Reading and interpreting digital special effects against the background of their hand-drawn predecessors, but also in relation to their function in the plot, provides an opportunity for uncovering surprising semantic territories hidden in filmic texts. These strategies, which were brought to the foreground in the afore-mentioned areas of visual production, would be intercepted by architects who approached animation with reverence to its ability of manipulating materials as well as susceptibility to employing these manipulations as its narrative or even as subject. They proceed by inventing plots as metacommentaries on artificiality, painting styles, film production and agreed-upon conventions. In the case of archi-tectural animations, they are the fallout of 'the demise of the pure, immutable art of architectural object [, which] began [...] during experiments in conceptual art during the 1960s and 1970s' (Tierney 2007: 151). While '[t]hese movements attempted a redefinition of the medium into an expanded field' (2007: 151), the resurgence of affined tendencies in digital realm, analogous to statements in pop art, focused on the process of simulation, image production and their circula-tion in mass media. Additionally – yet mainly in relation to digitalia – they raised subjects pertaining to code, algorithm and information (taken as act of commu-nication), in relation to represented space and digital models. Propagating this 'performative' perspective on formerly static environments puts them across as dynamic, mutable, processual. Treated as executable programmes, they are sus-ceptible to errors, opening up a discussion on the potential role of glitches and digital artefacts in the context of architecture (itself being reconsidered as soft-ware):

> As such, the architectural image, while remaining an inherent and integral part of the design process, has changes its ontological basis from representational trace to organism, from a two-dimensional static document to a three-dimensional entity with animate potential. Conceptually, this metamorphosis occurs during archi-tectural form generation, through the imposition of parameters or constraints at various stages whereby a given proposal may then generate any number of vari-ations through algorithmic processes.
>
> (Tierney 2007: 19)

The default architectural image, which has prevailed from the 'age of the machine' to present times, might need to give space to 3D models arrested in motion. Dis-creet with multiplicities that define it as a variation among a number of alterna-tives, this new architectural image is an *objectile*.[18] This ontological status of binary entities (of designer's conception), denotes

objects that are repeatable variations on a theme, such as a family of curves declining the same mathematical model; *objects* in flux, inflected like the signal modulating a carrier wave; or lines and surfaces of variable curve, such as the folds of Baroque sculpture or the decorative bands of plant motifs ...

(Cache and Girard 2013: 101, original emphasis)

In objectiles we will thus encounter animated constructs, which – only due to the modesty, novelty, and overwhelming force of architectural visualization studios – have remained in their initial state of 'suspended animation'. However, numerous apologists in of the likes of Lynn, Colletti, or Diaz Alonso, perpetually point to the kinetic aspects implied by their creations. Brought up through connotation, or flowing from the generative properties defined at the design/virtual sketchpad stage (de Ostos, Cantley), kinetic properties of objectiles are located at the base of this technique.

Conclusion: Suitable grounds for exuberance

Well into the digital age, after domestication of cyberspace, *Architectural Design* ran an issue on a 'baroque' virtuosity in contemporary designs, inspecting projects that take blobs and folds to the next level of complexity and biomorphic semblance. In the introductory article, Marjan Colletti writes that:

Having overcome the alienation and otherness of the cyber, having mastered the virtual qualities and protocols of the parametric, having achieved the intricacy and elegance of the digital, and having fully embraced the potential of 3D computer software and CAD/CAM manufacturing technologies, it was now time for architects, not engineers and programmers, to show off.

(Colletti 2010: 8)

Nevertheless, the eponymous 'exuberance' (interchangeable with 'excess', as Hernan Diaz Alonso remarks), is conceptualized by Marjan Colletti as 'Digital Poetics', or Post-Digital Plectic Architecture (Neil Spiller), when he writes that this post-digital

terrain can include a variety of complex architectural subcultures that are all composed of differing degrees of the digital, the virtual, the biological and the nanotechnological without banishing more off-piste, often less fashionable investigations, propositions and researches. Above all, these architectures seek to simplify, amplify or facilitate and make visible the complex entanglement of contemporary space.

(Spiller 2008: 363)

Dressing skill as theory can spawn numerous conflict zones, alongside opportunities for abuse, yet the generation of architects who recognize that CAD is a means, and not an end in itself, began to probe this vast terrain of architectural representations anew. Combining stark opposites, their projects blur distinctions between purely digital and material productions, employing outside artistic methods in order to propel the design from its initial conditions into unforeseen directions. Some branch out into what has formerly been reserved for commercial fly-through animations and films:

> Over the last decade, animation has emerged in architectural practice as a sophisticated design toy. Initially, at least, animation techniques have been able to impress almost on the strength of their novelty alone. This is true of their use in filmic walkthroughs, as popular pretentious gimmicks, and in the adoption in the creative process where they have been responsible for alluring, futuristic images, gyrating through space.
>
> (Castle 2001: 5)

Fly-throughs and walk-throughs, when viewed from a narratological perspective, subjugate all aspects of the presentation to a 'linear narrative' of efficiency, relayed via informative exploration of building design. This progression ought to be accompanied by plausible visual effects, which display the most effective and attractive 'showcasing' strategies.[19]

With a breadth of visualization companies offering immersive fly-through animations, we might have taken for granted that architectural animations are 'all about experience'. In fact, they rarely fulfil this premise. What commercially viable animations usually lack, is a sense of embodiment, although not understood as the model's shortfall of materiality, but an anthropocentric perspective employed in the panoramas and dynamic perspectives that stipulate camera as its mediator. All kinds of paraphernalia, from cars and trees to passers-by, are there to give a better sense of immersion into the future prospect. 'Animations are a relatively new resource for architectural representation that have mainly arise[n] due to the capability of moving the camera in digital models of projects, making possible to dynamically display volumes' (Alvarado et al. 2005: 299). It is not surprising then, that there has been a strong interest in expanding upon this form's filmic premise; of stepping outside of this narrative form's conventional and limited application, to greater extent incorporating storytelling and cinematography.

Outsourcing rendering work to visualization companies became an industry standard. Numerous academic papers addressed fly-through animations' 'coarseness', when it comes to narrative (Garcia, Alvarez, Parra y Navarro; Alvarado; Al-Saati, Botta, Woodbury), offering little more than a set of sweeping views,

which used to be communicated with greater conviction by a series of perspective renderings only a few decades before. These papers analyse the syntax of typical animations, correlating them to cinematic classics, documentaries, and mainstream animated films. Cinematic modes, analysed by the aforementioned authors, make great use of visual fragmentation (Alvarado 2008: 133). Any omission of spatial geometric properties acts in favour of a subjective account of given spaces (intuition, sensual stimuli, memory evocation) (Al-Saati, Botta, Woodbury et al. 2005: 13), but in equal measure does it enrich spatial accounts by means of diversity in image composition, camera set-ups, and choice of angles (2005: 147).

> In the case of camera pitch, [architectural] animations prefer high-angle shots (probably due the ease of locating aerial viewpoints on a digital model), while the documentaries focus on low-angle shots (due to the obvious difficulties in raising a camera above ground level).
>
> (Alvarado 2008: 143)

Symptoms of contemporary conservatism might be all the more surprising, given the fact that in:

> the late 1990s that several architectural firms switched to using 3D animation packages, such as Alias, that were originally designed for graphics, film and game industries. These packages allowed easy creation of fluid, smooth, complex forms. By 2000, the curvaceous 3D computer graphics forms popularized in games and film became evident in architecture. Buildings became free-flowing, smooth, complex, dynamic, and unpredictable.
>
> (Al-Saati et al. 2005: 1)

What the new millennium additionally witnessed, was a channelling of this potential back into the design stage. On the example of university programmes mixing graphic design modules of both architectural and cinematic origins, we can notice a partial redirection of interests from typical model-making to visual research on diversified readings of space. London's Bartlett School of Architecture definitely emerged as one of the prime institutions, which incorporate filmmaking and film studies into their curriculum.

> Over the last 10 years [or 17, from the standpoint of 2016], when the new breed of teachers and students have been given free rein to develop deeper agendas, the Bartlett has moved to a much more interdisciplinary and integrative approach to architecture, where many of the concerns with technology, digital media, history

and theory are equally commonplace in the design studio, and, vice versa. [...] What matters now is not so much the medium, but the overall aim that architecture and how we go about architecture as substance and as practice, are both continually questioned for the possibilities.

(Allen et al. 2009: 8)

Aside from the academia, there is yet another testbed for speculative projects. Annual festivals dedicated to cinematic architectural productions, like the Architectural 3D Awards, receive submissions in four categories, which loosely delineate the main line of architectural film productions: commissioned works, non-commissioned works, interactive/AR/VR/emerging technologies, and student (images/films). Clearly making distinction between productions on the basis of their ability to meet formal requirements, commissions such as these files speculative works under the last two categories. It is not just the architectural 'hard sell' that makes the cut, but a growing 'market' for visualization studios (in filmmaking, among other industries), advertising agencies, and animated film festivals. With this a new distribution channel opens up, gloriously prolonging the speculative discourse.

The projects discussed in the final chapter have therefore been picked from exhibitions of students' works. Such productions emerge annually, never failing to address contemporary issues related to architecture and the city. Conceived as films, storyboards, or mixed media, what is implied in either one of these embodiments, is an active, kinetic reading of the project. Likewise, the animated films, which are featured here, touch upon a range of spatial concerns mostly related to visual culture and digital modes of image production. Among them one can also include those conceptualizations of space, that envision it as a material, social, mental, image-based, and performable construct. 'These are serious propositions, and they contain more than a little sense of the world outside the university- and studio-based project. They are, in many ways, "as if" projects, designs which imagine a world where these projects really are built and realised' (Allen et al. 2009: 12). Filmmakers created a vast repository of means and methods, by which to encode meaning in represented space. Their transitioning into the 'cyber-spatial' realm of digitally-altered imagery, or an altogether purely artificial CG-space, opened up the domain to a wide range of indirectly related subjects connected with digital media, graphic representation, and performance of simulated environments. What will follow is a series of case studies. All are animated film productions from Bartlett's students and graduates, exemplary for their treatment of filmic space that converges with the discussions contained in the preceding chapters. The choice of films denotes a creative perspective on augmented architectural environments, complemented by speculations upon their future line of development.

Intrinsically, they closely match Spiller's philosophy, who wrote that: '[a]bove all, Post-Digital Design is relativistic, operates on both a local and global level and is constructed from a genius loci that includes not just anthropomorphic site conditions but also deep ecological pathways, mnemonics, psycho-geography and narrative' (Spiller 2008: 366).

7

Case Studies, Part Two:
Speculating with Architectural Animation

Architecture as a vehicle of communications dramatically increased the reliance of the discipline on the visual domain outside of modern graphic strategies. Images of consumer culture were drawn upon to generate the atmosphere of transience and circulation, or even equate lifestyle and architecture. Architecture as a web of imagery implied that building was not of the essence after all. Representation was architecture in itself.

(Steiner 2009: 32)

If architecture is already an image, does it yield to subjective impressions (or projections) of material space? As soon as architecture becomes a downloadable software, would it comply with all mishaps of digital data, including infestation and mutation (glitches)? Would our houses be seasonally crashing, just like operating systems do? Could architecture be shared, and would the term still connote a collective temporal inhabitation of social spaces? What would a Bernini glitch look like? As architecture becomes both the subject of representation, in terms of a simulated spatial experience, and a method of its realization, is actual construction likely to be any different from the act of design? But has that not already happened?

Conceiving of their speculative proposals as mixtures of magical realist narratives, spatial explorations and myths that administer the concept which goes beyond traditional architectural territory, architects-artists, like Chris Kelly, Jonathan Gales or Paul Nicholls, explore themes of augmented reality, post-technological lifestyle and simulation (Steiner 2009: 81). Their projects resound with similar mappings of this vague terrain, taking after contemporary science-fiction novels, which, by the way, are explicitly referenced in some of them, harvesting cinematic fictions such as *Blade Runner* or *2001: A Space Odyssey*, for atmospheres, imagery, settings and ethical dilemmas. Novels and short stories by William Gibson, James Graham Ballard, Neal Stephenson and Philip K. Dick are definitely a 'must-read' among these designers, being echoed in the projects'

narratives. Their spatially potent descriptions always found recognition among architects. For the best summary of this line of para-cinematic productions, we should consult project-makers themselves. As basically creators of animated works, their films engage dynamic modes of viewing and mobilized spatial subjects (intelligent environments, kinetic buildings), turning architecture into a literal 'machine' for living. These speculative projects should be viewed as intersections between 'a design led approach to film making' and 'a narrative led approach to architectural visualisation' – as outlined by the motto on the Factory Fifteen website (http://www.factoryfifteen.com).

Visual cognition and space

Chris Kelly: *Rubix/Tardis*

While 'Rubix' connotes the 3D activity of solving a Rubik's cube, and 'Tardis' is an explicit homage to the impossible space inside a time machine police box from the *Doctor Who* television series (1963–89; 2005–present), their combination in Chris Kelly's architectural project opts for an altogether unprecedented virtual space that neglects laws of physics. What we get in return is a landscape open to reconfigurtions. Coming as a complementary exercise, accompanying his architectural thesis *Time and Relative Dimensions in Space: The Possibilities of Utilising Virtual[ly Impossible] Environments in Architecture*, the five-minute animated short *Rubix/Tardis* (2013) presents a gamut of architectural interiors, environments and urban fragments, assembled in a malleable manner. Apparent motion propels narrative progression, as the plot is told from the point of view of a subject wearing a head-mounted display, yet locked in place. Combining various perspectives and walks/rides through urban fragments, the system constantly creates new sceneries out of these 'block pieces', giving us a glimpse into this 'INFINITE INTERCHANGEABLE CITY, combing rotation gains with overlapping architecture that uses interchangeable city tiles an infinite constantly morphing city could be explored naturally in the virtual environment' (Kelly 2013: 101). We are presented with a storyline that oscillates between a 'city symphony' (as the city is recomposed into a collage whose parts' arrangement shifts constantly) and an architectural 'walk-through', in which the camera's POV is often synonymous with a *flaneur*/passenger look upon the surroundings, traversing the film's looped infrastructure. In fact, it is the diegetic setting that moves around, doing so in conjunction with camera's motion, so that the

> animation represents a journey through the chosen site that was explored during an
> earlier project which was a stretch of the Docklands Light Railway between Beckton

and East India stations. The virtual journey is compressed into 5 minutes using transitional spaces that enclose the explorer whilst the environment shifts around them.

(Frearson 2013)

Synopsis

With its opening shot sliding down an interior wall, *Rubix/Tardis* 'locates' its viewer in a space that is reminiscent of a machine hall, where constant motion of cranes, forklifts and gantries distracts the spectator's eye from curious openings, providing a view onto the world outside. With all the beams, pipes and metal sheets seen up close it becomes confusing to tell the actual dimensions of this space, to tell apart floors from ceilings or walls, or read images as 3D, not just snippets from an abstract animated film.

> What we see and what we believe to know about what we are viewing can be very different. Our perceptions are unconscious inferences from sensory data or 'predictive, never entirely certain, hypothesis of what might be there'. Perception is separate to cognitive problem solving; it is an unconscious, almost instantaneous translation of the signals from our senses into what we perceive as reality.
>
> (Kelly 2013: 18)

In *Rubix/Tardis* this difficulty is deliberate, proving that initial inferences from the environment, as well as dependence on visual cues – such as size consistency, blurring of distant objects, cognitive map-making or movement at constant speed in relation to the landscape perceived – may often beguile us into a misconceived idea of space.

> There are a series of pictorial cues that we draw upon including perspective, texture, shading and shadow, reference frames, learnt sizes and aerial perspective. Perspective relates to the understanding that an objects size is inversely proportional to the distance from the viewer, texture relates to visual gradients, such as those seen on curved or slanted surfaces.
>
> (Kelly 2013: 34)

And so, the staircases lie on their side or hang upside down. At a 90-degree angle they flow into one another, interrelated, like in Escher's *Relativity* (1953). Chequered metal floor plates are pinned to the walls. Through bunker-like slits we see a passing train. The rail line makes a sudden turn, forcing the train to travel vertically. This world's 'building blocks' behave in a similar manner, inferring from how they shift into place, rotate, fit in. Rather, they appear as sections of

this landscape, which has been subdivided by ruthless incisions, just like (in) Archizoom's *No-Stop City*. In that project a single domestic unit is surrounded by mirrors. A small square plot of land is thus endlessly reflected, creating an impression of infinitude.[1]

> The most recurring elements in the designs are definitely the mirror and the orthogonal grid, which are two ways to dematerialize a surface: the grid, by turning it into a pure abstract geometry; the mirror, by duplicating the surrounding world.
>
> (Pizzigoni 2015: 27–28)

In Kelly's film the 'planetary urbanism' of *Rubix/Tardis* puts such visual sections of landscape on a conveyor belt, like prefabricates intended for an architectural gaming environment. When hinged, railings cease to perform their safety function and appear as bars. After all Duchamp was right in employing hinging as his prime strategy aimed at distorting our perception of mundane objects; from urinals to perspective projections.[2] Kelly's emphasis on delusory aspects of composited views and perspectives deems staticity an artificial and limiting mode of perceiving the world. 'Our understanding of spaces is one of multiple points of view, of moving through that space and exploring it. We are not static viewers of a physical world but appreciate our environments as a sensorimotor experience' (2015: 15). When sitting in a vehicle, we assume that it is us, not the scenery, which moves. However, without our prior experience and knowledge, there is no 'outside' to this preconception we could infer our – not scenery's – movement from. What really underwrites the *Rubix* project is thus a reversal of this relationship, in turn making virtual scenery move past and around us.

> Our understanding of space is not a direct function of the sensory input received from our sense organs but a perceptual undertaking in the brain where we are constantly making subconscious judgements that accept or reject possibilities supplied to us from our sensory receptors.
>
> (Pizzigoni 2015: 1)

The architecture in *Rubix/Tardis* relies on such optical illusions, adopting a mobile frame of reference in relation to an immobile observer.[3] His immaterial architecture is constructed out of data coming from the explorer's senses. It conveys sensations of immersion, traversal and locatedness and – in reaction to such incentives – develops a simulated architectural setting that contains one and makes (visual) sense of these impressions/stimuli.

Let us return to the narrative. As each of the urban pieces has fallen into place, we zoom in on one of the slits, catching a glimpse of a train arriving at the station.

The next point of view is the passenger's, looking from an elevated position of the railroad line at the high-rises in a business district. Overpasses rotate like 'draw-bridges' located on the sides of a Rubik's cube, meeting up again to be locked in place, forming terrain's continuous profile. Without any intermissions the trip is resumed. In the following esplanade sequence there is much similitude to the constructivist geometric abstracts of Yakov Chernikov. Aside from lending the scene its futuristic look, the connection is also established through these forms' austerity, or their violent relation to the site – an imposition of cubist shapes on an irregular surface. Primarily it is the method of assembly of both, Chernikov's architectural fantasies and *Rubix*'s sides, that informs this collage of architectural and urban elements.

Around a minute into the film we are presented with the static view of a glazed skyway, supplemented by peripheral views of skyscrapers and an opaque surface in front of us. Suddenly, the surface reflection slides sideways, exposing an empty elevator. There is much interplay with apparitions, reflections, and with apparent cantilevers 'supporting' a solid world on the outside of optical illusions. In fact, the latter is among the least stable and reliable of them all, subjected to constant shifts and transformations. We cannot even be sure whether it is the camera that roams through the city, or the city which passes, twists and turns before the 'eyes' of an immobile spectator. Kelly draws upon

> a number of theories of how we then recognise these borders and edges as specific objects, one being that we process the scene in three stages, as a 2D image, then a 2.5D image identifying which planes are closest and then as a 3D image connecting all the planes together and using their orientation and scale to identify their physical properties.
>
> (2013: 27)

And in this undertaking optical illusions, which are induced by movement, are of uttermost interest to him, employed as 'test patterns'. They have been introduced in the narrative for a better understanding of the way our perception (cognitive process) works, and how it operates, when one finds himself immersed in augmented architectural space. In essence a phenomenological account of one's environment, this predominant theme in the writings of Juhani Pallasmaa, Steven Holl and Peter Zumthor is reversed in *Rubix/Tardis*, where it is the user who generates the space to inhabit and/or traverse.

Rubix/Tardis *is ... paradox*

Furthermore it defies its traditional role as infrastructure, by undergoing constant transformations. As it is space and not the commuter that travels through Kelly's

FIGURES 7.1–7.6: Chris Kelly, *Rubix/Tardis*, 2013. Film still: self-produced. UK.

paradoxical 'world', what might have appeared illogical, impossible even, becomes quite mundane in the context of virtual reality environments designed as dynamic constructs manipulated by the user. In this 'scenario' vision and motion become entangled, blended,[4] 'reinforced' by optic illusions and perceptual traits that help us understand space as a mental construct. While live-action films can expertly handle impossible spaces on the basis of either trompe-l'oeil cinematography or montage juxtapositions, it is primarily animated ones which favour similar 'lapses of reason' in regards to architectural space. The disparities between the container and the contained add to an absurd quality of the Warner Brothers' cartoons, whereas, in artistic and experimental feature films, they constitute the surreal quality of places, such as heterotopias of haunted houses. Comedy and surrealism meet up in the science-fiction-ism of the *Doctor Who* series, in which the Tardis serves as the main character's control room. A paradoxical space that from the outside – as stated previously – resembles a police box, while inside it expands into a

multi-storey loft. The series also establishes a strong link with dream architecture, which displaces logic in favour of experience, although intensely ephemeral. By emphasizing absurdity and contradiction such spaces undermine our confidence in built environment's firmness and staticity. With the help of computer graphics architectural space can thus shrink, expand and upset our expectations about continuity, among other aspects of space we are likely to encounter.

Rubix/Tardis *is ... cinematic space*

This dream-like or rather nightmarish aspect of digitally generated environments becomes the setup for films like *Dark City* (1998) by Alex Proyas, whose initial reading as a film noir stylized metropolis becomes gradually debunked. Eventually, it appears to the main character as a construct akin to the Rubik's cube of *Rubix/Tardis*. Upon discovering that the construction is in fact a planet, the directions assumed at the outset are gradually contested by the planetoid's gravitational pull towards its centre. Other than that Proyas's nocturnal metropolis volunteers radical reading of a generic city, viewing it as a composite of standardized typologies, both urban and architectural, guided by opposite vectors of centre's densification and urban sprawl. This modular view can be traced back to the mega-structures of the 1950s, though placing this film in line with grotesque dystopias of the 1960s, counteracting principles of 'total design'. Instances of this anti-design movement can be both architectural, like in Superstudio and Archizoom's projects, or cinematic, as the underground complexes in *Logan's Run* (Anderson 1976) and *THX 1138* (Lucas 1971) evidenced. We will also find them in literature, such as Ballard's *Concentration City* (1957), in which the metropolis perpetuates its cellular programme ad infinitum. Proyas's unnamed 'dark city' neither grants exits to its inhabitants, aside from the simulacrum of Shell Beach – a childhood utopia. The second (yet reversed) reference to Kelly's project can be found in *Cube* (Natali 1997), in which a precise stereometric system, embedded in a tessellating machine, creates an ultimate prison for the remnants of mankind. Just like *Dark City*, *Cube* is a concentrated architectural entity, which we are able to explore only from within. To us – and to protagonists alike – it appears as an ever-rotating labyrinthine environment. We may recognize specific rooms along the way, or memorize their sequences (*enfilades*), yet they remain elusive, literally on the move. Given the number of permutations in which subsequent spaces can be juxtaposed – the order which translates to narrative progression – the cube can reconfigure itself in near-to-infinite possible ways. Both the 'cities' of Vincenzo Natali's and those of Alex Proyas's invention are variations on Rubik's cubes. In each of the plots characters' disorientation is exploited to the extreme, as they attempt to understand the urban/architectural structure, placing themselves within it, or/and inferring a

mental map from their surroundings. Unsurprisingly, they embark on an impossible task. In *Dark City* and *Cube* the reconfiguration processes are presented as occurring without a direct involvement of the characters, thus downgrading them to either witnesses or discoverers, horrified by the structure's uncontrollable behaviour. City can appear as an obscure mechanism, but behind this epiphanic crescendo there is always more than a fire exit.

Rubix/Tardis *is ... cognitive map*

On the other hand, the city's spatial arrangement in Kelly's short is presented as malleable from the very beginning; except for the initial suspense, when the camera sets out to explore more and more paradoxical interiors. The central premise of *Rubix/Tardis* states that movement is relative.

> We visually perceive movement in two ways by either an image moving across the retina, such as when an object passes across our vision and our eyes remain stationary (image-retina system), or by eye movements when we track a moving object with our eyes (eye-head system).
>
> (Kelly 2013: 20)

The director revisits classical fly-through animations through these lenses, although breaching their generic integrity. He builds upon the premise of a sequence of fly-bys around the structure, although as soon as its complexity and self-contradictiveness becomes incrementally revealed, the conventional narrative structure is exposed to act as a 'safety net' – a familiar terrain to outbalance the heady perspectives and trips around the vertical-horizontal perimeter that end with camera's pulling back and fading out. By means of cinematography we encircle the structures and explore them from within; alas, we acquire no better understanding of their architecture, when it comes to logic of assembly. We do not gain any coherent image of the complex either. Instead, new settings instantly appear and recompose themselves in nearest proximity to the observer, yet only for the time of their passage:

> It was found that when moving with natural locomotion, such as walking in a physical space our perception of distance and orientation is incredibly malleable and can be manipulated by replacing the visual sense with a virtual stimulus that differs from what we would experience in reality. This manipulation can take the form of redirection techniques, such as rotation and translation gains and overlapping architecture which result in a stretching or compressing of distances in the virtual environment we see whilst moving through a physical space.
>
> (Frearson 2013)

In *Rubix/Tardis* this act of dynamic cognition, that is, moving about a space to gather information requisite to construct an internal model of the scene, is congruent with the internal process of building its representation – a mental image. Remember that this 'map' is anything but an impregnated sheet that we consult with, when trying to find our way in a foreign city. We can view this representation as active, mutable – an assemblage of fragments continuously reconstituted, and likely to be confused by new inputs, distorted memories and abstract models, like the traditional cartographic aids. 'Cognitive maps can be accessed, reproduced and reoriented depending on the context of the task required. They span over all the senses and include information on other environments, such as memories, relationships, social and political meanings' (Kelly 2013: 32). The problem of mapping architectural space, so engagingly presented in *Rubix/Tardis*, boils down to the fact that space itself is already a representation of the mapping process – an act of recognition, attribution and placement. Not in relation to an abstract coordinate system but to an individual way of combining these fragments. Building up this representation in the narrative is often confusing, as we witness the process of verifying input data from environmental stimuli against the content (forms, urban fragments, architectural elements) stored in memory.

Providing that – in the future – we will be able to create a complete database of architectural fragments, akin to sound libraries, including styles, historical buildings, as well as complete unrealized projects, our spatial experiences in augmented reality – as postulated by Chris Kelly's work – could become personalized and defined by an array of precisely selected stimuli. Regardless of whether they have ever actually materialized, or were only intended as buildable, such typologically inclined 'spatial assembly algorithm' would have created an illusion of exploration. An exploration of virtually any type of architectural space allowing us to inhabit, with equal ease, buildings drawn by Escher, as those designed by Eisenman.

Building boom and cities for ghosts

Imagine a concrete maze, an urban enclosure. Jeffrey Smart chose labyrinth as the subject of his final painting, depicting a city's outskirts as a (hedge)maze of seemingly straight roads, narrow pathways dwarfed by high rises, and shadow-washed back alleys, in which not the Minotaur, but H. G. Wells, loses his way. Amidst the walls, he is nearly unrecognizable, though. Smart's paintings translate Hopperian street scenes and desolate views into a landscape of industrial non-places: cross-docks, building sites, overpasses, city edges and all that 'fallout' of the urban sprawl. This is the scenery we encounter, when watching the films of Jonathan Gales.

Jonathan Gales:
The Pentecostal Ministry of Fire; Speculative Landscape; Megalomania

In his most famous short, *Megalomania* (2011), Jonathan Gales took inspiration from Piranesi's *Prisons*, even though it is quite common for any artist to refer to the Venetian's creations when striving for a paradoxical account of built environment. Especially if architecture that is being mocked in the plot has already attained gargantuan proportions, while remaining deluded by this newfound grandeur. Exaggeration in Gales's film proves its semblance to the eighteenth-century master's etchings at a deeper level as well. Piranesi's life project challenged that era's archaeological and urbanist models, which sought solace in ancient Greek, rather than Roman past. Restoration projects undertaken by his contemporaries were in his opinion destructive, but also steeped to the marrow in historical tourism, producing a fashionable simulacra of ancient past. This erupting interest in antiquity finds its weight class equivalence some three centuries later, in an altogether different theme of the building boom experienced by thriving economies of Far East countries with one of the most vibrant in recent years in China.

Synopsis

Sunday is dawning on a city of megalomaniac building schemes, or so it seems, as no construction workers are to be seen anywhere near. Gloomy desolate landscapes, along with an impression of permanent work-in-progress, endows the world in *Megalomania* with character(e) of a contemporary ruin. Forsaken, though only partially complete, its vegetative span renders it difficult to discern parts that constitute this construction site's 'not yet' from those that mark the 'already been' period. The building's frames bear visible marks of time's passage. Upper levels were left incomplete. They impose a frigid and sketchy look, when compared to these buildings' fundaments that plunge into darkness, left to decay. The camera mostly takes on a first-person perspective. The protagonist's glasses reflect what is revealed to us as future London. This city testifies for a different mode of organization. One that considers citizens as either constructors or squatters. But policies of upward expansion reign over other aspects of social life as well. The only houses left in sight resemble provisional accommodation units located on the site's perimeter or attached to disused structures, like the corroded big wheel – *Megalomania*'s 'poster' image. Conversely, these buildings' flamboyant shapes and preposterous proportions evidence an unmoderated progress in which economic concerns already breached safety measures. Abandon all functionality, ye who enter. What seems like a (relatively) new construction gives off an appearance of

being arrested in collapse. Just like Piranesi, Gales exaggerates scale, bringing out the haphazard logic behind interrelated parts. His skeletal silhouettes in this havoc of a construction site defy gravity, let alone safety regulations, reaching for the sky like ravenous plants. Their life cycle is even more manic. When new levels are added, those down below are blown up. In terms of its narrative structure *Megalomania* echoes this vicious cycle. It abides its own inbred rationale of perpetual construction and destruction.

In his films Gales likes to play out pessimistic scenarios for urbanism's future, often channelling into the popular vein of post-apocalyptic neo-primitivism, popular with cinematic 'high road' chamber pieces, such as John Hillcoat's *The Road* (2009), Joseph Kosinski's *Oblivion* (2013) or Albert and Allen Hughes's *The Book of Eli* (2010). One of his anti-futuristic renditions finds London's famous shopping district turned into a temple for 'Haitian' Vodou cult. In *The Pentecostal Ministry of Fire* (2010) a derelict shopping mall (still) located at the Elephant & Castle junction comes close to playing out the scenario taken from a J. G. Ballard novel *Kingdom Come* (2006), although removed further in time – to an age when a twentieth century's customs and consumerist society are a bygone memory. In its place we see an altar bearing the Elephant & Castle restaurant chain logo. We look at the figures rummaging through the ruins – zealots of this new religion, lighting a candle to worship nascent gods. Tribal huts and exotic temples fill the landscape with wooden structures. As the camera pulls back and dollies a bit, we notice a monolith made of solid stone, surrounded with flaming volcanos and other signposts of the post-capitalist Neopaganism. Nevertheless, despite all their ersatz indigenousness the settings still resemble an amusement park ride. While the *Ministry of Fire* short is quite ironic, Gales's later efforts become a bit more grim. Among them is his first short, *Speculative Landscape* (2010), which should be considered a proper introduction to equally bleak *Megalomania*.

Narrated like a sequence of tableaux of framed views, seen from a train window, *Speculative Landscape* presents us with subsequent stages of urban development. Downsides of technical/economic progress are presented and epitomized by hail of litter, 'scorched' building sites and vast industrial wastelands, arriving at the passenger's field of view just after the initial optimism of electric windmills passed by in a blur. The final phase of this journey becomes truly dystopian, upon reaching closed-off areas, fenced in with barbed wire and concrete walls. They are described in Chinese characters, probably prohibiting any (visual) trespassing further beyond this point. Where *Speculative Landscape* takes off, *Megalomania* begins. It opens with the image of an eye. One recognizes cranes on the waterfront and suspension bridges reflected in the iris. The pupil dilates.

Having just arrived at the final station, the character gets off the train to examine a vast construction site. One of the shots juxtaposes built structures with those

arrested at a stage of building. We see an office building crammed far in the screen's right corner, reflecting scaffoldings in its glass panels. In the next scene white foils are fluttering on a winter's day. Ascending in slow motion, camera soon encompasses an entire panorama. Falling snowflakes in still light add a greyish hue to the scene. It is possible to spot London's iconic buildings on the skyline, like the skeletal rendition of Erno Goldfinger's Trellick Tower. The following shot concentrates on a hybrid building, equipped with cranes and deconstructivist forms on top. Suddenly, the camera descends into a deserted street, scouring corridors between buildings, eventually focusing its attention on numerous skyways, bridges and plant-like reinforcements shooting out from the structures. Others are joined with trusses of cables and cable computer buses. Buildings' supports explode, and their steel frame structures topple to the ground. Through a series of close-ups we notice that the sky-scraping monsters are composed of layers, most of which are already in ruin. Concrete fragments and twisted rebars (reinforcing bars) stick out of their vacant segments. Despite the damages inflicted to lower levels, upward expansion proceeds. In *Megalomania*'s final shot the camera focuses on the onlooker's face – a detail of his right eye, surveying the landscape from behind his glasses. It mirrors London's skyline *c.*2011. Was it just a premonition? Mere speck of dust waiting to be removed from the beholder's sleeping eye?

Ghosts of manhattanism

This is not a dream. Type in 'Chinese ghost cities' in the Google search bar, and a murder of images will pop up, resembling stills from *Omega Man* (Sagal 1971) remakes, along with a few Jeffrey Smart counterfeits. Empty streets and lone figures caught on photographs. Cities of the Far East are not exactly 'ghost towns', because they were not inhabited in the first place. This phenomenon raises interest in China's desolate landscapes. They start to appear in films, documentaries; they

FIGURES 7.7–7.8: Jonathan Gales, *Speculative Landscape*, 2010. Film still: Factory Fifteen. UK.

start to illustrate countless articles. Images of cities like Ordos in Inner Mongolia, with its (in)famous Kangbashi district, beckon people from afar. The kind of tourism it spawns is scavenger-tourism.[5] People who come to see Kangbashi – the eerie outcome of Chinese property bubble – are descendants of Romantic thrill seekers, who voyaged through Europe to witness for themselves the excavation sites at Herculaneum and Pompeii. Many building projects in China – caught on camera memory cards and captioned with the current date – are interlocked between completion and habitation. Despite the Chinese officials' claim only few of them actually are, because many projects ran out of financing in the course of their implementation. Now that the Western journalists make pilgrimages to Kangbashi in search of the sublime – always evoked by human absence, especially in highly developed urban areas – this trend already seems to be in decline.

> It generally takes at least a decade for China's new urban developments to start breaking the inertia of stagnation. But once they do, they tend to keep growing, eventually blending in with the broader urban landscape and losing their 'ghost city' label.
>
> (Shepard 2015)

Not all newly built cities are bound to follow that course. The bubble will eventually burst, leaving this extreme case of urban growth as an intriguing episode for prospected case studies; along the lines of logic behind manhattanization. The terms should not be confused, though. In *Delirious New York* Rem Koolhaas calls 'manhattanism' a lived fantasy – a movement in search of theory for processes that are at this point in full development. It describes urban congestion and vertical sprawl that inspired an 'ecstasy about architecture' (Koolhaas 1994: 10) in hi-tech fetishists, business district aficionados and architectural futurists. James Graham Ballard's *High-Rise*,[6] recently adapted for the 'big screen' (Wheatley 2015), remains among most immediate statements about the actual impact of high-density projects on population, assuming that they proceed not with care but are rushed by developers.

> Manhattanism is the one urbanistic ideology that has fed, from its conception, on the splendors and miseries of the metropolitan condition – hyper-density – without once losing faith In it as the basis for a desirable modern culture. *Manhattan's architecture is a paradigm for the exploitation of congestion.*
>
> (Koolhaas 1994: 10, original emphasis)

Still, as Nathaniel Coleman argues,

> [m]anhattanization is a global phenomenon with or without Koolhaas to legitimize it [with what he terms 'manhattanism']. During the twentieth century, especially

since World War II, cities everywhere, from Boston to Shanghai, and from Houston to Hong Kong, longed to *manhattanize*, which seemed necessary if they were to take part in the economic dynamism that appears to go hand in hand with skyscrapers and ultra-high-density development.

(Coleman 2005: 87)

Regardless of its negative or positive connotations 'manhattanization' is a pattern for urban expansion, which has recently taken over China at an unprecedented scale. Photographs of the Conch Bay district in Tianjin, very much like Disneyland mock-ups, or the fake Paris in Tianducheng (complete with its own Eiffel Tower and Haussmannian buildings), try to inject the logic of manhattanism – precisely, a 'lived fantasy' – into a patch of desert in Northern China.

These two 'plagues' infest the narrative of Gales's animated short. While manhattanization is reflected in the scope of construction projects presented in his film, the ghost cities phenomenon is rephrased in the construction site sequences. They are straightforwardly exposed as failures in planning. On its surface *Megalomania* does not propose direct solutions or alternatives to any of them. However, on second glance this future bleakness, regarded as stylistic device, makes it less difficult to discern possible antitheses for exaggerated renditions of such building projects. First, in term of scale; second, sustainability. The latter instantly comes to mind, when viewing Piranesian towers, or the ill-balanced steel-frame skeletons of buildings. The actual story of cities like Ordos has already been tagged as 'post-apocalyptic'. Why then resort to dystopian narratives of this sort? Gales decides upon a simpler storyline that flirts with anti-utopianism, yet frames the action in a convention of time-traveller's glance back, homeward bound.

The Sleeper – we may call him – being reminded of a Wellsian (*The Sleeper Awakes*, 1910) narrative strategy. Except from this framing device, *Megalomania* retains the observational mode of documentaries. Not as a random montage of views, but a paced, constant flow of information about the restricted site. At first, the city is portrayed as a wasteland; then it reveals itself as an area overbuilt with temporary cabins, challenging our assumptions of balance, stability and gravity. In the final act we witness the fate of these structures, beholding their collapse. This ensuing 'dialogue' of scenes showing upward expansion, intercut with frames displaying demolition, hints at a temporal span of the ongoing constructions – the co-existence of the chrysalis and the carcass. A phenomenon which is not at odds with what numerous reporters saw on their trip to Ordos, beholding 'a forest of dusty, unfinished towers fanned out from either side of the road. Cranes stood sentry over some of these construction sites, many of them rising as much as forty, fifty stories high above the desert' (Richter 2014). Similar cranes overlooking the

city's skyline can be seen in *Megalomania*. What seems troubling in Gales's short is not only the lack of any supervision over construction projects but their complete obliviousness to their future inhabitants. In authoritarian countries like China the citizen is regarded only as a minor obstacle for urban development projects. Takeovers of land and uprooting of farmers is unfortunately still commonplace, with few legal barriers standing before the municipalities' officials, who seek to increase their gross domestic product at any cost. What we see in *Megalomania* is therefore a city 'grown' artificially, somewhat independently of the inhabitants' needs, or – in this case – despite their resistance.

Babylon shrugged

We will find the same attentiveness to issues of urban redevelopment in Mamoru Oshii's *Patlabor: The Movie* (1989), in which

> [t]he emphasis [is] on a throwaway culture, of urban decay and ruin, the demolishing of historic districts, alongside extravagant new development in the form of the massive Babylon Project tower – a hi-tech Ark in Tokyo Bay – [as they] contrast and illustrate the issue in no uncertain terms. Oshii's feature is a thoughtful examination of urban development and architectural changes in our metropolises.
>
> (Hanson 2005: 38)

In turn, *Babeldom* takes the metaphor of a large-scale construction project to its conceptual lengths, locating its narrative structure on a dialogue – more specifically, a correspondence between an archaeologist from the future and a woman from an 'excavated' past. Calling upon the image of the Tower of Babel, an allegory of civilization's progress gone wrong, the director constructs a narrative woven around a series of letters exchanged between two distant lovers, in a way that is reminiscent of a similar device employed in Chris Marker's *Sans Soleil* (1983). This way Bush establishes a link between ancient settlements and the megalopolis of tomorrow; other than etymological. *Babeldom*'s 'portrait is assembled from film shot in modern cities all around the world and collected from the most recent research in science, technology and architecture' (*Babeldom, a film by Paul Bush*, 2012). What makes up its contents, that is, the tower's subsequent 'floors', is a collection of documentary shots of manhattanisms from around the globe: London, Berlin, Shanghai, Dubai and Osaka, giving testimony to homogenizing forces of manhattanization. Looking at rows of high-rises, it is practically impossible to tell these cities apart. City translates into knowledge amassed – Bush suggests. The metaphorical tower of his film is heterogeneous, incongruent and non-standardized, despite normalized modes of production (like the 'waste

product' of industrial animations, discussed in Chapter 2), that gave birth to most digital animations inserted into the storyline.

What *Babeldom* is governed by are essentially two constants. The first one propels vertical expansion, which parallels transformations taking place on the 'eternal construction site' in Gales's film. The past becomes associated with urban foundations – ruins of the city's previous iterations, like layers of the burned-down Troy, one built upon another. In comparison, future is a vector pointing at the sky – the second of the aforementioned constants. Babeldom's skyward expansion never ceases, accelerating until motion turns into a hazy blur. It literally disappears in clouds, but even there we can notice its multiple squid-like arms belonging to construction cranes, delivering materials and reinforcing the structure. *Megalomania* draws a similar image, though supplementing it with a Viertovian line of thought – city equals motion, constant progress, evolution. Due to its animated form and a timeframe that allows for a capsular narrative to expose absurd philosophy behind a city-scale construction site, Gales's film develops an anthropomorphic metaphor for the at-once vacant and at the same time overbuilt 'London'. Detaching the 'narrator's' point of view from the mode in which buildings are portrayed assigns to them the status of independent 'textual bodies' that command the narrative. Even though they may resemble standard architectural fly-throughs, these are in fact 'intermissions', which undermine the frame story's cinematographic ascription of a first-person point of view to the default mode of spatial navigation. In effect, *Megalomania*'s narrative gives away a close kinship to wildlife observation of urban processes, taken out of their proper cycle of construction, building's exploitation and decay. In the final stage ghost towns are formed after the local economy breaks down. With instances of building boom sparked off by speculative bubbles this cycle seems to be reversed, or disrupted – a new urbanistic shift, extrapolated in *Megalomania*. Oshii's two *Patlabor* movies rely on a similar strategy:

> [T]he city as ideated by Oshii serves to underscore the significance of the specifically bodily dimension of space, entailing the plausibility of a mutual transformation of architectural and organic bodies. On the one hand, human beings can be conceived of as artificial structures: here humanity is *architecturalized*. On the other hand, it is possible to think about buildings as bodies: here architecture becomes *humanized*. […] [T]he city is born, grows, conceives, reproduces and dies; it has sex, as suggested by the idea of the city reaching a climax; it follows certain diets; it develops diseases, neuroses and disabilities, such as congestion, tumorous overgrowth.
>
> (Cavallaro 2006: 126, original emphasis)

The city is simultaneously suspended in its decaying state, and permanent recovery by means of new construction projects. When we inspect the landscapes in

FIGURES 7.9–7.14: Jonathan Gales, *Megalomania*, 2011. Film still: Factory Fifteen. UK.

Megalomania, we see not just fractured bones, but new limbs. Under Gales's guidance the animated medium likens these constructs to bodies. Tobias Klein should be recalled here again, because with the medium of animated film CG corporeality ceases to be just a metaphor, whereas his creations literally 'collaged' body-scale fragments with urban-scale settings. The arguments presented in *Megalomania* work on yet another level – that of *rigging*[7] architectural structures, forcing them to 'behave' like animated 3D models of biological organisms. In Gales's film specifically we encounter them in the act of being fused into misaligned structures, (de)populating the chaotic construction site. They are like the gargantuan Prisons or Towers of Babel, which eventually fail to contribute to a healthy urban organism.

Interaction(s) with/in virtual environments

But as Spiller writes, 'The city can also be seen as the product of the invisible, the virtual – a complex mesh of interacting nodes which operate at a variety of scales simultaneously' (1998: 73). This instantly conjures up a discussion on

SmartCities and urban infrastructure's potential in adapting to this emerging paradigm, displaying versatility in regulating material, as well as immaterial, i.e. electronic flows.

> The smart city relies on intensive use of information and communications technology. It works through the development of electronic content and the increasing hybridisation of the latter with the physical world, a mingling that is often described as 'augmented reality'.
>
> (Picon 2015: 24)

Nicholls presents a distinctive view on 'smart' cities through an introspective account of a mediated universe of intelligent household appliances, or by turning interface into a surplus layer for augmented urban environments. Either way these technologically dependant futurescapes, where architecture is branded as a terminal for human actions, inevitably swerve in their narratives towards cautionary conclusions, forcing us to reflect on the proliferation of supportive technologies in our closest environment.

<div align="center">

Paul Nicholls:
Royal Re-formation; Golden Age: The Simulation; Golden Age: Somewhere

</div>

> *I think that film offers something which architecture has been trying to achieve for a long time: narrative. Architecture projects, particularly in education, are built around telling the story of your proposal. This is traditionally done by a carefully constructed portfolio of hundreds of drawings and images. A five minute film, in my opinion, can say a lot more about an 'architectural' concept than a million drawings, as its much more accessible and, more importantly, digested by the eye. Even in professional practice this methodology of storytelling exists in every planning report, competition, or client proposal. Film is a natural evolution of this, made more potent with recent technological advances, making it relevantly affordable to produce whatever you can think of.*
>
> (Holmes 2011)

Nicholls's own works – created under the 'banner' of Factory Fifteen, as well as comprising of his student films – best testify to this vision of architectural imaging, engaging in fervent critique of built environment and imaging techniques. In this he subscribes to Colletti's notion of 'digital poetics', employing the language of parametric design in an exploration of techniques of architectural visualization, modelling. Nicholls pursues his own line of inquiry, focused on technological transformations of domestic settings, reimaging spaces of

most frequent use in a way that diverts their previous programmatic apportionment.

A place to withdraw (synopsis)

In the 1980s Diller + Scofidio created numerous art gallery installations, amongst which we find the *withDrawing Room* (Capp Street Project in San Francisco, 1986). This project sets out to scrutinize domestic environments through the lens of cultural codes, giving a performative account of the activities that make up what is commonly understood as habitation. With this, as well as their subsequent endeavours, like the *Slow House* (1990), D+S were among the first to reflect on the role of electronic media and their permeation of daily domestic realities. In the aforementioned project house becomes a verb (though denoting much more than mere containment), whose dynamic constitution is organized by a system of chores and activities,[8] laid out as intentional arrangements of bodies in space (Diller and Scofidio 1994: 61). Living space may even stick with its 'machine' paradigm, although its post-functionalist agenda becomes clearer when viewed as a malleable framework for programmed functions, such as eating, sleeping, watching television, or 'surfing on the net'. As Jonathan Hill notes,

[T]he levels of physical protection between inside and outside, exclusion of outsiders and ordering of insiders define the safety of the home. But safety today is also dependent on protection against electromagnetic and media intrusions, such as a video entry-phone to monitor visitors, legal action to prevent publication of an unsolicited photograph, or anti-virus software to disarm a computer virus.

(Hill 2006: 23)

In *White Noise* (1985) Don DeLillo addresses this infestation of domestic space with electronic media in his characters' daily conversations:

'Waves and radiation', he said, 'I've come to understand that the medium is a primal force in the American home. Sealed- off, timeless, self- contained, self- referring. It's like a myth being born right there in our living room, like something we know in a dreamlike and preconscious way.'

(DeLillo 1985: 51)

What from the perspective of mid-1980s might have seemed abstract, is hardly uncommon in 2016. While DeLillo maps 'currents' of electromagnetic waves, penetrating the domestic environment, the strategy taken up by Nicholls centres

on their visualization by means of interfaces and enhanced settings that accommodate multimedia displays, touch screens, virtual controls, and holographic projections. It is the latter, which eventually tricks the user into believing in one's simulated surroundings – the theme which has been best developed in his *Golden Age: Somewhere* (2011).

Just like in all of previous case studies, the origins of his perspective on augmented reality, equipped with downloadable architectural textures, can be traced back to Nicholls's first cinematic trials, namely, the *Royal Re-formation* (2010) short. That film opens with an image showing millions of pieces floating through the city, reflected in skyscrapers' windows. Some of these fragments are recognizable, like household articles, and parcels. Others are pure debris. In a sequence reminiscent of a reversed action shot, characteristic of the early twentieth century's motion pictures, they flock in to fill a large cavity in the high-rise's middle section. Explaining his project, Nicholls describes this reversed dreamlike sequence as graphically abstracted construction/reformation of the Royal Cabinets, evoking the times of craftsmanship in the 'architecture of pieces' cast into the form of 'sculptural mail markets', the last of which stands for 'an aggressive expression of labour in an age of progressively automated manufacturing and fabrication processes' (Lambert 2011). After the objects are pulled back and re-fitted into place, the building starts to resemble a Lebbeus Woods mid-1990s projects, exhibiting scabs and wounds – interim phases of a damaged structure's regeneration. These growths create a canopy suspended high above the streets.

> Once formed the focus stays with the object, now in the form of the ornamentally re-branded building parts, before the nocturnal mail markets come to life, transforming into red jewels in the urban cityscape, becoming misplaced curious objects in themselves which have a strange visual balance of fragility and aggression.
>
> (Lambert 2011)

On a rainy night the 'scabs' are all lit up with an infernal red glow. In the final sequence we are shown a chaos unleashed inside the Cabinets building. Camera zooms in, and conducts a search, weaving its way among the mailbags. The film ends with a close-up on a single parcel.

While appearing as a traditional showcase sequence more attuned to the requirements met by *demoscenic* productions, this initial short animation subjugates its narrative to a special effect of reversal. Although already in the second part the brief storyline gives the abstract ballet of floating appliances a reasonable explanation. Taking place in a reimagined Canary Wharf business district of London, the project presents '[t]wo ideas of labor [that] are [...] existing in parallel. The capitalist driven one that we experience everywhere in the West, and

FIGURES 7.15–7.17: Paul Nicholls, *Royal Re-formation*, 2010. Film still: Factory Fifteen. UK.

the accomplishment of public service in a building that recounts its essence by its architecture' (Lambert 2011). Architecture becomes the purest expression of economic force in this short, translated into a 'chart' of spatial congestion – a point taken previously by *Megalomania*. Nonetheless, Nicholls's decision to compose architectural space in the building's cavity out of non-standard, artisan objects, follows a partisan view of architecture, perpetuated by the likes of Woods and his freespaces. Moreover, the flocking effect anticipates a similar effervescence in *Golden Age: The Simulation*, but – taken as a trilogy – also delineates the 'premises' of a visionary world that allows for architectural environments to be moulded, reassembled, or reconstituted from pieces, paralleling the way Nicholls's *Royal Cabinets* come into existence.

Nanomagicians

Nanomachineries of the *Golden Age* dyptich produce objects out of smart particles. It reconstitutes one's environments in real time. Both films are driven by the idea that nanotechnology will be able to build any type of complex material structures from scratch, changing their molecular structure. *Golden Age: The Simulation* (2010), being an abstract precursor to the capsular narrative of *Golden Age: Somewhere*, shows this plasticity/adaptability in performance. In a single take a variety of historical interiors are created from the same 'golden' mould. Certain sequences, like the opening panorama of a city, would be somewhat hard to decode, if read without any knowledge of the 'u-fog' device conceived by Neal Stephenson 'for' his novel *The Diamond Age* (1995).

> The film uses the book 'The Diamond Age' by Neil Stevenson [*sic*], (in which the entire world has been consumed by nano technology), as a building point to more scientific and technological research into the current advancements and theories towards molecular nanotechnology, in particular 'FOGLETS' which are swarms of nanoscopic that can take the shape of virtually anything.
>
> (Etherington 2011)

216

What we are watching is essentially a fly-through, which narrates a short journey through various recognizable fragments of interiors: cathedral transepts, Corbusierean hallways, 1950s-style model kitchens – all of them generated from morphogenetic magma; decorative, and startling with its gold-tinted look of 'digital Baroque'.

Golden Age: Somewhere commences at a later stage of that seamless glide, although now the camera hovers high above the city, instead of some abstract plain. We do not see buildings, but golden crystal growths. These spaces have already been present in *Simulation*, though observed from outside – 'blossoming' in a business district. New forms follow suit, springing up quickly to inhabit the skyline. One of these 'magmatic' globules fashions the framework of a house, whose interior gets instantly covered with texture. The user, who is responsible for this 'terraforming', can generate any kind of spatial illusion available in templates, refurbishing her flat's uniform framework with a new architectural skin – a downloadable software setting to be installed on an engineered hardware skeleton. The first environment in the narrative we are able to inspect closely, is a garden. This particular iteration has been composed with a colour palette extracted directly from Joseph Mallord William Turner's *Rain, Steam and Speed* (1844). Unfortunately, undesirable commercial decorations aggressively pervade Nicholls's 'SmartHouses' to no lesser extent. Sponsored hyperlinks are raiding the user's field of view, whereas 3D adverts prove to be considerably harder to avoid, as they occupy every cubic metre of the main character's visual space. This highly efficient and navigable virtual environment is far from ideal also due to other reasons. After downloading a dress in an online shop, a virus attacks the house's operating system. Its attractive casing begins to fall apart, melting all optic illusions that formerly constituted the user's surroundings, leaving nothing but a bare cage. It is only due to the system's breakdown that we are able to notice the 'mirroring act' in this CG 'simulation' – the algorithm at work, 'underlying' all this surface, which rendered this 'reality' into existence.

What *The Golden Age* project puts forward is a dematerialized architecture. At the same time that image-based architecture establishes itself as a genuine (though visual) environment. Nicholls describes a technological watershed moment that is likely to bring about such qualitative change, and possibilities for tuning and adjusting our immediate surroundings, up to a point of generating architecture as such:

> The notion of the online will radically change, the notion of the computer and the home will merge. We will download parks and places to relax, have Skype phone calls with simulated telepresence of our friends and family, be immersed

in nano-robotic replications of any kind of objects or furnishings downloaded on credit based systems. The local becomes the global and the global becomes the local.

(Frearson 2012)

In this world symbiosis with technology has advanced to the point at which the occupant of architectural space is unable to discern material settings from their CG doubles. Such 'magic' is caused by speculative application of nano-technology, serving as the prime constructor of reality in Nicholls's film. The prospected vision of a future world, engineered at an atomic scale by robot technicians, opens up vast (albeit in reality tiny) new territories for architecture. Some of them had been preliminarily sketched out in Neil Spiller's *Digital Dreams* (1998):

> The architecture of the future will have nano engineering at their disposal. This will enable them to produce an architecture of flux, of cyclic distillations affected by the personal attitudes of users, the natural cycles and differing scales of action. [...] Subtle manipulations of space at an atomic level will produce astounding changes at higher scales. This will influence human perception itself.
>
> (Spiller 1998: 30).

With settings that could be instantly refitted and readjusted Spiller's idea equates the roles of architects and programmers, game designers and graphic artists, rendering such factors as scale, or primary context, as having only secondary importance. Nanotechnology in *Golden Age* takes the form of a particle dust cloud, which instantly solidifies into specific architectural spaces (*Simulation*), or becomes responsible for transmuting the city's high-rises (*Somewhere*). Actually, the subtitle 'Somewhere' is there to indicate that architecture envisioned by Nicholls exists independently of the aforementioned factors. The only constraints remaining are those connected to limits in assembling molecular structures of matter.

Q: Is this real? / A: Does it matter?

In *Diamond Age* Stephenson created a world that is permeated by invisible, nanoscopic technologies; a world in which every household comes equipped with a 'matter compiler'. As the name indicates, this machine is a cross between a swarm of nanobots, and a 3D printer that receives data packets from the Feed (equivalent of Internet), converting them into desirable goods. The introduction to *Golden Age: Somewhere* showed swarms of invisible machines, converting old parts of the city into bold new structures, just after they had been broken

FIGURES 7.18–7.26: Paul Nicholls, *Golden Age: Somewhere*, 2011. Film still: Factory Fifteen. UK.

down into floating specks. Utility fog is yet another extrapolation of the nano-robotic swarm concept. In a 1993 paper by John Storrs Hall (1993: 115–26) u-fog was defined as an 'intelligent' cloud of miniature robots, which can assemble and disassemble into networks, forming a variety of physical structures, from granite doors to airbags. In Nicholls's scenario these flows of motes constitute architectural forms. Despite an (hypothetically) unstable nature, his animation becomes a swift display of form-changing and enclosure-building capabilities of these clouds of nanotechnology, employing – for this purpose – the animated medium's inclination to liquid forms, transitions, and transformations as such. Here, they are not only the result of parametricism's formal kinship with biological organisms, but also appear as arrested in a stage of their inception, displaying amorphousness and freeze-frame dynamics (*objectiles*) among their greatest advantages.

On the other hand, confusion about genuine substance of both, the Golden and Diamond Age realities, is not the main narrative thread in Paul Nicholls's film. Its central subject concerns one's privacy (virus attack) and ability to discern between modes of representation and our immediate settings (system crash). The latter also addresses themes of visual literacy, although these days terms like simulation and virtual reality do not sound as alarming as they used to. Neither does interactivity or artificial intelligence, especially when we realize that our domestic settings and

appliances are likely to emerge encrusted with both. *Golden Age: Somewhere* speculates on the emergence of new 'troubleshooting areas', along with a widespread harnessing of concepts such as: access (in Nicholls's short – the temporal access to interchangeable settings, their durability, and resistance to malicious software attacks), code (programmability, and customization of the downloaded architectural ornamentation and settings), or – as discussed previously – pattern (i.e. occupants' behaviour, habits, and daily needs which could be met by 'smart technologies' operating within the homely domain). Summing up these potential concerns in her editorial to *Architectural Design*'s special issue on interactive architecture, Helen Castle notes (after Michael Weinstock's article included in the issue), that:

> the terrain vague in which we currently live on a domestic level is now a place of transit, a threshold between digital and physical worlds, and that the 'coupling of space, technology and domesticity is part of our architectural legacy'. New technologies are the means to achieving topographic and environmental changes to architectural space and, via distributed intelligence and active material systems, living space that changes its internal parameters and performance in direct response to inhabitants' lives and external events is possible.
>
> (Bullivant 2007: 6–7)

This way old notions of homeliness and the concept of home become encroached. In this scenario of a 'system crash' there are similarities to Philip K. Dick's novels and their film adaptations, which should not be skimmed over. The female character in Nicholls's short also finds herself alone amidst a swarm of bewildered nanobots, when her apartment becomes optically dismantled due to infestation:

> [T]he nostalgic notion of private space as a sanctuary is also fast eroding in the glare of corporations and governments using infiltration technology. Ever more detailed information about us leaks out of buildings, seeps out of our devices and is accessible to anyone with the appropriate bit of hardware or software. The data that portray our lives and lifestyles are accessible by so many individuals and organisations that they can no longer claim to lie in some private domain. Our spaces, physical and digital, are no longer exclusively our own.
>
> (Haque 2007: 29)

After a 'showreel' of wonders presented in the *Golden Age* diptych, hinting at what the future might hold, Nicholls leaves his viewers with a 'bare bone' pessimistic ending, like any cunning science fiction text would. One more utopia undone.

All around with stencils and the myth of soft habitation

These incessant transitions from domestic to urban environments could have been confusing, given the classic definitions of these terms, if it were not for what remains in focus in the films discussed here – the merging of private and public spaces made available through augmented environments. When navigating them, we are immersed in a technological extension of our visual apparatus,[9] which mediates between us and the incentives. In this Lev Manovich's understanding of the term is called upon, itself deriving 'from Augmented Reality (AR), a technology that using a graphic overlay to augment the physical environment with data from an information source, usually the internet' (Matsuda 2010: 2). Augmented space and the architecture it visually 'formulates' echoes central motifs in Nicholls's shorts. At the same time it establishes conceptual connections with Peter Cook's *Instant City* and its distant kin in the street scenes right outside of the main character's secluded chapel in Terry Gilliam's *The Zero Theorem* (2013). Architecture of past centuries rises from the dead in brick and stone, washed in grey settings of Gilliam's film, where it is overlaid with motley banners and electronic façades that chase Qohen Leth down the alleyways, like in a nightmarish version of Archigram's 'poster child' project.

> The Instant City materialized like this: zeppelins and trucks bearing components would arrive at a town by road and air. Then, using the host city as skeleton, 'softerware' combined with the pre-existing hardware to form an enhanced district. In addition to skins and migrating units, much of the atmosphere was generated by displays with names such as Audio-Visual Jukebox, the Holographic Scene-Setter and even the Enviro-Pill (all of 1969).
>
> (Steiner 2009: 210)

At least forty years into the unspecified Orwellian future of Gilliam's feature, all that remains of *Instant City*'s techno craze is the parasitic skin, which, by this time, has already consumed the generic city underneath. In the megalopolis of today new layers have been added, now assaulting the passers-by with dynamic, flashy and personalized adverts – each one 'installed' on the urban 'operating system'.

Architecture regarded as software – in contrast to its understanding as interface – renders most previously established divisions and notions of programme obsolete in relation to the media-permeated daily routines. New concepts are formed to replace old notions of domesticity, some of which are shared with the aforementioned Diller+Scofidio's *withDrawing Room* aside from other installation works.[10] Keiichi Matsuda, the author of *Hyper-Reality* (2016) – an augmented

reality-themed animated short that displays city's architecture as media facades gone haywire – writes:

> This customised augmentation of space with programme has consequences for the previously defined dichotomies of public/private, settler/nomad and home/work. It allows a new type of 'soft' occupation, in which the power to define programme in a space is partially returned to the user.
>
> (Matsuda 2010: 31)

The filmmaker's thesis on the conflation of domestic (private) and city (public) spaces/spheres explains this shift by naming it the consequence of 'soft habitation', which emerges with augmented reality technologies and locative media. Matsuda sees this as a process of virtual domestication of the public sphere, akin to personalizing mobile devices. In spite of this, his animated shorts never stop at a hopeful premise, heading straight for the dystopian 'junction'. Diving directly into oppressive commercialization of that premise, these plots follow a similar shift to that which sets apart the enthusiastic (close to techno-fetishistic) collages by Archigram from Gilliam's 'Orwellian Realities Incorporated'.

This makes an apt summary for the line of speculative enquiries presented in this chapter, most of which witness a literal dematerialization of the architectural object, yet – maybe more importantly – redefine its function in the context of the transformations taking place in public/private space.

> For a long time architecture was thought of as a solid reality and entity: buildings, objects, matter, place, and a set of geometric relationships. But recently, architects have begun to understand their products as liquid, animating their bodies, hypersurfacing their walls, crossbreeding different locations, experimenting with new geometries.
>
> (Bouman 2005: 22)

While contemporary, cutting-edge projects channel this thought mainly by means of responsive, media-embedded, or (moderately) intelligent environments, speculative designers speculate on their intangible counterparts – by operating primarily on a time-based medium – taking these suppositions even further. They are envisioning spaces conflated by the time-shift indispensable to global telecommunications (Soki So); prospecting emergence of adjustable settings, which appear as malleable software, dangerously resembling applications written for our smartphones (Paul Nicholls); but also rendering them as an analytic method for mapping complex interrelationships taking place in (while taking over) the city sphere (Jonathan Gales). From there on, with the object's 'diffraction' into a multiplicity

of *objectiles*, architecture becomes much more than 'just' an immaterial substance. It turns into a spatial armature for researching intricacies of cognition, vision, and (digital) image construction (Chris Kelly). In effect, filmic projects put on display in this chapter share a perspective, in which 'architecture is a form of critical thinking in visual and spatial terms, when explored with ambition, creativity and intellect, then embedded in it – thought through it – is a whole series of critical reflections on what our world might be' (Borden 2009: 12).

Anti-journey towards anarchitecture (a conclusion)

This tendency to self-interrogate their methods of production and modes of visualizing and 'framing' space, though represented in 'four dimensions', is neither unique nor exclusive to the aforementioned projects. It is possible to trace it back – following the lineage of visionary projects and utopian concepts underlying them – to Piranesi. Apart from Nathaniel Coleman's optimistic assumption that '[a]rchitectural projects are a kind of action comparable to utopias', while '[d]rawings, including plans, sections and elevations (among other expressive representations) are the rhetorical means by which the non-reality of design is persuasively proposed as real long before, if ever, being constructed' (Coleman 2005: 46),

FIGURE 7.27: Terry Gilliam, *The Zero Theorem*, 2013. Film still: MediaPro Studios Voltage Pictures, Zanuck Independent A&E Productions (UK, Romania, France). Pop art imagery from *The Zero Theorem* echoing Archigram's *Instant City* project.

visionary architectural projects, existing predominantly as sets of drawings, fantastic renderings, models, and other instances of representative media, disclose predilections to utopian thought experiments, while taking advantage of the medium's inherent properties. Peter Cook reinstates such projects' claim for recognition, noting how

> architectural drawings are easily able to transcend any reference to reality. Yet this is [...] more an ambition that it essentially borne of the belief that architecture has much left to discover and that the architect can make drawings that transport him or her into a form of séance.
>
> (Cook 2008: 177)

Visionary drawings/films (or any other medium employed to communicate the project) are thus an enterprise in themselves, that is graphic though experiments that hint at dynamic and narrative accounts of spatial concepts represented by them, for which they engage various visual cues, techniques, and composition methods. Even if regarded as prostheses for building practice, or evaluated on behalf of their appearance as picturesque vignettes, visionary projects have always been involved in debates on architectural discourse, relevant to the period. In themselves they are a kind of test-site for ideas, 'at least' executed in drawn form, reconsidered, and archived as potential alternatives to the material status quo. This revision of visionary projects' history, recounted from a perspective of dynamic interconnections – definitely, a post-structural vantage point, focusing on time-based aspects intrinsic to the works – always points to what lies on the outside of convention. Oftentimes it propounds a discussion on kinetics implied by an object-image, but essentially impossible to represent in traditional media. For example, speculative architectural works touching upon themes of superstructures, but also tackling those of electronic media, semiotics, consumerist society, or space travel, have always employed radical imagery, understood as spatial expression of new technologies and concepts that had been introduced in the aforementioned domains. All this adds up to an understanding of architecture, which abstains from denoting

> just a building. It is, primarily, a particular relation between a subject and an object, in which the former occupies the latter, which is not necessarily a building, but can be a space, text, artwork or any other phenomenon that displays, or refuses to, the subject-object relations particular to architecture.
>
> (Hill 2005: 4–5)

What we in fact talk about when we talk about visionary drawings, collages, or animations, is a textual journey in architectural representations of philosophical, ethical and generally socio-cultural concepts through spatial forms. An anti-journey,

which usually remains (and is conducted) on paper, although by means of technology it constantly attains new palettes and means, in order to express itself in 3D or 4D space, or a suggestion thereof.

As a conclusion, instead of recalling the ultimate leftist architect Lebbeus Woods's words, which opened this book, the epilogue calls upon the lifelong conceptual project of his friend and comrade in disputes, Raimund Abraham. More than a decade ago, together they embarked on a journey – both territorial and discursive, taking them to 'the realm of architectural concepts', even though geographically the destination was set on Sainte Marie de La Tourette.

> In the summer of 2007, Raimund and I met, as we occasionally did, for lunch at the BBar on the Bowery. Without preamble, he said that we should go to La Tourette for a week, stay in the monk's cells, meet daily and discuss architecture.
>
> (Woods 2010)

There were plans for a book, which would have been the transcription of their dialogic (in Bakhtin's definition of the term) essay on 'the role of architectural history, the proper impact of technology, the nature of innovation, as well as the role of architects in effecting social changes, shook up the comfortable complacency of practitioners' (Woods 2011a). Lebbeus Woods never discriminated purely theoretical ventures, although gave precedence to 'reasonable' thought experiments. Nor did Abraham. This is because any kind of drawing has to be mentally 'constructed' in the first place. Further peregrinations of their 'paper' non- or un-buildings would be of lesser importance than the revolutionary/radical concepts put forward by each of them. Unfortunately, the prospected book never made it beyond the planning stage, this way contributing to a publishing industry's equivalent of the 'unbuilt' category, due to Abraham's premature death in a car accident, in 2010.

Eventually, their road trip surfaced as a travelogue published in a series of entries on Woods's blog. From these we'll learn that the journey was far from ideal, plagued by misfortunes, forcing the architects to extend their trip by car, and shorten the scheduled stay at La Tourette – an emblematic work for late Le Corbusier, while a tonal experiment in architectural composition by 'early' Iannis Xenakis. Referred to by the moniker 'anti-journey', Woods's narrative reads like a philosophical treaty, mapped along the preconceived route of a 'guided tour'. It follows the trail of past utopias inscribed in built form, like the partially built Royal Saltworks at Arc-et-Senans – Claude Nicolas Ledoux's pivotal project. Abraham and Woods made a stop there, to inspect its present-day state against the 'revolutionary's' original plans, which both of them, at this point, had probably learned by heart. At the same time their peregrinations turn inwards, as the two 'unbuildable'[11] architects immersed in dialogue and speculations on their

profession's new frontiers. In the course of their conversations, issues of freespaces were answered with adjustable *Houses for Euclid*, whereas *Glacial Cities* cutting into the post-traumatic landscape – in turn – countered with *High Houses* modelled after bullet trajectories in one of Woods's 'radical reconstructions'. However, in the transcript, there is a fragment which sets apart all other disputes on legacy and position held by speculative projects. It welcomes a broader understanding of what architectural representation – in its unceasing reflection on reality, while envisaging its future shape – embarks upon, when put into perspective:

Lebbeus Woods:	I consider myself to be an architect and I make designs and occasionally I might build something in some form, or not. The building part is not up to me.
Raimund Abraham:	But Lebbeus, visionary isn't a derogatory term. A fantasist is.
LW:	Hmmm ...
RA:	Because when you make a drawing, or I make a drawing, that is not a fantasy at all – that is reality.

(Woods 2011b)

Notes

Introduction: Lebbeus Takes Us Outside

1. Unbuilt, experimental architectural projects are often put in line with fantastic architectural renderings, regardless of their source. Thus, alongside architects and rendering artists collaborating with them, like in the case of John Soane and Joseph Gandy (illustrator, while also a notable architect), numerous matte and concept artists in cinema (Syd Mead, Chris Baker, Mamoru Oshii, Katsuhiro Otomo) have gained prominence, especially as both circles are equated in their contribution to the cinematic image.

2. Originally, the term would be mainly applied to describe the unrealized architectural projects in the Soviet Union of the 1970s and 1980s, made by a 'lost' generation of architects, who considered their works as polemics in graphic form (Cook 2008: 81–82). Following the abolishing of the Academy of Architecture in 1957, a group of graduates (mostly from the Moscow Architectural Institute) took on the name Paper Architects (which included Yuri Avvakumov, Michael Belov, Mikhail Flippov, Nadia Bronzova, and Alexander Brodsky and Ilya Utkin) as an expression of protest against the main line of standardized, mass-scale and unimaginative productions, promoting, instead, 'reactionary' avant-garde projects, exhibited collectively in 1984. In this book paper architecture is an expression extended to contain all architectural projects which, up to this day, have remained solely on paper, in addition to models and other visualizations, or were 'frozen' at their ideation/conceptualization stage, given the poetic licence of numerous projects that subscribe to:

 > a slogan coined by the Luxembourgish architect Léon Krier, 'I am an architect, because I don't build'. It's true that the echo of this provocative sentence has long hovered over the 'paper architecture' (projects that were intended only for the drawing board, not to be built) of the postmodern era.
 >
 > (Belardi 2014: 42)

3. A broader explanation of the term, as deriving from Michel Foucault's writings, concerns the understanding of:

culture [as] a code that orders human experience in three respects – linguistic, perceptual, practical; a science or a philosophy is a theory or an interpretation of that ordering. But the theories and interpretations in question do not apply directly to human experience. Science and philosophy presuppose the existence of a network or configuration of forms through which cultural productions are perceived. These forms already constitute, with respect to that culture, knowledge different from the knowledge constituted by sciences and philosophies. This network is invariant and unique to a given epoch, and thus identifiable through reference to it.

(Gutting 2005: 79)

4. Axonometric projection was first applied in 1820, though it was established as a widely used graphic method only in the late nineteenth century. It became an aesthetics preferred by the architects of the 1920s (Walter Gropius, Theo van Doesburg) and employed for its clarity nearly throughout the century by the likes of John Hejduk, James Stirling, Peter Eisenman and Rem Koolhaas.

5. See the discussion on the acquisitions of the First and Second ages (and differences between them), concentrating on such novelties as widely available home appliances: 'In the Second, highly developed mass production methods have distributed electronic devices and synthetic chemicals broadcast over a large part of society – television, the symbolic machine of the Second Age, has become a means of mass-communication dispensing popular entertainment' (Banham 1970: 10).

6. An acronym indicating computer-aided design/computer-aided manufacture.

7. In an issue of *Architectural Design* on a 'baroque age' in parametric design, the guest editor, Marjan Colletti, remarks on the transition from stark to decorative aspects of the digital aesthetics, linking them to artists' sophistication in handling the medium but also to a resistance to a uniquely engineering understanding of digital performance. He agitates for 'digital poetics', capable of counteracting cases of unimaginative treatment of computer modelling, while emphasizing 'phenomenological aspects of digitality, [...] the varied approaches towards digital design, [...] the non-engineered intelligence of digital space, [...] the profuseness of digi-bio-techno ornamentation' (Colletti 2010: 8).

8. For example, the genesis of Superstudio's *The Continuous Monument* project, which, in a series of drawn-over photomontages, presents an infinitely expanding grid structure over natural landscapes and cities, could be derived from a widespread application of graph paper in design classes at the University of Florence (among multiple other architectural institutions), which was in turn multiplied into the ultimate visual symbol of 'total urbanization' and that decade's prevailing utopian 'drive' (in Freudian terms) towards superstructures.

9. Shannon states that the 'communication system' consists of: an information source, transmitter, channel (medium used to transmit the signal), receiver, and a destination. Nevertheless, at the outcome of this processual succession, we can receive a distorted

message. 'If a particular transmitted signal always produces the same received signal, i.e. the received signal is definite function of the transmitted signal, then the effect may be called distortion' (Shannon 1948: 406), which is reversible, whereas in the case of noise, 'the signal does not always undergo the same change in transmission' (1948: 406), which itself is a chance variable, that can only be determined within the margins of probability.

10. Thus, it encompasses not only experimental architects' inclination to work in academia, but also instances of numerous unbuilt projects and the methods employed for their representation, introduced alongside concepts deriving from humanistic sciences, sociology and psychology, thus supplying innovative methodologies with which to survey built environment.

11. As many of the speculative proposals expand upon student projects, at their base are generally documented solutions to architectural problems. However, this should be applicable to all architectural blueprints, shouldn't it?

12. '[I]t becomes clear that the vortex or tunnel trope has classically operated as a device that marks the crossing of boundaries between two worlds; the tunnel itself being a kind of liminal zone connecting the real with the fantastical. However, following 2001, many of the 1970s films placed much more emphasis upon the journey through this liminal zone, sometimes to the point where it does not appear to lead to an alternative world or, for that matter, anywhere at all' (Cornea 2007: 89).

13. '[T]hey began, some to make shelters of leaves, some to dig caves under the hills, some to make of mud and wattles places for shelter, imitating the nests of swallows and their methods of building' (Vitruvius 1931: 79).

14. Although he mostly puts present-day notion of performativity in the spotlight, that which is ideologically akin to exerting the best and economically feasible performance, Scheer states that '[s]imulation makes of performance an end in itself. Meaning is reduced to operation. The personal, the expressive, the idiosyncratic are denied legitimacy' (Scheer 2014: 226), adding that 'simulation is cutting the ground from under the very modes of thought that [...] architects have applied for building' (2014: 227), thus deeming simulation as non-reflexive and, immersion-laden. With architectural animations made, for example, by Factory Fifteen, exactly the opposite is true, as their methods do not only resort to the tradition of drawn, mainly experimental projects, but also update analogue techniques in digital environment instead of substituting them. This example best answers his doubts and a yearning for inventive, representation-based treatment of performance-style simulation, expressed in his writing, when he states: 'Architecture presently is split between representation and simulation. [...] The conditions for architecture created by simulation seem barren in the light of traditional ideas, but may present new possibilities if seen through different eyes' (2014: 192).

15. For example, Bryan Cantley's projects are made with a combination of computer and post-digital drawing methods.

16. 'D[igital] P[oetics] constructs multiple viewpoints of speculation spiralling at, around, inside, outside-inwards and back inside-out the human-computer feedback system that lays at the core of digital design. The theory of DP presumes a dynamic architect; one who can scrutinize something from numerous perspectives, who can zoom in and out, and who is able to navigate through multiple theories and designs; one who could attribute spatial and atmospheric properties to drawings, appreciate the winding roads of design process, find his or her own routes through mathematical and geometric jungle of CAD software' (Colletti 2010: 8).

17. This can always be just the reflection of 'in-progress' states which characterize these projects; nevertheless, this too is likely to be seen as an invitation for the 'viewer' to complete the work with the help of one's spatial imagination.

18. This subject, however, demands a separate analysis in the fields of cognitive neuroscience and theories of perception and image construction, with an emphasis on spatial visualization in connection with CGI environments in cinema. This should conclude the study of film set design and represented space in Chapter 7.

19. An inherent ambiguity of this statement is caused by the present surge of architectural projects, which aim at bringing traditional design – hand drawing – onto a new level. In doing so, they combine both digital and analogue techniques and develop ideas in multiple phases in each environment. The 2013 issue of *Architectural Design* (*Drawing Architecture*), guest edited by Neil Spiller, speculates even on the examples of 'growing' drawings (using morphogenetic computer algorithms propelling the emergence of 2D designs), as well as putting forward new spatial territories covered by the artists, with architects regularly borrowing techniques from literature studies, sociology, neurosciences and so on.

20. A somewhat popular line of productions that fall into this category is termed 'animatics'. During film pre-production they are employed to animate storyboards for better comprehension, while documentary filmmakers frequently do the same with archival photographs. Grégoire Dupont made use of this technique also in conjunction with *Carceri d'Invenzione*, creating a short animated film (2010) that explores the space in Piranesi's etchings by means of projection mapping the vistas onto 3D CG models.

21. Which is quite peculiar, as his former colleagues from Situationist International, especially Guy Debord, created an impressive filmographic output, realizing group's ideas on cities and contemporary culture in the form of film essays.

22. Such means, coming from new media and outside graphic techniques, would render projects more attractive to clients, while in their speculative incarnation more challenging as a statement, and, in turn, viewed as a daringly inquisitive mode of reassessing technological novelties as media for architectural speculations.

23. The cinematic notion in Le Corbusier's works is somewhat distilled in Pierre Chenal's short film *Architecture d'aujourd'hui* (1930), in which he fully exploits the cinematic potential of the design (the ramp and villa's interiors), focusing on the *promenade architecturale*

planned out along the lines of Sergei Eisenstein's montage theory of film, though here right angles, walls and sudden turns organize the space accordingly to the shifting viewpoint and juxtapositions achieved in the process of editing (Samuel 2015: 44–49).

24. It focuses on the supposed scientific specificity of perspective and its influence on depicted forms and objects, while being in fact a reductive geometric representation of architectural space.

25. Lucretian term denoting inclination, a sudden swerve from past trajectory.

26. This does not relate solely to speculative and experimental projects. Diller Scofidio + Renfro has pursued the problematics of vision in most of their architectural projects, being studies of movement and (mediated) seeing (Dimendberg 2013).

27. Which have substantially been transformed with the introduction of visual special effects, and then – employing an all-permeating term – computer-generated imagery.

28. Erika Fischer-Lichte describes the period of the 1960s as a time when 'traditional art forms tended to realize themselves as performances and new art forms such as performance and action art were created, which in their terminology already explicitly referred to their performance nature' (Fischer-Lichte 2008: 29), although even a decade prior to that John Cage's performance pieces already were contributing to the cultural landscape. Assigning to the performative turn such qualities of art -forms as self-referentiality, constitutiveness (bringing to life a reality evoked by a given piece), and collapsing of binary oppositions, numerous works of architecture from that period, which instead of ending up as built artefacts, were executed as performance gallery pieces and happenings, could easily meet this definition. However, even in the case of traditional visual arts, a desire to capture this newly conceptualized dynamics could be seen in both subject and form. One can thus clearly see how film – as a medium of, at least, archiving value – emerged as an accomplice in this undertaking.

29. Marjan Colletti, Marcos Novak, Bryan Cantley, Philip Beesley and Nic Clear, to name a few.

1. On Techniques of Architectural Representation

1. In Italian, *designo* can also be translated as 'sketch'.

2. Neil Levine writes more about the purely graphic aspects of Boullée's projects, characterizing them in similar terms to how Lebbeus Woods wrote about his drawings. 'Unlike other eighteenth-century architects who imitated the paintings of Claude or Poussin to re-create scenes of an Arcadian landscape, Boullée turned to the pictorial not to reproduce its imagery but rather to invoke its special power to recall emotion through the very act of representation' (2009: 93).

3. One should not discern the built from the unbuilt but only remark that the symbolic quality the Enlightenment's architectural spaces strive for is (in the case of drawings) emphasized with draughting skills, atmosphere and the intention to express the project's *caractère*.

On the example of *Cenotaph for Newton*, it is to be found in the building's ideally spherical shape and the voided depths, 'whose sarcophagus is placed at the center of a spherical cavity, symbolic of the globe on the exterior and of the universe on the interior' (Etlin 1994: 21).

4. While, as Rick Altman argues, the prevailing myth of classic cinema's purity might be purity itself, it is definitely more beneficial to look, after Janet Staiger's advice, for patterns of plot structure and conventions of representation [which] do persist throughout decades (and some plot structures and conventions predate the emergence of cinema). (Staiger 2003: 186). Later she Staiger goes on to describe Mikhail Bakhtin's characterization of novel form as a mixture, or hybridization, of 'styles' and 'languages' in order to inaugurate a dialogue (2003: 197). Similar strategies in architectural drawings often provide cues and extra-textual references that support the main 'narrative' of the project.

5. As in Raphael's 1519 letter to Pope Leo X, when reporting on the archaeological survey of ancient Rome, in which the painter gave precedence to constructional and design drawing over perspective projection (Maynard 2005: 42).

6. 'Rene Descartes (1596–1650) was important to this new mathematical movement in three ways: he posited a logical new theory of existence and "self"; he worked out a detailed hypothesis of the mathematical structure of the material universe; and, with his invention of analytical geometry, he established the first direct relationship between numbers (arithmetic and algebra) and geometry space)' (Dunning 1991: 90).

 Yet, as Hannah B. Higgins observes, Descartes' method simplifies the world, instead of retaining its complexity, even though his writings state otherwise. This has earned him most detractors among modern scholars, pointing out that the apparatus of Cartesian space is in fact both homogenizing and reductive, reducing the entire world to a single, geometrically homogeneous space to which a mathematical system can be applied wholesale' (Higgins 2009: 163).

7. '[T]he 1824 reform that enshrined the principle of the pedagogical autonomy of perspective by establishing a specific course for architecture reflected the new importance that the École des Beaux-Arts was placing on perspective. Although not a central part of the curriculum, perspective became a mandatory hurdle in architectural training' (Thomine- Berrada 2008: 142).

8. This is an important distinction, and it will be elaborated on in subsequent chapters, because it considers the projects' origins. They can be statements and purely visual constructs of utopian proportions and ambitions (not to mention their speculative character, which brings them closer to science-fiction texts), as opposed to unlucky competition entries (although in many cases this too should not be regarded as a derogatory factor).

9. Making a distinction between readerly and writerly texts, Barthes accentuates the factors involved in rendering them as either user-oriented, supplying the reader with a prepared, enclosed object of consumption, in which situation (s)he 'is left with no more than the poor

freedom either to accept or reject the text: reading is nothing more than a referendum' (1974: 4), or open-ended in terms of interpretation, incomplete to some extent, as for they invite the former 'consumer' to become an active participant. These, in turn, are texts characterized as writerly:

> is a galaxy of signifiers, not a structure of signifieds; it has no beginning; it is reversible; we gain access to it by several entrances, none of which can be authoritatively declared to be the main one; the codes it mobilizes extend *as far as the eye can reach*, they are indeterminable.
>
> (Barthes 1974: 5–6, original emphasis)

Paper architecture, visionary drawings and speculative animations touch upon a similar distinction, engaging the viewer in a search outside of the codified rules of the 'genre'.

10. In terms of an interplay of forms and their ordering.
11. 'Doodling on one large sheet of paper pinned to the wall, a quickly growing urban plan takes form where recollections of real buildings merge with unreal fragments forming connective tissue (sympathetic landscapes, ameliorating vestibules, forced-perspective alleys) and collide against other agendas as fresh authors dig in. [...] Colin Rowe, Lee Hodgden, Robert Slutzky, Bernhard Hoesli, Werner Seligmann, Lee Hirsche, John Shaw, Jerry Wells and Hejduk – the bulk of the group that would come to be referred to as the Texas Rangers – invented this drawing-in-the-round game at the University of Texas School of Architecture in Austin in the mid-1950s as part of a Thursday night "seminar for faculty"' (Morris 2013: 21).
12. Many of the projects in Factory Fifteen's oeuvre – some of them analysed in the final chapter – employ a chronogram diagramming method (i.e. Soki So's *Hong Kong Labyrinths*, etc.), which analytically dissects a temporal sequence, breaking it up into crucial stages of the project's development/evolution and examining specific 'shots' (key frames) in detail. A modern sibling to the *analytique*, it resembles that method only to some extent, as it is assigned to events unfolding in space, not space alone.
13. Traditionally, excluding indications of depth, resorting to orthogonal projections.
14. 'Memory takes root in the concrete, in spaces, gestures, images, and objects; history binds itself strictly to temporal continuities, to progressions and to relations between things' (Nora 1989: 9), writes Nora, defining sites of memory not as institutionalized entities but emergent due to ritualistic practices around them. As *lieux de mémoire* oppose the destructive power of history, in the context of Brodsky & Utkin's projects they take on a double entendre (as places of commemoration and spaces, where memory is amassed). The resistance of the duo's paper architecture thus becomes twofold. It counteracts official history with private accounts of historical districts of cities and architectural monuments, erased by new building projects. Additionally, it operates from within the apparatus of an institutionalized archive-memory, which best epitomizes the relationship between state's

censorship and propaganda, and the bottom-of-the-drawer repository of private archives. Moreover, the technique and narrative mode of the architects' projects subvert the requirements of technical documentation, referring to the tradition of visionary architectural projects by considering at the same time as a marginalized 'archive' and a discourse around it, which perfectly suits Nora's characterization of the *lieux* as 'places of refuge, sanctuaries of spontaneous devotion and secret pilgrimage, where one finds the living heart of memory' (1989: 23).

2. Architecture in Filmic Space

1. Consider this description of Centricity's architecture, whose 'structures, organized by interrelated and sometimes contradictory symmetries, are of permanent construction, yet are overlaid with more transitory tectonic elements' (Woods 1989: 3). The city is a living organism in that it constantly undergoes transformations, inscribed in its modus operandi:

 > The quadrupolar forms of Centricity are distorted by dynamism of growth and decay, of construction and its inevitable succumbing to entropy. As each cycle of construction ends, some portion of its quadrupolar structure remains, a fragmentary vestige that influences to some degree all future developments of the urban form.
 >
 > (Woods 1989: 2)

2. Constructivist sets created by Robert Mallet-Stevens for Marcel L'Herbier's *L'Inhumaine* (1924) could be recalled here, while tracing back the tradition to the turn of the century, with shared genesis in the psychological space of theatrical plays, in which scenery is turned into a projection of the character's subconscious. It features in Strindberg's later works – the *Inferno kammerspiel* plays – like the examples of Hummel's apartment in *The Ghost Sonata* (1916), but most prominently in:

 > *To Damascus I*, which appeared in print in 1898, was written at a time when concepts of theatrical illusion and stage setting were acquiring new meaning, radically at odds with the naturalistic objectivity promulgated by Strindberg himself only a few years earlier. [...] As [Pär] Lagerkvist's modern manifesto observes, the complex spatial and temporal dynamics of Strindberg's later dramas could not be adequately realized in performance until the more modern techniques of a new stagecraft – the cyclorama, advanced methods of lighting and back projections and not least the revolving stage – were introduced.
 >
 > (Robinson 2009: 136)

The last of these devices, noting on the margin, was of interest to Frederick Kiesler, who designed at least a few variations of the so-called Endless Theater, and contributed set designs to the 1922 production of Karel Čapek's *R.U.R.* and Sartre's *No Exit* (1946), each of them employing a complex spatial entity/machine to correlate with the characters' inner world.

3. '*Shoeshine, Bicycle Thieves, Miracle in Milan* and *Umberto D* demonstrate the social destruction which accompanied the physical and which lingered long after the ruins had been cleared away. Neorealist images of post-war urban crisis are an especially important legacy because Italy was the only one of the defeated Axis powers whose cinematic representations of the city achieved iconic status internationally so soon after its military defeat. [...] In neorealist cinema [...] the destruction was not only human and physical but also metaphysical and existential' (Shiel 2006: 68–69).

4. The most famous example is probably Giulio Camillo's sixteenth-century re-enactment of ancient oratory skills and mnemonic system, visualized in the form of a distorted version of the Vitruvian theatre, in which the spectator replaces the actor's place on stage, gaining him access to seven times seven gates located in the auditorium. 'The Theatre is a system of memory places, though a "high and incomparable" placing; it performs the office of a classical memory system for orators by "conserving for us the things, words, and arts which we confide to it"' (Yates 1999: 144), although in Camillo's case, the 'filing cabinet' is based on a Cabalistic system of deities and planets. It 'is a vision of the world and of the nature of things seen from a height, from the stars themselves' (1999: 144).

5. In film it is unimportant what were the initial qualities of the depicted object, as actual interiors can be flattened out by long focus or telephoto lens, while matte paintings, thanks to digital imaging, are often rendered in 2.5D, appearing as nearly 3D backgrounds.

6. The term was invented by Greg Lynn in order to describe the emergent language of CG forms. While Palmer's *The Historical Dictionary of Architecture* files it under Expressionism (2008: 107) and considers it a technologically facilitated extension of 1920s' concepts of the Weimar paper architects, *The Visual Dictionary of Architecture* defines it as '[a] contemporary architectural movement typified by building designs that incorporate organic, bulbous, amoeba-shaped forms, which are created using CAD (computer aided design) software' (Ambrose et al. 2008: 64).

7. This accords with Neil Leach's definition of morphogenesis in architecture, which witnesses a change in design paradigm from formal concerns to performative ones (form generation, pattern-making, form finding rather than form making). While remarking on how this term originally derives from biological sciences, Leach remarks how the structural logic of these new 'bulbous' projects 'has been appropriated within architectural circles to designate an approach to design that seeks to challenge the hegemony of top-down processes of form-making, and replace it with a bottom-up logic of form-finding' (2009: 34).

8. Regularly dissected in documentary portions of Blu-ray/DVD editions of films.

9. Which translates to 'production designers', after William Cameron Menzies introduced the term, and 'art directors', before he began working on *Gone with the Wind* (Victor Fleming, 1939).

10. 'With *Roma, città aperta* (1945) and then *Paisà* [1946], the war precipitates from the sky to the earth. Both movies are viewed on the ground, consistently shot at eye level as if, if not always in fact, by a hand-held camera. For Italian post-war cinema, war is no longer an aestheticized technological spectacle, [...] but a very impure, contaminating experience, as uncertain and disorienting as traversing a landscape' (Minghelli 2013: 54).

11. 'In 1947, the Supreme Court declared the major Hollywood studios illegally monopolistic and ordered their divestment of control over exhibition. In the same year, the HCUA mounted its investigation, which would proceed for five years, into Communist infiltration of the film industry. The years following saw the economic decline of the major studios, the rise of competition from television, and the flourishing of independent film production circumventing the studio system' (Morrison 1998: 149).

12. For example, contours are considered as non-perceptual elements of the picture, which help in structuring delineated forms. This convention is generally acceptable, as far as our suspension of disbelief is likely to hold out. For Patrick Maynard contemporary researches on the issues of visual cognition and representation acknowledge this fact, sharing an 'assumption that the widespread success of such devices in depiction would be owing to a continuity of pictorial perception with the way we commonly perceive things in our environments, through some sort of transfer' (Maynard 2005: 100). He also adds that the transfer 'often goes two ways', thus allowing us to read a representation both as a symbolic depiction, supporting its 'argument' on optical cues, and as an experience of a given space, action or scene (2005: 101).

13. In Lang's film a combination of miniatures with parts of sets, and later with actors, assisted with an inventive use of mirrors, allowed for the quickest expansion of the gargantuan city by means of reflected light rays, amounting to an impression of overwhelming sceneries filmed by the camera.

14. As in the example of Le Corbusier's *promenade architecturale*'s spatial sequence, designed by the architect in the Villa Savoye.

15. 'The introduction of digital modeling software into architectural design provided a departure from the Euclidean geometry of discrete volumes represented in Cartesian space and made possible the present use of "topological", "rubber-sheet" geometry of continuous curves and surfaces that feature prominently in contemporary architecture. The highly curvilinear surfaces in the architecture of the digital avant-garde are described mathematically as NURBS, which is an acronym that stands for Non-Uniform Rational B-Splines. What makes NURBS curves and surfaces particularly appealing is their ability to easily control their shape by interactively manipulating the *control points*, *weights* and *knots*. NURBS make the heterogeneous, yet coherent, forms of the digital architectures computationally

possible and their construction attainable by means of computer numerically controlled (CNC) machinery' (Kolarevic 2003: 21).

16. We can also recall here Ray Bradbury's short story *There Will Come Soft Rains* (1950) (also adapted into an animated film by Nazim Touliakhodjaev [1984]), with its central character – an automated house – operating indefinitely, after the end of the world event swept away its dwellers.

17. According to Nigel Coates's typology, an instance of a biotopic narrative, that is, a spatial field incorporating multiple programmes, akin to plotlines engaging an interreacting 'system of narrative components' and one of 'functional parts'.

18. Fincher's treatment of architectural space, along the lines of advantageous and disadvantageous areas of the apartment, could itself be compared to Beatriz Colomina's study of Adolf Loos's Moller house (Vienna, 1928), which has a:

> raised sitting area off the living room with a sofa set against the window. [...] [giving its inhabitant a] sense of security [,] [...] produced by the position of the couch, [and] the placement of its occupants against the light. Anyone who, ascending the stairs from the entrance (itself a rather dark passage), enters the living room, would take a few moments to recognize a person sitting on the couch.
>
> (Colomina 1998: 234–38)

19. We instantly recognize each room's function within the scheme, and the building's general layout, thanks to a plot device that is a 'guided tour' from a real estate agent.

20. Providing we are using lossless methods of compression:

> Once video and audio are converted to the digital domain, they become data, or numbers, and if those numbers can be delivered to the other end of a digital interface unchanged then the interface has not caused any loss of quality. This is one of the strengths of digital technology.
>
> (Rumsey and Watkinson 2013: 352)

3. Leaving Buildings on Paper

1. *Architecture Must Blaze*, as proclaims his poem from 1980, references the *Flaming Wing* project from the same year, which was installed above the courtyard of the Technical University in Graz, Austria, to the joint horror of firefighters and safety inspectors (Kandeler-Fritsch 2005: 46).

2. Etlin distinguishes three approaches to the eighteenth-century neoclassical architecture. The first two are: 'the creation of a new grammar for architecture, a concern that in many respects parallels the narrative aspect of symbolic space' (Etlin 1994: 89), and one which

'addresses the articulation of a new typology for architectural form, which has similarities with metaphorical character in architecture' (1994: 89). Together they are representative of the taxonomical bias of the century, explaining the thorough studies of reduced geometrical structures in the works of Ledoux, or Quatremere De Quincy. Etlin comments on the fact, writing that:

> [t]he relationship between the basic elements of the classical vocabulary of architecture that [Jean-Louis de] Cordemoy and [Marc-Antoine] Laugier postulated [...] were not merely of a grammatical but also of a typological nature. If grammar defined the way columns, cutablatures, and pediments could be combined, then typology governed the meaning of their forms.
>
> (Etlin 1994: 101)

3. 'Public buildings for the eighteenth-century observer could not simply be monumental or hygienic. They also had to display an intelligibility achieved through appropriate expression. This expression was termed *caractère*, or character' (Etlin 1994: 13).
4. Among other reasons, because their designers conceived them as: arguments in potential polemics, critical essays, thought experiments suited for education, alternative scenarios to those evidenced by built forms in the cityscape, or merely artistic impressions, which exhibit their shocking value in order to stir up the critics' circles.
5. It is highly dubious that he ever conceived of his renderings as pages in a manifesto, as most of his works comprised of other architects' projects, given a highly evocative and poetic artist's touch.
6. 'In no other art could one claim that there were two forms of architectures, plans on paper and structures in stone and brick' (Harbison 1993: 161), writes Robert Harbison (1993: 161), discussing various examples of architectural works, which were not built due to material and engineering constraints. Another reason was their sheer inviability, like in the case of Erich Mendelsohn's *Einstein Tower* (1993: 170–71). Still, it did not hinder the Weimar architects' artistic development (Finsterlin 1993: 169). Also, they simply might have not have been intended as such, as shown by the example of *Hypnerotomachia Polifili* intended as an illustrated treaty on the possibilities of built form and human imagination (1993: 162–63).
7. This international avant-garde group was active in the years 1948–51, named after the capitals of the participants' countries of origin – Copenhagen, Brussels, Amsterdam.
8. It seems like with the passage of time and, most probably, Constant's frustration with the permanent incompleteness of his project, in his paintings and drawings violent scenes began to appear. Revolts and massacres would take place in the ever-narrowing corridors and entrapments of the great labyrinths and sectors, as seen on the canvases titled *La révolte* (1972) and *Le Viol* (1974).

9. For example, the works of Tobias Klein – *Slow Selfie 2* (2014), *375 Park Avenue* (2014), *Garden of Earthly Delights* (2014) – problematize traditional modernist forms in relation to their blobitectural counterparts, engaging in a dialogue with architectural monuments. This way Ludwig Mies van der Rohe's Seagram Building becomes cut in half, deconstructed, and injected with magmatic geometries taken from the MRI scans of Klein's own body, translated into the irregular geometries of the building. Functionalism counters exuberance. Forging an architectural account of body-space is achievable with methods of digital imaging. For Klein the 'dissolution of [the body's] anatomical boundaries allows rethinking and recreating it as a new physical/representational territory in constant flux and change' (*Studio Tobias Klein: Works and Ideas* 2015: 14). This literal conflation of architectural and body spaces will return in the last chapter, in the analyses of films by Chris Kelly.

4. Inscription Deconstructed by Means of Cinematography

1. '[A]fter World War II, automobile ownership made possible a new kind of commuting. Developers and builders, helped by cheap loans and federal subsidies, built more modest suburbs, and the federal government funded up to 90 percent of highway costs. The freeway, the supermarket, and the suburban mall, reinforced by zoning and tax regimes, gave strong incentives to move out of town. In the 1960s and 1970s, these long-established trends were reinforced by "white flight"' (Hodgson 2006: 36).
2. Founded by Lebbeus Woods in 1988.
3. In Busbea's words:

> Urban space came to be seen not as a neutral container but as a conductive medium for the movements and exchanges of people, information, and objects. Nowhere was this model of urban space more explicit and poetic as it was in the avant-garde spatial city – perhaps the exemplary desideratum of the epoch – where all displacements and transmissions would flow freely, held aloft above the surface of the earth in floating, crystalline structures.
>
> (2007: 10)

4. As Cook writes, 'A very high proportion of the drawings in this book were made for competitions, as book or publicity illustrations, and either directly for exhibition, or highly conscious that they would be exhibited at some time' (2008: 50), listing main sites for distribution of the unrealized projects, immediately adding that the whims of art market made at least slight impact on the course of 'unbuildable' production's development, as their:

effect on the galleries has been mixed, with drawings being published in newspapers for visualisation purposes to reveal to a general public a proposal for a likely building. This has pulled back the contemplation of serious innovation into the coteries: the schools of architecture or the reviewers of competitions.

(2008: 81)

5. Not including world fairs and international exhibitions, which have always served as prolific grounds to test out more radical designs.
6. 'The Illinois Tower is of historic importance, and, although never built, it paved way for future tall buildings. [...] Wright was not a structural engineer, but his instincts were correct in proposing a structurally logical and stable form. [...] The rigid steel core would be sheathed with thin concrete and support steel cables attached to a metallic curtain wall, which would consist of aluminium or tungsten plates. Wright [...] was conscious to ensure that the design would prevent excessive oscillation at its top under wind loads, and the tower would sway in such a way that all parts of it would maintain a delicate balance and equilibrium. [...] Joseph Colaco carried out an investigation on a hypothetical mile-high concrete building to examine the feasibility of a tower of this height with positive results' (Al-Kodmany and Ali 2013: 399).
7. The exhibition organized by Henry-Russell Hitchcock and Philip Johnson that introduced Bauhaus and Miesian modernism to the American audience, 'repackaging' it as International Style:

> 1932 Modern Architecture: International Exhibition opened at the Museum of Modern Art. Although it ran for only a few weeks, the exhibition and its accompanying text garnered a fair amount of attention in both the popular press and architectural journals. The exhibit and book assume a central place in most narratives of twentieth-century American modern architecture.
>
> (Flowers 2009: 75)

Colomina's assertion further disrobes the exhibition's impact from claims to bringing about new style or a truly international artistic current, stating that:

> [t]he International Style was over in 1932 because it never existed outside of its representation: the exhibition and accompanying publications. It both came into being and ended with its consumption in a sea of publicity. The moment the practice of some architects was labelled 'International Style' and identified (by its insertion in the museum) as high art, it necessarily left that domain to be disseminated in and as popular culture.
>
> (1998: 202–03)

8. Whereas in her book Beatriz Colomina sees this as the factor distinguishing modern architecture from its predecessors, she writes that:

> one look at the architectural avant-garde in these terms suggests that modern architecture becomes 'modern' not simply by using glass, steel, or reinforced concrete, as is usually understood, but precisely by engaging with the new mechanical equipment of the mass media: photography, film, advertising, publicity, publications, and so on.
>
> (1998: 73)

9. The term was put forward by Busbea (2007: 34–45). It favoured structures supposedly suspended on *pilotis* over the actual infrastructure, this way expressing love for engineering structures, while highlighting such characteristics as portability, movement, and adaptation. The proposed massive constructions remained invisible, 'everywhere and nowhere', while 'structuring space and experience' of the city.

10. '[U]rbicide refers to the destruction of buildings qua representatives of urbanity. In other words, buildings are destroyed because they are constitutive of the existential condition known as 'urbanity'. 'Urbicide' thus refers to an assault on buildings in order to destroy urbanity. [...] Urbicide is thus an attack on buildings as the condition of possibility of a plurality or heterogeneity' (Coward 2009:15).

11. 'Instead of the grand narrative, Lyotard argues for a multiplicity of little narratives which resist and challenge the dominant narratives, the fragmented quality of the former protecting them from being incorporated into any of the latter. The little narrative is the antithesis of the grand narrative, representing flexibility and constantly reinventing itself, free from the weight of tradition and the restrictions of preconceived ideologies' (Sim 2011: 88).

 Angélique du Toit highlights the term's transgressiveness: 'By their nature little narratives accept difference and the transient nature of knowing which is in opposition to the modernist structure of binary opposites' (2011: 87).

12. 'The term *Usonia* itself [...] was borrowed from Samuel Butler's utopian novel *Erewhon*. Wright used the term to refer to the low-cost, relatively straightforward domestic architecture that was the focus of much of his creative energy from the onset of the Great Depression through the Korean War. The development of the Usonian home occurred simultaneously to and is conceptually inseparable from Wright's larger utopian scheme for Broadacre City' (Beard 1985: 3).

13. Its main result is a new form-language, which – as Charles Jencks remarked – 'is growing besides the fractal, an aesthetic based on waves, folds and undulations' (Jencks 1997: 13). He points to a digital morphogenesis, which was still in development at the time, when it comes to design software, even though it has attracted the attention of architects interested in modern physics and chaos theory alike, as:

part of the new repertoire are the twist and warp, characteristic motifs of dramatic change which Catastrophe Theory has illuminated in so many areas. It is no surprise to find these jumping shapes emerging in what might be called Nonlinear Architecture (after nonlinear dynamics, a generic name for the complexity sciences). A new shared language of expression is growing, an aesthetic of undulating movement, of surprising, billowing crystals, fractured planes, and spiralling growth, of wave-forms, twists and folds – a language more in tune with an unfolding, jumping cosmos than the rigid architectures of the past.

(Jencks 1997: 13)

14. Primarily, Tim Adams's *The Eisenman-Deleuze Fold* (1993), Bernard Cache's *Earth Moves: The Furnishing of Territories* (1995) and Sophia Vyzoviti's *Folding Architecture: Spatial, Structural and Organizational Diagrams* (2005), where folding is characterized as a 'generative process in architectural design [...] [which is] essentially experimental: agnostic, non-linear and bottom up' (Vyzoviti 2004: 8).

15. For an in-depth case study of the Network of Urbicande image-concept, refer to my article 'Houses for Descartes': Grid Pattern as an Ambiguous Image in a Critique of Utopian Megastructures and Modernistic Uniformity (Stasiowski 2017).

16. 'Over the past few decades, visualisation of our environment has profoundly shaped our understanding of it and has yielded entirely new sensibilities. [...] Now there are new visualisation and simulation techniques that focus on self-organisational processes such as environmentally sensitive plant growth. What can be learned from these new methods is not only new sensibilities relative to the visualised processes, but also the specific configurations and features of the tools and their potential contribution in rethinking approaches to design that aim for instrumentalising self-organisation' (Hensel 2006: 13).

By defining plant behaviour or, for example, the development of a building's programme in use as the formal grammar for this iterative process:

such models might also provide a new analytical and generative sensibility to architectural design, as they may facilitate a much better understanding of synergies between systems and environments, or subsystem interaction, in terms of their behavioural characteristics and capacities with respect to the purpose they serve locally and within the behavioural economy of a larger system.

(Hensel 2006: 14)

17. Although the constructivists' projects of the 1920s were definitely an important source of inspiration for the architects of the 1980s.

18. For example, in the *New Scapes: Territories of Complexity* Paola Gregory writes, that '[h]aving lost its own connotations of "state of things", object and figure, architecture seems

aimed toward a "derealization" of its being in the sense of a "breakdown" of its actual physical limits in the flow of relations and interconnections' (Gregory 2003: 21). The energy introduced into the 'architectural system' came from an ontological shift in the understanding of space, which Gregory urges to read as either a Japanese Ma – a negative space 'outlined' by the objects – or as a mathematical field (Vidler 2000; Jencks 1997), due to its saturation with electronic infrastructures. This way architecture appears as deterritorialized, taken out of its 'comfort zone'. Enumerating new composition/design techniques, such as:

> *layering* (organization by levels), *scaling* (reduction/enlargement), *folding* (folding of the surfaces), *warping* (deformation of the surfaces), *morphing* (progressive iteration from one form to another). These techniques undo the closed organism of architecture in favor of the rhizomatic multiplication of heterogeneous elements and concentrations that flow continuously across things
>
> (Gregory 2003: 22, original emphasis)

19. Wigley's insight is crucial in defining architectural deconstruction, without falling back upon deconstructivism as architectural genre's aftershock aesthetics. He says, '[T]o translate deconstruction in architecture is not simply to transform the condition of the material architectural object. It is not the source of a particular kind of architecture, but an interrogation of the ongoing discursive role of architecture' (Wigley 1993: 30). Not a strategy, but a structural condition 'suspended' in the act of self-interrogation. Earlier on Wigley writes about privileging the 'alien', which is already present, though marginalized (or repressed) in architectural discourse:

> rather than offering new accounts of the architectural object to replace the one that dominates the disciplines of philosophy and architecture, deconstructive discourse unearths the repressive mechanisms by which other senses are hidden within [...] that traditional figure, senses that are already threatening in their very multiplicity.
>
> (1993: 29)

20. '[D]econstruction in philosophy is a project which seeks to expose the paradoxes and value-laden hierarchies which exist within the discourse of Western metaphysics. In opposition to structuralism, it stresses the 'differal' – the play and slippage of meaning – that is always at work in the process of signification' (Leach 1997: 300).
 Rather than a 'technique of reversed construction', as Leach writes, 'it is a "probing" which "touches the technique itself upon the authority of the architectural metaphor, and thereby constitutes its own architectural rhetoric"' (1997: 300).

21. Manovich analysed these structuring devices in the examples of Peter Greenaway's and Dziga Viertov's films, as well as other filmmaker's experiments with new media, for example, Chris Marker's *Immemory* (1997), CD-ROM.

5. Case Studies, Part One: 'Analogue' Projects

1. 'With all the attention being paid to the project's design in the early 1970s, a strong associative link was forged between architectural flaws and Pruitt-Igoe's deterioration. [...] By 1972 these crucial elements of the story had been all but forgotten in the rush to condemn the architecture. It is the privileging of these design problems over the much more deeply embedded economic and social ones that constitutes the core of the Pruitt-Igoe myth' (Bristol 1992: 358).

2. Virilio's stance remains in stark contrast with Woods's fair weather forecasts, writing that:

> with the progressive **digitalization** of audiovisual, tactile and olfactory information going hand in glove with the decline of immediate sensations, the *analogue resemblance* between what is close at hand and comparable would yield primacy to the *numerical probability* alone of things distant – of all things distant. And would in this way pollute our sensory ecology once and for all.
>
> (2005b: 114)

His perspective on the Underground Berlin complex would probably be all the more pessimistic, rendering the potential of fibre-cable interconnectedness and mediation by the machine in a fashion more akin to E. M. Forster's take on the subject, although without the optimistic prophecy of Machine's eventual expiration, augured by the novel's title.

3. Paolo Soleri created a whole glossary of eco-architectural concepts, reminiscent of Pierre Teilhard de Chardin's philosophy, in which *arcology* is defined as a '[c]ity made in the image of man, and therefore three-dimensional, complex, and miniaturized' (Lima 2003: 65), while '[a] true city, in Soleri's terms, manifests and activates the forces that characterize life and love: cooperation, altruism, beauty, synergy, and passion. [...] Soleri's city is a spiritualizing machine governed by the laws of complexity and miniaturization' (2003: 12).

4. 'Young anarchists and socialists took over entire streets and parks in the corners of West Berlin. Any given squat would house between eight and fifty people, either living rent-free or paying a low lease, sometimes attending the Berlin State School of Fine Arts or the Technical University, but fundamentally acting on anti-establishment rage. [...] The organizational soundness of the culture afforded an artistic scene complete with cafes, [...], discos, and makeshift libraries. Berlin's constantly changing cast didn't impede the microcosm's day-to-day life, but instead, change was built into the scene's basic operation'.

> (Reed 2013: 86)

5. It was meant to subvert the city's status quo with equally radical force, exactly as the strategies employed by Situationist International had hoped.

6. 'Adenauer believed that Nazism was the result of deep ills in German history and society: above all Prussian authoritarianism, the weakness of individualism, the 'materialist world view of Marxism' which eroded religious faith and fostered nihilism, and an ideology of racial superiority[;] [...] his view of the depth of Nazi support led him to pursue a strategy of democratisation by integration of former and hopefully disillusioned followers of Nazism, or [...] of pursuing power by de-emphasizing memory of the crimes of the Nazi era' (Herf 2002: 188).

7. Amounting to the significance of Alexanderplatz, considered as a symbolic space for the transitioning process, are events such as the demonstration held in Alexanderplatz on 4 November 1989, when half million GDR citizens asserted their sovereignty, or the debates held in early 1990s on its future development.

8. Although the pictures' ambiguous look probably urged the editor to counterbalance short with another take on the tale. Drawn by Wally Wood, it is conveyed in a more 'tamed', even cartoonish style, which avoids the unfamiliarly abstract 'Lebbeus look' for the benefit of superhero comic book style.

9. See the discussion on iconic abstraction as simplification of the realistic image in McCloud's *Understanding Comics*. In the book he analyses artistic style and drawing conventions, employed by specific authors (McCloud 1994: 52–53), or attributed to certain genres, which involve precise amounts of 'cartooning', thus iconic abstraction of the image, as opposed to realism (McCloud 1994: 41–59).

10. Of course, there is a profound sense of mourning. Human absence is signalled by recounted events, yet the only characters in the story are a housekeeping computer programmed to perform its actions ad infinitum, and a stray dog, which compels the machine to launch an attack on the intruder. This final, unscheduled action reduces the building to ruin, and destroys the order kept, up to this point, with attentiveness worthy of a museum conservator.

11. In defining 'poor theatre', in his 1965 manifesto, Jerzy Grotowski envisioned it as an opposition to the panoply of strategies of the 'Rich Theatre', hence, an overabundance of distractive elements (stage sets, props, costumes, etc.).

> The Rich Theatre depends on artistic kleptomania, drawing from other disciplines, constructing hybrid-spectacles, conglomerates without backbone or integrity, yet presented as an organic artwork. [...] Since film and TV excel in the area of mechanical functions, [...], the Rich theatre countered with a blatantly compensatory call for 'total theatre'.
>
> (Grotowski 2002: 19)

Revolting against this, 'poor theatre' was shedding the skin of its nineteenth century prototypes, relying on 'personal and scenic technique of the actor', modest decorum, and austerity of other elements that could be found distractive, drawing away attention from the 'holy actor'. Moreover, this heterogeneity, or wealth of artistic sources, which – in Grotowski's

opinion – turn this art form into a cross-breed, are highly reminiscent of Wagner's concept of *Gesamtkunstwerk* – the ultimate artwork, which abolished differences between the nine Muses, even though, for the composer, this proclamation was to remain superficial, as it is the other art forms that ought to be working for the opera.

12. 'The term degenerate also had other specific connotations at the time. The Nazis used it to identify supposedly inferior racial, sexual, and moral types. Hitler's order to Goebbels to target 20th-century avant-garde art for inclusion in the Entartete Kunst exhibition aimed to impress on the public the general inferiority of the artists producing this work. [...] Among the 112 artists whose works the Nazis presented for ridicule were [...] Otto Dix, Max Ernst, [...] and Kurt Schwitters' (Kleiner 2014: 765).

13. 'Metafiction is a term given to fictional writing which self-consciously and systematically draws attention to its status as an artefact in order to pose questions about the relationship between fiction and reality. In providing a critique of their own methods of construction, such writings not only examine the fundamental structures of narrative fiction, they also explore the possible fictionality of the world outside the literary fictional text' (Waugh 2003: 2).

14. 'The novels of Samuel Beckett, Alain Robbe-Grillet and Julio Cortazar fragment time and narrative order, and increasingly resist recuperative readings attaching their disjunctive temporality to the representation of human subjectivity (as in early modernist literature) [...] Robbe-Grillet, for example, eschews character development and coherent plots in favour of looping or labyrinthine narrative structures and detailed descriptions of diegetic spaces. [...] [T]he past and the present are so tightly wound together that the distinction between them is erased. The reader is presented with multiple, contradictory versions of events, so that establishing a linear, causal flow of time is made impossible' (Cameron 2008: 32).

15. Woods sued the creators of *12 Monkeys* for an uncredited reproduction of a structure from one of his drawings. In Gilliam's film it served the function of an interrogation chamber, located in the underground complex, completely at odds with the role Woods conceived for it.

16. This invention was favoured by nineteenth-century artists, who used it for 'muffling' visual incentives, abstracting the subject from surrounding scenery – in this way reducing the level of 'noise' in the draughtsman-landscape system.

17. After the completion of restoration works, which reinstated a period-themed nymph statue under the renewed cupola, the place now became a popular venue for wedding receptions.

18. A reference to Edwin A. Abbott's *Flatland: A Romance of Many Dimensions* (2006).

19. In Webb, as in Virilio's *dromoscopic* framing of spatial relationships of the moving (speeding) observer, the space always stands for the distance covered. It is a speed-space, congruent with an:

automobile's visual aesthetics of penetration. Dromoscopic perception thus differs from panoramic perception. Unlike the steady, lateral vision out the side of an automobile or train, separated from the field of view, dromoscopic perception plunges us into the visual field. It is defined by the languid gaze at passing forms and building outlines than by a headlong immersion into a free space of movement around which buildings recede.

(Schwarzer 2004: 98–99)

20. A method of visualizing spacetime in order to demonstrate special theory of relativity and, for example, Lorentz transformations. The symmetrical future and past light cones spread out from a single event (e.g. propagating light), when plotted on time axis. They are drawn at a 45-degree angle in relation to the straight line representing the time-like vector of velocity. In comparison, the future light cone in Webb's project is set at a much more acute angle, signalling alteration of the diagram's 'landscape' by a constantly accelerating body.

21. Regarding the received image's resolution, as well as the shape of the floodlight distributed on the temple's dome, each of the parties in this visual experience has to travel the same photon path as does the sightline of the moving observer.

22. Game is invoked here in John Cage's definition of the term, indicating a sequence of actions executed by the performer.

23. The chosen few include Neil Spiller's *The Island of (Communicating) Vessels* (2000–present), Frederick Kiesler's *Endless House* (1947–60) – among subsequent projects. The research on the concept of 'endlessness' preoccupied him throughout his life – and Michael Webb's *Temple Island* (1977–present).

24. '[I]n Kiesler's view there is a parallel between the installation of images as a machine and vision itself – a reversal of the vision machine into a machine of vision. It's obvious that his 1938–42 drawing of the *Vision Machine* hardly shows boundaries between the brain and the paintings surrounding it. For him, sight is a flow, a continuity' (Spuybroek and Pélenc 2008: 102).

 This explains further that Kiesler considered it as a model for demonstrating his cor-relativity principle, according to which sight and motion are interrelated phenomena, and one should not contemplate one without the other.

25. Nevertheless, it is still regarded as a forcefully imposed ordering scheme.

 The resulting verse of the *grille*, or grid, format was the culmination of CIAM's obsession with order, systems and strategy. The latticework of the grid simplified the presentation of complex problems and tidied the chaotic strains of the city into the categories of the work-leisure-transportation-home model, violating the planner of 'extraneous' diversions.

 (Steiner 2009: 74)

26. Excerpt from *The Continuous Monument* series.

27. Which can also be found in other Clarke's novels, for example, *Childhood's End* (1953).

28. Prina mentions one, depicting a flooded Italian city on the cover for J. G. Ballard's *The Drowned World*, with a corresponding image of a church turret sticking over the water's surface. It made reference to the 1966 flood of Arno river, which caused damages to a great number of monuments in Florence.

29. Such contemporary crises included urban congestion in J. G. Ballard's *High Rise* and *Concrete Island*, chaotic expansion of cities in Ballard's *Concentration City*, overpopulation, or the superstructural remedy in Robert Silverberg's *The World Inside*.

30. Whose novels and short stories expand futuristic concerns, touching upon mind more than the matter of future modes of living, thus examining human psyche and perception under the influence of technology.

31. As the narrator recounts, upbringing provides a four-year isolation plan and teaching programme, before the walls of each new citizen's enclosure permanently disappear and the individual is integrated into the society.

6. *Digitalia*

1. 'The movement-image defines and describes the quality of cinematic images that prevail in the medium over its first fifty years. From 1895 to 1945 cinema became the seventh art by embodying images not in movement but *as* movement. [...] A cut between two shots is part of the image, and thus a temporal gap that allows the eye to perceive an effect of movement' (Parr 2010: 179, original emphasis).

 Or, in Deleuze's words, '[C]inema does not give us an image to which movement is added, it immediately gives us a movement-image. It does give us a section, but a section which is mobile, not an immobile section + abstract movement' (1996: 2). Listing five discrepancies between movement- and time-image defines the former, by pointing to intrinsic qualities that appear to be either 'malfunctioning' or missing:

 > It no longer refers to a totalising or synthetic situation, but a dispersive one. Characters begin to multiply and become interchangeable. It loses its definition as either action, affection or perception when it cannot be affiliated with a genre. An art of wandering – the camera seems to move on its own – replaces the storyline, and plots become saturated with clichés. Finally, narratives are driven by a need to denounce conspiracy. Reality itself becomes 'lacunary and dispersive'.
 >
 > (Parr 2010: 180)

2. Deleuze characterizes a crisis of the sensory-motor aspects of movement-images, occurring in cinema after the Second World War, which detaches the 'slices of movement', interrelated to the 'motoric' motivations of characters in relation to depicted spaces and events, eventually abandoned for a 'direct time-image [which] always gives us access to the Proustian dimension where people and things occupy a place in time which is incommensurable with the one they have in space' (2000: 39). A meta-investigation and self-interrogation, which brings out the artifice in narrative's construction, comes to dominate the logic behind image-making. This becomes a surrogate mode of situating narrative in space, in which:

> perceptions and actions ceased to be linked together, and spaces are now neither coordinated nor filled. Some characters, caught in certain pure optical and sound situations, find themselves condemned to wander about or go off on a trip. These are pure seers, who no longer exist except in the interval of movement, and do not have the consolation of the sublime, which would connect them to matter or would gain control of the spirit for them.
>
> (Deleuze 2000: 40–41)

Filmic space changes in an ontological way, in relation to its 'temporary inhabitants', as for:

> what characterizes these spaces is that their nature cannot be explained in a simply spatial way. They imply non-localizable relations. These are direct presentations of time. We no longer have an indirect image of time which derives from movement, but a direct time-image from which movement derives.
>
> (Deleuze 2000: 129)

3. More accurately, McLaren remarked that '[a]nimation is not the art of drawings that move but the art of movements that are drawn' (Solomon 1987: 11).

4. This one should be of particular interest, due to being an early attempt at harnessing computer algorithm for the purpose of generative city planning, in a manner akin to Gordon Pask's cybernetic architectural projects.

5. For instance, James Whitney's *Lapis* (1966) was created with cardboard dot matrices, processed in computer environment, then transferred on film with a micro-film plotter.

6. With a few exceptions, like Peter Foldes's employment of the first key frame animation software in his 1971 short *Metadata*, or *Hummingbird* (Charles A. Csuri and James Shaffer, 1967), as these are instances of animations employing modified hand drawings. The paradigm of completely digital environment applies mainly to a scientific line of productions, like the simulation of an artificial satellite's behaviour in earth's orbit, created by Edward E. Zajac (1963), which points to a parallel lineage of computer animations, namely, visualizations of real-time data models.

7. Giuliana Bruno writes on the impossibility of transmitting spatial phenomena through picture and composition, distinguishing film as the medium, which came to evolve surrogate depiction strategies. In them:

> the haptic nature of cinema involves an architectural itinerary, related to motion and texture rather than flatness. It takes the haptic to be the measure of our tactile apprehension of space, an apprehension that is an effect of our movement in space.
>
> (Bruno 2002: 250)

8. Colomina describes Le Corbusier's troubled relationship with photography. As means of conveying his projects, the architect would retouch his own photographs, turning them into 'sterilized' photomontages, published in *L'Esprit nouveau* architectural review, from which any context whatsoever was eliminated, leaving his designs geographically stranded upon nearly abstract planes.

9. John Whitney Sr's first experimental animated films were made with Mark 7 military equipment, which was an anti-aircraft gun, cannibalized for its parts, and re-employed for directing movement of figures and painted shapes, directly below the camera (Sito 2013: 26).

10. Jim Blinn's *Voyager* flyby films visualized a space probe's progress through our solar system, making sense of the transmitted images, even when – or especially if – he had to recreate them by using models and newly invented bump-mapping in the studio, projecting outerspace imagery onto a spherical maquette.

11. Wells brings up various implications of the animated medium's 'plasmaticness' for the narrative, noticing – for example – how:

> in two-dimensional animation, and relies on the viewer's understanding of the actual weight of figures and objects in the 'real world' and the ease of movement of those figures and objects through materials pace, and in relation to other figures and objects.
>
> (Wells 1998: 112–13)

Animation often engages in a metatextual play with photorealistism (in 3D computer animations, or digitally-enhanced live-action), or convention (i.e. Disney's hyperrealism), and the abstract, non-figurative substance of these representations. For this reason, Wells's *plasmaticness* connotes the metaphorical. 'Metaphors make the literal interpretation of images ambiguous and sometimes contradictory because they invite an engagement with the symbolic over and above the self-evident' (1998: 84), writes Wells, while noting that '[a]nimation liberates the symbol and its attendant meaning from material and historical constraint, enabling evocation, allusion, suggestion and, above all, *transposition* in narrative strategies' (1998: 84), further emphasizing the ambiguous 'matter' that constitutes all texts encoded in this medium.

12. Examples include: film and photography applied to urban survey by the 'Venturis', Superstudio's use of screenplay as a genre of graphic notation and Tschumi's cinegrams.

13. Due to the interdisciplinary character of the Macy Conferences, cybernetics established itself as a knowledge of systems and models applicable in various areas.

> The crucial conceptual shift was a movement from first-order cybernetics' attention to homeostasis as a mode of autonomous self-regulation in mechanical and informatic systems to concepts of self-regulation – especially as that notion captured the apparent self-ordering and self-regulation of bodies and minds – and to self-reference and autology as the abstract logical counterparts of recursive operations in concrete and worldly systems.
>
> (Clarke 2009: 35)

Also, Spiller defines his concept of emerging architectural practice in terms of second-order cybernetics, when stating that: 'Plectic Architecture can be nothing if not a second-order cybernetic system and its designers nothing if not epistemologically observing and acting conversational dynamos' (Spiller 2008: 365).

14. In a matter resembling the creation of evolutionary models of biological forms for the purpose of attaining convincing CGI, jungles are 'grown', as in the example of Jon Favreau's *The Jungle Book* (2016), owing it to a combination of algorithms, defined control points, and precise alignment of live footage and computer modelling.

15. Although, as Maynard remarks, 'modern criticism has tended to [...] insist that figurative pictures rely upon abstract shapes, volumes, tensions and movements' (2005: 186), he himself refuses to follow in their footsteps.

16. As far as irony goes, the plasmaticness in the animations of the studio's competitors and runner-ups, like the Fleischer Studios or in Émile Cohl's cartoons, never gained comparable fame. The Warner Brothers, with their *Merrie Melodies*, were among the hopeful carriers of this 'tradition'.

17. As in the case of drawings traced over 3D animated sequences, or CG/2D hybrid techniques employing 3D models and painting software, in order to achieve the look of hand-drawn animations, as in Disney's *Paperman* (John Kahrs 2012).

18. 'Deleuze noted that Leibniz's mathematics of continuity introduced and formulated a new conception of object. [...] The objectile is a kind of parametric function which may determine an infinite variety of objects. The objects are all different (one for each set of parameters), yet all similar (the underlying function is the same for all). The objectile, in a sense, is the technical object of the digital age. Infinite variants of the same object can be produced at the same cost as identical copies' (Cronin 2013: 88).

19. The digital special effects sequence is – from a narrative standpoint – usually regarded as a still-life moment, or an instance considerably slowing down the action. Yet these too contribute to the narrative, offering a detailed glimpse at elements considered crucial

to the plot. They serve as to expose specific traits of the characters/objects, or – in their most widely proliferated instance – present the audience with spectacular stunts. In each case, the:

> [s]pecial effects sequences which function as explicit demonstrations/celebrations of digital effects technologies (featuring familiar fare: explosions, vehicular chases, impossible vistas and impossible bodies) continue to be heavily promoted as the initial 'draw' for moviegoers, excised from the surrounding film so that they can circulate in a dense paratextual realm of multi-platform trailers, web-sites, TV spots, social media, and smart phone apps.
>
> (Purse 2013: 25)

7. Case Studies, Part Two: Speculating with Architectural Animation

1. As Hanneke Grootenboer writes in her book on illusionism in Flemish painting, infinity is a concept that can be graphically enclosed through a symbol, suggestion or an iterative procedure (as in Archizoom's example, or its painted equivalents), although we only perceive a limited number of its initial iterations. 'The problem with infinity is [...] that it can never be seen but only imagined; we can apprehend it without necessarily comprehending it' (2005: 78).

2. Duchamp's procedure of 'hinging' should be counted among the twentieth century's most important artistic strategies, which operates on multiple levels, from linguistic (*Door: 11 rue Larrey*, 1927) to conceptual ones (*Fountain*, 1917), in which this simple procedure reveals a drastic reversal.

> Thanks to the literal and paradoxical use of the idea of the hinge, Duchamp's doors and ideas open while remaining closed, and vice versa. If we have recourse to the same procedure, the expression 'hinge picture', opening out (closing) on itself
>
> (Paz 1978: 94)

The artist often exercised this subversive tactic in a playful manner, upsetting audience's and critics' expectations, and their potential interpretations, on the other hand, allowing him to research themes related to concept-formation, thus embarking on meta-investigations, usually discussed in relation to his final works – *The Large Glass* (1915–23), and *Étant donnés* (1946–66).

Reversibility: seeing through opaqueness, not-seeing through transparency. The wooden door [*Étant donnés*] and the glass door [*Large Glass*]: two opposite facets

of the same idea. This opposition is resolved in an identity: in both cases we look at ourselves looking. Hinge procedure.

<div style="text-align: right">(Paz 1978: 98)</div>

3. Although this is achieved by means of gyroscopic devices, which retain body movements and translate them into in-game/VR kinetics, keeping the subject in place.

4. As Moholy-Nagy writes:

> *[V]ision in motion* is a simultaneous grasp. Simultaneous grasp is creative perform-ance – seeing, feeling and thinking in relationship and not as isolated phenomena. It instantaneously integrates and transmutes single elements into a coherent whole. This is valid for physical vision as well as for the abstract.

<div style="text-align: right">(Moholy-Nagy 1947: 12)</div>

He hails at the same time the rise of kinetic architectural forms, displaying a post-relativist perspective on reality. 'Mobile architecture is space-time reality. Automobiles and trains can be viewed as mobile buildings' (1947: 256).

5. Edward Chaney clearly demarcates the border between tourism (as a pauperized, mass-scale practice) and Grand Tourism (described as young intellectuals' pilgrimage to the ancient spring of Western Culture, namely Italy), writing that his book:

> [u]nlike most works on the Grand Tour, it [...] deals not so much with fully-fledged eighteenth-century phenomenon, when young men from perhaps the most powerful nation on earth patronized a museum set in a picturesque landscape, but rather with the sixteenth and seventeenth centuries, when the English travelled to a country whose contemporary culture was as impressive as its past and in many respects still outshone their own.

<div style="text-align: right">(Chaney 1998: xi)</div>

6. Originally written in 1975, at the height of the post-war social housing crisis in Great Britain.

7. This means supplying a 3D character model with a script defining (placement and move-ments of) joints and control handles, thus equipping it with a complete 'skeleton' that enables manoeuvring the newly formed 'puppet'. This technique comes from the traditional puppet/stop motion animation (e.g. claymation).

8. 'D+S's works often deal with the situation of our "body" in society. Their projects retrace the various "folds" our bodies weave with the world (body, in Greek thought, flesh, in the Christian tradition). These creases, these grooves, are acquired by the human body through various physical and emotional, vital and affective, psychic and social experiences' (Teyssot 1994: 9).

9. Technological extension as opposed to a prosthesis, which would be the case with heavy VR headsets some twenty years ago.

10. Like *Para-Site* (MoMa, New York, 1989), *Soft Sell* (Times Square, New York, 1993), *Loophole* (Second Artillery Armory, Chicago, 1993) and *Exit* (Fondation Centre, Paris, 2009).

11. In fact, by 2007, at the time of their voyage, each of them had more than a single project/building realized, aside from a portfolio replete with 'drawn architectures'. Among Abraham's most famous works are the Austrian Cultural Forum New York (1993–2002) and the ellipsoidal House for Musicians (1999; although completed posthumously in 2013) in Hombroich, near Düsseldorf. In contrast, Lebbeus Woods's material legacy encompasses numerous installation works, with Light Pavilion in Chengdu (China) among them. It fills the middle section of Steven Holl's Sliced Porosity Block.

Acknowledgements

'Anything that doesn't take years of your life and drive you to suicide hardly seems worth doing' – sallies Cormac McCarthy in an interview for *The Wall Street Journal* (Jurgensen 2009). The dilemma concerns time's passage in the light of output ratio. Is it more viable to write short stories or bury yourself in another Great American Novel? Forwarding this question to the context of academia, similar issues seem to extort pressure: do we fast-track by producing articles for high-ranking journals, or 'waste time' on quixotic endeavours, like a stand-alone publication? While working on this book, which began as doctoral dissertation, I haven't necessarily been driven to such dismal considerations as the one evidenced by the quote, although silver linings weren't all that common either. If this has been a journey – or an anti-journey, as suggested in the epilogue that references a still-to-be-published travelogue by Lebbeus Woods and Raimund Abraham – the co-passengers, fellow travellers, mentors, and threshold guardians who convinced me not to turn around from this path should be given due credit, as their intangible contribution to and influence on this piece of writing is ubiquitous.

I have been collaborating on and off with Dr Graham Cairns for the past nine years, ever since we had met a conference at Ravensbourne University, London. For an inexperienced scholar this might have been a bubble-bursting experience – attending an event at which he was promoting his then book *The Architecture of the Screen*; one on architecture and film. The one I was planning to write. Tactfully empathetic, Dr Cairns pointed out several discrepancies between my sketchy blueprint and his palpable opus, proceeding to rewrite my conspectus on the spot in the course of a brief conversation. One of many more we were to have over the years. Luckily, I memorized most of it. My thesis supervisor from Cracow, Professor Andrzej Pitrus, now lives in Torrevieja, which suits his sardonically effervescent personality much better than the Slavic doom and gloom. Throughout the entire cycle of (re)writes, incomplete submissions, and semi-proofread bits, he remained calm like a monk, eventually becoming genuinely interested in my ruminations on unbuildable buildings. I am glad to be able to consider them both

friends at this point, which hopefully will not be a revelation to neither one of them, upon seeing these words put in writing.

Initially, any research project looms over the researcher like a dust cloud; changing shape, seemingly impossible to contain, suffocating. Daunting and confusing, but all the more intriguing because of the fact. Ricardo deOstos of NaJa & deOstos architectural studio, himself a co-designer of a sort of hypothetical billowing cloud of broadcasted uncertainty named *The Hanging Cemetery of Baghdad*, and Nigel Coates (whose reputation outgrew his 1980s experimentations with Narrative Architecture TOday) provided me with both a foothold and the impetus, clarifying, expounding, replacing a trail of breadcrumbs with a laser guiding system. Both welcomed me in their London studios, and showed much more than fleeting interest in the research, for which I will remain grateful. But there were many others as well, whom I never had the chance to meet in person. Even as benevolent online presences their input (which far exceeds image credits) has to be acknowledged. I had stimulating – even if jiffy – conversations with Tobias Klein, Riet Eeckhout, Neil Spiller, Gian Piero Frassinelli, Bryan Cantley, and Chloe Parent, daughter of the co-creator (with Paul Virilio) of Architecture Principe. I have no doubt their architectural projects, experimental drawings and writings will continue to inspire not just like-minded enthusiasts. I am also thankful to reviewers of this manuscript, and Professor Alicja Helman, who – during the dissertation defence – posed the only unforeseen and demanding question concerning instances of architectural thinking outside of architect's comfort zone, as always proving to be way ahead of the debate, while others were still skimming through the abstract. Piotr Mirski was also present on that day, busy writing down every word. Yet his role goes far beyond mere secretary duties, and the value of having such an acquaintance to co-write with, compete against, or hang out with is inexpressible.

Anarchitectural Experiments has 'outlived' a long line of production editors from Intellect, and even though they have faded from sight at some point of the manuscript's development, I won't forget the assistance and support I received from Mareike Wehner, Faith Newcombe, Georgia Earl, and Debora Nicosia who remained stoic amidst the pre-sign off turmoil, having endured to see its release.

Bibliography

Abbott, E. A. (2006), *Flatland: A Romance of Many Dimensions*, Gloucester: Dodo Press.

Adams, T. (1993), *The Eisenman-Deleuze Fold*, Auckland: University of Auckland.

Alison, J., Brayer, M.-A., Migayrou, F. and Spiller, N. (eds) (2007), *Future City: Experiment and Utopia in Architecture*, London: Thames & Hudson.

Alvarado, R. G. (2008), 'Analysis of filmmaking techniques for architectural animations', *Middle East Technical University: Journal of the Faculty of Architecture*, 25:2, pp. 133–49.

Alvarado, R. G., Castillo, G. A., Márquez, J. C. P. and Mayorga, S. N. (2005), 'Filmic development of architectural animations', *International Journal of Architectural Computing*, 3:3, pp. 299–316, https://doi.org/10.1260/147807705775377320. Accessed 7 December 2022.

Ambrose, G., Harris, P. and Stone, S. (2008), *The Visual Dictionary of Architecture*, Lausanne: Ava Publishing.

Appleyard, D., Lynch, K. and Myer, J. R. (1965), *The View from the Road*, Cambridge: MIT Press.

Asensio, P. (ed.) (2003), *Antonio Sant'Elia*, London, New York and Paris: Te Neues.

Aureli, P. V. (2011), *The Possibility of an Absolute Architecture*, Cambridge and London: MIT Press.

Banham, R. (1970), *Theory and Design in the First Machine Age*, New York and Washington: Praeger Publishers.

Barsacq, L. (1976), *Caligari's Cabinet and Other Grand Illusions: A History of Set Design*, Boston: New York Graphic Society.

Barthes, R. (1974), *S/Z* (trans. R. Miller), Oxford: Blackwell.

Baudrillard, J. (1995), *The Gulf War Did Not Take Place* (trans. P. Patton), Bloomington and Indianapolis: Indiana University Press.

Beard, R., Henken P. and Henken D. (1985), 'Introduction', in *Realizations of Usonia: Frank Lloyd Wright in Westchester*, New York: Salina Press, pp. 3–5.

Belardi, P. (2014), *Why Architects Still Draw: Two Lectures on Architectural Drawing* (trans. Z. Nowak), Cambridge and London: MIT Press.

Benson, T. O. (1993), *Expressionist Utopias: Paradise, Metropolis, Architectural Fantasy*, Los Angeles: Los Angeles County Museum of Art.

Bergfelder, T., Harris, S. and Street, S. (2007), *Film Architecture and the Transnational Imagination: Set Design in 1930s European Cinema*, Amsterdam: Amsterdam University Press.

Bevan, R. (2004), *The Destruction of Memory: Architecture at War*, London: Reaktion Books.

Bingham, N. (2013), *100 Years of Architectural Drawing*, London: Laurence King Publishing.

Bloch, E. (1996), *The Utopian Function of Art and Literature: Selected Essays*, Cambridge: MIT Press.

Borden, I. (2009), 'Bartlett Designs', in L. Allen, L. Borden, N. O'Hare and N. Spiller (eds), *Bartlett Designs: Speculating with Architecture*, London: Wiley.

Bouman, O. (1998), 'Amor(f)al architecture or architectural multiples in the post-humanist age', in G. Lynn (ed.), *Folds, Bodies & Blobs: Collected Essays*, Bruxelles: La Lettre volée, pp. 7–14.

Bouman, O. (2005), 'Architecture, liquid, gas', in L. Bullivant (ed.), *Architectural Design (4dspace: Interactive Architecture)*, vol. 75, no. 1, London: Wiley, pp. 14–22.

Bradbury, R. (1979), *The Martian Chronicles*, New York: Bantam Books.

Branzi, A. (ed.) (2006), No-Stop City: *Archizoom Associati*, Orleans: HYX.

Bristol, K. G. (1992), 'The Pruitt-Igoe myth', in K. L. Eggener (ed.) (2004), *American Architectural History: A Contemporary Reader*, London and New York: Routledge, pp. 352–64.

Brodey, I. S. (2008), *Ruined by Design: Shaping Novels and Gardens in the Culture of Sensibility*, New York and London: Routledge.

Bruno, G. (2002), *Atlas of Emotion: Journeys in Art, Architecture, and Film*, New York: Verso.

Buckland, W. (2007), *The Cognitive Semiotics of Film: The Body on the Screen and in Frame*, Cambridge: Cambridge University Press.

Bullivant, L. (2007), 'Alice in technoland', in L. Bullivant (ed.), *Architectural Design (4dsocial: Interactive Design Environments)*, vol. 77, no. 4, London: Wiley, pp. 6–13.

Burden, E. (2000), *Visionary Architecture: Unbuilt Works of the Imagination*, New York: McGraw-Hill.

Burry, M. (2001), 'Beyond animation', in B. Fear (ed.), *Architecture + Animation (Architectural Design)*, vol. 71, no. 2. London: Wiley, pp. 6–16.

Busbea, L. (2007), *Topologies: The Urban Utopia in France, 1960–1970*, Cambridge and London: MIT Press.

Bush, P. (2013), 'Babeldom, a film by Paul Bush', *Aesthetica*, 27 February, http://www.aestheticamagazine.com/babeldom-a-film-by-paul-bush/. Accessed 5 November 2020.

Cache, B. (1995), *Earth Moves: The Furnishing of Territories* (ed. M. Speaks, trans. A. Boyman), Cambridge: MIT Press.

Cache, B. and Girard, C. (2013), 'Objectile: The pursuit of philosophy by other means?', in H. Frichot and S. Loo (eds), *Deleuze and Architecture*, Edinburgh: Edinburgh University Press, pp. 96–110.

Cairns, G. (2013), *The Architecture of the Screen: Essays in Cinematographic Space*, Bristol and Chicago: Intellect.

Cameron, A. (2008), *Modular Narratives in Contemporary Cinema*, Basingstoke and London: Palgrave Macmillan.

Cantley, B. (2011), *Mechudzu: The Architecture of Rhetorical Space*, Vienna and New York: Springer Vienna Architecture.

Cantley, B. (2013), 'Two sides of the page: The antifact and the artefact', in N. Spiller (ed.), *Architectural Design (Drawing Architecture)*, vol. 83, no. 5. London: Wiley, pp. 36–43.

Carpo, M. (ed.) (2013), *The Digital Turn in Architecture 1992–2012*, London: Wiley.

Carpo, M. and Lemerle, F. (eds) (2008), *Perspective, Projections & Designs: Technologies of Architectural Representation*, London and New York: Routledge.

Castle, H. (2001), 'Editorial', in B. Fear (ed.), *Architecture + Animation (Architectural Design)*, London: Wiley, p. 5.

Cavallaro, D. (2006), *The Cinema of Mamoru Oshii: Fantasy, Technology and Politics*, Jefferson and London: McFarland & Company, Inc.

Chaney, E. (1998), *The Evolution of the Grand Tour: Anglo-Italian Cultural Relations since the Renaissance*, London and Portland: Frank Cass Publishers.

Clarke, B. (2009), 'Heinz von Foerster's demons: The emergence of second-order systems theory', in B. Clarke and M. B. N. Hansen (eds), *Emergence and Embodiment: New Essays on Second-Order Systems Theory*, Durham and London: Duke University Press, pp. 34–61.

Clear, N. (2013), 'Drawing time', in N. Spiller (ed.), *Architectural Design (Drawing Architecture)*, vol. 83, no. 5, London: Wiley, pp. 70–79.

Coleman, N. (2005), *Utopias and Architecture*, Abingdon and New York: Routledge.

Colletti, M. (2010), 'Exuberance and digital virtuosity', in M. Colletti (ed.), *Architectural Design* 80 (*Exuberance: New Virtuosity in Contemporary Architecture*), Issue 2 (March/April), London: Wiley, pp. 8–15.

Colletti, M. (2013), *Digital Poetics: An Open Theory of Design-Research in Architecture*, London and New York: Routledge.

Colomina, B. (1998), *Privacy and Publicity: Modern Architecture as Mass Media*, Cambridge and London: MIT Press.

Cook, P. (2008), *Drawing: Motive Force of Architecture*, London: Wiley.

Cornea, C. (2007), *Science Fiction Cinema: Between Fantasy and Reality*, Edinburgh: Edinburgh University Press.

Cotta Vaz, M. and Barron, B. (2002), *The Invisible Art: The Legends of Movie Matte Painting*, San Francisco: Chronicle Books.

Coward, M. (2009), *Urbicide: The Politics of Urban Destruction*, London and New York: Routledge.

Cridge, N. P. (2015), *Drawing the Unbuildable: Seriality and Reproduction in Architecture*, London and New York: Routledge.

Cronin, M. (2013), *Translation in the Digital Age*, London and New York: Routledge.

Curti, C. (2010), 'Experimental dialogues: Sex machines', *Cluster: City – Design – Innovation*, http://www.cluster.eu/2010/08/31/experimental-dialogues-sex-machines/. Accessed 13 July 2016.

Damisch, H. (1994), *The Origin of Perspective*, Cambridge and London: MIT Press.

Damrau, K. (2000), 'Fantastic spatial combinations in film', in B. Fear (ed.), *Architecture + Film II (Architectural Design)*, London: Wiley, pp. 58–61.

Deleuze, G. (1993), *The Fold: Leibniz and the Baroque* (trans. T. Conley), London: Athlone Press.

Deleuze, G. (1996), *Cinema 1: The Movement-Image* (trans. H. Tomlinson and B. Habberjam), London: Athlone Press.

Dernie, D. (2010), *Architectural Drawing*, London: Laurence King Publishing.

Deleuze, G. (2000), *Cinema 2: The Time-Image* (trans. H. Tomlinson and R. Galeta), London: Athlone Press.

DeLillo, D. (1985), *White Noise*, New York: Picador.

Díaz Alonso, H. (2010), 'Exuberance, I don't know; excess, I like', in M. Colletti (ed.), *Architectural Design (Exuberance: New Virtuosity in Contemporary Architecture)*, vol. 80, no. 2, London: Wiley, pp. 70–77.

Dimendberg, E. (2013), *Diller Scofidio + Renfro: Architecture after Images*, Chicago and London: University of Chicago Press.

Dunn, N. (2012), *Digital Fabrication in Architecture*, London: Laurence King Publishing.

Dunning, W. V. (1991), *Changing Images of Pictorial Space: A History of Spatial Illusion in Painting*, Syracuse: Syracuse University Press.

Edwards, B. (2008), *Understanding Architecture Through Drawing*, Abingdon and New York: Taylor & Francis.

Elder, R. B. (2007), 'Hans Richter and Viking Eggeling: The dream of universal language and the birth of absolute film', in A. Graf and D. Scheunemann (eds), *Avant-Garde Film*, Amsterdam and New York: Rodopi, pp. 3–53.

Elkins, T. H. and Hofmeister, B. (2005), *Berlin: The Spatial Structure of a Divided City*, London and New York: Methuen.

Estévez, D. and Tiné, G. (2008), 'Project and projections: Some advantages of the principle of opacity', in M. Carpo and F. Lemerle (eds), *Perspective, Projections & Designs: Technologies of Architectural Representation*, London and New York: Routledge, pp. 163–73.

Etherington, R. (2011), 'The Golden Age: The Simulation by Paul Nicholls', *Dezeen*, 13 July, http://www.dezeen.com/2011/07/13/the-golden-age-the-simulation-by-paul-nicholls/. Accessed 5 November 2020.

Etlin, R. A. (1994), *Symbolic Space: French Enlightenment Architecture and Its Legacy*, Chicago and London: University of Chicago Press.

Farrelly, L. (2009), *Basics Architecture 01: Representational Techniques*, Lausanne: AVA Publishing.

Fear, B. (ed.) (2000), *Architecture + Film II (Architectural Design)*, London: Wiley.

Fear, B. (ed.) (2001), *Architecture + Animation (Architectural Design)*, London: Wiley.

Ferriss, H. (1929), *The Metropolis of Tomorrow*, New York: Ives Washburn Publisher.

Fischer, L. (ed.) (2015), *Art Direction & Production Design*, New Brunswick: Rutgers University Press.

Fischer-Lichte, E. (2008), *The Transformative Power of Performance: A New Aesthetics* (trans. S. I. Jain), London and New York: Routledge.

Flowers, B. (2009), *Skyscraper: The Politics and Power of Building New York City in the Twentieth Century*, Philadelphia: University of Philadelphia Press.

Foote, J. (2015), 'Extracting desire: Michelangelo and the *forza di levare* as an architectural premise', in M. Mindrup (ed.), *The Material Imagination: Reveries on Architecture and Matter*, Farnham: Ashgate, pp. 29–45.

Foster, H. (2013), *The Art-Architecture Complex*, London and New York: Verso.

Frassinelli, G. P. (1971), 'Twelve cautionary tales for Christmas', *Architectural Design*, 41:12 (December), pp. 737–42, 785.

Frassinelli, P. (2003), 'Journey to the end of architecture', in P. Lang and W. Menking (eds), *Superstudio: Life without Objects*, Milan: Skira, pp. 79–83.

Frazer, J. (2013), 'The Architectural Relevance of Cyberspace', in Carpo, M. (ed.), *The Digital Turn in Architecture 1992–2012*, London: Wiley, pp. 48–56.

Frearson, A. (2012), 'The Golden Age: Somewhere by Paul Nicholls', *Dezeen*, 9 March, http://www.dezeen.com/2012/03/09/the-golden-age-somewhere-by-paul-nicholls/. Accessed 5 November 2020.

Frearson, A. (2013), '*Rubix* by Chris Kelly', *Dezeen*, 13 June, from http://www.dezeen.com/2011/07/13/the-golden-age-the-simulation-by-paul-nicholls/. Accessed 5 November 2020.

Friedman, Y. (2020), *L'architecture mobile: Vers une cité conçue par ses habitants eux-mêmes (1958–2020)*, Paris: Éditions de l'Éclat.

Frotscher, E. and Frotscher, F. (2013), *Imagine: Fictional Architecture and the Liberation of Ideas*, Muharraq: Bin Matar House.

Frye, N. (1973), *Anatomy of Criticism: Four Essays*, Princeton: Princeton University Press.

Garcia, M. (2013), 'Emerging technologies and drawings: The futures of images in architectural design', in N. Spiller (ed.), *Architectural Design* 83 (*Drawing Architecture*), Issue 5 (September/October), London: Wiley, pp. 28–35.

Giddings, B. and Horne, M. (2005), *Artists' Impressions in Architectural Design*, London and New York: Spon Press.

Gombrich, E. H. (1984), *Art and Illusion: A Study in the Psychology of Pitorial Representation*, London: Phaidon Press.

Gregory, P. (2003), *New Scapes: Territories of Complexity*, Basel and Boston: Birkhauser.

Groihofer, B. (ed.) (2011), *Raimund Abraham: [Un]built*, Vienna and New York: SpringerWienNewYork.

Grootenboer, H. (2005), *The Rhetoric of Perspective: Realism and Illusionism in Seventeenth-Century Dutch Still-Life Painting*, Chicago and London: University of Chicago Press.

Grotowski, J. (2002), 'Towards a poor theatre', in E. Barba (ed.), *Towards a Poor Theatre*, New York: Routledge, pp. 15–25.

Guney, Y. I. (2007), 'Type and typology in architectural discourse', *Balikesir Universitesi Fen Bilimleri Enstitüsü Dergisi*, 9:2, pp. 3–18.

Gutting, G. (ed.) (2005), *The Cambridge Companion to Foucault*, Cambridge and New York: Cambridge University Press.

Hall, J. S. (1993), 'Utility fog: A universal physical substance', in G. A. Landis (ed.), *Vision-21: Interdisciplinary Science and Engineering in the Era of Cyberspace*, Westlake: NASA Publication, pp. 115–16.

Hanson, E. (2000), 'Digital fictions: New realism in film architecture', in B. Fear (ed.), *Architecture + Film II (Architectural Design)*, London: Wiley, pp. 62–69.

Hanson, M. (2005), *The Science Behind the Fiction: Building Sci-Fi Moviescapes*, Burlington: Focal Press.

Harbison, R. (1993), *The Built, the Unbuilt & the Unbuildable: In Pursuit of Architectural Meaning*, London: Thames & Hudson.

Haque, U. (2007), 'Distinguishing concepts: Lexicons of interactive art and architecture', in L. Bullivant (ed.), *Architectural Design (4dsocial: Interactive Design Environments)*, vol. 77, no. 4, London: Wiley, pp. 24–31.

Heisenberg, W. (1958), 'The representation of nature in contemporary physics', *Daedalus (Symbolism in Religion and Literature)*, 87:3, pp. 95–108.

Hensel, M. (2006), 'Computing self-organisation: Environmentally sensitive growth modelling', in M. Hensel (ed.), *Architectural Design (Techniques and Technologies in Morphogenetic Design)*, vol. 76, no. 2, London: Wiley, pp. 12–17.

Hepp, A. (2013), *Cultures of Mediatization*, Cambridge and Malden: Polity Press.

Herf, J. (2002), 'The emergence and legacies of divided memory: Germany and the Holocaust after 1945', in J. W. Müller (ed.), *Memory and Power in Post-War Europe: Studies in the Presence of the Past*, Cambridge: Cambridge University Press, pp. 184–205.

Higgins, H. B. (2009), *The Grid Book*, Cambridge and London: MIT Press.

Hill, J. (ed.) (2005), *Occupying Architecture: Between the Architect and the User*, London and New York: Routledge.

Hill, J. (2006), *Immaterial Architecture*, New York: Routledge.

Hjarvard, S. (2013), *The Mediatization of Culture and Society*, London and New York: Routledge.

Hodgson, G. (2006), 'The American century', in C. Bigsby (ed.), *The Cambridge Companion to Modern American Culture*, Cambridge and New York: Cambridge University Press, pp. 33–52.

Holmes, K. (2011), 'Are Factory Fifteen inventing the future of architecture?', *The Creators Project*, 23 August, http://thecreatorsproject.vice.com/blog/are-factory-fifteen-inventing-the-future-of-architecture. Accessed 5 November 2020.

Jacobs, J. (1961), *The Death and Life of Great American Cities*, New York: Vintage Books.

Jackowski, N. and de Ostos, R. (2007), *The Hanging Cemetery of Baghdad* (ed. L. Woods), Vienna: SpringerWienNewYork.

Jackowski, N. and de Ostos, R. (n.d.), *The Hanging Cemetery of Baghdad*, http://naja-deostos.com/projects/the-hanging-cemetery-of-baghdad/. Accessed 5 November 2020.

Jameson, F. (2007), *Archaeologies of the Future: The Desire Called Utopia and Other Science Fictions*, London and New York: Verso.

Jencks, C. (1997), *The Architecture of the Jumping Universe: A Polemic – How Complexity Science Is Changing Architecture and Culture*, London: Academy Editions.

Johnson, P. and Wigley, M. (1988), *Deconstructivist Architecture*, Boston: Little, Brown.

Jon Ahi, M. and Karaoghlanian, A. (2012), 'Panic Room', *Interiors*, http://www.intjournal. com/0112/panic-room/. Accessed 5 November 2020.

Jurgensen, John (2009), 'Hollywood's Favorite Cowboy', interview with Cormac McCarthy, *The Wall Street Journal*, 20 November, https://www.wsj.com/articles/SB10001424052748 7045762045745297035772745572. Accessed: 22 February 2023.

Kandeler-Fritsch, M. and Kramer, T. (eds) (2005), *Get Off of My Cloud: Wolf D. Prix: Coop Himmelb(l)au, texts 1968–2005*, Ostfildern: Hatje Cantz.

Kaufmann, E. (1952), *Three Revolutionary Architects: Boullée, Ledoux and Lequeu*, Philadelphia: The American Philosophical Society.

Keller, E. (2003), *Chronomorphology: Active Time in Architecture*, New York: Columbia University in the City of New York.

Kelly, C. (2013), *Time and Relative Dimensions in Space TARDIS: The Possibilities of Utilising Virtual[ly Impossible] Environments in Architecture*, London: The University of Greenwich.

Kipnis, J. (2007), 'Diagram', in P. Dean (ed.), *Hunch 11: Rethinking Representation*, The Berlage Institute Report, Rotterdam: Episode Publishers, 2007, pp. 86–90.

Klein, T. (n.d.), *Contoured Embodiment*, http://art.kleintobias.com/contoured-embodiment. Accessed 5 November 2020.

Klein, T. (2015), *Studio Tobias Klein: Works and Ideas*, https://www.kleintobias.com/. Accessed 5 November 2020.

Kleiner, F. S. (2014), *Gardner's Art through the Ages: The Western Perspective*, Boston: Cengage Learning.

Kobiałka, M. (2009), *Further On, Nothing: Tadeusz Kantor's Theatre*, Minneapolis and London: University of Minnesota Press.

al-Kodmany, K. and Ali, M. M. (2013), *The Future of the City: Tall Buildings and Urban Design*, Southampton and Boston: WIT Press.

Koeck, R. (2013), *Cine\Scapes: Cinematic Spaces in Architecture and Cities\Scapes: Cinematic Spaces in Architecture and Cities*, New York and London: Routledge.

Kolarevic, B. (2003), 'Digital morphogenesis' in B. Kolarevic (ed.), *Architecture in the Digital Age: Design and Manufacturing*, New York and London: Spon Press, pp. 17–45.

Koolhaas, R. (1994), *Delirious New York: A Retroactive Manifesto for Manhattan*, New York: Monacelli Press.

Lambert, L. (2011), '#STUDENTS /// Royal Cabinets/Re-Formation by Paul Nicholls', *The Funambulist*, 12 April, http://thefunambulist.net/2011/04/12/students-royal-cabinetsre-formation-by-paul-nicholls/. Accessed 5 November 2020.

Lamster, M. (2009), 'Underground architects', *Design Observer*, 20 September, http://designo bserver.com/feature/underground-ar/20058/. Accessed 5 November 2020.

Lang, P. (2003), 'Suicidal desires', in P. Lang and W. Menking (eds), *Superstudio: Life without Objects*, Milan: Skira, pp. 31–51.

Lang, P. and Menking, W. (2003a), 'Only architecture will be our lives', in P. Lang and W. Menking (eds), *Superstudio: Life without Objects*, Milan: Skira, pp. 11–29.

Lang, P. and Menking, W. (2003b), 'Superexistence: Life and death', in P. Lang and W. Menking (eds), *Superstudio: Life without Objects*, Milan: Skira, pp. 79–83.

Leach, N. (ed.) (1997), *Rethinking Architecture: A Reader in Cultural Theory*, London and New York: Routledge.

Leach, N. (2009), 'Digital morphogenesis', in L. P. Puglisi (ed.), *Architectural Design (Theoretical Meltdown)*, vol. 79, no. 1, London: Wiley, pp. 32–37.

Levine, N. (2009), *Modern Architecture: Representation & Reality*, New Haven and London: Yale University Press.

Lima, A. I. (2003), *Soleri: Architecture as Human Ecology*, New York: Monacelli Press.

Lynn, G. (1998), 'The folded, the pliant and the supple', in G. Lynn (ed.), *Folds, Bodies & Blobs: Collected Essays*, Bruxelles: La Lettre volée, pp. 109–33.

Lyssiotis, P. and McQuire, S. (2000), 'Liquid architecture: Eisenstein and film noir', in B. Fear (ed.), *Architecture + Film II (Architectural Design)*, London: Wiley, pp. 6–8.

MacLeod, S., Hanks, L. H. and Hale, J. (eds) (2012), *Museum Making: Narratives, Architectures, Exhibitions*, London and New York: Routledge.

Madge, J. and Peckham, A. (eds) (2006), *Narrating Architecture: A Retrospective Anthology*, London and New York: Routledge.

Mandoul, T. (2008), 'From rationality to Utopia: Auguste Choisy and axonometric projection', in M. Carpo and F. Lemerle (eds), *Perspective, Projections & Designs: Technologies of Architectural Representation*, London and New York: Routledge, pp. 151–62.

Manovich, L. (2001), *The Language of New Media*, Cambridge and London: MIT Press.

Marin, L. (1973), *Utopiques: Jeux d'espaces*, Paris: Les Éditions de Minuit.

Matsuda, K. (2010), *Domesti/City: The Dislocated Home in Augmented Space*, London: Bartlett School of Architecture.

Maturana, H. R. and Varela, F. J. (1980), *Autopoiesis and Cognition: The Realization of the Living*, Dordrecht, Boston and London: D. Reidel Publishing Company.

Maynard, P. (2005), *Drawing Distinctions: The Varieties of Graphic Expression*, Ithaca, NY, and London: Cornell University Press.

McClean, S. T. (2007), *Digital Storytelling: The Narrative Power of Visual Effects in Film*, Cambridge and London: MIT Press.

McCloud, S. (1994), *Understanding Comics: The Invisible Art*, New York: HarperPerennial.

McKernan, B. (2005), *Digital Cinema: The Revolution in Cinematography, Post-Production, and Distribution*, New York and Chicago: McGraw-Hill.

Minghelli, G. (2013), *Landscape and Memory in Post-Fascist Italian Film: Cinema Year Zero*, New York and London: Routledge.

Modena, L. (2011), *Italo Calvino's Architecture of Lightness: The Utopian Imagination in an Age of Urban Crisis*, New York and London: Routledge.

Moholy-Nagy, L. (1947), *Vision in Motion*, Chicago: Paul Theobald.

More, G. (2001), 'Animated techniques: Time and the technological acquiescence of animation', in B. Fear (ed.), *Architecture + Animation (Architectural Design)*, London: Wiley, pp. 20–27.

Morris, M. (2013), 'All night long: The architectural jazz of the Texas Rangers', in N. Spiller (ed.), *Architectural Design (Drawing Architecture)*, vol. 83, no. 5, London: Wiley, pp. 20–27.

Morrison, J. (1998), *Passport to Hollywood: Hollywood Films, European Directors*, Albany: State University of New York Press.

Moylan, T. (2000), *Scraps of the Untainted Sky: Science Fiction, Utopia, Dystopia*, Boulder, CO: Westview Press.

Murray, T. (2008), *Digital Baroque: New Media Art and Cinematic Folds*, Minneapolis and London: University of Minnesota Press.

Nesbitt, L. E. (2015), 'Man in the metropolis: The graphic projections of Brodsky & Utkin', in L. Nesbitt (ed.), *Brodsky & Utkin*, New York: Princeton Architectural Press, pp. 5–14.

Nichols, C. (2016), 'Environments: A major key to VR's success', *Computer Graphics World*, 39:2, pp. 6–8.

Noë, A. (2004), *Action in Perception*, Cambridge and London: MIT Press.

Noever, P. (1992), 'Introduction', in L. Woods (1992), *Anarchitecture: Architecture Is a Political Act*, London: Academy Editions, pp. 6–7.

Nora, P. (1989), 'Between memory and history: Les Lieux de Memoire', *Representations (Memory and Counter-Memory)*, 26, pp. 7–24.

Pai, H. (2002), *The Portfolio and the Diagram: Architecture, Discourse, and Modernity in America*, Cambridge and London: MIT Press.

Pallasmaa, J. (2007), *The Architecture of Image: Existential Space in Cinema* (trans. M. Wynne-Ellis), Helsinki: Rakennustieto Publishing.

Palmer, A. L. (2008), *Historical Dictionary of Architecture*, Lanham and Toronto: The Scarecrow Press.

Panofsky, E. (1991), *Perspective as Symbolic Form* (trans. C. S. Wood), New York: Zone Books.

Parr, A. (ed.) (2010), *The Deleuze Dictionary*, Edinburgh: Edinburgh University Press.

Patton, P. (1995), 'Introduction', in J. Baudrillard (1995), *The Gulf War Did Not Take Place* (trans. P. Patton), Bloomington and Indianapolis: Indiana University Press, pp. 1–21.

Paz, O. (1978), *Marcel Duchamp: Appearance Stripped Bare* (trans. R. Phillips and D. Gardner), New York: Arcade Publishing.

Pehnt, W. (1985), *Expressionist Architecture in Drawings* (trans. J. Gabriel), New York: Van Nostrand Reinhold Company.

Penz, F. (2003), 'Introduction', in F. Penz and M. Thomas (eds), *Architectures of Illusion: From Motion Pictures to Navigable Interactive Environments*, Bristol and Portland: Intellect Books, pp. vii–xiii.

Pérez-Gómez, A. and Pelletier, L. (2000), *Architectural Representation and the Perspective Hinge*, Cambridge and London: MIT Press.

Picchione, J. (2009), 'Baroque poetry in Italy: Deception, illusion, and epistemological shifts', in L. A. Boldt-Irons (ed.), *Disguise, Deception, Trompe-l'oeil: Interdisciplinary Perspectives*, New York: Peter Lang, pp. 61–70.

Picon, A. (2015), *Smart Cities: A Spatialised Intelligence*, London: Wiley.

Pizzigoni, V. (2015), 'Superstudio's utopia and classicism', in A. Angelidakis, V. Pizzigoni and V. Scelsi (eds), *Super Superstudio*, Milan: SilvanaEditoriale, pp. 22–31.

Plato (1992), *Republic* (trans. G. M. A. Grube), Indianapolis and Cambridge: Hackett Publishing Company.

Potié, P. (2008), 'Sophisticated geometry, baroque composition', in M. Carpo and F. Lemerle (eds), *Perspective, Projections & Designs: Technologies of Architectural Representation*, London and New York: Routledge, pp. 105–13.

Prina, D. N. (2015), 'Superstudio's dystopian tales: Textual and graphic practice as operational method', *Writing Visual Culture*, 6, pp. 1–19.

Prince, S. (2012), *Digital Visual Effects in Cinema: The Seduction of Reality*, New Brunswick: Rutgers University Press.

Psarra, S. (2009), *Architecture and Narrative: The Formation of Space and Cultural Meaning*, Abingdon and New York: Routledge.

Purse, L. (2013), *Digital Imaging in Popular Cinema*, Edinburgh: Edinburgh University Press.

Rainey, L., Poggi, C. and Wittman, L. (eds) (2009), *Futurism: An Anthology*, New Haven and London: Yale University Press.

Ramírez, J. A. (2012), *Architecture for the Screen: A Critical Study of Set Design in Hollywood's Golden Age* (trans. J. F. Moffitt), Jefferson: McFarland.

Reed, S. A. (2013), *Assimilate: A Critical History of Industrial Music*, Oxford and New York: Oxford University Press.

Richter, D. (2014), 'Welcome to Ordos, China: The world's largest "ghost city"', *The Bohemian Blog*, 13 February, http://www.thebohemianblog.com/2014/02/welcome-to-ordos-world-largest-ghost-city-china.html. Accessed 5 November 2020.

Rickitt, R. (2000), *Special Effects: The History and Technique*, New York: Billboard Books.

Riley, T. (ed.) (2002), *The Changing of the Avant-Garde: Visionary Architectural Drawings from the Howard Gilman Collection*, New York: Museum of Modern Art.

Robertson, B. (2003), 'Painting the town', *Computer Graphics World*, 26:9, http://www.cgw.com/Publications/CGW/2003/Volume-26-Issue-9-September-2003-/Painting-the-town.aspx. Accessed 5 November 2020.

Robinson, M. (ed.) (2009), *The Cambridge Companion to August Strindberg*, Cambridge and New York: Cambridge University Press.

Rossi, A. (1982), *The Architecture of the City* (trans. D. Ghirardo and J. Ockman), Cambridge and London: MIT Press.

Rowe, C. and Koetter, F. (1983), *Collage City*, Cambridge and London: MIT Press.

Rumsey, F. and Watkinson, J. (2013), *Digital Interface Handbook in Kolarevic*, Burlington and Abingdon: Focal Press.

al-Saati, M. Z., Botta, D. and Woodbury, R. (2005), 'The emergence of architectural animation: What architectural animation brought to the fore and pushed to the background', *International Scientific Journal Architecture and Engineering*, 1:1, pp. 1–7, https://doi.org/10.15640/jea. Accessed 14 July 2016.

Sadler, S. (2005), *Archigram: Architecture without Architecture*, Cambridge and London: MIT Press.

Samuel, F. (2015), 'Architectural promenades through the Villa Savoye', in P. B. Jones and M. Meagher (eds), *Architecture and Movement: The Dynamic Experience of Buildings and Landscapes*, London and New York: Routledge, pp. 44–49.

Sant'Elia, A. ([1914] 2009), 'Futurist architecture', in L. Rainey, C. Poggi and L. Wittman (eds), *Futurism: An Anthology*, New Haven and London: Yale University Press, pp. 198–202.

Saunders, Z. (n.d.), 'Interview with Marjan Colletti', *Arch2O*, http://www.arch2o.com/interv iew-with-marjan-colletti-arch2o/. Accessed 5 November 2020.

Schaal, H. D. (2000), 'Spaces of the psyche in German expressionist film', in B. Fear (ed.), *Architecture + Film II (Architectural Design)*, London: Wiley, pp. 12–15.

Schaedler, T. (2015), 'The art of designing digital sets', *Computer Graphics World*, 38:6, pp. 6–7.

Schaffner, A. K. (2010), 'From concrete to digital: The reconceptualization of poetic space', in J. Schäfer and P. Gendolla (eds), *Beyond the Screen: Transformations of Literary Structures, Interfaces and Genres*, Bielefeld: Transcript Verlag, pp. 179–97.

Scheer, D. R. (2014), *The Death of Drawing: Architecture in the Age of Simulation*, London and New York: Routledge.

Schuiten, F. and Peeters, B. (1985), *La fièvre d'Urbicande*, Bruxelles: Casterman.

Schwarzer, M. (2004), *Zoomscape: Architecture in Motion and Media*, New York: Princeton Architectural Press.

Scolari, M. (2012), *Oblique Drawing: A History of Anti-Perspective*, Cambridge, London: MIT Press.

Sennott, S. (ed.) (2004), *Encyclopedia of 20th-Century Architecture*, vol. 1, New York and London: Fitzroy Dearborn.

Shannon, C. E. (1948), 'A mathematical theory of communication', *The Bell System Technical Journal*, 27: 3, pp. 379–423.

Shepard, W. (2015), 'The myth of China's ghost cities', *Reuters*, 22 April, http://blogs.reuters.com/great-debate/2015/04/21/the-myth-of-chinas-ghost-cities/. Accessed 5 November 2020.

Shiel, M. (2006), *Italian Neorealism: Rebuilding the Cinematic City*, London and New York: Wallflower.

Shields, J. A. E. (2013), *Collage and Architecture*, New York and London: Routledge.

Shimamura, A. P. (ed.) (2013), *Psychocinematics: Exploring Cognition at the Movies*, Oxford and New York: Oxford University Press.

Sim, S. (ed.) (2011), *The Lyotard Dictionary*, Edinburgh: Edinburgh University Press.

Sito, T. (2013), *Moving Innovation: A History of Computer Animation*, Cambridge and London: MIT Press.

Sky, A. and Stone, M. (1976), *Unbuilt America: Forgotten Architecture in the United States from Thomas Jefferson to the Space Age*, New York: McGraw-Hill.

Smith, K. S. (2005), *Architects' Drawings: A Selection of Sketches by World Famous Architects through History*, Amsterdam: Architectural Press.

Smith, K. S. (2008), *Architects' Sketches: Dialogue and Design*, Amsterdam: Architectural Press.

So, S. (2009a), 'Hong Kong labyrinths', in N. Clear (ed.), *Architectural Design (Architectures of the Near Future)*, vol. 79, no. 5, London: Wiley, pp. 36–41.

So, S. (2009b), 'Soki So | 2009 | Hong Kong Labyrinths', *unitfifteen-archive*, http://www.unit fifteen-archive.com/Hong-Kong-Labyrinths-Soki-So. Accessed 5 November 2020.

Solomon, C. (1987), 'Animation: Notes on a definition', in C. Solomon (ed.), *The Art of the Animated Image: An Anthology*, Los Angeles: The American Film Institute, pp. 9–12.

Sorkin, M. (1991), *Exquisite Corpse: Writing on Buildings*, London and New York: Verso.

Sorkin, M. (2011), *All Over the Map: Writing on Buildings and Cities*, New York and London: Verso.

Spiller, N. (1998), *Digital Dreams: Architecture and Cyberspace*, London: Ellipsis.

Spiller, N. (2000), 'Towards an animated architecture against architectural animation', in B. Fear (ed.), *Architecture + Film II (Architectural Design)*, London: Wiley, pp. 83–85.

Spiller, N. (2007), *Visionary Architecture: Blueprints of the Modern Imagination*, London: Thames & Hudson.

Spiller, N. (2008), *Digital Architecture Now: A Global Survey of Emerging Talent*, London: Thames & Hudson.

Spiller, N. (2008–13), 'Architectural drawing: Grasping for the fifth dimension', unpublished.

Spiller, N. (2010), 'Liberating the infinite architectural substance', in P. Beesley (ed.), *Hylozoic Ground: Liminal Responsive Architecture*, Toronto: Riverside Architectural Press, pp. 50–55.

Spuybroek, L. and Pélenc, A. (2008), 'The soft machine of vision', in L. Spuybroek (ed.), *The Architecture of Continuity: Essays and Conversations*, Rotterdam: V2_publishing, pp. 94–111.

Staiger, J. (2003), 'Hybrid or inbred: The purity hypothesis and Hollywood genre history', in B. K. Grant (ed.), *Film Genre Reader III*, Austin: University of Texas Press, pp. 185–99.

Stasiowski, M. (2017), 'Houses for Descartes: Grid pattern as an ambiguous image in a critique of utopian megastructures and modernistic uniformity', *The International Journal of the Image*, 8:3, pp. 9–22.

Steiner, H. A. (2009), *Beyond Archigram: The Structure of Circulation*, London and New York: Routledge.

Superstudio (1971), 'Storyboard of *The Continuous Monument*', *Casabella*, 358, pp. 20–23.

Suvin, D. (1977), *Metamorphoses of Science Fiction: On the Poetics and History of a Literary Genre*, New Haven and London: Yale University Press.

Tafuri, M. (1976), *Architecture and Utopia: Design and Capitalist Development*, Cambridge and London: MIT Press.

Tafuri, M. (1987), *The Sphere and the Labyrinth: Avant-Gardes and Architecture from Piranesi to the 1970s* (trans. P. d'Acierno and R. Connolly), Cambridge and London: MIT Press.

Tafuri, M. (1998), 'Toward a critique of architectural ideology' (S. Sartarelli trans., K. M. Hays ed.), *Architecture Theory since 1968*, Cambridge and London: MIT Press, pp. 2–35.

Tashiro, C. S. (1998), *Pretty Pictures: Production Design and the History Film*, Austin: University of Texas Press.

Tawa, M. (2011), *Agencies of the Frame: Tectonic Strategies in Cinema and Architecture*, Newcastle upon Tyne: Cambridge Scholars Publishing.

Teyssot, G. (1994), 'The Mutant Body of Architecture' (trans. J. Svoboda) in E. Diller and R. Scofidio (eds), *Flesh: Architectural Probes*, New York: Princeton Architectural Press, pp. 8–35.

Thomine-Berrada, A. (2008), 'Pictorial versus intellectual representation', in M. Carpo and F. Lemerle (eds), *Perspective, Projections & Designs: Technologies of Architectural Representation*, London and New York: Routledge, pp. 141–50.

Tierney, T. (2007), *Abstract Space: Beneath the Media Surface*, Abingdon and New York: Taylor & Francis.

Trancik, R. (1986), *Finding Lost Space: Theories of Urban Design*, New York and Chichester: Wiley & Sons.

Tschumi, B. (1994), *The Manhattan Transcripts*, London: Academy Editions.

Tschumi, B. (1996), *Architecture and Disjunction*, Cambridge and London: MIT Press.

Tschumi, B. (2012), *Architecture Concepts: Red Is Not a Color*, New York: Rizzoli International Publications.

Unwin, S. (2009), *Analysing Architecture*, London and New York: Routledge.

Upton, D. (2009), 'Signs taken for wonders', in A. Vinegar and M. J. Golec (eds), *Relearning from Las Vegas*, Minneapolis and London: University of Minnesota Press, pp. 147–62.

Venturi, R. (2002), *Complexity and Contradiction in Architecture*, New York: The Museum of Modern Art.

Venturi, R., Scott-Brown, D. and Izenour, G. (1972), *Learning from Las Vegas*, Cambridge: MIT Press.

Vidler, A. (2000), *Warped Space: Art, Architecture, and Anxiety in Modern Culture*, Cambridge and London: MIT Press.

Vinegar, A. and Golec, M. J. (eds) (2009), *Relearning from Las Vegas*, Minneapolis and London: University of Minnesota Press.

Virilio, P. (2005a), *Desert Screen: War at the Speed of Light* (trans. M. Degener), London and New York: Continuum.

Virilio, P. (2005b), *The Information Bomb* (trans. C. Turner), London and New York: Verso.

Vitruvius Pollio, M. (1931), *On Architecture* (trans. F. Granger), London and New York: William Heinemann Ltd.–G.P. Putnam's Sons.

Vonnegut, K. (2009), *The Sirens of Titan*, New York: Dial Press.

Vyzoviti, S. (2004), *Folding Architecture: Spatial, Structural and Organizational Diagrams*, Amsterdam: BIS Publishers.

Walker, S. (2009), *Gordon Matta-Clark: Art, Architecture and the Attack on Modernism*, London and New York: I.B. Tauris.

Warlamis, E. (2005), *Poetic Architecture*, London: New Architecture.

Waugh, P. (2003), *Metafiction: The Theory and Practice of Self-Conscious Fiction*, London and New York: Routledge.

Webb, M. (1987), *Temple Island: A Study by Michael Webb*, London: Architectural Association Publications.

Webb, M. (2014), 'Landschaft: Revisiting the journey and drive-in house', in B. Sheil (ed.), *Architectural Design (High Definition: Zero Tolerance in Design and Production)*, vol. 84, no. 1, London: Wiley, pp. 60–73.

Webb, M. (n.d.), 'Temple Island', *The Archigram Archival Project*, http://archigram.westmins ter.ac.uk/project.php?id=236&src=9. Accessed 5 November 2020.

Wees, W. C. (1992), *Light Moving in Time: Studies in the Visual Aesthetics of Avant-Garde Film*, Berkeley: University of California Press.

Wells, P. (1998), *Understanding Animation*, London and New York: Routledge.

Wells, P. (2006), *The Fundamentals of Animation*, Lausanne: Ava Publishing.

Welter, V. M. (2008), 'Lebbeus Woods, *Underground Berlin Project*, 1988', http://images.friedm anbenda.com/www_friedmanbenda_com/Woods_BerlinFinalReportVolker.pdf. Accessed 5 November 2020.

Wigley, M. (1993), *The Architecture of Deconstruction: Derrida's Haunt*, Cambridge and London: MIT Press.

Wigley, M. (1998), *Constant's* New Babylon: *The Hyper-Architecture of Desire*, Aldershot and Burlington: 010 Publishers.

Woods, L. (1989), *OneFiveFour*, New York: Princeton Architectural Press.

Woods, L. (1992), *Anarchitecture: Architecture Is a Political Act*, London: Academy Editions.

Woods, L. (1993), *War and Architecture (Pamphlet Architecture 15)*, New York: Princeton Architectural Press.

Woods, L. (1997), *Radical Reconstruction*, New York: Princeton Architectural Press.

Woods, L. (2004), 'Taking on risk: Nine experimental scenarios', http://www.lebbeuswoods. net/CARNEGIE.pdf. Accessed 5 November 2020.

Woods, L. (2009), '*Underground Berlin*: The film treatment', *Lebbeus Woods*, 15 September, https://lebbeuswoods.wordpress.com/2009/09/15/underground-berlin-the-film-treatment/ . Accessed 5 November 2020.

Woods, L. (2010), 'ANTI – journey to architecture', *Lebbeus Woods*, 9 March, https://lebbeuswo ods.wordpress.com/2010/03/09/anti-journey-to-architecture/. Accessed 5 November 2020.

Woods, L. (2011a), 'ANTI – journey to architecture: PRELUDE', *Lebbeus Woods*, 29 June, https://lebbeuswoods.wordpress.com/2011/06/29/anti-journey-to-architecture-1/. Accessed 5 November 2020.

Woods, L. (2011b), 'ANTI – journey to architecture: Day 5 discussion', *Lebbeus Woods*, 22 September, https://lebbeuswoods.wordpress.com/2011/09/22/anti-journey-to-architecture-day-5-discussion/. Accessed 5 November 2020.

Yates, F. A. (1999), *The Art of Memory*, London and New York: Routledge.

Filmography

Anderson, M. (1976), *Logan's Run*, USA: United Artists.

Anderson, P. W. S. (1997), *Event Horizon*, USA: Paramount Pictures.

Annaud, J.-J. (1986), *The Name of the Rose*, USA: Columbia Pictures.

Anno, H. and Tsurumaki, K. (1997), *The End of Evangelion*, Japan: Toei Company.

Barney, M. (2002), *Cremaster 3*, USA: Palm Pictures.

Benning, J. (2004a), *13 Lakes*, USA: James Benning.

Benning, J. (2004b), *Ten Skies*, USA: James Benning.

Benning, J. (2011), *Nightfall*, USA: James Benning.

Bigelow, K. (1995), *Strange Days*, USA: Universal Pictures.

Bush, P. (2012), *Babeldom*, UK: Paul Bush Films.

Cameron, J. (1991), *Terminator 2: Judgement Day*, USA: TriStar Pictures.

Carpenter, L. (1980), *Vol Libre*, USA: Loren Carpenter.

Cavalcanti, A. (1926), *Rien que les heures*, France: Les Films du Panthéon.

Crichton, M. (1973), *Westworld*, USA: Metro-Goldwyn-Mayer.

Csuri, A. A. and Shaffer, J. (1967), *Hummingbird*, USA: MoMA.

Cuarón, A. (2013), *Gravity*, USA: Warner Bros. Pictures.

Disney, W. and Iwerks, U. (1928), *Steamboat Willie*, USA: Celebrity Productions.

Docter, P. (2001), *Monsters, Inc.*, USA: Buena Vista Pictures.

Duchamp, M. (1926), *Anemic Cinema*, France: Rrose Sélavy.

Dunning, G. (1968), *Yellow Submarine*, USA: United Artists.

Farmer, D. (2008a), *Cortical Plasticity* (video recording), unitfifteen-Archive, http://unit fifteen-archive.com/Cortical-Plasticity-Dan-Farmer. Accessed 5 November 2020.

Farmer, D. (2008b), *Synaptic Landscapes* (video recording), YouTube, https://www.youtube.com/watch?v=vQ45S2NkbDU. Accessed 26 November 2018.

Ferdand, L. (1924), *Ballet Mécanique*, France: Fernard Leger.

Fincher, D. (1992), *Alien³*, USA: 20th Century Fox.

Fincher, D. (2002), *Panic Room*, USA: Columbia Pictures.

Fincher, D. (2014), *Gone Girl*, USA: 20th Century Fox.

Foldes, P. (1971), *Metadata*, Canada: NFB.

Folman, A. (2013), *The Congress*, France: ARP Sélection.

Francis, L. (2013), *The Hunger Games: Catching Fire*, USA: Lionsgate Films.

Francis, L. (2014), *The Hunger Games: Mockingjay – Part 1*, USA: Lionsgate Films.

Francis, L. (2015), *The Hunger Games: Mockingjay – Part 2*, USA: Lionsgate Films.

Gales, J. (2010a), *Speculative Landscape* (video recording), Vimeo, https://vimeo.com/16562 542. Accessed 5 November 2020.

Gales, J. (2010b), *The Pentecostal Ministry of Fire* (video recording), Vimeo, https://vimeo.com/12084636. Accessed 5 November 2020.

Gales, J. (2011), *Megalomania* (video recording), Vimeo, https://vimeo.com/38091515. Accessed 5 November 2020.

Gilliam, T. (1985), *Brazil*, USA: 20th Century Fox.

Gilliam, T. (1995), *12 Monkeys*, USA: Universal Pictures.

Gilliam, T. (1998), *Fear and Loathing in Las Vegas*, USA: Universal Pictures.

Gilliam, T. (2013), *The Zero Theorem*, USA: Stage 6 Films.

Heffron, R. (1976), *Futureworld*, USA: American International Pictures.

Hillcoat, J. (2009), *The Road*, USA: Dimension Films.

Hitchcock, A. (1927), *The Lodger: A Story of the London Fog*, UK: Woolf & Freedman Film Service.

Hitchcock, A. (1940), *Rebecca*, USA: United Artists.

Hitchcock, A. (1946), *Notorious*, USA: RKO Radio Pictures.

Hitchcock, A. (1948), *Rope*, USA: Warner Bros. Pictures.

Hitchcock, A. (1954a), *Dial M for Murder*, USA: Warner Bros.

Hitchcock, A. (1954b), *Rear Window*, USA: Paramount Pictures.

Hitchcock, A. (1958), *Vertigo*, USA: Paramount Pictures.

Hitchcock, A. (1960), *Psycho*, USA: Paramount Pictures.

Hopper, D. (1969), *Easy Rider*, USA: Columbia Pictures.

Howard, R. (1988), *Willow*, USA: Metro-Goldwyn-Mayer.

Hughes, A. and Hughes, A. (2010), *The Book of Eli*, USA: Summit Entertainment.

Iñárritu, A. G. (2014), *Birdman (The Unexpected Virtue of Ignorance)*, USA: Fox Searchlight Pictures.

Kahrs, J. (2012), *Paperman*, USA: Walt Disney Studios Motion Pictures.

Kamnitzer, P. (1970), *CityScape*, France: Light Cone.

Keiichi M. (2010a), *Augmented (Hyper)Reality: Augmented City 3D* (video recording), Vimeo, https://vimeo.com/14294054. Accessed 5 November 2020.

Keiichi M. (2010b), *Augmented (Hyper)Reality: Domestic Robocop* (video recording), Vimeo, https://vimeo.com/8569187. Accessed 5 November 2020.

Kelly, C. (2013), *Rubix/Tardis* (video recording), Vimeo, https://vimeo.com/67994387. Accessed 5 November 2020.

Knowlton, K. and VanDerBeek, S. (1964– 67), *Poem Field* series, France: Light Cone.

Kon, S. (2006), *Paprika*, Japan: Sony Pictures Entertainment Japan.

Kosinski, J. (2010), *TRON: Legacy*, USA: Walt Disney Pictures/Sean Bailey Productions.

Kosinski, J. (2013), *Oblivion*, USA: Universal Pictures.

Kubelka, P. (1960), *Arnulf Rainer*, France: Light Cone.

Kubrik, S. (1968), *2001: A Space Odyssey*, USA: Metro-Goldwyn-Mayer.

Kurosawa, A. (1950), *Rashomon*, Japan: Daiei Motion Picture Company.

L'Herbier, M. (1924), *L'Inhumaine*, France: Cinégraphic.

Landis, J. (1991), *Black or White*, USA: Epic Records.

Lang, F. (1927), *Metropolis*, Germany: UFA.

Leonard, B. (1992), *The Lawnmower Man*, USA: New Line Cinema.

Lisberger, S. (1982), *TRON*, USA: Buena Vista Distribution.

Longo, R. (1995), *Johnny Mnemonic*, USA: 20th Century Fox.

Lucas, G. (1971), *THX 1138*, USA: Warner Bros Pictures.

Marker, C. (1997), *Immemory*, USA: Electronic Arts Intermix.

Marker, C. (1983), *Sans Soleil*, France: Argos Films.

Matsuda, K. (2007), *The Technocrat Retrofit of London* (video recording), Vimeo, https://vimeo.com/4929345. Accessed 5 November 2020.

Matsuda, K. (2016), *HYPER- REALITY* (video recording), Vimeo, https://vimeo.com/166807261. Accessed 5 November 2020.

McCay, W. (1912), *How a Mosquito Operates*, CA: Image Entertainment.

McCay, W. (1921a), *Bug Vaudeville*, USA: Image Entertainment.

McCay, W. (1921b), *The Flying House*, USA: Image Entertainment.

McCay, W. (1921c), *The Pet*, USA: Image Entertainment.

Mendes, S. (2012), *Skyfall*, USA: Sony Pictures Releasing.

Mendes, S. (2015), *Spectre*, USA: Sony Pictures Releasing.

Menzies, W. C. (1936), *Things to Come*, USA: United Artists.

Meyer, N. (1982), *Star Trek II: The Wrath of Khan*, USA: Paramount Pictures.

Montgomery, R. (1947), *Lady in the Lake*, USA: Metro-Goldwyn-Mayer.

Murnau, F. W. (1924), *The Last Laugh/The Last Man*, Germany: UFA.

Namakura, R. (1998), *Serial Experiments Lain*, Japan: TV Tokyo.

Natali, V. (1997), *Cube*, USA: Trimark Pictures.

Niccol, A. (1997), *Gattaca*, USA: Columbia Pictures.

Nicholls, P. (2010a), *Golden Age: The Simulation* (video recording), Vimeo, https://vimeo.com/26367437. Accessed 5 November 2020.

Nicholls, P. (2010b), *Royal Re-formation* (video recording), Vimeo, https://vimeo.com/12082308. Accessed 5 November 2020.

Nicholls, P. (2011), *Golden Age: Somewhere* (video recording), Vimeo, https://vimeo.com/38211080. Accessed 5 November 2020.

Noe, G. (2009), *Enter the Void*, Germany: Wild Bunch Distribution.

Nolan, C. (2010), *Inception*, USA: Warner Bros Pictures.

Oppenheimer, J. (2012), *The Act of Killing*, Denmark: Det Danske Filminstitut.

Oppenheimer, J. (2014), *The Look of Silence*, France and Germany: Why Not Productions and Koch Media.

Oshii, M. (1985), *Angel's Egg*, Japan: Tokuma Shoten Publishing Co. Ltd.

Oshii, M. (1987), *Twilight Q: Mystery Article File 538*, Japan: Network Frontier.

Oshii, M. (1989), *Patlabor: The Movie*, Japan: Shochiku.

Oshii, M. (1995), *Ghost in the Shell*, Japan: Shochiku.

Pastrone, G. (1914), *Cabiria*, USA: Kino Video.

Proyas, A. (1998), *Dark City*, USA: New Line Cinema.

Radford, M. (1984), *Nineteen Eighty-Four*, USA: 20th Century Fox.

Ray, M. (1923), *Le Retour a la Raison*, France: Man Ray.

Resnais, A. (1961), *The Last Year at Marienbad*, France: Cocinor.

Richter, H. (1921), *Rhythmus 21*, Germany: Hans Richter.

Roman, A. (2009), *The Third & The Seventh* (video recording), Vimeo, https://vimeo.com/7809605. Accessed 5 November 2020.

Ross, G. (2012), *The Hunger Games*, USA: Lionsgate Films.

Rusnak, J. (1999), *The Thirteenth Floor*, USA: Columbia Pictures.

Russell, K. (1980), *Altered States*, USA: Warner Bros Pictures.

Ruttmann, W. (1927), *Berlin: Die Sinfonie der Großstadt*, EU: Fox Europa.

Sagal, B. (1971), *Omega Man*, USA: Warner Bros Pictures.

Sakaguchi, H. (2001), *Final Fantasy: The Spirits Within*, USA: Columbia Pictures.

Scorsese, M. (2011), *Hugo*, USA: Paramount Pictures.

Scott, R. (1982), *Blade Runner*, USA: Warner Bros Pictures.

Servais, R. (1994), *Taxandria*, Sweden: ANAGRAM.

Singh, T. (2000), *The Cell*, USA: New Line Cinema.

Snow, M. (1967), *Wavelength*, Canada: Canadian Filmmakers Distribution Centre.

So, S. (2008a), *Homogeneous Multiplicity* (video recording), Vimeo, https://vimeo.com/1944340. Accessed 5 November 2020.

So, S. (2008b), *Spacetime Hybridity* (video recording), Vimeo, https://vimeo.com/1879797. Accessed 5 November 2020.

So, S. (2009), *Hong Kong Labyrinths* (video recording), Vimeo, https://vimeo.com/13499981. Accessed 5 November 2020.

Spielberg, S. (1993), *Jurassic Park*, USA: Universal Pictures.

Spielberg, S. (2002), *Minority Report*, USA: DreamWorks Pictures.

Strand, P. and Sheeler, C. (1921), *Manhatta*, France: Light Cone.

Superstudio (1972), *Life, Supersurface*, Italy: ANIC and Lanerossi.

Superstudio (1973), *Ceremony*, Italy: ANIC and Lanerossi.

Tati, J. (1967), *PlayTime*, Italy and France: Jolly Film and Specta Films.

Trousdale, G. and Wise, K. (1991), *Beauty and the Beast*, USA: Buena Vista Pictures.

Tulyahodzhaev, N. (1984), *There Will Come Soft Rains*, Uzbekistan: UzbekFilm.

Tykwer, T. (2009), *The International*, USA: Columbia Pictures.

Van Sant, G. (1991), *My Own Private Idaho*, USA: Fine Line Features.

Vertov, D. (1929), *A Man with a Movie Camera*, Ukraine: VUFKU.

Warhol, A. (1963), *Sleep*, New York: Andy Warhol.

Warhol, A. (1964), *Empire*, New York: Andy Warhol.

Weiwei, A. (2012), *Ordos 100*, China: Ai Weiwei.

Wenders, W. (1993), *Faraway, So Close!*, USA: Sony Pictures Classics.

Wheatley, B. (2015), *High-Rise*, France: StudioCanal.

Whedon, J. (2012), *The Avengers*, USA: Walt Disney Studios Motion Pictures.

Whedon, J. (2015), *Avengers: Age of Ultron*, USA: Walt Disney Studios Motion Pictures.

Whitney, J. (1961), *Catalog*, France: Light Cone.

Whitney, J. (1966), *Lapis*, France: Light Cone.

Whitney, J. (1968), *Permutations*, France: Light Cone.

Wiene, R. (1920a), *Cabinet of Dr. Caligari*, Germany: Decla-Bioscop.

Wiene, R. (1920b), *Genuine*, Germany: Decla-Bioscop.

Wiseman, L. (2012), *Total Recall*, USA: Columbia Pictures.

Yeaworth, I. S. Jr (1958), *The Blob*, USA: Paramount Pictures.

Zemeckis, R. (1994), *Forrest Gump*, USA: Paramount Pictures.

Index

Ingram Content Group UK Ltd.
Milton Keynes UK
UKHW032228300323
419436UK00004B/32

9 781789 385427